GREAT
PAINTINGS

GREAT
PAINTINGS

contents

 Penguin Random House

Senior Editor Angela Wilkes
Senior Art Editor Michael Duffy
Editors Anna Kruger, Hugo Wilkinson
Production Editor Tony Phipps
Production Controller Mandy Inness
Picture Research Sarah Smithies
Managing Editor Stephanie Farrow
Managing Art Editor Lee Griffiths
US Editors Shannon Beatty, Rachel Bozek

DK INDIA

Managing Art Editor Ashita Murgai
Managing Editor Saloni Talwar
Project Art Editor Rajnish Kashyap
Project Editor Garima Sharma
Senior Art Editor Anchal Kaushal
Assistant Designer Diya Kapur
Production Manager Pankaj Sharma
DTP Manager Balwant Singh
DTP Designers Shanker Prasad
Mohamad Usman
Managing Director Aparna Sharma

This American Edition, 2018. First American Edition, 2011
Published in the United States by DK Publishing
345 Hudson Street, New York, New York 10014

Copyright © 2011, 2018 Dorling Kindersley Limited
DK, a Division of Penguin Random House LLC
18 19 20 21 22 10 9 8 7 6 5 4 3 2 1
001–309599–June/2018

Published in Great Britain by Dorling Kindersley Limited.
A catalog record for this book is available from
the Library of Congress.

ISBN 978-1-4654-7439-1

DK books are available at special discounts when purchased
in bulk for sales promotions, premiums, fund-raising, or
educational use. For details, contact: DK Publishing Special
Markets, 345 Hudson Street, New York, New York 10014
SpecialSales@dk.com. Printed and bound in China

A WORLD OF IDEAS:
SEE ALL THERE IS TO KNOW
www.dk.com

CONTRIBUTORS

Karen Hosack Janes
Arts and culture educationalist, who teaches History of Art at Oxford University Department for
Continuing Education. Formerly Head of Schools at the National Gallery, London and now an advisor
to several arts and education projects. Has written two series of art books for children, as well as
articles for the *Times Educational Supplement*.

Ian Chilvers
Writer and editor, whose books include *The Oxford Dictionary of Art*, *A Dictionary
of Twentieth-Century Art*, and *The Artist Revealed: Artists and their Self-Portraits*.
Chief consultant on *Art: the Definitive Visual Guide*.

Iain Zaczek
Writer, who contributed to *The Collins Big Book of Art*, *Masterworks*, *Art: the Definitive
Visual Guide*, and *Art: The Whole Story*.

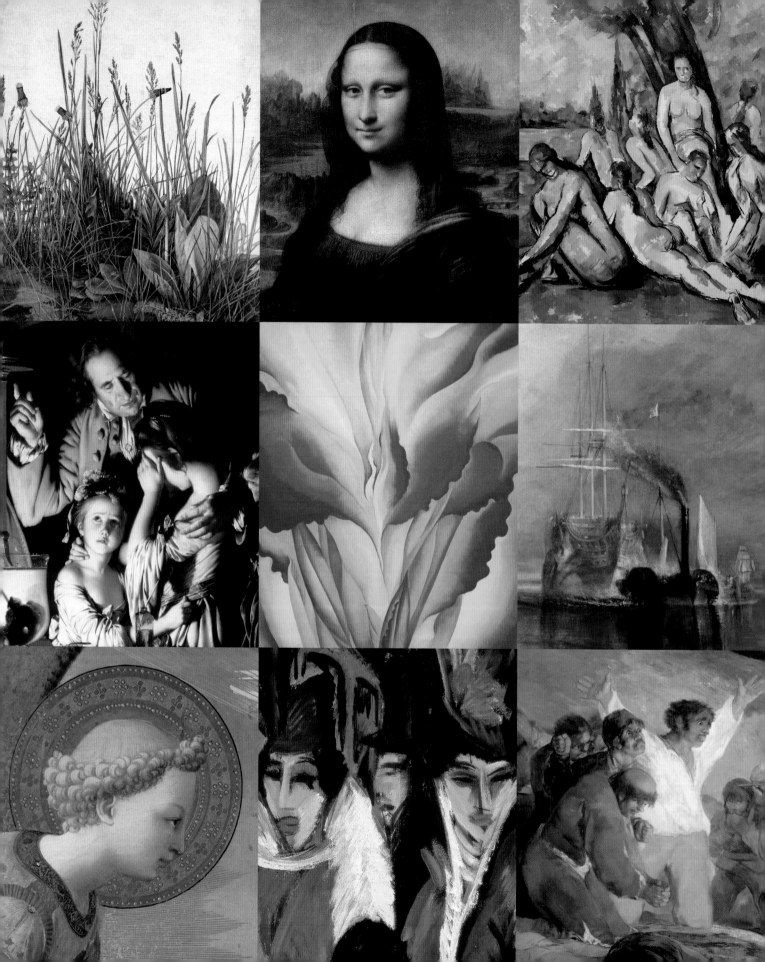

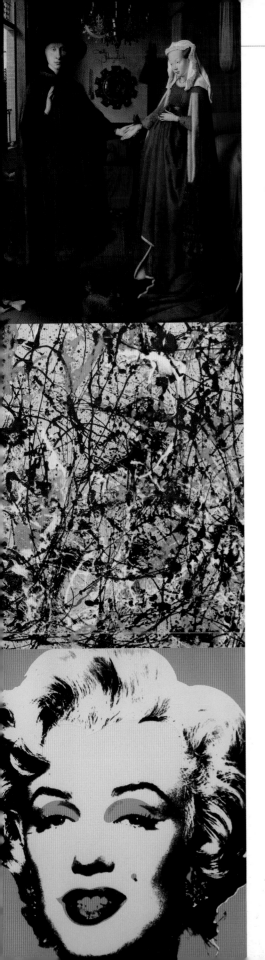

Looking at Paintings

Great paintings come in many guises. The smallest could be held in one hand, while the largest extend magnificently across the vast ceilings of palaces and chapels. Paintings vary just as much in other respects too, ranging from microscopic depictions of the natural world to bold, swirling abstracts, and from beguiling, intimate portraits to interpretations of key moments in history, myth, or literature. The 66 paintings in this book span many centuries and they represent a huge wealth of human experience. Some tell stories, some transport you to faraway places, and some celebrate beauty; others are scenes of almost unbearable horror. Each painting, however, is unique.

Looking at any painting is a personal experience, but one that benefits from broader knowledge—the more you know about works of art, the closer you look at them, and the more you see and enjoy. Like a helpful guide standing next to you in a gallery, museum, or church, this book will help you to look at each painting with fresh eyes and expert knowledge: you will find out about each painting's background, its historical context, and the artist who created it. You will also learn about the techniques of the world's greatest painters—how they have used color, perspective, light, and shade to capture a likeness or a moment in time, and to convey the feelings that it inspired. Perhaps more importantly, this book will lead you through the key details of each painting, elements you may barely notice at first—a tiny reflection in a mirror, a crescent moon high in the sky, a slipper dangling carelessly on a foot—that help to reveal what a painting is really about.

Great paintings often have hidden levels of meaning, but once you start to unravel the clues, everything begins to make sense. Finding your way into a great painting is like setting off on a voyage of discovery—endlessly fascinating and deeply rewarding.

1100–1500

The Qingming Scroll

c.1100 ▪ INK AND COLOR ON SILK ▪ 10in × 17ft 3in (25.5cm × 5.25m) ▪ PALACE MUSEUM, BEIJING, CHINA

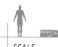

SCALE

ZHANG ZEDUAN

Astonishing in its intricacy, this magnificent silk painting on a handheld scroll depicts scenes of everyday city life in 12th-century China. The scroll was designed to be held by the viewer, who would unroll an arm's length at a time, starting from the right. Below you can see the central section of the scroll. With its bustling streets and beautiful arched rainbow bridge spanning a curving river, the urban landscape is full of vivid, narrative detail.

View of an ideal city

The city shown in the painting is thought to be the Northern Song capital, Bianliang (modern Kaifeng), in Henan Province, although the artist has not included specific features, such as a famous temple, that would make identification certain. The word "Qingming" in the title has perplexed scholars over the years. It was thought to relate to a festival that took place 100 days after the winter solstice, when ancestral graves were swept with willow brooms. There is, however, little evidence of the willows in the painting: branches would have been hung up on house roofs but none are shown. Other objects associated with the festival, such as displays of paper houses outside shops, are also missing.

An alternative interpretation of the painting, which the lack of unique landmarks would seem to bear out, is that it portrays an idealized cityscape. "Qingming," which literally means "bright-clear" and "peaceful and orderly," would then refer to a splendid city where all members

of society live harmoniously. Indeed, if you look carefully at the painting, there is no evidence of poverty and people from all social classes are mingling in the streets.

The scroll begins at the far right with a morning scene in the country (see p.13), and at its midpoint the artist, Zhang Zeduan, has depicted its most striking feature—the crowded bridge and the drama taking place on the river below. Very little information exists about the artist, and his reasons for painting this masterpiece have not been documented. Yet from the colophons (written notes) at the end of the scroll, it seems likely that Zhang was trying to recall and recapture the illustrious past of the Northern Song dynasty in China—a period of peace, prosperity, and high artistic achievement.

ZHANG ZEDUAN

c.1085–1145

The Qingming Scroll is the only surviving documented work by Zhang Zeduan, but this alone establishes him as one of the great painters of the Northern Song period (960–1126).

What we know about the artist is revealed only in the colophons of *The Qingming Scroll*. In addition to notes from the various Chinese owners of the scroll, together with their seals, Zhang's place of birth is given as Dongwu (now Zhucheng, Shandong Province), China, although there is no date. He traveled to the Northern Song capital, Bianliang, to study painting when he was young, and may then have become a member of the Imperial Hanlin Academy. This was set up to support contemporary artists by Emperor Huizong, who reigned from 1100 to 1126. Zhang Zeduan's great skill was in depicting everyday scenes in exquisite and extraordinary detail on the high-quality silk that was widely produced in the region.

With each viewing, the observer gains new understanding of the people and the city shown in such vivid detail

VALERIE HANSEN *THE BEIJING QINGMING SCROLL AND ITS SIGNIFICANCE FOR THE STUDY OF CHINESE HISTORY*, 1996

Visual tour

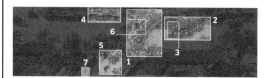

KEY

▶ **BOAT ADRIFT** On the river below the bridge, boatmen struggle to regain control of a large boat; it has a broken tow rope, and has been pushed off course by the powerful current. Some of the crew are trying to lower the mast, while others attempt to steady the boat with poles. One man is trying to reach the bridge above with a long boat hook. Onlookers lean over the bridge, shouting warnings or words of encouragement, and one has thrown down a rope that is uncoiling.

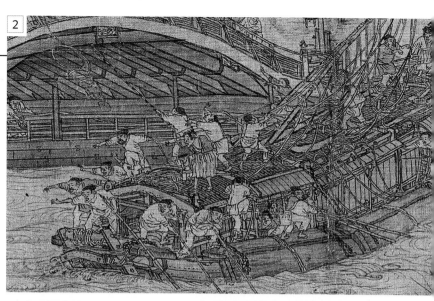

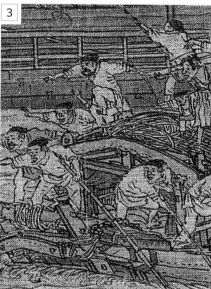

▲ **INTERACTION** A sense of drama is conveyed by the reaction of the spectators watching the drifting boat. Although you cannot make out the details of their faces, they are all intent on the action and are pointing or gesturing. The man above is standing on the roof of his boat, gesticulating at the drifting vessel. The river is high and the water is swirling dangerously.

◀ **RAINBOW BRIDGE** The main focus of this part of the painting, and indeed of the whole scroll, is the beautiful, arched rainbow bridge spanning the river. It is thronged with people, traders, and animals. Food is being cooked and sold at stalls, with room for sitting and eating. Other vendors display their goods on the ground, sheltered under temporary awnings. Although this rainbow bridge is very distinctive, similar bridges also existed in other Chinese cities besides Bianliang, the Northern Song capital.

▼ **HOUSEBOATS** Long, flat houseboats are moored along the side of the river—one even has its own potted garden. Behind them, the riverbank is lined with cafés. The tables are not yet occupied. In the evenings, the cafés and restaurants would have been lit by lanterns.

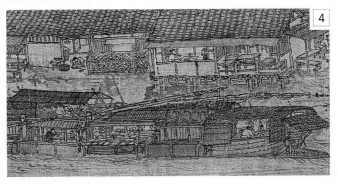

4

5

◄ **WHEELBARROW** It takes two men to maneuver this wheelbarrow with a giant wheel—one at the back, and another at the front, who pulls with the aid of a donkey. There is room for passengers on either side.

6

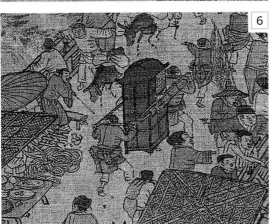

▲ **SEDAN CHAIR** The wealthy traveled in enclosed sedan chairs, carried on poles by bearers. The servants of the person inside this one are disputing who has right of way with the servants of the man on horseback.

▼ **TAKEOUT** The scroll is full of incidental detail, depicting characters going about their everyday lives. Here you can see a man carrying two bowls of takeout food—probably noodles—and chopsticks.

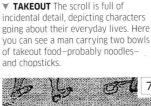

7

ON **TECHNIQUE**

Zhang Zeduan drew the buildings and other structures in *The Qingming Scroll* with a fine brush, and used a ruler to help him draw straight lines. The colophons (written Chinese characters) at the end of the scroll refer to this technique as "ruled-line painting." It is also known as *jiehua*, which means "boundary" or "measured" painting. Most of the scroll is monochrome and has faded to brown with age, but a few details are in color, such as the green buds of the willow trees. Zhang has drawn most of the scenes from overhead, enabling you to see the tops of roofs, umbrellas, and people's heads. However, sometimes the perspective shifts so that the viewer can explore other angles. From certain viewpoints you can see both the top and the underside of the bridge.

IN **CONTEXT**

Following the course of the day from morning until mid-afternoon, the scroll begins on the right with a quiet, rural landscape and ends on the left in the busy capital city. Signs of commerce appear throughout the scroll, from the donkeys laden with wood on their way to market in the opening scene to a pharmacy with two female customers in the final one. *The Qingming Scroll* is a unique and precious historical document that provides a fascinating glimpse of what life was like in China 800 years ago.

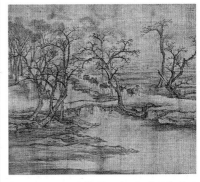

▲ The first scene of *The Qingming Scroll*, to the far right of the scroll, shows the river meandering through a peaceful rural scene in the country.

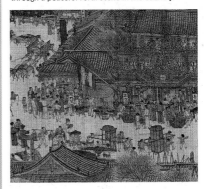

▲ The last scene, to the far left of the scroll, shows the teeming life in the city streets.

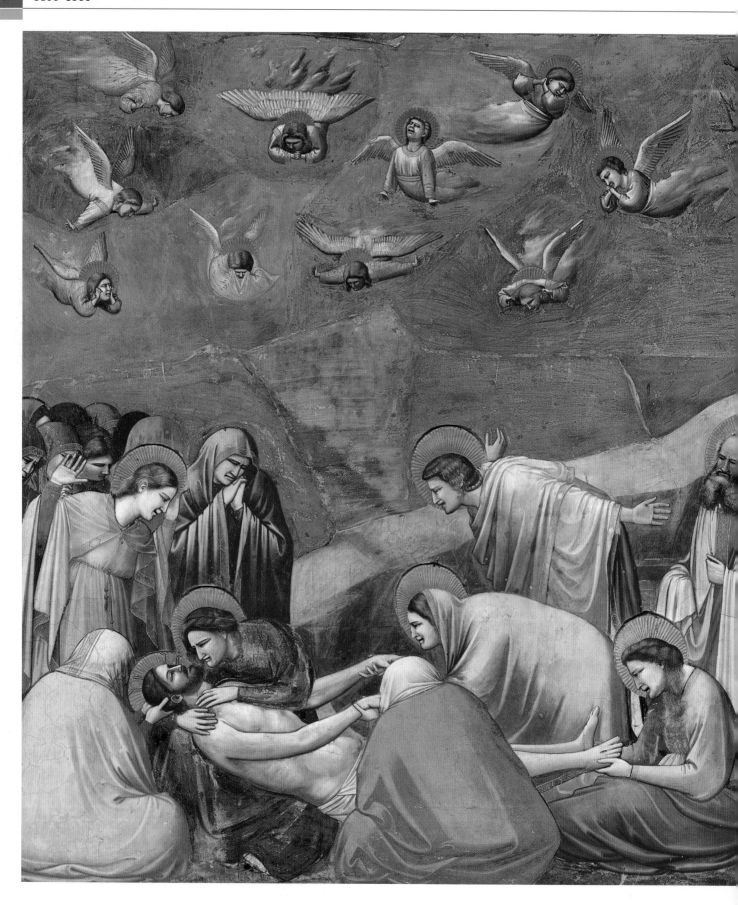

The Lamentation of Christ

c.1305 ▪ FRESCO ▪ 72¾ × 78¾in (185 × 200cm) ▪ SCROVEGNI CHAPEL, PADUA, ITALY

GIOTTO

SCALE

Painted on the wall of the Scrovegni Chapel in the old university town of Padua, the drama depicted in this fresco is unbearably poignant. The griefstricken faces and postures of the figures, the strong composition, and the use of space all convey a sense of tragedy at Christ's death. This scene forms part of a sequence of frescoes depicting episodes from the lives of Christ, the Virgin Mary, and the Virgin's parents, Anne and Joachim, and is in many ways the emotional highpoint of the Chapel.

With these frescoes, Giotto succeeded in breaking away from the artistic conventions of the day, and his new, naturalistic style of painting marked a turning point in the development of Western art. Before Giotto created his innovative images of realistic, three-dimensional people, the stiffness of figures in the Byzantine tradition and the flat, one-dimensional space they inhabited made it difficult for the viewer to experience any real connection with the subject matter. Mosaics had often been used previously for religious images, but these were not only expensive and time-consuming to produce, they were also primarily decorative and were not intended to engage the viewer emotionally. This engagement is exactly what makes *The Lamentation of Christ* so powerful. It portrays the most emotional episode in the sequence of frescoes and Giotto endows the scene with an intensity that is both touching and beautiful.

Bringing the narrative to life

In the biblical account depicted here, Christ's body has been taken down from the cross and is encircled by his grieving family and friends. The Virgin Mary cradling her dead son is the focal point of the painting. Like Christ's large and elongated body, Mary's grief seems unbearably heavy. To Mary's right, John the Evangelist throws back his arms in a gesture that expresses shock and dismay, and Mary Magdalene sits mourning at Christ's feet.

Giotto's use of simple shapes and blocks of color helps the viewer to concentrate on the main areas of emotional expression in the painting: the faces and hands. The solid masses of the figures in the foreground are draped with clothes that describe the shape of the bodies underneath. We do not need to see these people's faces—their sorrow is expressed by their bowed heads and hunched shoulders. The proportions of the composition are realistic and there is a convincing sense of space. In this respect, Giotto anticipates the techniques of perspective that were to be formulated and developed in detail over a hundred years later.

GIOTTO DI BONDONE

c.1270–1337

One of the giants of the history of art, Giotto is generally considered to be the founder of the mainstream of modern painting.

Born in Colle di Vespignano, near Florence, Giotto studied under the Florentine painter Cimabue and went on to create a powerful, naturalistic style that broke away from the flat, remote conventions of Byzantine art, which had been dominant for centuries. His figures seem solid, weighty, and set in real space, and they express human emotion with conviction and subtlety.

This huge achievement was recognized in Giotto's lifetime. He worked in various major art centers, from Florence to Naples, and was the first artist since classical antiquity to become renowned throughout Italy. Unfortunately, many of his paintings have perished over the centuries and his career is difficult to reconstruct in detail. However, his masterpiece—the fresco decoration of the Scrovegni Chapel in Padua—survives in good condition, and this work alone is enough to secure his reputation as one of the greatest artists of all time.

Visual tour

KEY

> **MARY MAGDALENE**
The simple figures in Giotto's composition have no objects surrounding them to help us identify them. Here, however, Mary Magdalene is recognizable from her humble posture and actions. The dead Christ's feet rest on her lap and she touches them lovingly, just as two other women touch Christ's hands. Mary Magdalene seems to be weeping at the terrible sight of the wounds. In many images of the period she is shown with a jar of ointment.

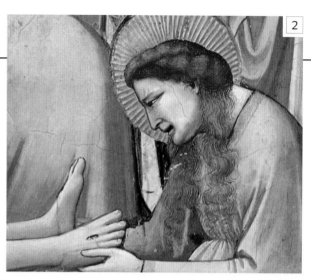

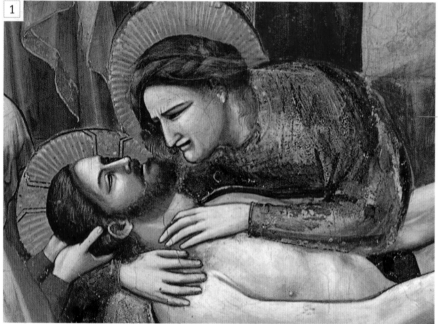

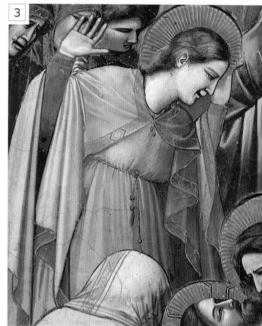

▲ **MOTHER AND SON** The Virgin Mary holds the dead Christ in her arms, an expression of the most intense grief on her face. The close contact between mother and son, their faces almost touching, helps us to empathize with the human tragedy before us. Bereavement is a universal experience and the painting resonates on an emotional and very personal level, whether or not you hold religious beliefs.

> **SEATED FIGURES** The people with their backs to us in the foreground of the painting strengthen the composition in several ways. They and the other people in the crowd encircle Christ, giving the scene a greater feeling of intimacy. The space between the two figures also draws us into the heart of the scene, bringing the drama to a human level. It is as though we are offered the choice of watching from afar or becoming emotionally involved.

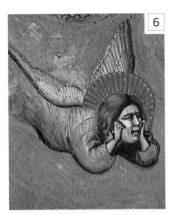

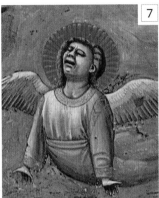

◄ ANGUISHED ANGELS
Ten angels, like shooting stars—some with flaming trails—look down from the azure sky on the holy scene below. Their tiny, contorted bodies express their anguish eloquently. Some pray, some are clearly weeping, and others simply hold their heads in their hands to show their despair.

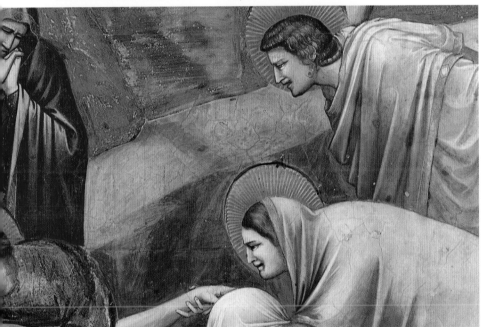

▲ MOURNERS The faces of the mourners are natural and animated, yet have a sculptural quality. They are all inclined toward the body of Christ, as if no one can quite believe their eyes. There is a calm dignity about the group and their gestures are expressive, but not overly theatrical: they hold their hands up in despair or clasp Christ's hands and feet. In their facial expressions you can discern pain and anger—emotions that they are trying hard to keep under control. This acute sense of realism is Giotto's trademark.

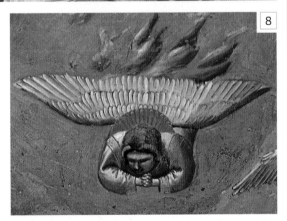

▲ STILLNESS AND MOVEMENT The swooping and twisting bodies of the angels in the sky form a strong contrast with the stillness of the scene below. The tension between these two opposing forces helps to create a powerful and somber atmosphere.

ON **TECHNIQUE**

To paint these frescoes, Giotto transferred a preliminary sketch directly on to the plaster of the wall. The outlines of the sketch were pricked, and powdered charcoal was then brushed through the holes. Applying water-based paint while the final layer of plaster was still wet (*fresco* means "fresh" in Italian) allowed the colors to embed. Giotto had to work quickly, completing small sections at a time. Once dry, frescoes become part of the plaster on the wall and some last for hundreds of years. Giotto used gold leaf on the halos, on the angels' wings, and for detailing on clothes. When the chapel candles were lit, the gold would have helped light up the scenes.

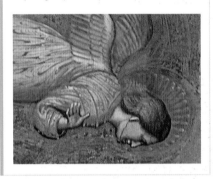

IN **CONTEXT**

The series of frescoes, including *The Lamentation of Christ*, was commissioned around 1300 by a wealthy banker and merchant, Enrico Scrovegni, to decorate the walls of the chapel next to his palace in Padua. Giotto was asked to depict stories from both the Old and New Testaments. The vaulted roof of the chapel is decorated like a star-studded blue sky and the walls are lined with the framed panels of fresco. The series ends with *The Last Judgment*, which fills the whole of the west wall facing the altar.

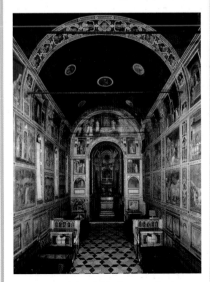

▲ The Scrovegni Chapel (also known as the Arena Chapel) interior, looking toward the altar

The Madonna Enthroned

c.1308–11 ▪ TEMPERA AND GOLD ON PANEL ▪ 7 × 13ft (2.13 × 3.96m)
MUSEO DELL'OPERA DEL DUOMO, SIENA, ITALY

DUCCIO DI BUONINSEGNA

SCALE

Hailed as one of the greatest masterpieces of the age, Duccio's painting helped to change the course of Italian art. For much of the medieval period, the prevailing influence in art came from the East. Byzantine devotional art was powerful and hieratic, but its ancient images were regarded as sacred and painters were expected to copy them faithfully. Originality, personal expression, and any form of realism were not encouraged. Led by Giotto (see pp.14–17) and Duccio, Italian masters gradually broke away from many of these constraints. In Duccio's

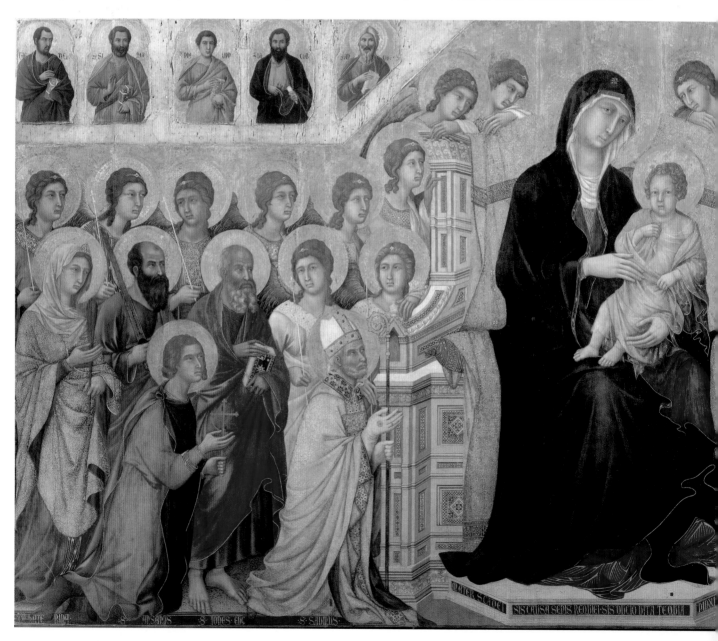

remarkable altarpiece there are signs of human warmth in many of the figures, there is genuine drama in the narrative scenes, and the draperies look far more fluid and natural than in their Byzantine counterparts.

A monumental undertaking

This imposing panel dominated the front of a huge altarpiece commissioned for Siena Cathedral. It represents the *Maestà* (Virgin in Majesty) or *The Madonna Enthroned*. Presiding over the Court of Heaven, surrounded by saints and angels, are the Virgin and Child. Siena's four patron saints kneel at Mary's feet, interceding for her favor. This is entirely appropriate, as the Virgin had been officially designated as the city's patron and protector. The inscription beneath her throne reads, "Holy Mother of God, bestow peace on Siena."

Duccio was commissioned to produce the altarpiece by Siena's civic authorities. A contract from 1308 has survived, indicating the lavish nature of the project. It is notable, for example, that the patrons pledged to provide all the artist's materials. Accordingly, the Virgin's robes were painted in ultramarine—a rare and expensive pure blue pigment made from lapis lazuli, only found in quarries in Afghanistan. By contrast, the blue coloring in the *Rucellai Madonna* in the Uffizi, Florence, which is attributed to Duccio, was composed of azurite, a much cheaper pigment that is slightly more turquoise in tone.

The altarpiece was completed in 1311 and carried in a triumphal procession to the cathedral. At this stage, it was even more massive than it is now. In addition to the *Maestà*, there were originally scenes from the infancy of Jesus and the Death of the Virgin on the front, with further episodes from the life of Christ on the reverse. Unfortunately, the altarpiece was cut down in 1771 and some sections were lost or sold.

DUCCIO DI BUONINSEGNA

c.1255–c.1318/19

A Sienese painter, Duccio was one of the key figures in the development of early Italian art. He owes his fame to a single masterpiece—the magnificient altarpiece in Siena Cathedral.

Very little is known about Duccio di Buoninsegna's life. There is no reliable evidence about his birthplace or training. Some scholars have suggested that he may have been a pupil of Cimabue or Guido da Siena, but the first documentary reference to him dates from 1278. Records of several commissions have survived, but *The Madonna Enthroned* is the only work that can be attributed to him with absolute certainty. Hints about his character emerge from other documentary material, suggesting that he had a rebellious streak. He was fined for a variety of offenses—for refusing to do military service, for declining to swear an oath of fealty, and perhaps even for a breach of the regulations against sorcery.

Whatever faults Duccio may have had, they were clearly outweighed by his prodigious talent. The Sienese authorities were anxious to secure his services for their most important commission and the reasons for this are plain to see. Along with Giotto, Duccio was instrumental in freeing Italian art from the limitations of its Byzantine sources.

Visual tour

KEY

▼ ST. ANSANUS The four figures in the foreground, kneeling before the Virgin, are the guardian saints of Siena: Ansanus, Savinus, Crescentius, and Victor. Their prominent position confirms that Duccio's altarpiece was a civic commission as well as a religious one. This man is St. Ansanus. He came from a noble Roman family, as his aristocratic attire indicates, but he was betrayed by his father for preaching the Gospel. Condemned to death by Emperor Diocletian, Ansanus was thrown into a vat of boiling oil, before being beheaded.

▼ ST. JOHN THE BAPTIST This distinctive figure is John the Baptist. He can be identified by his unkempt appearance and his tunic made out of animal skins. These refer to his ascetic lifestyle, wandering in the desert, living off locusts and honey. John was frequently included in paintings of the "Court of Heaven" because of his status as the forerunner of Christ. He was also regarded as a symbolic link between the two parts of the Bible—the last of the Old Testament prophets and the first of the New Testament saints.

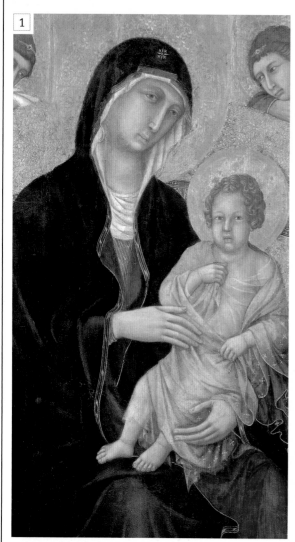

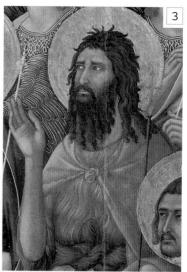

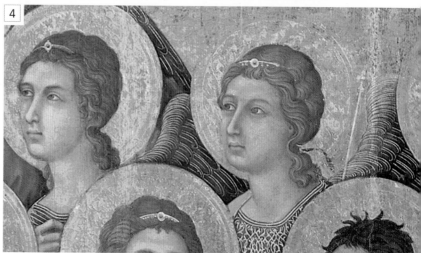

▲ THE VIRGIN AND CHILD Italian artists borrowed the theme of *The Virgin Enthroned* from Byzantine sources (see opposite). Early examples can be found in the mosaics at Ravenna in Italy, which for a brief time was the Western capital of the Byzantine Empire. The Virgin represents the Queen of Heaven, as well as the personification of Mother Church. In keeping with the normal medieval practice, she is depicted on a larger scale than the other figures, to underline her importance. The star on her cloak—another Eastern feature—refers to her title, "Star of the Sea."

▲ ANGELS' FACES Duccio followed tradition in his depiction of the figures surrounding the Virgin. Artists had developed their own conventions for the physical appearance of many of the better-known saints, based on the accounts of their lives. St. Paul, for example (on the left, immediately above St. Ansanus), was normally shown as a bald man with a dark beard. Angels, on the other hand, were frequently given the same, idealized faces. They were regarded as sexless beings, so painters invariably strove to make them appear androgynous. Sometimes their bodies were omitted altogether and they were represented by a head encircled by three pairs of wings.

◀ **ST. AGNES** This is St. Agnes, a Roman virgin who was one of the many Christians to suffer martyrdom during Diocletian's reign (284–305). She is carrying her traditional attribute, a young lamb. This association probably arose because of the similarity to her name (*agnus* is Latin for "lamb"). Agnes was a young girl, aged about 13, who was thrown into a brothel after refusing the attentions of a high-ranking official.

▼ **NATURALISTIC INTERACTION** The Byzantine models for this type of picture were deliberately stiff and hieratic. By contrast, Western artists gradually adopted a more naturalistic approach. Rather than depicting rows of repetitive figures, Duccio introduced a degree of variety into the scene. His saints and angels exchange glances and appear to commune with each other.

ON **TECHNIQUE**

Duccio's Virgin is loosely based on a Byzantine format known as *Hodegetria* (meaning "She who shows the Way"). Here, Mary gestures towards Jesus, indicating that he is the way to salvation. Both figures gaze at the viewer and there is no show of maternal affection. The original was said to be by St. Luke, so painters followed its format, as in the *Virgin of Smolensk*. Duccio was one of the first Italian artists to soften this approach, giving it a warmer, more naturalistic appearance.

▲ *Virgin of Smolensk*, c.1450, tempera on fabric, gesso, and wood, 53¾ × 41¼in (139 × 105cm), Tretyakov Gallery, Moscow, Russia

IN **CONTEXT**

The back of the altarpiece, which is now displayed opposite the front, tells the story of Christ's Passion in 26 scenes. Duccio made the Crucifixion, the climax of the story, larger than the other panels and gave it a central position.

▲ *The Crucifixion*, detail of panel from the back of *The Madonna Enthroned*, 1311, Museo Dell'Opera del Duomo, Siena, Italy

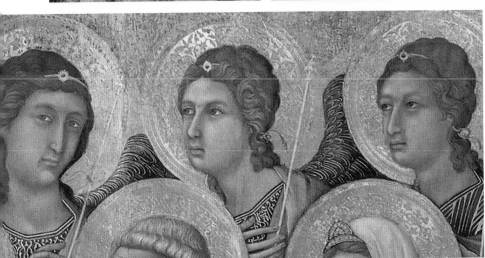

▶ **FEET AND ROBES** Duccio's career predates the development of mathematical laws of perspective. However, he did make some attempt to create a sense of depth in this picture by showing the feet and robes of some figures overlapping with the edge of the platform. In part, this was to draw attention to the inscriptions on the base, which identified some of the lesser-known saints.

The Annunciation

c.1430–32 ■ TEMPERA ON PANEL ■ WHOLE ALTARPIECE 76¼ × 76¼in (194 × 194cm) ■ PRADO, MADRID, SPAIN

FRA ANGELICO

SCALE

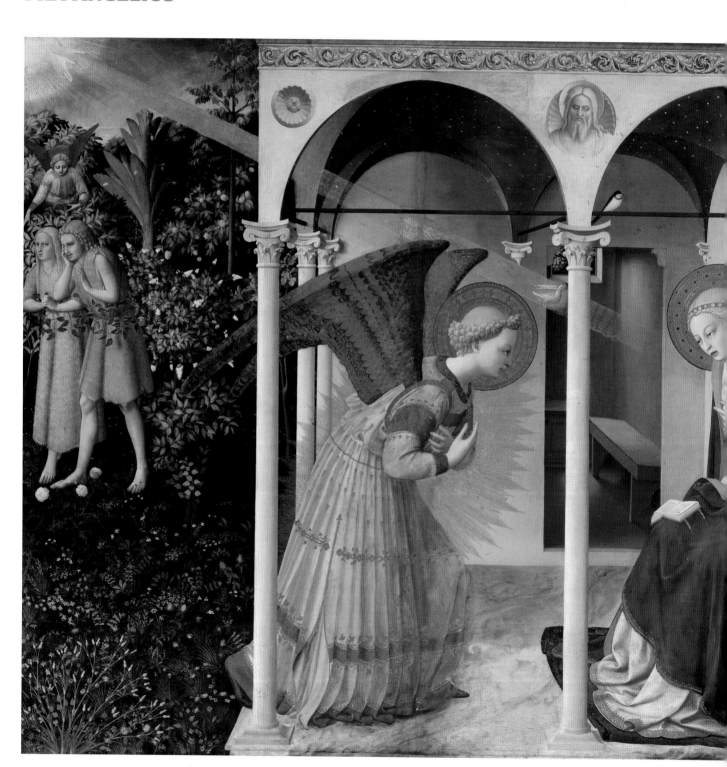

Fra Angelico is not an artist properly so called, but an inspired saint

JOHN RUSKIN *MODERN PAINTERS, VOLUME II,* 1846

In a portico filled with light and color, we witness a significant encounter between two haloed figures. Both adopt a similar attitude of graceful humility, inclining their heads and crossing their hands. This still, meditative tableau depicts one of the defining moments of the Christian tradition, when the Archangel Gabriel announces to the Virgin Mary that she has been chosen by God to be the mother of Christ. *The Annunciation* as interpreted by Dominican friar Fra Angelico was created as a devotional panel for the altar of San Domenico in Fiesole, near Florence. The painting has a predella (horizontal panel of religious scenes) below it, hence its square shape.

The diagonal shaft of holy light falls on Mary, illuminating the intense ultramarine of her cloak and the complementary peach tones of her dress. On the other side of the central column, Gabriel's shining, gold-patterned robe, a similar shade to Mary's dress, also complements the rich, saturated blue. The angel's rounded back harmonizes with Mary's graceful pose and is echoed by the curve of his massive, exquisitely detailed wings. The tips of Gabriel's wings project beyond the portico structure into the first section of the painting, which takes up a quarter of the composition and depicts a scene from Genesis, the first book of the Bible. It is the expulsion of Adam and Eve from the Garden of Eden, an episode that adds drama to the whole painting and sets the Annunciation in context: Christ will be born on earth to save humanity from original sin.

Color, light, and space

This precious work displays Fra Angelico's keen observational skills and fine craftsmanship. The use of light, glowing color and the naturalness of the poses animates the figures of Mary and Gabriel, giving them weight and making them lifelike. The architectural structure also reveals Fra Angelico's command of perspective. With its receding columns and the open chamber at the rear, the composition has a sense of depth and creates the impression that both figures inhabit a real, physical space. In this respect, it is possible to see the influence of other early Renaissance painters such as Masaccio—Fra Angelico's contemporary and one of the first artists to paint convincingly lifelike figures in settings that appeared three-dimensional. Fra Angelico's work, however, possesses delicacy and gracefulness that set it apart from that of his contemporaries.

Fra Angelico painted numerous altarpieces and frescoes, including several Annunciation scenes, all characterized by simplicity of line and vivid color. For him, painting was an act of spiritual devotion and his works seem to convey the strength and inspiration he derived from his Christian faith, as well as the beauty he saw in the world around him.

FRA **ANGELICO**

c.1395–1455

A devout friar, Fra Angelico painted many fine frescoes and altarpieces. His fine line and use of light and pure color inspired other Renaissance artists, including Piero della Francesca.

Born Guido de Petro, Fra Angelico was already illustrating or "illuminating" manuscripts when he joined the Dominican order at Fiesole, near Florence. He was known as Fra Giovanni; the epithet "Angelico" (angelic) was probably added after his death. What little is known about Fra Angelico is derived mainly from the writings of Giorgio Vasari.

Apart from the church's patronage, Fra Angelico also received other commissions and he traveled widely in his later years. He is perhaps best known for the beautiful frescoes that he painted in the monks' cells of the monastery of San Marco, Florence, c.1440. He was later referred to as "Beato (blessed) Angelico" and was in fact officially beatified in 1982.

Visual tour

KEY

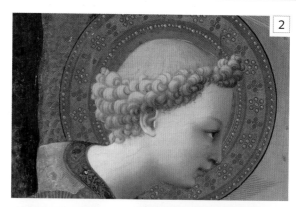

◄ **ARCHANGEL GABRIEL** The glowing halo around Gabriel's head, which has been painted with gold leaf and then burnished and tooled, reinforces the divinity of God's chief messenger. Gabriel's respectful pose is as graceful as Mary's submissive gesture and the two figures, each framed by an arch, complement each other perfectly. Fra Angelico has skilfully portrayed the intensity of their encounter, yet there is also a sense of stillness, which gives the altarpiece a meditative quality.

◄ **WINGS** Fra Angelico has given Gabriel a solid, human form and his stance is realistic. In contrast, the beautifully shaped wings define him as a divine being. Each feather is carefully depicted, and the overall impression is of a real bird with a large wingspan. You can almost feel the weight of the wings on the angel's back.

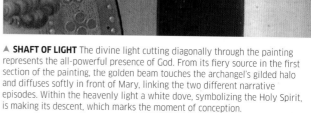

▲ **SHAFT OF LIGHT** The divine light cutting diagonally through the painting represents the all-powerful presence of God. From its fiery source in the first section of the painting, the golden beam touches the archangel's gilded halo and diffuses softly in front of Mary, linking the two different narrative episodes. Within the heavenly light a white dove, symbolizing the Holy Spirit, is making its descent, which marks the moment of conception.

◄ **VIRGIN MARY** In the delicate portrayal of Mary's face you can see Fra Angelico's expertise at painting detail. As an illuminator of manuscripts, he would have needed an aptitude for fine, small-scale work. Mary's pose, with her hands crossed, symbolizes her submission to God's will. As protector, she played a central role for the Dominican friars, Fra Angelico's order.

▶ ADAM AND EVE Beyond the confines of the portico, we see the dejected figures of Adam and Eve who have fallen from God's grace and are being expelled from the fertile Garden of Eden. The forbidden fruit under their bare feet, they move beyond the frame of the painting. Fra Angelico contrasts their sinfulness with Mary's immaculate state and reminds us that Christ was born to redeem the sins of humanity.

▼ GOD THE FATHER Above the central column of the portico is the sculpted head of a bearded male. This is an image of God, the wise, all-seeing Father.

▲ DECORATIVE PLANTS The Garden of Eden, which lies beyond the portico and takes up the first quarter of the painting, is so richly patterned with plants that it resembles a medieval tapestry. In the stylized treatment of the meadow flowers in the foreground, Fra Angelico's work reveals the influence of the earlier Gothic style.

◀ SWALLOW Perched on the central column, above the heads of Mary and Gabriel and below the image of God, is a swallow. It probably symbolizes the resurrection of Christ. Just as Christ dies and is then reborn, so the swallow disappears, then returns each spring. Its presence in the painting brings together the trinity of God the Son, God the Father, and God the Holy Spirit.

ON **TECHNIQUE**

Fra Angelico uses linear perspective to convince the viewer that the area within the classical portico structure is a real, three-dimensional space. The Corinthian columns decrease in size and appear to recede into the background, as do the arches of the star-studded ceiling. A small room can be seen through the doorway, with a window set into its back wall. There is, however, no single vanishing point and the perspective is not completely resolved. Fra Angelico was working at a pivotal point in Florentine art, when the Gothic conventions were giving way to more sophisticated techniques.

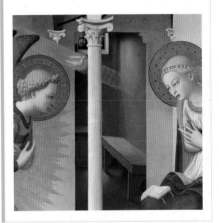

IN **CONTEXT**

Fra Angelico revisited the theme of the Annunciation in paintings and frescoes made at different times in his career. The Madrid *Annunciation* was made at roughly the same time as another altarpiece for the church of San Domenico in Cortona, Tuscany. Although the two are similar in composition, the Cortona altarpiece is more decorative and features gold text flowing from the mouths of the archangel and Mary. Fra Angelico created a third celebrated *Annunciation*, a fresco (shown below), for the convent of San Marco, near Florence, where it can be seen on the wall at the top of the dormitory stairs. Compared with the two earlier versions, which are dramatic and colorful, it is a pure, serene image of contemplation.

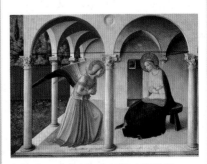

▲ *The Annunciation*, Fra Angelico, c.1438–45, fresco, 90½ × 126¼ in (230 × 321cm), Convent of San Marco, Florence, Italy

The Arnolfini Portrait

c.1434 ▪ OIL ON PANEL ▪ 32¼ × 23½in (82.2 × 60cm) ▪ NATIONAL GALLERY, LONDON, UK

SCALE

JAN VAN EYCK

The exquisite detail in Jan van Eyck's masterpiece and the level of precision in the painting give this celebrated double portrait an authenticity that is very convincing. The sense of space is realistic, the light is handled with immense skill, and the composition is tightly controlled. In a richly furnished room, a prosperous couple stand together, the reflections of their backs glimpsed in an elaborately carved mirror at the center of the tableau.

There has been much speculation about the identities of the man and woman in the double portrait. They were long thought to be the Italian merchant Giovanni di Arrigo Arnolfini and his wife, who lived in Bruges, and the painting was known as *The Arnolfini Marriage*, until it was established that the couple was married some years before the 1434 date written on the wall in the painting. It is now thought that the painting depicts Giovanni's cousin and his wife. Central to the composition and beautifully illuminated by the light from the window, their hands touch in a display of togetherness.

Social documentation

Most people who see the painting wonder whether Arnolfini's wife is pregnant. Apart from her rounded stomach, which was considered a becoming feature in women and often seen in portraiture at the time, there are other small details that may suggest pregnancy. However, it is possible that she is simply holding up her dress to display the folds of its sumptuous fabric. Indeed, the main purpose of the painting was probably to emphasize the couple's wealth and social standing in 15th-century Bruges. The interior of the fashionable Flemish house is richly furnished, both sitters are dressed in fine clothes, and particular visual symbols, which were employed by other artists and would have been understood by cultured audiences of the day, underline their strong moral principles and beliefs. The proportions of both figures also emphasize their stature in society. Their bodies appear elongated, emphasizing the volume of their garments and reinforcing the impression of wealth and status.

It is, however, the skill of the artist that is perhaps the most striking aspect of this work. Van Eyck perfected the technique of oil painting at a time when tempera (pigment mixed with egg) was still the most popular medium. By carefully building up layers of paint and adding detail and texture, he created the illusion of real objects and surfaces. The fur linings of the couple's heavy robes are painstakingly reproduced and look soft to the touch. The patina of the wooden floor with its worn grain seems accurately depicted, and the oranges on the table and the windowsill look good enough to eat.

JAN **VAN EYCK**

c.1390–1441

One of the greatest artists of the Northern Renaissance, van Eyck was an early master of oil painting. He was famed for his ability to produce detailed paintings.

In his early years, van Eyck probably trained as a manuscript illuminator. This might account for his immense skill in observing and representing objects and figures in great detail. His earliest known works show his interest in painting people in a landscape, which was very unusual at the time.

Van Eyck is first recorded working as an artist in August 1422 in the Hague. There he took up the post of court painter to the Count of Holland, John of Bavaria. After the Count's death, he moved to Bruges and became painter to the court of Philip the Good, the Duke of Burgundy. This post offered opportunities for travel and van Eyck was inspired by the scenery and works of art he encountered. *The Arnolfini Portrait* and the *Ghent Altarpiece* are his most celebrated works and display not only his his acute powers of observation, but also his naturalism and superb craftsmanship, particularly when describing the fall of light.

Van Eyck's **inspired observations of light** and its effects, **executed with technical virtuosity**…enabled him to create **a brilliant and lucid kind of reality**

SISTER WENDY BECKETT *THE STORY OF PAINTING*, 1994

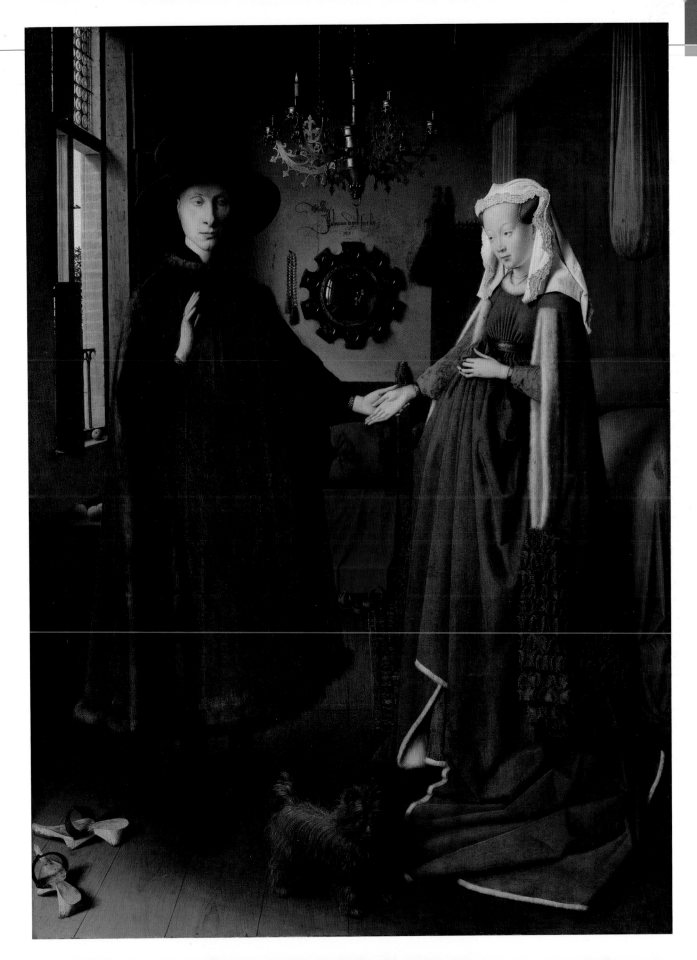

Visual tour

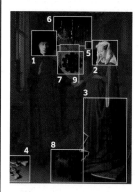

KEY

▼ **ARNOLFINI** Crowned by an enormous hat, the figure of Arnolfini conveys the impression of great wealth and status. His eyes are downcast and his expression is serious. This is in contrast to the welcoming gesture of his right hand, almost like a wave, as he moves to place it into his wife's open palm.

▲ **ARNOLFINI'S WIFE** A headdress of fine linen with an intricate frill frames the youthful face of Arnolfini's wife, which is bathed in light. Both the husband and wife's faces are seen in three-quarter view. Van Eyck employed this angle in other paintings and it brings a natural human quality to the figures.

▼ **COSTLY FABRIC** The superb modeling of the folds of the emerald-green gown emphasize the fabric's quality and heavy weight. The fabric is probably velvet, which was extremely expensive at the time. The intricate ruffles and pleats on the sleeves increase the overall impression of luxury and opulence.

◀ **SHOES** In the bottom left-hand corner of the painting Arnolfini has taken off his wooden, clog-like shoes. Look closely at them and you can see the fine detail of the wood grain and splashes of mud. The wife's daintier red shoes are visible in the background, under the bench beneath the mirror.

◀ **CARVED STATUE** The figure of St. Margaret with a dragon has been carved into the high back of what is probably the bedpost, and the hanging brush to the left is associated with St. Martha, patron saint of housewives. St. Margaret is the patron saint of childbirth, which would support the view that the wife is pregnant.

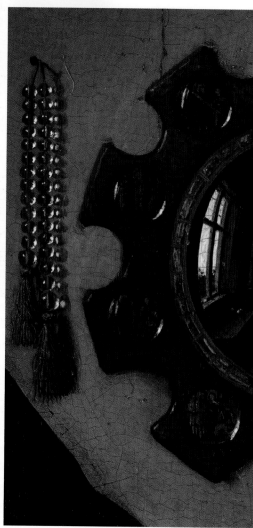

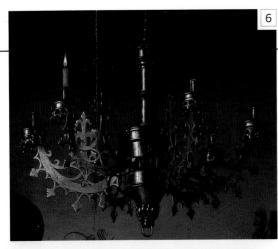

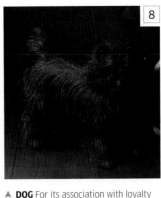

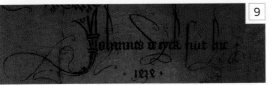

◀ CHANDELIER There is a solitary candle burning in the impressive brass chandelier. The single flame symbolizes the all-seeing eye of God. Together with other signs of devotion, such as the prayer beads on the wall and the miniature paintings of the Passion of Christ around the mirror, it demonstrates the couple's strong Christian beliefs.

▲ DOG For its association with loyalty and its reputation as a faithful companion, the dog was widely used as a visual symbol. In this painting, the dog stands between the feet of its owners, uniting them in fidelity.

◀ CENTRAL MIRROR Ten miniature paintings encircle the round, convex mirror. They depict in astonishing detail the events leading up to and including the crucifixion of Christ. The craftsmanship in such a piece would have been highly valued in the Netherlands at the time. At least four figures can clearly be seen reflected in the mirror. Two of them are the couple seen from behind, the third is probably van Eyck, and the identity of the fourth person is unclear.

◀ SIGNATURE The Latin inscription on the wall with the date 1434 can be translated as "Jan van Eyck was here." Van Eyck often signed and dated his paintings in creative ways.

ON **TECHNIQUE**

Van Eyck used oils rather than tempera to bind powdered pigments (finely ground particles). He attained a level of precision using oil paint that had not been seen previously and his techniques were innovative and influential. Using layers of translucent glazes to build effects for a multitude of textures, he was able to depict light on surfaces with extraordinary skill. In *The Arnolfini Portrait* you can see his mastery of oil paint in the glints on the chandelier and the magical reflective quality of the mirror.

ON **COMPOSITION**

Van Eyck uses perspective to add a sense of depth and create the illusion of interior space. The straight lines of the floorboards, echoed by the angle of the bed and window frames, draw your eye toward the central focus of the composition, the mirror on the back wall. This is the vanishing point of the painting where the lines meet, as can be seen in the overlay below.

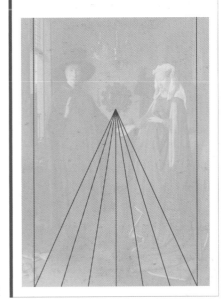

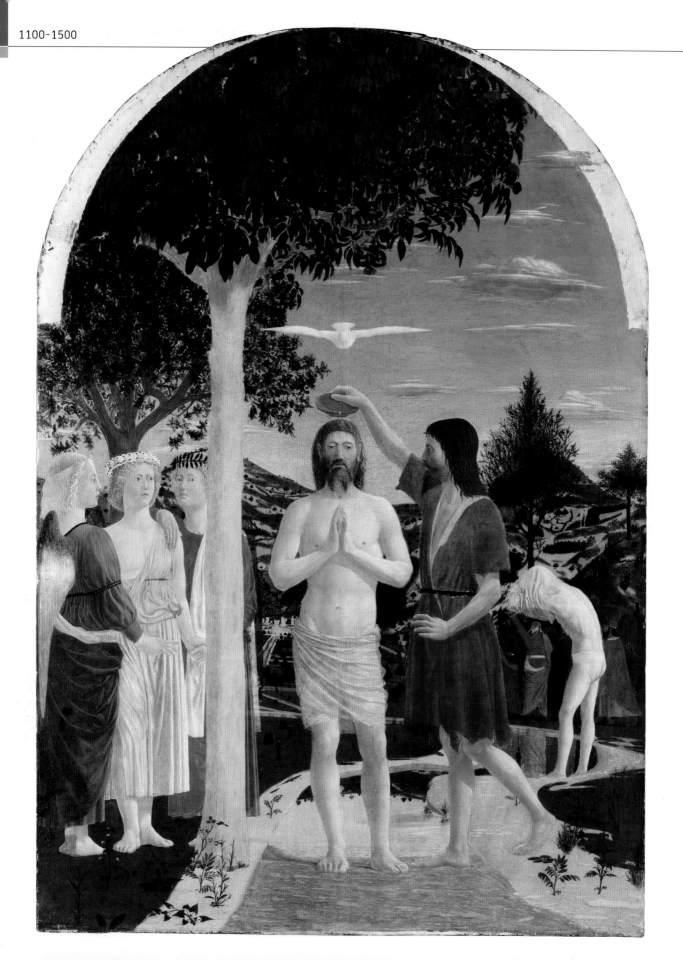

The Baptism of Christ

c.1450 ■ TEMPERA ON PANEL ■ 65¾ × 45½in (167 × 116cm) ■ NATIONAL GALLERY, LONDON, UK

SCALE

PIERO DELLA FRANCESCA

Solemn in mood yet ravishing in coloring, lofty in attitude yet full of earthy details, this altarpiece exemplifies the perfect balance between science and poetry that makes Piero's art so memorable. He was a profoundly thoughtful artist who worked slowly and deliberately in a rational, scientific spirit (in his old age, when fading eyesight perhaps made him give up painting, he wrote treatises on mathematics and perspective). His love of lucidity and order was matched by an exquisite feeling for color and light, however, so his paintings never seem like dry demonstrations of theories. He was influenced by some of his great Italian predecessors and contemporaries in this handling of color and light, but an innate sensitivity to the beauty of nature must have been equally important to him.

A fresh look at a popular theme

Nothing is recorded about the commissioning of this picture, but circumstantial evidence indicates that it was painted as an altarpiece for a chapel dedicated to St. John the Baptist (one of the two principal figures in the painting) in an abbey in Sansepolcro in Tuscany. When the abbey closed in 1808, the painting was transferred to Sansepolcro's cathedral, which sold it in 1859, an indication that Piero was regarded as a minor figure at that time, rather than far and away the town's greatest son, as he is now. Two years later, it was bought by the National Gallery, London, whose director at the time, Sir Charles Lock Eastlake, played a leading role in Piero's rediscovery. There is no external evidence to help with dating the painting, but because it has such a feeling of springlike freshness, it is generally considered to come from fairly early in Piero's career. It is perhaps the first work in which he revealed his full powers.

The Baptism of Christ has been a popular subject from the earliest days of Christian art, and many aspects of Piero's painting can be paralleled in works by other Italian artists of the time. None of them, however, rivaled Piero in creating a scene of such monumental dignity and authority. Nor did any of them give the event such a lovely setting. In the biblical accounts, Jesus is baptized by his cousin John in the River Jordan. Piero, however, places the scene in the kind of hilly countryside that he saw around his own hometown. Indeed the town (with its fortified towers) that can be glimpsed between Jesus and the tree bears a strong resemblance to Sansepolcro, which has changed comparatively little since Piero's day.

> Painting is nothing but a representation of surface and solids…put on a plane of the picture…as real objects seen by the eye appear on this plane

PIERO DELLA FRANCESCA *DE PROSPECTIVA PINGENDI,* c.1480–90

PIERO DELLA FRANCESCA

c.1415–92

Piero's majestic powers of design, combined with his extraordinarily sensitive handling of color and light, have made him one of the most revered figures in Renaissance art.

Piero spent most of his life in his hometown of Borgo San Sepolcro (now known as Sansepolcro) in the Tiber valley, southeast of Florence, Italy. It was a prosperous town, but not particularly distinguished artistically, so he also found employment in several other places, including major art centers such as Florence and Rome.

Much of Piero's work has been destroyed over the centuries, and few of his surviving paintings are well documented, so his career can be followed only in broad outline. He was highly respected in his lifetime and worked for some of the most eminent patrons of the day, but after his death his reputation faded. This was largely because his major works were in rather out-of-the-way places. Before the days of photography and easy travel, they therefore tended to be overlooked. It was not until the late 19th century that his reputation began to rise to its present exalted heights.

Visual tour

KEY

▼ **JESUS** In Renaissance paintings, Jesus is usually depicted as fine-featured and otherworldly, emphasizing his divine nature. In contrast, Piero gives him the look of a robust farmer, the kind of figure he could have seen working in the countryside at any time around Sansepolcro. In this painting, Jesus is far from conventionally handsome—his ears are large, his lips thick, and his hair rather lank. Nevertheless, there is nobility in his bearing, and his grave, pensive expression leaves no doubt as to his holiness.

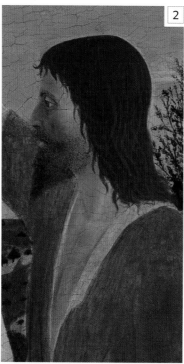

◄ **JOHN THE BAPTIST** John was the forerunner or herald of Jesus, and the baptism marked the beginning of Jesus's public ministry. In art, he is often depicted as something of a "wild man"—an ascetic who lived in the desert and dressed in animal skins. Piero, however, shows him as rather better groomed than Jesus.

► **CENTRAL AXIS** Jesus is very much at the center of the painting. The water pouring from John the Baptist's bowl creates an imaginary central line. The line runs vertically through the picture, bisecting Jesus's head and praying hands. Piero prevents the effect from being stiff or obvious by giving a slight twist to Jesus's lower body. He stands naturally and convincingly, his weight solidly on the ground.

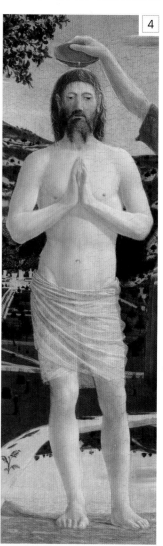

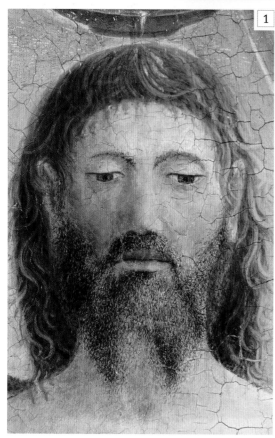

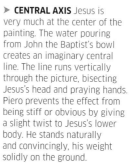

▲ **DOVE** The biblical accounts say that when Jesus was baptized the Holy Spirit descended on him from Heaven like a dove, and it became common in art to depict an actual dove hovering above him. A dove was used in a similar way in other religious scenes, and often as a generalized symbol of peace, innocence, or good tidings. Piero's renowned skill in perspective and foreshortening is shown in the difficult head-on position in which he has chosen to depict the bird. The dove's shape also echoes the shapes of the clouds.

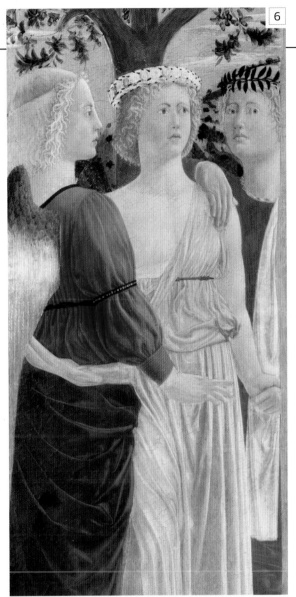

◀ **ANGELS** Paintings of the Baptism of Christ often include two or three angels standing to one side, sometimes holding Christ's garments, but sometimes used more ornamentally or to balance other features of the composition. Piero's angels are among the most individual and lovable ever painted. Like the figure of Jesus, they seem based on the observation of real people rather than conventional ideas of celestial beings. They look like chubby, blonde-haired peasant children who have dressed up for a village festival, and one leans on the shoulder of another with a delightfully casual gesture. However, for all this charm, they do not detract from the picture's solemn atmosphere.

ON **TECHNIQUE**

Piero's lifetime coincided with the introduction of oil paints in Italy. By the end of his career, he had adopted them, appreciating—like many other artists—their flexibility and versatility. When he painted *The Baptism of Christ*, however, he was still using the older technique of tempera, in which pigments are mixed with egg rather than oil. Tempera can produce beautiful, durable results, but it is difficult to master, requiring patient craftsmanship. Colors cannot easily be blended (whereas they can with oils), so effects have to be painstakingly built up, layer after layer, touch after touch. Sometimes, paintings in this transitional period were begun with tempera and finished with oils.

IN **COMPOSITION**

Piero was a mathematician as well as an artist and his paintings often have almost geometrical lucidity. The painting has a round top, and in its basic proportions it is made up of a square topped by a circle—two of the fundamental geometric forms. Less obviously, the diagonal of John the Baptist's left leg is part of a triangle whose apex is formed at Jesus's hands. In this way, even the most dynamic part of the composition—as John leans forward with the baptismal bowl—is anchored in geometrical order.

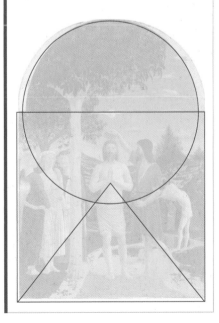

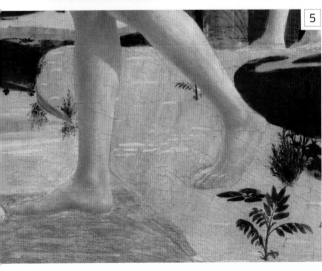

◀ **FEET ON THE GROUND** The monumental grandeur of Piero's style is encapsulated in Jesus's legs, which almost seem like marble columns and are as firmly planted on the ground as the tree alongside them. Yet there is great subtlety in the way the light molds their form and in the way the water is observed around the ankles. In reality, Jesus's baptism may have involved total immersion, but Piero, like many artists of the time, reduces a substantial river, the Jordan, to a small stream winding through the painting. According to the biblical accounts, the event took place "during a general baptism of the people," and the legs to the right of this detail belong to a man who is stripping off to take his turn.

The Hunt in the Forest

c.1470 ▪ TEMPERA AND OIL ON PANEL ▪ 29 × 69¾in (73.3 × 177cm) ▪ ASHMOLEAN, OXFORD, UK

PAOLO UCCELLO

SCALE

A striking panorama, this hunting scene displays Uccello's mastery of the new techniques of perspective, in which objects and figures appear to grow smaller with distance, creating the illusion of space and depth. Riders, horses and huntsmen, either galloping or running alongside their dogs, move directly toward the center of the painting. Here a stag disappears into the the forest and the lines of vision converge in a central vanishing point.

Uccello cleverly uses perspective to evoke the excitement of the chase and to draw us further into the darkness as we follow the men with their horses and hounds as they disappear rapidly into the trees. The bright vermilion of the hunters' hats and jackets, the beaters' leggings, and the horses' harnesses stand out dramatically against the verdant grass and foliage and the dark background, giving the composition a decorative, jewel-like quality.

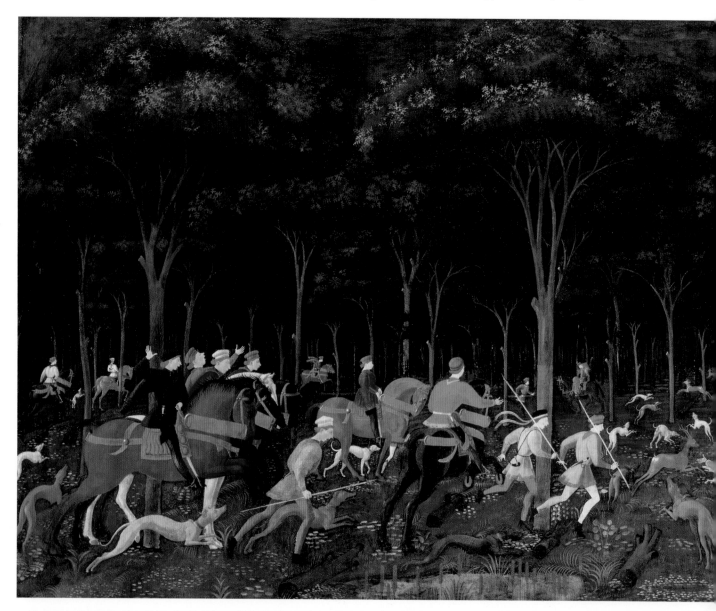

The meaning of *The Hunt in the Forest* is not immediately clear. The stylized setting and symbolic motifs create an air of pageantry and suggest that this is a scene of chivalric make-believe rather than a realistic depiction. One interpretation is that the painting is an allegory of the quest for love. This quest, which can lead into the darkness of unknown territory, is perhaps represented symbolically by the hunt, and the painting may have been intended as a wedding gift, such as a decoration for the headboard of a large bed.

Alternatively, the painting may simply have been commissioned from Uccello by a sophisticated nobleman who wanted a unique and ornamental scene by a contemporary artist that could be set into the wooden paneling of a grand interior.

PAOLO **UCCELLO**

c.1397–1475

Most of Uccello's surviving paintings demonstrate his passion for perspective. His innovative use of this technique to create the illusion of depth in paintings helped transform the course of art.

Born Paolo di Dono in Florence, this artist was nicknamed Uccello (*uccello* is Italian for "bird") because of his love of birds and animals. He trained in the workshop of the Florentine sculptor, Lorenzo Ghiberti. The chronology of his career is difficult to establish, but records show that he was invited to Venice to work on mosaic designs for the Basilica di San Marco (St Mark's Cathedral) in 1425. In Florence he worked on *The Creation of the Animals* and *The Creation of Adam*, two frescoes for the cloisters of the church of Santa Maria Novella, and later produced two more. He also designed stained glass windows for Florence Cathedral, the *Duomo*, two of which survive. *The Hunt in the Forest*, the three panels that make up *The Battle of San Romano* (see p.37), and *St. George and the Dragon* are perhaps his most famous paintings.

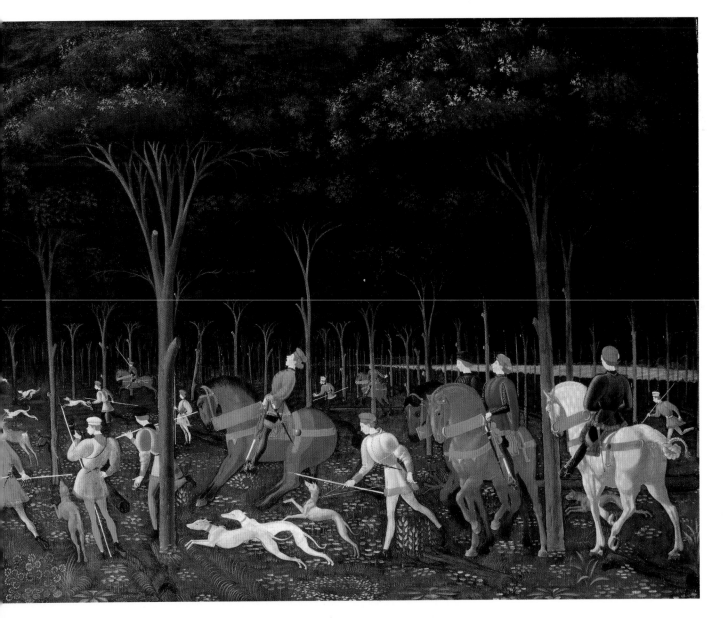

Visual tour

KEY

1

2

▲▶ **HUNTERS** All the hunters in the painting have similar faces. Even though some adopt different poses and others appear to be shouting, they all have the same distinctive nose, eyes, and facial proportions. Most of the hunters are shown in profile and this makes it easier to spot the similarities between them. This repetition, together with the use of bright red for their clothing and hats, gives the scene a pattern-like uniformity and makes it seem like part of an imaginary world.

3

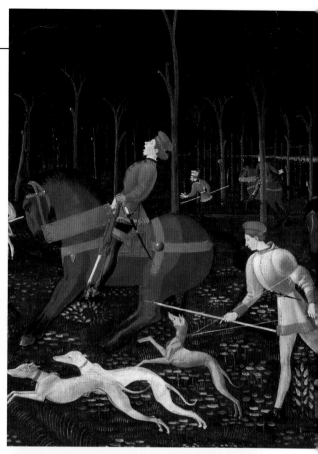

5

4

▲ **STAGS** The stylized forms of the stags are, at first glance, similar to those of the dogs. However, when comparing the two, you can see that the dogs are running, whereas the stags are leaping. Uccello's skill in depicting the forms of animals with a strong degree of realism, however stylized and decorative the treatment, is clear when you study the painting closely.

◀ **DOGS** The speed at which the hunting dogs are running is expressed by their outstretched legs and arched backs. Some look almost identical and parts of their bodies overlap to give the picture a three-dimensional quality. The dogs' collars are exactly the same shade of vermilion as the hunters' jackets. This complements the green of the grass in the foreground, adding to the vibrancy of the painting.

6

◄ **HORSES** Uccello loved painting animals and would have made many preliminary drawings of horses, using real animals as models, for this and other works. He would then simplify the forms of the animals so they were in harmony with the overall composition of the painting.

▼ **MOON** In the center of the dark blue sky is another reference to Diana, a slender crescent moon. Whether this suggests evening or nighttime, this detail is almost impossible to see without the aid of a magnifying glass.

7

ON **COMPOSITION**

Uccello's skilful use of perspective can be seen clearly from the diagram below. Here the radial lines that make up a grid system to guide the artist in the initial design have been overlaid on the painting. Above the horizon line, the trees diminish in size and appear to recede into the distance, whereas everything below the horizon converges on a central vanishing point. The tree trunks on the ground and patterned areas of foliage also follow the lines. The principles of perspective as applied to painting were first described in a treatise written by Leon Battista Alberti in 1435.

IN **CONTEXT**

Uccello's battle scene below is one of three that were once in the Medici Palace. It was assumed that they were commissioned for it but research published a few years ago shows that they were painted for the Bartolini Salimbeni family and were later seized by Lorenzo de Medici.

Uccello has used the same perspective devices in this painting as in *The Hunt in the Forest*. Note how the lances on the ground point toward a spot above the white horse's head. The lines in the fields also lead your eyes into the distance, although they converge at a different point.

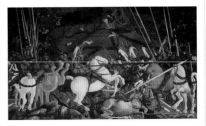

▲ *The Battle of San Romano*, Paolo Uccello, c.1456, tempera on panel, 71½ × 126in (182 × 320cm), Uffizi, Florence, Italy

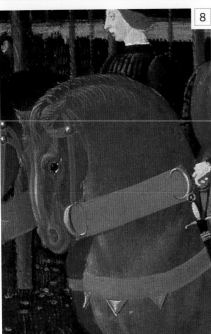

8

9

▲ **CRESCENT MOTIF** The symbol of the Roman goddess of hunting, Diana, is a crescent moon. Gold crescents decorate the horses' reins and appear on the harness straps on their rumps. Diana is the protector of chastity. It was more common for wedding gifts to depict Venus and Mars, the god and goddess of love.

◄ **TREES** We can see that the trees are oaks from the shape of their leaves, some of which would once have been decorated with gold leaf. Uccello made sure that there were no branches below the canopy to obstruct our view of the hunt. Oak groves were sacred to the Roman goddess Diana.

The Birth of Venus

c.1485 ▪ TEMPERA ON CANVAS ▪ 68 × 109¾in (172.5 × 278.5cm) ▪ UFFIZI, FLORENCE, ITALY

SANDRO BOTTICELLI

SCALE

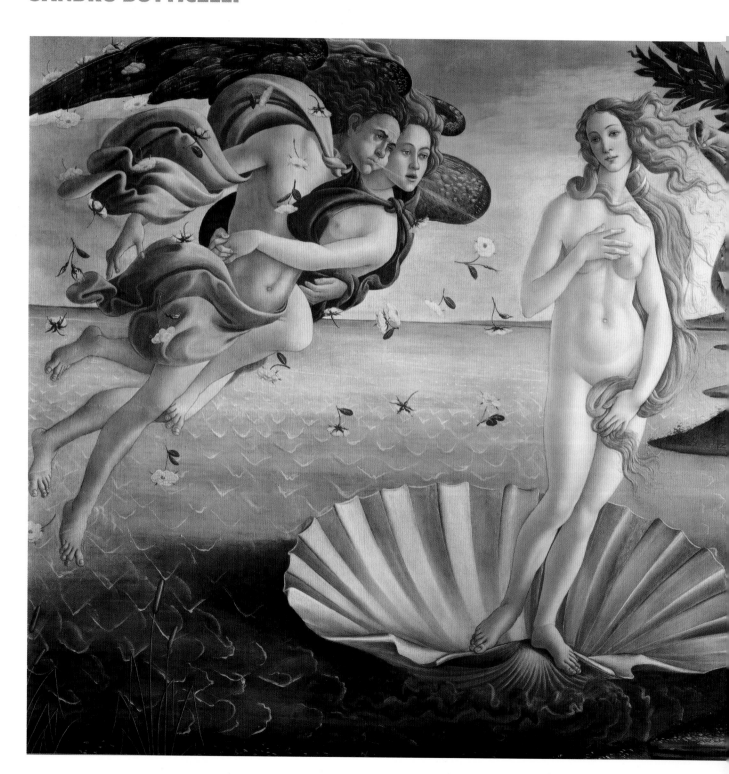

This supremely graceful painting is full of gentle movement and harmony. It depicts the arrival of Venus, Roman goddess of love, beauty, and fertility, on the island of Cyprus. All around her are signs of spring, which is a time of new beginnings and renewal. The extraordinarily beautiful, iconic figure of Venus is positioned right at the center of the perfectly balanced composition. Botticelli's Venus embodies the Renaissance ideal of beauty. Her pale limbs are long and elegant, her shoulders slope, and her stomach is sensuously rounded, yet there is something otherworldly about her, especially the expression on her exquisite face.

The painting was probably commissioned by a member of the wealthy Medici family, Lorenzo di Pierfrancesco de' Medici, for his villa at Castello near Florence. A cultured individual, he would have been familiar with the stories of classical Greek and Roman mythology as well as the philosophy of Plato, so Botticelli's Venus can be seen as the physical manifestation of a divine and perfect beauty.

In Renaissance Italy, mythological scenes were usually commissioned to decorate wooden furniture such as *cassone* (wedding chests). Religious images, on the other hand, were created on a grander scale and used in churches, often as altarpieces. In creating the *The Birth of Venus*, Botticelli broke with tradition, producing the first work on canvas to feature a mythological image that was comparable in size to a large-scale religious painting.

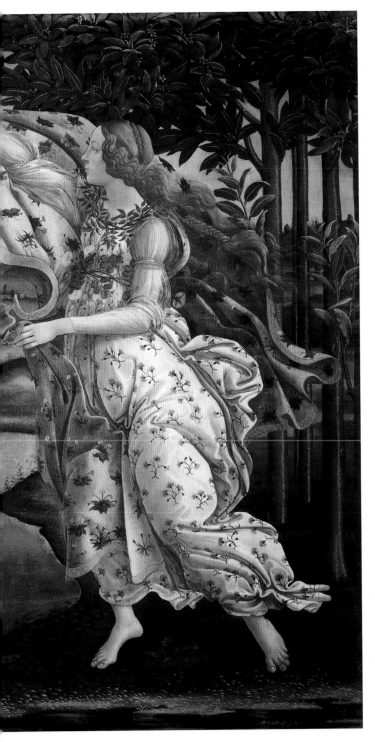

> Aphrodite **the fair**… she with the **golden wreath**…was conveyed by the **swelling breath of Zephyrus**, on the waves of the **turbulent sea** "

HOMERIC HYMN TO APHRODITE, c.5000 BCE

SANDRO **BOTTICELLI**

c.1445–1510

One of the most celebrated painters of the Renaissance, Botticelli developed a graceful and ornamental linear style that harked back to elements of the Gothic style in art.

Alessandro di Mariano Filipepi, known as Sandro Botticelli, was born in Florence. He worked as an apprentice in the studio of Fra Filippo Lippi, then established his own workshop c.1470. At the high point of his career Botticelli was producing work for Florence's churches as well as receiving commissions from the most powerful families in Florence, particularly the Medici. By 1481, his reputation was such that he was summoned to Rome to paint frescoes in the Sistine Chapel. Botticelli's good fortune did not last, however. The Medici family was expelled from Florence, his style of painting went out of fashion, and he died in poverty and obscurity. It was only in the late 19th century that interest in his work revived.

Botticelli's masterpieces were his large mythological paintings, *The Birth of Venus* and *Primavera* (see overleaf). *The Mystic Nativity*, 1500, another of his great works, was the only painting of his that was signed and dated.

Visual tour

KEY

▼ **SHELL** Venus is about to alight from her boat, a scallop shell, which anchors her in the center of the composition. Despite the painting's title, the moment of her birth occurred under less poetic circumstances. According to Greek mythology, Venus emerged from the fertile foam that was created when her father Uranus's severed genitals were thrown into the sea.

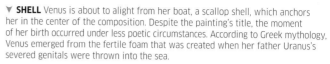

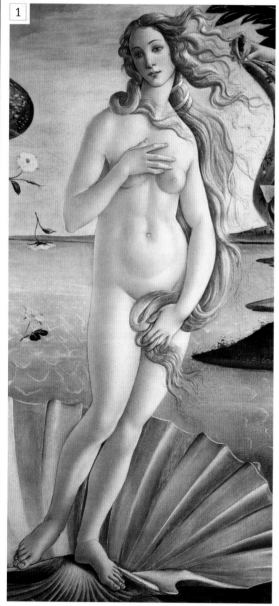

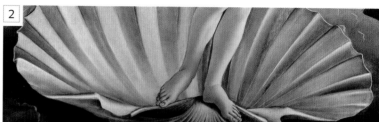

◄ **VENUS** The mythological goddess emerges as a fully grown woman. Her right hand covers one of her breasts, while her left holds long skeins of golden hair over her pubic area. Her classical pose is known as the *Venus pudica*, the modest Venus; some artists portrayed the goddess as a more erotic figure. Botticelli's Venus represents the 15th-century Italian ideal of female beauty—she has a small head, an unnaturally long neck, steeply sloping shoulders, and a rounded stomach. Apart from the pink roses wafting down on her, Venus is pictured without her usual attributes, such as her pearl necklace or Cupid, her son.

▲ **ROSES** Around Zephyrus and Chloris, delicate pink roses tumble, each with a golden heart and gilded leaves. Known as the flower of Venus, the beautiful and fragrant rose is a symbol of love, with thorns that can cause pain. It also represents fertility.

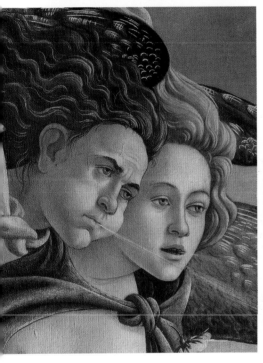

◄ FLORA The female figure on the right is generally identified as Flora, the goddess of flowers, who appears similarly attired in Botticelli's *Primavera*. An allegorical figure, she represents spring, the time of rebirth. Around her neck she wears leaves of the myrtle, a tree sacred to Venus; her dress is sprigged with cornflowers, and she wears a high sash of roses. There are more spring flowers on the billowing pink cloak she holds out to the naked Venus.

▼ GOLD HIGHLIGHTS The foliage of the orange trees is picked out in gold leaf, as are the individual feathers on the wings of Zephyrus. All the figures have gold highlights in their hair, and the veins of the shell, the stems and centers of the roses, and the grass stalks in the foreground are similarly gilded. With these gold details the whole painting would appear to glimmer after dark when lit by candlelight.

ON **TECHNIQUE**

In the painting, Venus stands with her weight on her left leg, giving her body a graceful S-shaped curve. The pose is based on that of classical statues. Venus's stance, and the way in which she has been painted without shadows, give her delicacy and make her seem almost to float. In Botticelli's ink drawing (below), the female figure adopts the same pose, this time with her weight on her right leg. Being able to represent a figure in this relaxed pose was greatly esteemed by Renaissance artists.

▲ *Allegory of Abundance or Autumn*, Botticelli, 1480–85, pen and ink on paper, 12½ × 10in (31.7 × 25.2cm), British Museum, London, UK

IN **CONTEXT**

There is much debate as to whether *The Birth of Venus* is a companion piece to Botticelli's other allegorical masterpiece, *Primavera*, perhaps commissioned by Lorenzo di Pierfrancesco de' Medici about five years earlier. Both are symbolic representations of the cycle of spring and both depict Venus, Zephyrus, Chloris, and Flora. *Primavera* (which means "spring" in Italian) is, however, painted on wood rather than canvas. In this painting, Flora has Chloris and Zephyrus on her left and Venus on her right. Venus is fully clothed and can be identified by her son, Cupid, who is flying overhead. On the left is Mercury, the messenger of the gods, and next to him are the three Graces, Venus's handmaidens.

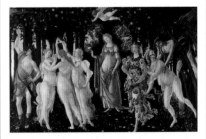

▲ *Primavera*, Botticelli, c.1482, tempera on panel, 78 × 123½in (203 × 314cm), Uffizi, Florence, Italy

▲ ZEPHYRUS AND CHLORIS The personification of the west wind, the winged Greek god Zephyrus brings movement to the scene. His cheeks are puffed out as he blows the waves that cast Venus toward the shore. He is clasped by a semi-clad female, probably Chloris, a mortal nymph abducted by Zephyrus to be his bride. Chloris was later transformed into the goddess Flora, the gorgeously clothed figure on the right of the painting. In terms of composition, Zephyrus and Chloris are balanced by the graceful figure of Flora.

➤ LAPIS LAZULI The intense blue of the cornflowers on Flora's dress comes from ultramarine, an expensive pigment made by crushing lapis lazuli, a semiprecious stone. Botticelli's wealthy patron clearly spared no expense when he commissioned this painting.

1500 – 1600 CT

The Garden of Earthly Delights

c.1500 ▪ OIL ON PANEL ▪ 86½ × 153in (220 × 389cm) ▪ PRADO, MADRID, SPAIN

HIERONYMUS BOSCH

SCALE

Across three large panels an astonishing vision unfolds. Scores of figures—some human, some monstrous—inhabit a visionary world that encompasses radiant beauty as well as scenes of hideous torment. The two outer panels depict the Creation of Eve on the left and Hell on the right. In the central panel, teeming nude figures engage in unbridled sexual activity in a luscious garden. Although many of the details are baffling to the ordinary observer, the general idea of the painting seems clear—God gave man and woman an earthly Paradise, but the sins of the flesh have led them to the tortures of Hell. However, because the painting is so unconventional and the circumstances of its creation are unknown, there has been endless commentary on how exactly it should be interpreted.

Open to speculation

The painting was first documented in 1517, the year after Bosch's death, when it was said to be in a palace in Brussels belonging to Count Hendrik—Henry III of Nassau. Paintings in triptych (three-paneled) format were very common as altarpieces in Bosch's time, but this one is so personal that it was almost certainly created for a private patron rather than a church, and in the absence of other evidence it is reasonable to assume that this patron was Hendrik or one of his relatives.

Bosch left behind no letters or other writings, and there are no reminiscences by people who knew him. There are numerous contemporary documents relating to him, mainly preserved in the municipal archives of 's-Hertogenbosch. While they provide some information about the outline of his life, they throw no light on his character. The gaps in our knowledge have been filled with a wealth of speculation by modern writers, who have portrayed Bosch as everything from a scholarly theologian to a heretic with a disturbed mind. It has been proposed, for example, that the figures in the central panel of *The Garden of Earthly Delights* are members of an obscure sect who practised ritual promiscuity to try to recapture the initial innocence of Adam and Eve. Bosch is

alleged to have belonged to the sect and, therefore, to have exalted lust in the painting rather than condemned it. Such theories can be entertaining, but they are based on little or no hard evidence.

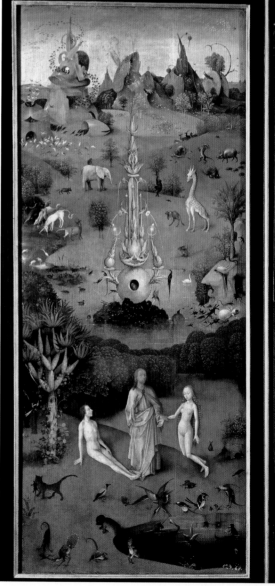

Instead, all the contemporary records indicate that Bosch was a respected member of society who held conventional religious views. Aspects of his work that seem strange to us probably reflect the popular culture of his time rather than bizarre personal views. Religious pageants and plays, for example, sometimes used repulsive demon masks to suggest the horrors of Hell.

> …it is his ability to **give form to our fears** that makes his imagery timeless

LAURINDA DIXON *BOSCH*, 2003

HIERONYMUS **BOSCH**

c.1450–1516

Bosch produced some of the strangest and most perplexing paintings in the history of art. Very little is known of their creator, inspiring much speculation about his character and motives.

As far as is known, Bosch spent all his life in the town after which he is named, 's-Hertogenbosch, which is now in the southern Netherlands, near the Belgian border. In Bosch's time, when the map of Europe was very different from that of today, the town was in the Duchy of Brabant. Bosch was the leading painter of the day in 's-Hertogenbosch, which was prosperous and a notable cultural center. By the end of his life, his work was sought by leading collectors in Italy and Spain as well as his homeland. His paintings continued to be admired and influential throughout the 16th century, but thereafter they were long neglected. It was not until about 1900 that there was a serious revival of interest in him.

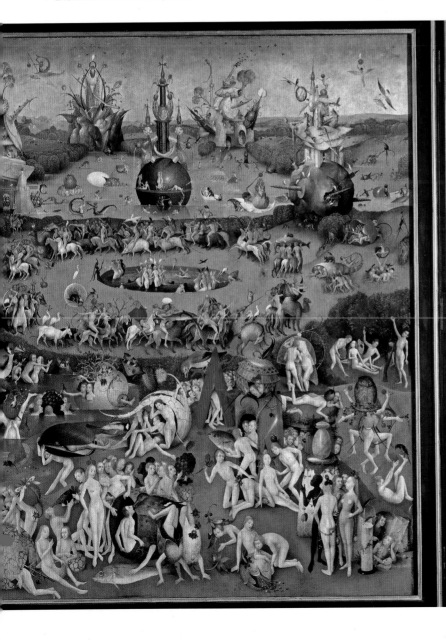

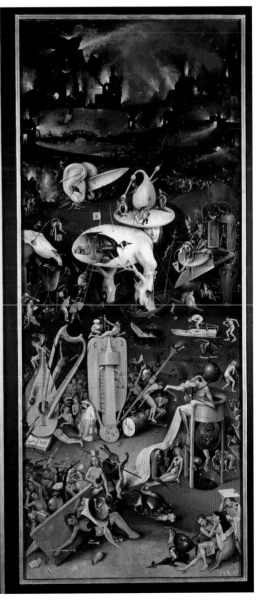

Visual tour

KEY

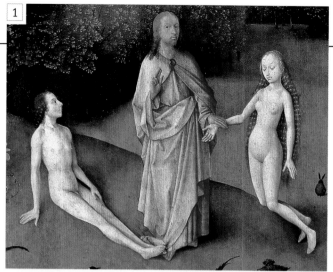

▼ **FOUNTAIN OF LIFE** This strange and beautiful structure in the left-hand panel is the Fountain of Life, from which the rivers of Paradise flow. It is not mentioned in the biblical account of creation, but it appears in Christian art from the 5th century onward.

◄ **ADAM AND EVE** In the biblical account of the first days of the world, God creates Eve from a rib he has taken from the sleeping Adam. Here God, looking very like the traditional image of Christ, takes Eve's wrist and presents her to Adam. With his other hand, he makes a gesture that confers blessing on their union.

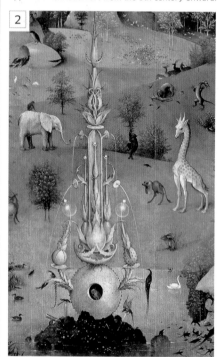

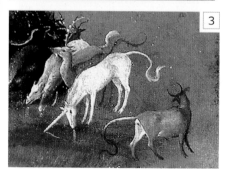

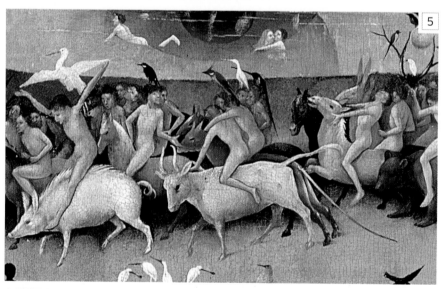

▲ **EXOTIC ANIMALS** Scenes of the Garden of Eden allowed artists to depict all manner of animals, both real and imaginary, to illustrate the abundance of God's creation. The mythical unicorn was adopted into Christian art as a symbol of purity.

▲ **NAKED MEN RIDING ANIMALS** Groups of men—mounted on real and imaginary animals—energetically circle a pool, from which women look out invitingly. Animals were traditionally associated with the lower or carnal appetites of humankind, and in Bosch's day, as now, the act of riding was often used as a metaphor for sexual intercourse.

▼ **GIANT STRAWBERRY** In art, the strawberry was sometimes interpreted as an allusion to drops of Christ's blood. However, it was also used as a sexual metaphor, its juicy voluptuousness suggesting carnal activity.

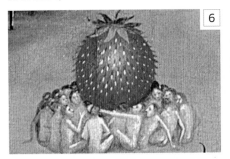

▼ **BUTTERFLY AND THISTLE** Few details in the painting have escaped symbolic interpretation. The butterfly has been seen as an allusion to inconstancy or capriciousness and the thistle to corruption. In other contexts, however, both can have positive associations.

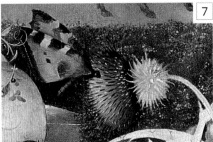

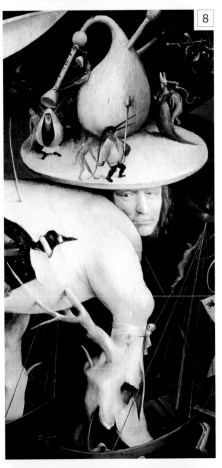

▲ **POOL OF NAKED WOMEN** In the middle of the central panel is a pool full of naked women who excite the circling men. Medieval moralists writing on sexual matters invariably saw women as temptresses—following the example of Eve. This "Fountain of Flesh," a kind of crazy merry-go-round of courtship, can be seen as a sinful counterpart to the Fountain of Life depicted in the first panel of the triptych.

▶ **TREE MAN** Part man, part egg, part tree, this weird construction defies precise analysis, but it is surely intended as Hell's counterpart to the Fountain of Life on the left-hand panel. It has been suggested, although without any real evidence, that the haunting, pale face is a self-portrait of Bosch. On his head, demons lead their victims around a disc, which in turn supports a bagpipe, an instrument that often had sexual connotations.

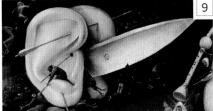

▶ **KNIFE AND EARS** A pair of ears and a knife present an obviously phallic appearance. The knife bears the letter "M", as do other blades in paintings by Bosch. Various explanations have been offered for this. One suggestion is that the letter stands for *mundus* ("world" in Latin).

ON **TECHNIQUE**

Bosch was a free spirit in terms of technique as well as imagery. Most of his contemporaries in the Netherlands cultivated smooth, tight, precise handling of paint, but Bosch's brushwork is fluid and vigorous. He was also one of the first artists in northern Europe to produce drawings intended as independent works. This typically lively example is a variant of the tree man in *The Garden of Earthly Delights*.

▲ *The Tree Man*, Hieronymus Bosch, c.1505, quill pen and brown ink, 11 × 8¼in (27.7 × 21cm), Grafische Sammlung Albertina, Vienna, Austria

IN **COMPOSITION**

The hinged side panels of the triptych can be closed over the central panel to form an image of the Earth, painted in shades of grey. God can be seen top left; his creation of the world—shown here as barely formed and unpopulated—forms a prelude to the creation of Eve inside.

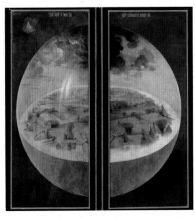

▲ *Creation of the World*, the monochrome exterior side panels of *The Garden Of Earthly Delights* as they appear when the triptych is closed

The Great Piece of Turf

1503 ■ WATERCOLOR, PEN, AND INK ON PAPER ■ 16 × 12½in (40.8 × 31.5cm) ■ ALBERTINA, VIENNA, AUSTRIA

SCALE

ALBRECHT DÜRER

The minute detail in this exquisite painting of a simple piece of meadow turf is of almost photographic precision. Painted more than 500 years ago, it is one of the first great nature studies.

Here, Dürer has given us an insect's perspective of nature. He has recreated the small, tangled plants with such clarity that it is possible to identify each one, making it one of the first European studies of biodiversity. *The Great Piece of Turf* is a masterpiece in its own right but, like his Italian contemporary, Leonardo da Vinci, Dürer made his nature studies primarily to increase his understanding of the natural world and to help him with the detail in his engravings, such as *The Fall of Man*, 1504, his woodcuts, and his large-scale paintings, such as *The Feast of the Rose Garlands*, 1506.

Dürer has used watercolor here, enabling him to work relatively quickly and concentrate on the colors and textures of the plants. With watercolor, unlike oil paint, which Dürer used in his large works, it is easy to mix subtle shades quickly and layer washes of paint on top of each other without having to wait too long for them to dry. Dürer mixed the different shades of green with great accuracy, both to differentiate each plant from the others and to create a sense of depth in the composition.

Visual tour

KEY

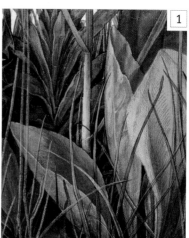

▲ **KEEN OBSERVATION** The fleshy leaves of a greater plantain stand out among the grasses. Note how Dürer has used fine, dry strokes of a deeper green to model the forms of the leaves, and fine white lines to highlight the veins and the edges of the leaves.

◄ **PALE BACKGROUND** This detail shows a spent dandelion head. You can trace the fading stem of the plant down to its familiar tooth-edged leaves. The top of the painting is covered with a pale wash so that the plants are delineated clearly against it.

▲ **SILVERY ROOTS** Dürer has not limited his study to what grows above the ground. He has cleared the soil away in places to reveal the fine, threadlike roots of the plants and has set them against a dark wash to make them more visible. The dark sepia tones weave around the bases of the plants and give the composition depth and solidity.

ALBRECHT **DÜRER**

1471-1528

Surely the greatest of all German artists, Dürer was a brilliant Northern Renaissance draftsman, printmaker, and painter. His work was characterized by accuracy and inner perception.

Born the son of a master goldsmith in Nuremberg, a center of artistic activity and commerce in the 15th and 16th centuries, Dürer was apprenticed with Michael Wolgemut, whose workshop produced woodcut illustrations, then travelled as a journeyman, making woodcuts and watercolors. He visited Italy twice and was deeply influenced by Italian Renaissance art and ideas. Back in Nuremberg, Dürer took printmaking to new heights. He completed several series of revolutionary woodcuts on religious topics, studied the nude, and published books on proportion in the human body and perspective. Dürer became an official court artist to Holy Roman Emperors Maximilian I and Charles V. He was also the first artist to produce several self-portraits.

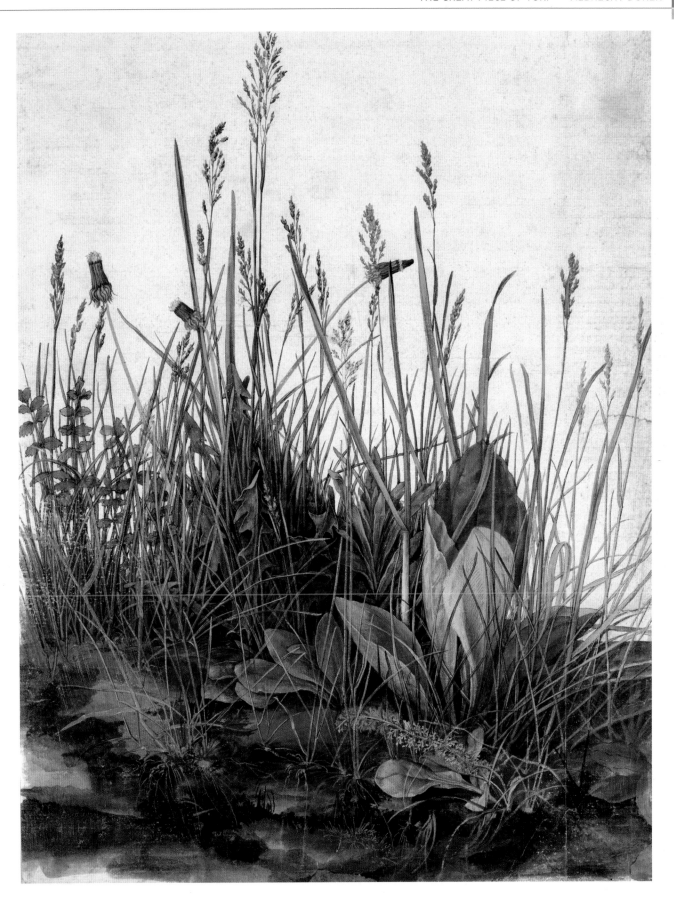

Mona Lisa

c.1503-06 ■ OIL ON POPLAR ■ 30¼ × 22in (77 × 53cm) ■ LOUVRE, PARIS, FRANCE

SCALE

LEONARDO DA VINCI

From behind bulletproof glass in the Louvre, France's national gallery, *Mona Lisa* (also known as *La Gioconda*) looks out at her adoring crowds. Mystery surrounds this beautiful woman, not only because her identity has been debated for so long, but also because her facial expression is ambivalent: strangely open and yet quietly reserved at the same time.

She sits turned slightly toward you as if on a terrace, with an imaginary landscape in the background. Framed by two barely visible columns, she smiles and gazes almost straight into your eyes, but her folded arms keep you at a distance. With this amazing image, Leonardo established a sense of psychological connection between the sitter and the viewer, an innovation in portrait painting that was soon taken up by other artists.

Realism in portraiture

Leonardo's great skill was to breathe life into this remarkable portrait. It is almost as if a real person is sitting in front of you. The softness of Mona Lisa's skin, the shine on her hair, and the glint in her eyes are all achieved by minute attention to detail. Plainly dressed and appearing relaxed, she is particularly renowned for her smile, often described as enigmatic. It is very difficult to determine her exact mood from the mouth or eyes alone. The flicker of a smile plays on her lips, yet her eyes show little sign of humor.

The fashion in portraiture at the time was to paint women as mythological, religious, or historical figures embodying desirable female traits, such as beauty or grace. Such portraits exaggerated women's features to realize these ideals: noses were elongated and necks lengthened. Mona Lisa is represented neither as Venus, the Roman goddess of beauty, love, and fertility, nor as the Madonna—both popular and idealized roles for women at the time. In celebrating this woman's own perfectly balanced features without any need for allegorical embellishment, or even decorative jewelery or costume, Leonardo was clearly breaking with tradition.

There are no existing records of a commission for this portrait and what we know about the sitter comes from biographies of Leonardo. She was probably Lisa

Gherardini, the wife of Francesco del Giocondo, a wealthy Florentine merchant, hence her other title, la Gioconda. *Monna* meant "Mrs." Giocondo's purchase of a new home around the time the portrait was painted, as well as the birth of the couple's third child in 1502, are both plausible reasons for commissioning a portrait. Mona Lisa is seated in a half-length composition, one of the earliest Italian examples of this kind of pose in a portrait.

> She has the **serene countenance** of a woman sure she will **remain beautiful** forever

THÉOPHILE GAUTIER
GUIDE DE L'AMATEUR AU MUSÉE DU LOUVRE, 1898

LEONARDO **DA VINCI**

1452-1519

A genius of the Renaissance, Leonardo is now famous for the range and variety of his talents, embracing science as well as art. He is regarded as the main creator of the High Renaissance style.

Born in or near Vinci, close to Florence, Leonardo served an apprenticeship in the workshop of the Florentine artist Andrea del Verrocchio. He then spent most of his career between Milan and Florence. His last years were spent working for the French monarchy and he died in Amboise, France.

The diversity of Leonardo's interests meant that he produced few finished paintings, but he left behind many sensitive, highly detailed drawings and notebooks. Among other subjects, he studied anatomy, the flight of birds and insects, the forms of rocks and clouds, and the effects of the atmosphere on landscape. All of his observations informed his paintings, in which he combined grandeur of form and unity of atmosphere with exquisite detail. Leonardo's mastery of composition and harmony can be seen in another of his most celebrated works, *The Last Supper* (c.1495-97). Sadly, the painting has deteriorated badly over time because of the experimental technique he used.

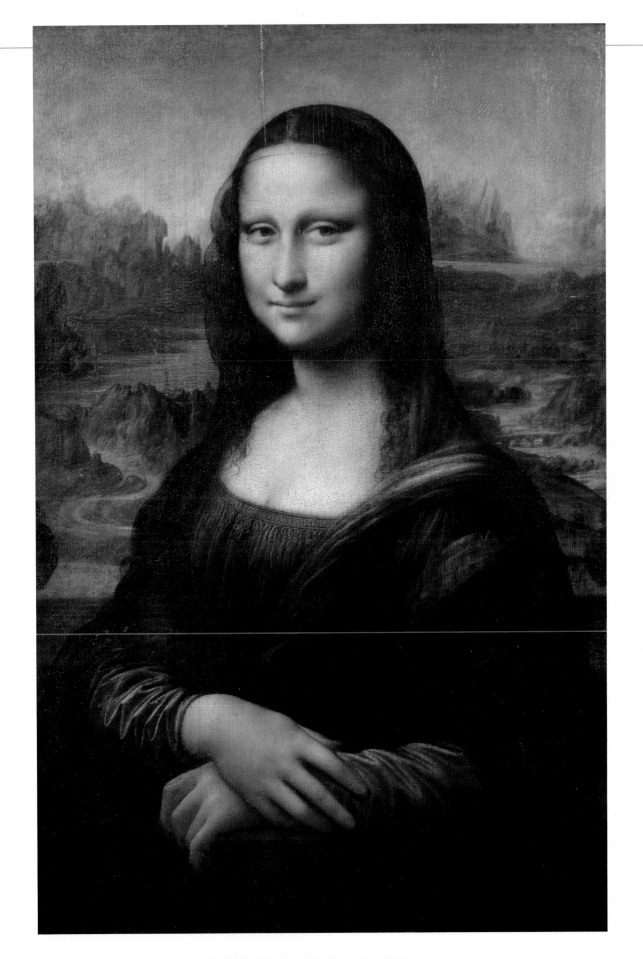

Visual tour

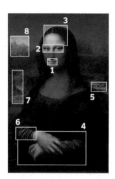

KEY

▶ **ENIGMATIC SMILE**
Leonardo introduced a painting technique known as *sfumato*, which makes subtle use of blended tones. Used here to great effect, it gives Mona Lisa's smile a mysterious softness. Her lips tilt gently upward at the edges, but her expression is hard to read. Alongside other aspects of her pose, this gives *Mona Lisa* an air of remote calmness.

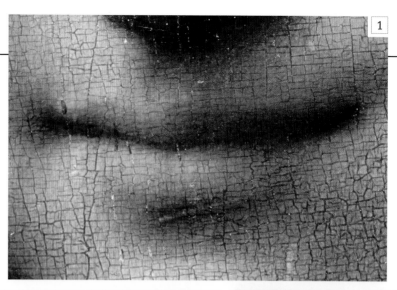

1

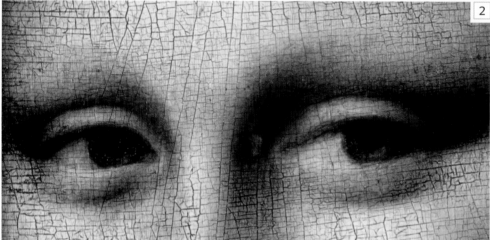

2

▲ **EYE CONTACT** It is natural to look into someone's eyes. As is the case with many portraits, Mona Lisa's eyes seem to look straight back at you and to follow you around if you move. Leonardo achieves this illusion by directing the left eye squarely at the viewer, and positioning the right eye slightly to one side.

▲ **ARMS AND HANDS**
Mona Lisa's folded arms form the base of a triangle that reaches up from each arm to the head. Leonardo used this compositional technique to place his model within a harmonious space—in a geometrical sense—that is pleasing to the eye. Mona Lisa wears neither rings nor bracelets, and her hands look youthfully plump. Her hands and arms look relaxed, as if she is sitting comfortably.

3

▶ **HAIR** Look carefully at this part of the painting and you can see a dark veil over Mona Lisa's head and to the side of her face, probably indicating her virtuousness. Her hairline and eyebrows may have been plucked, as was fashionable at the time.

▼ **BRIDGE IN PERSPECTIVE** Just behind the right shoulder, you can make out the arches of a bridge spanning a river. As with other parts of this imaginary landscape, Leonardo has painted it so that you look down on it. Mona Lisa's eyes, however, are at the same level as the viewer's.

▼ **SLEEVES** Leonardo's skilful application of oil paint can be seen in the modeling and tones of the sleeves. Originally these sleeves would have been saffron yellow, but the pigment has faded over many years and the varnish applied to the surface to conserve the paint has also darkened the color.

▲ **SOFT FOCUS** The hazy appearance of the landscape has been achieved with a technique called glazing, in which layers of thinned, transparent oil paint are applied one over the other. Each layer of paint has to be dry before the next is applied. Blue emphasizes the dreamlike effect of the landscape and helps to create the illusion that the background is receding.

▲ **WINDING PATH** In an early drawing, Leonardo had already used the pictorial device of a long path or river to lead the viewer's eye into the distance. Visually, the feature appears simply to be part of the landscape but the device is used very cleverly to give the painting depth and to make the space appear less flat and one-dimensional.

ON **TECHNIQUE**

Leonardo would have made studies of every aspect of the portrait, sketching each part individually beforehand. Such attention to detail was unusual and helped to give his paintings their realistic quality.

This study of drapery shows how Leonardo modelled the material using charcoal, chalk, and wash to create the impression of creases. He used the same technique with oil paint on the sleeves of the *Mona Lisa*.

Leonardo dipped rags in plaster to help him paint drapery. The plaster held the fabric in place and emphasizied its folds, giving Leonardo the time to make detailed drawings.

▲ *A Study of Drapery*, Leonardo da Vinci, 1515–17, charcoal, black chalk, touches of brown wash, white heightening, 6½ × 5¾in (16.4 × 14.5cm), The Royal Collection, London, UK

IN **CONTEXT**

This iconic image has been subverted through the ages, perhaps most famously by Marcel Duchamp in his 1919 "readymade," *L.H.O.O.Q.* (below). Duchamp drew a beard and moustache on a postcard of the portrait with those letters beneath it—a crude pun in French suggesting that Mona Lisa is a sexually available woman. Duchamp may also have intended to underline the ambiguity of the sitter's gender.

▲ *L.H.O.O.Q.*, Marcel Duchamp, 1919, pencil on card, 7¾ × 4in (19.7 × 10.5cm), Centre Pompidou, Paris, France

The School of Athens

c.1509–11 ▪ FRESCO ▪ 16ft 4¾in × 25ft 3in (500 × 770cm) ▪ VATICAN, ROME, ITALY

RAPHAEL

SCALE

The School of Athens is the most famous of the frescoes commissioned by Pope Julius II when he remodeled his private chambers in the Vatican Palace. Raphael and his assistants undertook the task of decorating all four of these *stanze* (grand rooms) in 1508. They continued their work under Julius's successor, Leo X, but Raphael died before the rooms were completed. This monumental fresco, which depicts an imaginary gathering of classical philosophers and scholars, sits above head height on the wall of the *Stanza della Segnatura* with its vaulted ceiling. It is justly famous for the graceful poses of its figures, the sense of movement they embody, and their expressiveness—all of which Raphael achieved after making hundreds of detailed studies and sketches. The painting's other outstanding feature is the harmony of its composition.

Pursuit of truth and knowledge

The pictorial scheme of the *Stanza della Segnatura* shows that it was used as the papal library and private office. The theme of the frescoes on all four walls is the search for truth and enlightenment, and *The School of Athens* represents the pursuit of rational truth through philosophy. Central to the composition are the figures of the two great classical Greek philosophers, Plato and Aristotle, who represent different schools of thought.

The majestic style of *The School of Athens*, the serene movements and gestures of the figures, and the grand architectural composition with its sense of symmetry and spatial depth all combine to make this work a masterpiece of the High Renaissance. In the brilliant portrayal of the subject matter and the assured style of its execution, Raphael has encapsulated the classical ideal of the pursuit of knowledge.

RAPHAEL

1483–1520

The precociously talented Raphael took on major commissions at a young age. Together with Michelangelo and Leonardo da Vinci, he dominated the High Renaissance period.

Born in Urbino in central Italy, Raffaello Sanzio initially trained with his father, Giovanni, who was a poet as well as a painter. He later assisted in the workshop of the painter, Perugino. In 1508, with his reputation already established, the 25-year-old Raphael was summoned to Rome by Pope Julius II and given a prestigious commission—the decoration of the papal apartments.

Other major commissions followed but these were increasingly executed by assistants in Raphael's workshop. The workshop was so well organized that it is often hard to tell how much workshop contribution there is in a painting. Apart from *The School of Athens* and the other frescoes of the *Stanza della Segnatura*, Raphael's designs for the 10 tapestries for the Sistine Chapel are considered to be among his finest work. He also painted several portraits. Under Julius's successor, Pope Leo X, Raphael became Papal Architect. He died in Rome of a fever, aged just 37.

Visual tour

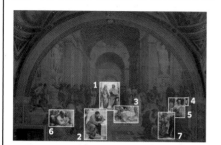

KEY

◀ **HERACLITUS** The expressive body language of this figure gives him an air of melancholy. He represents the pre-Socratic Greek philosopher Heraclitus, commonly known as the "weeping philosopher." His well-built frame leans on a block of marble and he seems to be writing dark thoughts on a piece of white paper. This figure is a portrait of Michelangelo, another of Raphael's contemporaries, who was working on the nearby Sistine Chapel when Raphael was painting *The School of Athens*. Raphael is paying the artist a great honor by depicting him in such illustrious company.

▲ **DIOGENES** A controversial character in Greek philosophy, Diogenes chose to drop out of society and live in poverty inside a barrel. He is pictured here lounging on the steps partially clothed, but he is usually depicted as a beggar living on the streets, unwashed and dressed in rags.

◀ **PLATO AND ARISTOTLE** These two great Greek philosophers represent theoretical and natural philosophy. Under his left arm Plato holds the *Timaeus*, one of his dialogues. Plato believed that a world of ideal forms existed beyond the material universe, so Raphael shows him pointing towards the heavens. He looks like Raphael's contemporary, Leonardo da Vinci, to whom the artist is paying tribute. Aristotle is holding his famous *Ethics* and is gesturing towards the ground. Unlike Plato, Aristotle held that knowledge is only gained through empirical observation and experience of the material world.

▶ **SELF-PORTRAIT** The figure looking out of the far right of the painting straight at the viewer is Raphael himself. Wearing a dark beret, the customary headgear of the painter, he is not only identifying himself but possibly making a link between the worlds of the past and the present.

▼ **EUCLID** Leaning over and demonstrating a mathematical exercise with a pair of dividers, the Greek mathematician Euclid is surrounded by a group of young men. Known as the "Father of Geometry," Euclid's writings include observations on "optics," which is closely related to perspective. The figure is a portrait of the architect Bramante.

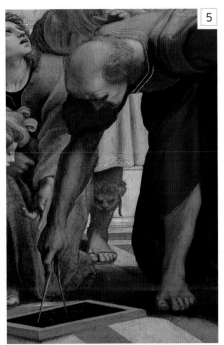

IN **CONTEXT**

Raphael worked on the fresco scheme of the *Stanza della Segnatura*, where each fresco represents one of four themes, between 1508 and 1511. Besides *The School of Athens*, there are three other frescoes in the vaulted *Stanza*. On the wall opposite is the *Disputation of the Most Holy Sacrament* (see below), a representation of theology. Above the painted horizon is the Holy Trinity with saints and martyrs arranged in a semicircle; below them are the Church's representatives on earth, similarly arranged with the Sacrament in the center.

▲ *Disputation of the Most Holy Sacrament,* Raphael, 1509–10, fresco, 16ft 4¾in × 25ft 3in (5 × 7.7m), Vatican, Rome, Italy

ON **COMPOSITION**

The architectural setting of the fresco is imaginary, but its scale and splendor represent the ideals of the High Renaissance. The setting was inspired by the plans of Raphael's friend and distant relative, the architect Donato Bramante, for the papal basilica of St. Peter's. It is an acknowledgment of Rapahel's admiration for Bramante.

In *The School of Athens*, the large central arches decrease in size, creating the illusion of depth. Raphael has placed the two most important figures, Plato and Aristotle, in the center of the painting, where the horizon line converges with the central vertical (see overlay below). Lines radiate outwards from this point. These can still be seen in the original drawing made for the fresco.

▲ **PYTHAGORAS** On the opposite side of the painting to Euclid, we find the celebrated Greek philosopher and mathematician Pythagoras. He is demonstrating theories of geometry and, like Euclid, is being watched eagerly by a group of students. One of them holds up a diagram on a slate.

▲ **ZOROASTER AND PTOLEMY** By bringing together philosophy's greatest minds in this painting, Raphael took the opportunity to depict discussions that could never have taken place. Here we see Zoroaster, prophet and philosopher of ancient Persia, talking to Ptolemy, the Greek mathematician, geographer, and astronomer. Ptolemy, who believed the earth was the center of the universe, holds a terrestrial globe in his left hand; Zoroaster is holding a celestial sphere.

Sistine Chapel Ceiling

1508-12 ▪ FRESCO ▪ 45 × 128ft (13.7 × 39m) ▪ VATICAN, ROME, ITALY

SCALE

MICHELANGELO

Painted single-handedly over a period of four years and including almost 300 figures, this superhuman achievement earned its creator the title *il Divino* (the Divine) during his lifetime. Michelangelo, an artist with a profound religious faith, also planned the whole imaginative design, making hundreds of detailed, preliminary drawings for the frescoes and skilfully working out the complicated perspective needed for the large, curved surface that would be seen from 20 meters below. His elaborate scheme divides the vaulted roof into narrative scenes, each illustrating a key episode from the creation story in the book of Genesis. Between the scenes are naked, muscular youths, known as *ignudi*. Like all the other figures on the ceiling, they reveal Michelangelo's

deep admiration of classical Roman sculpture and the way it expressed the beauty of the human body. In the niches below the *ignudi*, Old Testament prophets alternate with sibyls, the female seers of ancient Greek mythology. Michelangelo filled the arches around the high windows with more paintings of biblical scenes.

Summoned to the Vatican

Leading Renaissance artists, such as Botticelli and Perugino, had been commissioned to decorate the walls of the Sistine Chapel some 20 years earlier, and Pope Julius II, an ambitious and authoritarian figure, was determined that Michelangelo should renovate the ceiling, which had been painted to resemble a star-studded sky. After initial

reluctance—Michelangelo saw himself primarily as a sculptor not a painter—the special scaffolding designed by the artist was put in place and Michelangelo embarked on years of lonely and physically demanding work, while beneath him church services were conducted as normal. The great ceiling fresco was finished in October 1512.

Before the most recent restoration work, which was completed in 1992, Michelangelo's biblical scenes looked dark and muted. Once hundreds of years' worth of accumulated grime had been expertly removed, however, the brilliance of the colors shone through. Even in reproduction the ceiling is an awe-inspiring sight as well as a fitting testament to the extraordinary vision and artistic genius of this intensely spiritual man.

> ## As we look upwards we seem to look into…a world of more than human dimensions ,,

ERNST GOMBRICH *THE STORY OF ART*, 1950

MICHELANGELO

1475-1564

One of the greatest artists of the Renaissance, Michelangelo Buonarroti was a sculptor, painter, architect, and poet. No other artist has ever equalled his mastery of the nude male figure.

Born near Arezzo, Tuscany, into a minor aristocratic family, Michelangelo worked as an apprentice in the workshop of the painter Domenico Ghirlandaio, where he learned fresco painting. Soon afterward, he joined the household of Lorenzo de' Medici and made figure drawings based on the works of Giotto and Masaccio. After Lorenzo's death, Michelangelo moved to Rome, where he made his name with the beautiful, sorrowful *Pietà*, the marble sculpture of the Virgin Mary cradling the dead Christ. His technical mastery was also evident in *David*, the colossal statue he created for the city of Florence, completing it in 1504.

A year later, Pope Julius II commissioned Michelangelo to create sculptures for his papal tomb, but this grand scheme was scaled down dramatically. Meanwhile, the deeply devout artist had embarked on another prestigious commission for Julius—the Sistine Chapel ceiling. Michelangelo was just 37 years old when he finished it. Other commissions, some for the Medici family and several for the papacy followed, notably the painting of *The Last Judgement* on the altar wall of the Sistine Chapel, which was commissioned by Pope Paul III. This huge fresco depicts the terrible fate of corrupt humanity.

Michelangelo was appointed architect to St. Peter's in Rome in 1546, and the last years of his life were devoted mainly to architecture, notably redesigning the great dome of the church. He died in Rome.

Visual tour

KEY

▼ **CREATION OF PLANTS, SUN, MOON, AND STARS** In this scene, Michelangelo shows the third and fourth days of Creation, with two massive figures representing God. The figure with swirling robes seen from the back is a depiction of God creating vegetation and fruit trees on earth. The bearded figure with outstretched arms points to a ball of golden light, the sun. The other beautifully modeled hand points back to the moon, the second "light" in the heavens.

◄ **SEPARATION OF LIGHT FROM DARKNESS** "Let there be light" (Gen. 1:3–5). In the first of Michelangelo's scenes depicting the biblical creation of the world, the figure of God is shown directly overhead. Stretched out full-length, he seems to be twisting through the stormy atmosphere. He is separating light from darkness with his powerful arms.

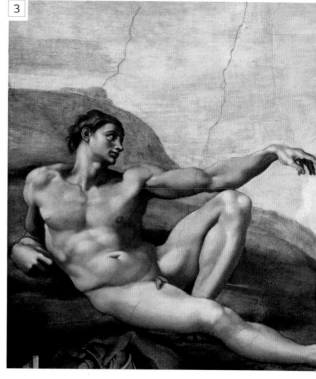

► **CREATION OF EVE** On the sixth day of creation, God created Adam "in his own image." After sending him into a deep sleep, God made Eve, the first woman, from one of Adam's ribs. Here Eve is shown emerging, her hands raised to the cloaked figure of God, who appears to be gesturing for her to rise.

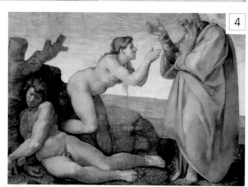

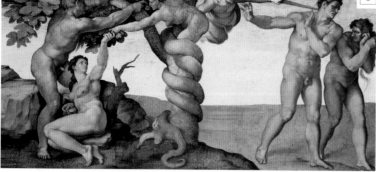

▲ **THE CREATION OF ADAM** Probably the most celebrated scene of the whole *Sistine Chapel*, this famous image is recognizable from the central detail alone—two beautifully sculpted fingers on the point of touching. God, the grey-haired, authoritative Father, is a dynamically charged figure who extends his physical and spiritual energy out toward Adam. With his athletic body and lovely face, Adam embodies beauty that is divine in origin. The anatomical accuracy and youthful grace of this figure recall the perfection of *David*, which Michelangelo created in 1501–04.

◄ **THE FALL AND EXPULSION** This scene depicts two separate episodes from the Book of Genesis. On the left, Adam and Eve are in the Garden of Eden and a serpent with a powerful female body and a coiled tail is offering Eve the forbidden fruit from the tree of knowledge of good and evil. To the right, the sinful couple, ashamed and remorseful, are being banished from leafy Eden by a warrior angel and are heading into a barren landscape.

▼ **THE FLOOD** In a scene of great turbulence, Michelangelo shows people fleeing from the rising flood waters—God's punishment for humanity's corruption. In the background floats Noah's wooden ark, while in the foreground families struggle to higher ground, hair and clothes whipped about by the wind. Chaos and panic reign.

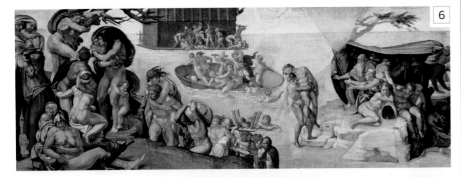

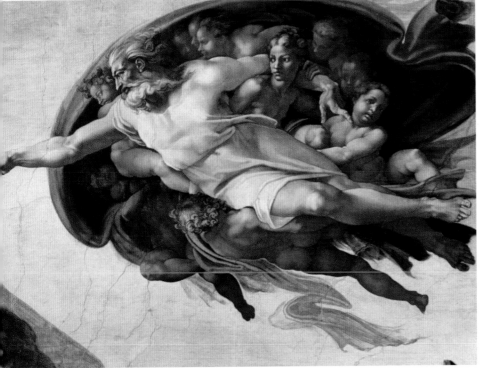

ON **TECHNIQUE**

Michelangelo's depiction of male figures on the ceiling of the Sistine Chapel shows that he was greatly influenced by the classical marble sculptures of antiquity, such as the *Belvedere Torso* (below). Signed by Apollonius, a Greek sculptor, little is known of the statue's origins, but by 1500 it was considered one of the world's greatest works of art, together with the *Apollo Belvedere*, and Michelangelo probably made many studies of it. The similarity between the rugged *Belvedere Torso* and Michelangelo's powerful, anatomically exact male forms is most apparent in the muscular, seated figures of the *ignudi* at the sides of the ceiling's central scenes.

▲ *Belvedere Torso*, Apollonius, 62½in (159cm) high, Vatican Museums, Rome, Italy

IN **CONTEXT**

In 1535, Michelangelo was commissioned to paint *The Last Judgement* on the altar wall of the Sistine Chapel. In this monumental work, a commanding, vengeful Christ is at the center of the composition, delivering the final verdict on human souls. It is a vision from which the artist's earlier idealism is absent; instead, the fresco reflects Michelangelo's own spiritual anguish. *The Last Judgement* was censured by Catholic elders, who objected to the level of nudity on display, and after Michelangelo's death, some strategically placed painted drapery was added.

▲ *The Last Judgement*, Michelangelo, 1536-41, fresco, c.48 × 44ft (14.6 × 13.4m), Sistine Chapel, Vatican, Rome, Italy

◄ **DRUNKENNESS OF NOAH** According to the book of Genesis, Noah cultivated vines, became drunk on his own wine, and fell asleep unclothed. When one of Noah's sons saw his father naked, he called his two brothers. The three are shown attempting to cover Noah's nakedness while averting their gaze. In his depiction of the drunken Noah, Michelangelo may have been inspired by antiquities displayed in the papal collection: the pose resembles that of a classical Roman river god. Noah's sons, too, are barely covered and their sturdy bodies look very sculptural.

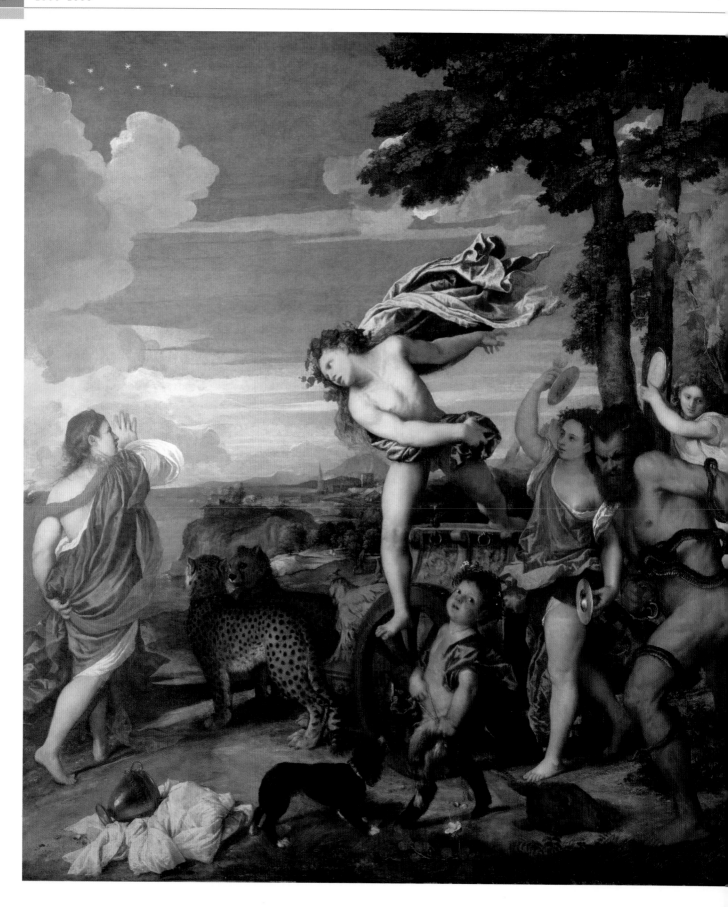

Bacchus and Ariadne

1520-23 ▪ OIL ON CANVAS ▪ 69½ × 75in (176.5 × 191cm)
NATIONAL GALLERY, LONDON, UK

SCALE

TITIAN

This dynamic scene captures the highly charged moment when Bacchus, Roman god of wine, first sets eyes on Ariadne, daughter of King Minos of Crete, and the pair fall in love. The painting is full of movement, from the leaping Bacchus with his rippling cloak to the dancing forms of the revelers who follow the god and play their musical instruments. This rather chaotic retinue fills the lower right-hand section of the painting, while the left side is dominated by the beautifully draped figure of Ariadne. Bacchus, apparently caught in midair, is the focal point of the composition, the astonished expression on his face elegantly captured. The painting truly glows: Titian's brilliant colors, especially the pure ultramarine of the sky and the women's garments, give the painting exuberance and harmony. It is an uplifting work, brimming with energy and passion, that brings this celebrated mythological love story alive.

The details of *Bacchus and Ariadne* closely follow those in the original Latin poems by Ovid and Catullus. After helping her lover, Theseus, slay the Minotaur—the fabled beast imprisoned in a labyrinth—Ariadne has been abandoned on the Greek island of Naxos. When Bacchus arrives on the island in his chariot and sees Ariadne, it is love at first sight and the two later marry. Alfonso d'Este, Duke of Ferrara, a wealthy patron of the arts, commissioned *Bacchus and Ariadne* as part of a series of mythologically themed paintings for his small private picture gallery, the *camerino d'alabastro* (alabaster cabinet). Titian took on three of the paintings—the other two are the *Worship of Venus* and *Bacchanal of the Andrians*—after much persuasion by the duke. *Bacchus and Ariadne* was the second painting and the artist, who was in great demand and working on big religious and secular commissions, took two and a half years even to start it. The patronage of such a sophisticated, cultured nobleman as Alfonso was important for the ambitious Titian and he created a magnificent celebration of love that would both please the duke and flatter his intelligence.

TITIAN

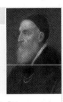

C.1488-1576

The greatest painter of 16th-century Venice, Titian was a master colorist and one of the most successful artists of the High Renaissance.

Born Tiziano Vecellio in a small town in Italy's Dolomite mountains, Titian was apprenticed in Venice at a young age. At that time Giovanni Bellini was the city state's official painter. When Bellini died in 1516, Titian had few rivals. He became the greatest painter of the Venetian school and brought a new vitality and expressiveness to altarpieces, mythological scenes, and portraits. Titian's innovations in composition can be seen in religious works such as the *Pesaro Altarpiece*, 1519-26; his mythological canvases are vibrant, colorful, and sensuous; and his equestrian portrait of Emperor Charles V, leader of the Hapsburg dynasty, set the standard for royal portraiture.

A jubilant shout of a painting…with its immensity of implausibly pure ultramarine

MARK HUDSON *TITIAN: THE LAST DAYS*, 2009

Visual tour

KEY

▶ **ARIADNE** The abandoned princess appears shocked by Bacchus and his rowdy followers. With her body turned and her hand raised high towards her lover's departing ship, she is caught unaware. The twist of her body as she looks over her shoulder at Bacchus is skillfully depicted and the spiraling movement is emphasized by her streaming robes, sash, and hair. The rich, bright red of Ariadne's sash is echoed in the pink of Bacchus's cloak and provides a visual link between the two figures. The shape of Ariadne's billowing right sleeve is also picked up by the cloud forms directly above.

▼ **BACCHUS** The dynamic, leaping figure of the Roman god is the focus of the painting. Bacchus is recognizable by the crown of laurel and vine leaves around his head and his expression has been painted by the artist with great sensitivity. His beautifully modeled pink cloak unfurls behind him like a pair of wings, and he seems to be launching himself toward Ariadne. The clouds in the sky above Bacchus emphasize his trajectory.

▲ **THESEUS'S SHIP** On the distant horizon is a boat with white sails, towards which Ariadne appears to be reaching. This tiny detail refers to the earlier part of the mythical story—Ariadne's abandonment by Theseus, who could not have killed the Minotaur and escaped from the labyrinth without her help. Theseus brought her from Crete to the island of Naxos then sailed away, leaving her alone. Titian was creating a work that would be seen by a cultured audience, so all the details, however small, had to be correct.

CROWN OF STARS The stars above Ariadne's head are a reference to the romantic ending of the myth. After falling in love with her, Bacchus promises Ariadne the sky if she will marry him. When she agrees, he takes her crown and throws it in the air, where it is transformed into a constellation of stars.

BACCHANALIAN REVELLERS The god of wine and the bringer of ecstasy (Dionysus in Greek myth) was usually accompanied by a noisy retinue that included satyrs. With pointed ears, small horns, and hairy bodies that usually ended in a goat's tail, these creatures were lecherous nature spirits who liked to chase nymphs through the forests. The writhing, muscled figure in the foreground, wrapped in snakes, is based on Laocoön, a Trojan priest in the classical sculpture, *Laocoön and His Sons*. It had been discovered in 1506 and was greatly admired by Renaissance artists.

CHEETAHS Echoing Bacchus and Ariadne's first electrifying glance, the cheetahs pulling the god's chariot look meaningfully into each other's eyes. According to some accounts, Alfonso d'Este had a menagerie which housed cheetahs. Titian had been a guest at the duke's court, so this inclusion is a personal reference. Usually, Bacchus's chariot would have been pulled by leopards.

URN The bronze urn resting on the piece of yellow fabric bears the Latin inscription, *TICIANUS F(ECIT)*, which means "Titian made this." It is a novel way to sign a painting and, perhaps, as a discarded vessel from the partying group, refers to Titian's own extravagant lifestyle.

ON **TECHNIQUE**

The exquisite ultramarine of Ariadne's robe is made from finely crushed lapis lazuli, a costly semiprecious stone. When used in its purest form, as in the darkest areas in the painting, the paint dries very slowly and is prone to cracking as the surface shrinks. These cracks are visible in the original painting.

When the painting was X-rayed, it was clear that Ariadne's bright red sash had been painted on top of the flesh tones of her shoulder, and that both shoulder and sash had been applied over the background of sea. This helps to explain how Titian worked on the painting. It appears that he did not create an underdrawing to map out the position of the figures but adopted a more flexible approach to the composition.

IN **CONTEXT**

Once the theme for his private gallery was established, Alfonso d'Este wished to commission the best Italian artists of the day. He commissioned Bellini's painting *The Feast of the Gods* (1514) and approached Raphael and Fra Bartolomeo. Both artists produced preliminary drawings but died shortly after, so Titian took on the commissions.

Shown below is one of the two other mythological scenes Titian created for Alfonso, *Bacchanal of the Andrians*. A celebration of the effects of a flowing stream of red wine on the inhabitants of an island blessed by Bacchus, it is a sensuous, energetic work.

▲ *Bacchanal of the Andrians*, Titian, 1523–26, oil on canvas, 69 × 76in (175 × 193cm), Prado, Madrid, Spain

The Ambassadors

1533 ■ OIL ON PANEL ■ 81½ × 82½in (207 × 209.5cm) ■ NATIONAL GALLERY, LONDON, UK

SCALE

HANS HOLBEIN THE YOUNGER

The powerful realism of this double portrait, which stands taller than the average man, is startling. The ambassadors of the title are two distinguished young men posing against a rich emerald-green backdrop. Gazing directly out from the composition and shown full-length, each with an arm resting proprietorially on a what-not (a table with shelves for ornaments), they immediately engage our attention. Every detail of their clothing—and of the scentific, musical, and astronomical instruments arranged between them—has been immaculately depicted. The heavy, beautifully textured robes, the selection of objects, and the confident posture of both men testify to their powerful status, wealth, and learning; and both are less than 30 years of age.

Symbols and reference points

Holbein portrayed his subjects in a realistic yet deeply respectful fashion. *The Ambassadors*, commissioned by Jean de Dinteville, the sumptuously attired man on the left, is one of his most magnificent works. De Dinteville, the young French Ambassador to the English Court of Henry VIII, is pictured with his friend, Georges de Selve, Bishop of Lavaur, during a visit to England in 1533 at a time of political and religious crisis in Europe. Holbein, who had left Switzerland in 1532, painted them in London, where they were on a difficult and ultimately unsuccessful mission to prevent Henry from severing ties with the Roman Catholic Church.

It was usual to portray learned men with their books and personal objects, but what makes this painting so remarkable is the extraordinary attention to detail and the amount of information it contains. The objects on the upper shelf on which de Dinteville and de Selve are leaning are scientific instruments, while those on the lower shelf indicate other intellectual and artistic pursuits, such as music. However, the most unusual element in the painting is the strange distorted disk, set at an angle in the foreground between the two men. It is a stretched-out skull that becomes recognizable when the painting is viewed from a point to the right. Holbein may have been displaying his technical abilities by

incorporating this perspective device to emphasize the transitory nature of life. The youth of the sitters, their wealth and status, along with the precious objects in the painting must be seen in the context of this central reference to human mortality.

Holbein's double portrait is even more complex than it first appears. With its many, sophisticated symbols, it serves as a memorial to the two young ambassadors.

> A chilling reminder **that amidst all this wealth,** power, and learning, **death comes to us all** "

JEREMY BROTTON *THE RENAISSANCE BAZAAR*, 2003

HANS **HOLBEIN THE YOUNGER**

c.1497-1543

The greatest German painter of his generation, Holbein is famed mainly for his penetrating portraits. But he was a highly versatile artist, with many other sides to his talent.

Holbein was born in Augsburg, Germany, into a family of artists, and he spent his early career mainly in Basel, Switzerland. He quickly became the leading artist of the day there, producing book illustrations (it was a major publishing center), altarpieces, murals, and designs for stained glass, as well as portraits.

In spite of his success, religious strife between Catholics and Protestants encouraged him to try his fortune elsewhere and, in 1526, he moved to England. He returned to Basel in 1528, but in 1532 he settled in England permanently. By 1536, he was working for Henry VIII. He is now most famous for portraits (drawn and painted) of members of the royal family and court, in which he memorably captured the intrigue, as well as the glamour, of the age. When he died in London—probably of the plague—he was still in his forties and at the peak of his powers.

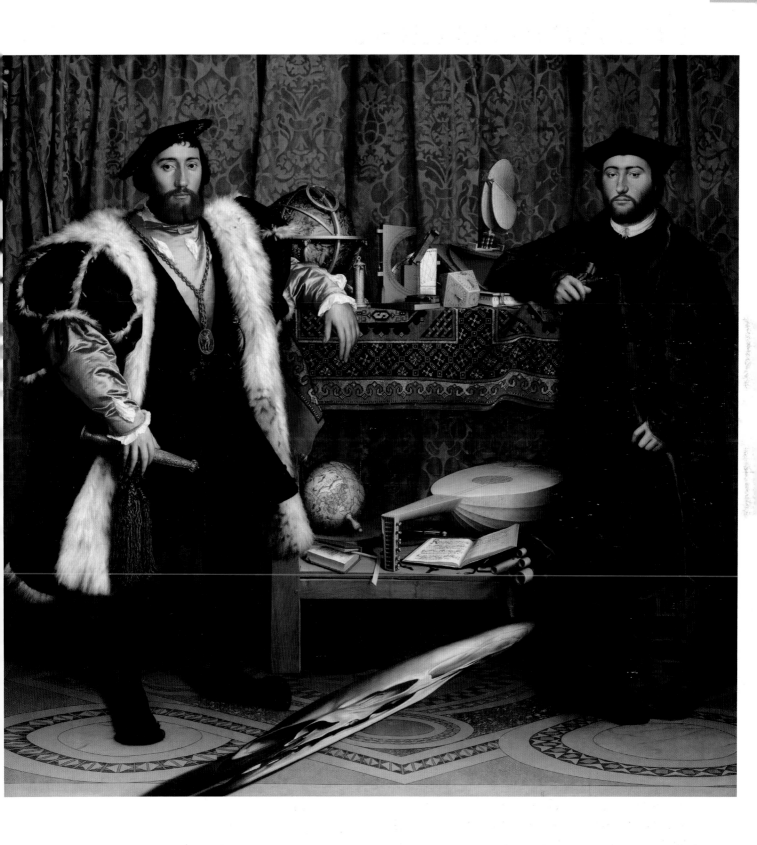

Visual tour

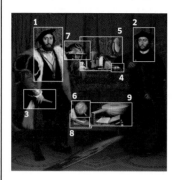

KEY

▶ **JEAN DE DINTEVILLE** The French nobleman wears a heavy black coat with a lynx-fur lining. The texture of the fur has been rendered in exquisite detail and there is a beautiful sheen on the pink silk beneath. On de Dinteville's hat is a skull, his personal insignia, and his gold chain bears the pendant of a high chivalric order.

▼ **THE FRIEND** Georges de Selve was a classical scholar and became Bishop of Lavaur. He was sent to many European countries as an ambassador and was in London in 1533. This painting commemorates his stay.

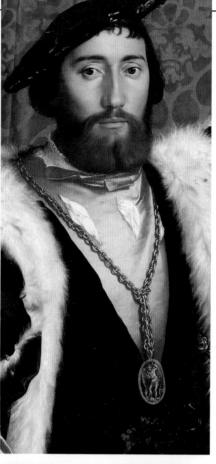

▲ **MEASURING INSTRUMENTS** On the top shelf is a range of instruments including a sundial for measuring the time of day and a navigational instrument for finding the position of stars. Both men lived in an age of great discovery, when advances in the development of scientific instruments made the circumnavigation of the globe possible. The instruments clearly place the painting in its historical context.

◀ **DAGGER** Jean de Dinteville has his hand on a dagger in a gold sheath. On it are embossed the characters *AET. SUAE 29*. These are in Latin and, in abbreviated form, refer to de Dinteville's age– 29 years. This is an ornamental, ceremonial knife, rather than one designed for combat.

◀ **BOOK** The Latin text written on the edges of the pages of the book under George de Selve's right arm reads *AETATIS SUAE 25*. Like the inscription on de Dinteville's dagger, it tells us the sitter's age–25. The book could be a bible, complete with a decorative clasp.

▼ TERRESTRIAL GLOBE Turned on its side, the globe has been positioned to show places important to de Dinteville, under whose right hand it is positioned. Polisy, near Troyes, the name of Jean de Dinteville's château, is one of the few places marked on the globe. The painting first hung in the château.

▲ CELESTIAL GLOBE This globe was used by astronomers to find and map the positions of stars, the moon, and the planets. The stars are highlighted in gold and the patterns of the constellations are depicted with background illustrations.

◄ MATH BOOK AND T-SQUARE A German mathematics book, published in 1527, has been included on the lower shelf, complete with T-square. It signifies that both figures are men of great intellect and broad education.

► LUTE The collection of musically themed objects on the lower shelf of the table includes a lute, a Lutheran hymn book, and a set of cases for flutes. Although barely visible, one of the lute's strings is broken—a possible reference to the increasing discord between Catholics and Protestants. The hymn book has been seen as a plea for religious harmony.

ON TECHNIQUE

The Ambassadors may have been designed to hang in a stairwell or beside a doorway so that it would be approached from the right-hand side. Only from this viewpoint is the skull seen in the correct perspective. This technique of distorting objects is known as anamorphosis. Artists usually employed it in works of a lighthearted nature as a piece of visual trickery, intended to amuse.

The diagrams below attempt to demonstrate how Holbein might have achieved the distorted perspective. He would probably have planned out the skull on a grid of squares first. This image was then transferred and fitted into a grid of rectangles in the required ratio.

IN CONTEXT

The Ambassadors was painted at a time of religious conflict throughout Europe following Luther's call for the reform of the Catholic Church and the establishment of Protestantism. Pope Clement VII's refusal to annul the marriage of King Henry VIII and Catherine of Aragon had also resulted in a major religious crisis in England. In 1534, Henry defied Rome and set up the Church of England with himself as its leader.

There is a partially hidden crucifix behind the green curtain (above de Dinteville's right shoulder). This may refer to the religious conflict. It has also been convincingly argued that the painting is concerned with what was thought to be the 1500th anniversary of Christ's Crucifixion.

Spring Morning in the Han Palace

c.1542 ▪ INK AND COLORS ON SILK ▪ 12in × 18ft 10in (30.6cm × 5.74m)
NATIONAL PALACE MUSEUM, TAIPEI, TAIWAN

QIU YING

SCALE

This exquisite silk handscroll shows an imaginary scene inside the grounds of a Chinese imperial palace. Although made around 1542, the painting is set over 2,000 years ago, during the Han dynasty, which ended in 220 BCE. Qiu Ying, a Ming dynasty artist, was commissioned by the celebrated collector Hsiang Yüan-pien to make this painting during a period when China was reasserting its cultural and political identity. The meticulously decorated scroll was designed to be unfurled an arm's length at a time and read much like a book, starting from

the right (bottom right below), then following the narrative all the way along to the far left (top left below). Beautifully shaped trees and rocks adorn the grounds of the imperial palace, and pillars and porticos define the structure of the pavilions. The panoramic narrative depicts the concubines of the imperial court taking part in various leisure activities on a spring morning. Through open screens we see into the enclosed and privileged world of the palace, where concubines make music or play chess, dance, have tea, entertain their children, or take a stroll.

These exquisitely dressed females are all slender, delicate, and similar in size. The beautiful patterns and colors of their garments, however, are subtly different. The decorative elegance of the whole scroll is achieved with a limited palette of muted orange, with touches of green, bright red, and blue spread throughout. Rhythm and pattern are created by urns, plants, fencing, and latticework, which help to unify the composition, and also by the loose black chignons of the concubines, which punctuate the painting and look, to a Western viewer, almost like notes on a musical score.

A story within the story

Inside the first pavilion on the left sits the court artist Mao Yen-shou. According to a famous story, Mao was ordered by Emperor Yüan-ti to paint the portraits of all the imperial concubines, to help the Emperor remember who was who. Each concubine bribed Mao to make her look more beautiful than she really was, except for the virtuous Wang Chao-chün. The artist made her portrait less attractive, and the emperor, believing it to be a true likeness, married her off to a northern barbarian chieftain. When he saw Wang Chao-chün, however, he realized that she was the most beautiful of all and in a fit of rage ordered that the artist be executed.

> The marvelous visual effects …may explain why Qiu's name became so intimately connected with this kind of courtly-style painting

QIU YING

1494–c.1552

One of the "Four Great Masters" of Chinese painting of the Ming dynasty (1368–1644), Qiu Ying was renowned for his decorative landscapes and depictions of palace life.

Born into a family of modest means in Jiangsu Province, Qiu Ying made his income from selling his paintings. He was not technically a member of the *literati*—highly educated men who were not obliged to earn a living, but painted, studied calligraphy, and wrote poetry to express themselves—but he associated with them and was ranked alongside *literati* painters.

After studying with Zhou Chen, who also taught Tang Yin—one of the other Four Great Masters—Qiu Ying learned to paint in many styles and genres, tailoring them to the tastes of his prosperous patrons. Showing great skill in many techniques, he made exact copies of ancient T'ang and Sung dynasty masterpieces, incorporating his own ideas about color into the work. Qiu Ying painted landscapes in translucent blues and greens with a sensuous delicacy that appealed to the tastes of wealthy Ming dynasty collectors, and his beautifully defined figures show his exquisite draftsmanship.

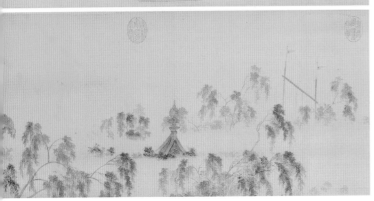

Visual tour

KEY

▶ **PALACE GATES** Unrolling a handscroll is both like setting off on a journey and starting to read a story. Starting at the right, you begin by moving through a misty wood of graceful Oriental trees, then come across the boundary of the palace's walled garden. The ornate red gate is open, and once inside the garden, the mist suddenly clears and you see birds. Spring is in the air.

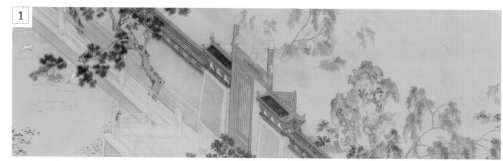

▶ **TENDING THE GARDEN** Here two women converse, while a third bends over to tend a shrub, which softens the strong outline of an ancient rock. Qiu Ying creates rapport between the numerous figures shown in the scroll by arranging them in harmonious small groups engaged in different activities— a characteristic of his personal style.

▼ **ELEGANT COSTUMES** Although the setting of the painting is imaginary, the elaborate garments worn by the concubines are faithful reproductions of Han dynasty costumes. The willowy forms of the palace ladies are draped in flowing silk robes that enhance their beauty and graceful gestures.

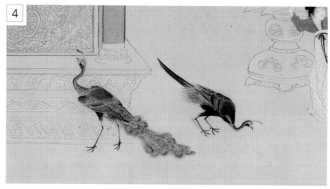

▲ **ROYAL PEACOCKS** A pair of peacocks forage for food near the palace gates. They are standing parallel to each other, their tails pointing in opposite directions, echoing the diagonal lines of the moat and the garden wall. These diagonals are repeated in the palace architecture throughout the scroll, creating a sense of rhythm and continuity. The peacock, with its crown of feathers and ornamental tail, has long been a traditional symbol of royalty in both Asian and European art.

◀ IDEAL BEAUTY These two women are reading quietly. Resting on their elbows, their perfectly oval faces are turned slightly sideways. They may represent a form of ideal beauty: their eyes are exactly halfway between their chins and hairlines, their eyebrows and lips are fine, and their noses are shown in profile and drawn with a single line.

▼ LADIES OF LEARNING The way in which the imperial concubines pass their time shows how educated and cultured they are, emphasizing their status. Some play chess or learn the art of calligraphy. Others are shown painting or playing music. The rapt gestures of the women convey their lively enthusiasm for aesthetic and intellectual pursuits.

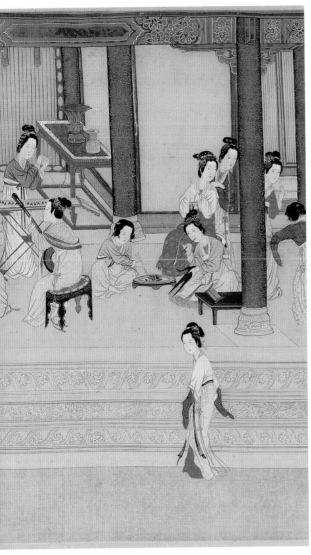

▲ PORTRAIT PAINTER One of Emperor Yüan-ti's concubines is having her portrait painted. This small scene is a reference to the famous story about the court artist Mao Yen-shou and the beautiful Wang Chao-chün (see p.71).

◀ MUSIC AND DANCE Many concubines were artistically gifted. Here three women play musical instruments, underlining the sense of harmony in the painting, while others dance.

ON TECHNIQUE

Qiu Ying was a master of the *gongbi* technique, in which lines had to be painted with the utmost precision, using a fine brush. Objects and the postures and proportions of figures also had be drawn accurately at the first attempt. This technique was in contrast to the faster, more expressive freehand style of painting known as *xieyi*. In the *gongbi* technique, even lines were painted on nonabsorbent paper or silk. Any expression had to be created, therefore, not with the flick of a brush, but with perfectly placed lines that described movement or the flow of fabric, for example (see below). Once in place, the outlines were filled in with colored ink washes, to create subtle shading. Qiu Ying, with his acute sense of observation and remarkable drawing skills, excelled at this technique.

IN CONTEXT

Like many handscrolls, *Spring Morning in the Han Palace* has colophons—written notes in Chinese characters—at each end of the scroll, sometimes on additional sheets of silk. Colophons could contain information from the painter himself, or comments added by friends, viewers, or collectors at a later date. Some of these would sign their comments with personal seals bearing their names. These red seals (see below) denoted an artist's pride, a viewer's approval, or a collector's ownership.

Netherlandish Proverbs

1559 ▪ OIL ON PANEL ▪ 46 × 64¼in (117 × 163cm) ▪ GEMÄLDEGALERIE, STAATLICHE MUSEEN, BERLIN, GERMANY

SCALE

PIETER BRUEGEL THE ELDER

Rich in detail, this famous painting is a masterful example of Bruegel's organizational skill and comic invention. Illustrations of more than a hundred proverbs and moral sayings are displayed in an imaginary village, where folly holds sway. This type of subject had been popularized by Sebastian Brant's satirical bestseller *The Ship of Fools*, 1494, and was also a favorite theme for engravers such as Frans Hogenberg. Hogenberg's *Blue Cloak* may have provided Bruegel with inspiration for his picture, as with the man in the foreground crawling into a globe (illustrating the saying, "A man must stoop low if he wishes to get through the world").

A world of folly

Bruegel rapidly outstripped his sources. His complex setting created an illusion of perspective that none of the printmakers matched. He also introduced an element of interaction between some of the scenes. The cuckold in the blue cloak, for example, is watched with interest by two women who represent a maxim about gossips, while to his right a man who is feeding roses to his pigs gazes in disbelief at another act of folly. Bruegel continued to incorporate this material into his work, sometimes focusing on a single proverb. The blind leading the blind, for example (just visible on the horizon, top right), became the subject of one of his greatest masterpieces.

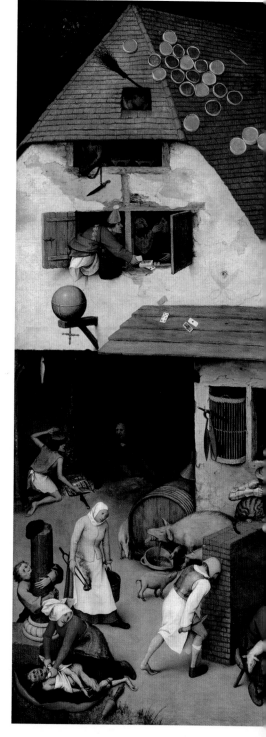

PIETER **BRUEGEL** THE ELDER

c.1525–69

One of the outstanding figures of the Northern Renaissance, Bruegel had an impressively varied repertoire. He is famed for his grotesque fantasies, his lively peasant scenes, and his pioneering landscapes.

The details of Bruegel's early life are sketchy. He may have been born near Breda, now in the Netherlands, but he trained in Antwerp, where he became a master of the Painters' Guild. His teacher was probably Pieter Coecke van Aelst, whose daughter he later married. In c.1552, he embarked on a lengthy tour of Italy, and upon his return worked mainly for the printseller Jerome Cock, chiefly employed as a designer of engravings. Bruegel's compositions from this period are often crowded with scores of tiny figures, and he deliberately exploited the continuing demand for Hieronymus Bosch's nightmarish creations (see pp.44–47). All this changed after 1563, when he moved to Brussels and began working for a more courtly clientele. His figures became larger and his themes more ambitious. Almost all his greatest masterpieces date from this final, glorious phase of his career.

After Bruegel's death, his reputation became somewhat distorted. He was characterized as "Pieter the Droll," a purveyor of comical peasant scenes. Some even believed that he had been a peasant himself. In reality, though, he was a cultivated man with an impressive roster of patrons. He used the kind of popular imagery that was normally found in prints but applied it to the most serious issues of the day—preaching humility and moderation at a time when his homeland was being torn apart by religious and political strife.

There are few works by his hand that
the observer can contemplate solemnly
and with a straight face

KAREL VAN MANDER *THE BOOK OF PAINTERS*, 1604

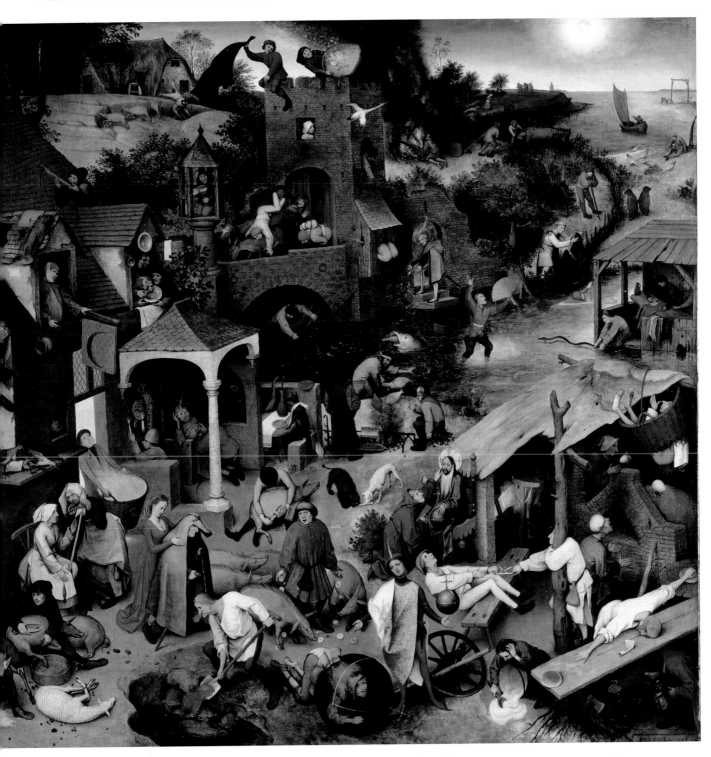

Visual tour

KEY

▶ **"BANGING ONE'S HEAD AGAINST A BRICK WALL"** No one portrayed lumpen stupidity with greater verve than Bruegel. The futility of attacking a wall is obvious enough, but the artist took delight in imagining the type of idiot who might try. His fool has donned a breastplate and is carrying a sword. The rest of his attire is rather less martial. He appears to have put his armor on over a nightshirt and is only wearing one shoe. There is a bandage on his leg, which hints that he has injured himself before, while undertaking another of his ridiculous ventures.

▲ **"THE WORLD TURNED UPSIDE DOWN"** In Christian art, a globe surmounted by a cross represents the world. The cross should always point upward, like the one held by Christ in the lower right corner of the painting. When inverted, the globe represents a topsy-turvy world. Its prominent position here indicates that the entire village is governed by folly.

◀ **"THE BLUE CLOAK"** "She hangs a blue cloak around her husband" or, in other words, she makes him a cuckold. At the time, the color blue was a traditional symbol of deceit. Bruegel's version bears some similarities to Hogenberg's *Blue Cloak* print, but he gives the image a much livelier, more anecdotal flavor. The husband is older, walks with a stick, and seems oblivious to his wife's actions, while she is young, tall, and well-endowed.

▼ **"DON'T CRY OVER SPILLED MILK"** In this case, the fool is trying to scoop up gruel rather than milk. In keeping with the country setting, many of the proverbs revolve around food production and farming. Apart from the gruel, there are loaves, tarts (on the roof), eggs, chickens, geese, and other forms of livestock.

▼ **"THROWING MONEY DOWN THE DRAIN"** In a graphic example of yet another form of human folly—wastefulness—the man in the red cloak is throwing his money into the water (the drain). The two bottoms hanging out of the window next to him illustrate a lesser known proverb, "It hangs like a privy over a ditch," which means "It is obvious."

▲ **"SET SAIL WHEN THE WIND BLOWS"** Two popular sayings have been linked with this tiny detail: "It is easiest to sail when the wind blows" and "He has one eye on the sail" (in other words, he stays alert). Bruegel lived in a major port, so it is hardly surprising that he often included boats in his pictures.

◄ **"HE CANNOT MAKE ENDS MEET"** The original version is "He cannot reach from one loaf to the next." In other words, he cannot afford to buy enough food. There is nothing comical or moral about the saying itself, but Bruegel has managed to turn it into an entertaining visual pun. His peasant is simply too stupid to move one of the loaves.

ON **COMPOSITION**

This kind of composition was extremely popular in Bruegel's day. It was known as a *Wimmelbild* (a picture teeming with tiny figures) and was more commonly found in prints than in paintings. The idea of the *Wimmelbild* was to depict dozens of separate incidents, packing them together in a single image. This should have been a recipe for chaos, with one episode blocking out the one behind, but artists could achieve the desired effect by adopting a high viewpoint and bending the laws of perspective. In *Netherlandish Proverbs*, Bruegel tilted up his landscape, shifting his viewpoint as he moved into the scene. He also ignored the rules of foreshortening, showing most of his figures head on, even though they were being viewed from above.

IN **CONTEXT**

Not all paintings of peasants were humorous or moralizing. In 1565, Bruegel produced a marvellously atmospheric series of six panels, collectively known as *The Months,* for one of his chief patrons, an Antwerp merchant called Niclaes Jongelinck. *Harvesters* represents the months August and September, and shows laborers gathering in wheat or resting in the relative shade of a pear tree. *The Months* were to prove highly influential. They shaped the course of the northern landscape tradition, and looked forward to the work of artists such as Courbet and Millet, who also depicted peasants in the rural landscape.

▲ *Harvesters*, Pieter Bruegel the Elder, 1565, oil on panel, 45¾ × 62¾in (116.5 × 159.5cm), Metropolitan, New York, US

Spring

1573 ■ OIL ON CANVAS ■ 30 × 25in (76 × 63.5cm) ■ LOUVRE, PARIS, FRANCE

SCALE

GIUSEPPE ARCIMBOLDO

The sheer cleverness of this painting is instantly arresting. It is easy to admire the leap of Arcimboldo's imagination that conceives a woman's head as being made up of flowers and to marvel at the skill with which the idea has been carried through. Arcimboldo's contemporaries likewise enjoyed his wit and trickery, but they also saw deeper meanings in such paintings, for at the time it was common to present serious ideas in fanciful form. This was especially true at the highly sophisticated courts at which Arcimboldo worked.

The Hapsburg emperors whom Arcimboldo served ruled vast areas of Europe, and the art that was created for them often paid tribute to their power, either directly or indirectly. Arcimboldo's paintings are subtle allegories of their authority and influence. *Spring* is part of a set of four paintings representing the seasons. They were commissioned by Maximilian II as a gift for a fellow ruler Augustus I, Elector of Saxony. Individually, the paintings convey the bounty of Habsburg rule and collectively they suggest that the dynasty will endure, just as the seasons follow one another in an endless cycle.

GIUSEPPE **ARCIMBOLDO**

c.1527–93

Arcimboldo created a novel type of portrait head. His paintings were virtually forgotten for centuries, but since their rediscovery they have continued to delight and fascinate viewers.

Arcimboldo began and ended his career in his native city of Milan, Italy. However, he made his memorable contribution to art in Central Europe, in Vienna then Prague, in the service of three successive Holy Roman Emperors: Ferdinand I, Maximilian II, and Rudolf II. He was acclaimed in his time, but after his death his works tended to be regarded as mere curiosities. The revival of interest in his paintings began with the Surrealists, who shared his love of visual puns and paradox and regarded him as a forerunner of their movement.

Visual tour

KEY

▶ **FLORAL HAIR** The flowers making up Spring's hair (or perhaps hat) create an enchanting, tapestry-like effect. They are more delicately painted than the flowers and leaves in the enclosing frame, which is thought to have been added during the 17th century.

▶ **YOUTHFUL BLOOM** Spring's face is mainly made up of roses, which suggest the beauty and fragrance of youth. The four seasons were often depicted as being four different ages—with Winter the oldest. So, in effect, they could also represent the Ages of Man (the number of ages varied from three to seven, although four was common). Flowers have often been used to symbolize the passage of time and the insubstantiality of all earthly achievement—even the most beautiful bloom must wither and die.

▲ **IRIS** Spring is holding an iris. Like many flowers, its symbolic associations vary with context—the "language of flowers." Here, it probably alludes to earth's renewal after the chill monotony of winter.

▲ **VEGETABLES** The shoulder and torso are made up of various vegetables. These have less resonance in art than flowers, tending to represent nature's general abundance rather than specific qualities. Still, the artist has lavished as much diligent craftsmanship on the humble vegetables as on the glamorous flowers.

Cypress Tree

c.1580-90 ■ EIGHT-PANEL SCREEN, COLOR AND GOLD LEAF ON PAPER
■ 5ft 6¾in × 15ft 1in (1.7 × 4.6m) ■ TOKYO NATIONAL MUSEUM, JAPAN

SCALE

KANŌ EITOKU

Bold and beautiful in its design, Eitoku's magnificent folding screen (*byōbu*) is dominated by the mighty trunk and twisted branches of an ancient cypress tree, outlined against a shimmering background of golden clouds. The painting was commissioned during Japan's celebrated Momoyama period (1573–1615), when powerful warlords unified the country, building splendid castles with lavishly decorated interiors. The huge tree perhaps represented the strength and power of the painting's military patron, while the extravagant gold leaf—a symbol of wealth and status—would have reflected any available light in the dim castle interior, transforming the already striking work into a beautiful, glowing panorama.

Eitoku was trained in the Chinese art of ink painting by his famous grandfather Kanō Motonobu, and his mastery of the technique is apparent in the expressive lines of the

work. However, the decorative quality and flat, bright colors follow the Japanese tradition known as *yamoto-e*, and the grand scale and bold brushwork evident here and in Eitoku's other compositions were truly innovative.

The majestic, lichen-encrusted cypress extends across the eight panels of the screen, its gnarled form depicted with sweeping brushstrokes. Yet we can only see the midsection of the huge tree: the bottom of the trunk is hidden from view and the upper boughs disappear into lustrous golden clouds pierced by a jagged mountain peak. The foreground dominates and the background space is almost flat, creating a sense of pattern rather than depth. Strikingly asymmetric, the composition is supremely bold and confident, and its scale and dynamism convey the strength and grandeur of the monumental tree.

KANŌ **EITOKU**

1543–90

Part of an established family of professional artists, Eitoku forged a new style and became the most sought-after painter in Kyoto, creating large-scale, decorative works for Japan's feudal warlords.

Eitoku was the great-grandson of Kanō Masanobu, founder of the Kanō school, which was the most influential school of Japanese painting for over 300 years. Eitoku displayed prodigious talent from an early age, and the opulence of Japan's Momoyama period suited the large-scale compositions for which he became renowned. He created monumental, decorative works, often sliding doors (*fusuma*) or folding screens, with bold, opaque color and lavish backgrounds of gold leaf, and these innovative paintings ensured that the Kanō family continued to enjoy the patronage of Japan's military rulers. Most of the castles containing his paintings have been destroyed, along with their contents, as a result of civil war, but some works, such as the pair of six-panel folding screens *The Hawks in the Pines* (Tokyo University of the Arts), have survived. Eitoku died in his forties.

Visual tour

KEY

▼ **TRUNK** The massive trunk of the cypress is the main focus of the composition. It emerges diagonally from the base of the three panels on the right side of the screen, and its contorted branches extend sideways over all eight panels in a bold, graphic manner. Eitoku has shown neither the top nor the bottom of the tree, and this cropping emphasizes both its solidity and size, while its off-center position creates an arresting design.

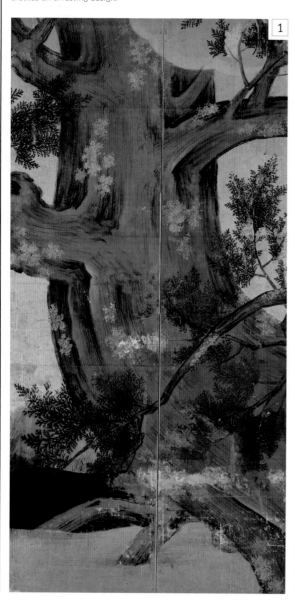

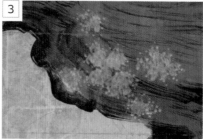

▲ **LICHEN** The pale, grey-green patches of lichen are repeated over the rugged surfaces of the venerable tree and give an impression of texture; more importantly, they add rhythm and create a strong sense of pattern throughout the composition.

▶ **FINE DETAIL** Small, delicate brushstrokes in deep green describe the tree's needlelike leaves and contrast with the large, sweeping strokes of the trunk and branches. Silhouetted against the golden clouds, the leaves form exquisite patterns.

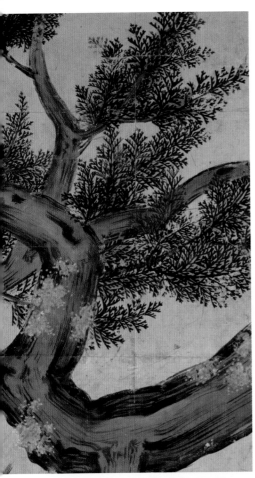

◄ **TWISTING BRANCHES** Sharply delineated against the shimmering gold background, with their strong shapes outlined in black, the gnarled and twisted branches seem to be alive with a powerful energy. Their sinuous forms snake over the whole screen and inject movement and rhythm into the painting. With branches reaching down to the earth and up into the clouds, the cypress perhaps represents the absolute power of the Momoyama warlords and the huge territories over which they held sway.

▼ **GOLD-LEAF CLOUDS** The billowing shapes of the clouds echo the twisted form of the tree and the lustrous gold leaf lights up the branches. At night, this costly material would have cast a beautiful glow in the opulent, candlelit rooms of the warlord's castle.

5

6

▲ **ROCKS AND WATER** On the far-left panel, bare rocks jut out of the deep water. The solidity of their forms, created by strong diagonal brushstrokes and layering, echo and balance the massive trunk of the cypress; the same lichen patterning appears on both tree and rocks. The age of the screen makes it difficult to be sure of the original color of the water, but it is possible that it was a much brighter azure blue, which would have made a striking contrast with the rich gold of the clouds.

ON **TECHNIQUE**

Eitoku limited his colors and tonal range, and there is little modeling on the trunk of the tree (see below). The patches of lichen seem to float over the surface of the bark and are perhaps used as a motif to give the overall design a sense of pattern, rather than as a naturalistic feature. The artist's consummate skill at depicting the natural form of the tree lies in the confident, sweeping brushstrokes, which give a strong impression of the life force flowing within the tree. To create his dramatic designs on such a grand scale, Eitoku is said to have used a large, coarse straw brush, making the rapid, energetic strokes that render the tree so eloquently and with such immediacy.

IN **CONTEXT**

Eitoku's early work was equally distinguished. *Birds and Flowers of the Four Seasons* was part of a commission for the Jukoin sub-temple of Daitoku-ji, Kyoto. The 23-year-old Eitoku already outshined his father (and Kanō school leader) Kanō Shōei in ability, and he worked on the most important rooms in the sub-temple. This panorama of the seasons unfolds over four sets of sliding screens (*fusuma*), starting with spring (below), which shows the first plum blossoms of the year. The delicate depiction of nature in this early masterpiece, painted in ink with a faint gold wash, later evolved into the lavish, more decorative style seen in *Cypress Tree*.

▲ *Birds and Flowers of the Four Seasons* (detail), Kanō Eitoku, 1566, sliding door panels, ink on paper, 5ft 4in × 4ft 8in (1.75 × 1.42m) per panel, Jukoin sub-temple, Daitoku-ji, Kyoto, Japan

Akbar's Adventures with the Elephant Hawa'i in 1561

c.1590-95 ■ OPAQUE WATERCOLOR AND GOLD ON PAPER ■ 13 × 7¾in (33 × 20cm)
VICTORIA AND ALBERT MUSEUM, LONDON, UK

SCALE

BASAWAN AND CHETAR

Richly detailed and with a fine sense of drama, this jewel-like miniature depicts an episode in the *Akbarnama (Book of Akbar)*, the authorized chronicle of the reign of the 16th-century Mughal emperor Akbar, a tolerant ruler and patron of the arts. Written between 1590 and 1596 by Abu'l Fazl, the *Akbarnama* contains 116 miniatures made by numerous artists.

This episode celebrates Akbar's bravery and masterfulness. The emperor is shown mounted on a ferocious elephant that is in hot pursuit of another elephant. They are charging across a pontoon bridge toward Agra Fort in northern India, dislodging the boats beneath them and spreading chaos in their wake. All around them, animated figures dressed in vivid colors struggle to control their boats or climb to safety.

Stylistically, the painting shows the influence of Persian Safavid manuscript illustration on Indian art during the Mughal Dynasty. However, the realistic modeling of the figures and the sense of perspective seen in the fort in the background also suggest the influence of northern European art of the time.

BASAWAN

Active c.1556-1600

One of the most talented artists in the Imperial Mughal workshops, Hindu painter Basawan contributed to the lavishly illustrated manuscripts of the Mughal dynasty for 40 years.

The artists who worked at the Imperial Mughal workshops came from all over India, but followed the Persian Safavid practice of drawing the outlines of the picture first, then filling in with color. Basawan, who drew *Akbar's Adventures with the Elephant Hawa'i in 1561*, was assisted by an artist called Chetar, who did the color work. Basawan is credited with developing a clear, narrative style in Mughal painting and is renowned for his vivid detail and dramatic color contrasts, which were characteristic of the Hindu painting tradition.

Visual tour

KEY

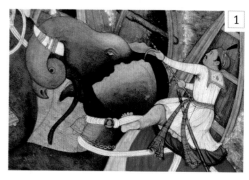

▲ **AKBAR AND HAWA'I** Many of the stories illustrated in the *Akbarnama* demonstrate the emperor's strength of character. Akbar is riding Hawa'i, his wildest Imperial elephant. Wedging his foot under the elephant's harness for stability, he looks calm and in control. He has set the elephant in combat against an equally dangerous beast.

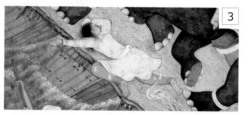

◀ **RAN BAGHA** Thundering ahead across the bridge of boats is Ran Bagha, Hawa'i's fierce opponent. When Akbar recounted this episode to historian Abu'l Fazl, he explained his rash actions in terms of his absolute trust in God. If displeased, God would allow the elephants to kill him. The painting illustrates Akbar's courage and firm leadership.

◀ **PONTOON** The collapsing bridge across the River Jumna creates a strong diagonal in the painting. Seen from above, a man lies flat on the ground, trampled underfoot, his turban unwound beside him. The elephants, by contrast, are drawn side-on.

◀ **MINOR FIGURES** The scene is full of activity and interest, from the boatmen trying to steady the pontoon in the foreground to the fishermen skirmishing in the background. The artist has depicted each individual character with imagination, skill, and attention to detail.

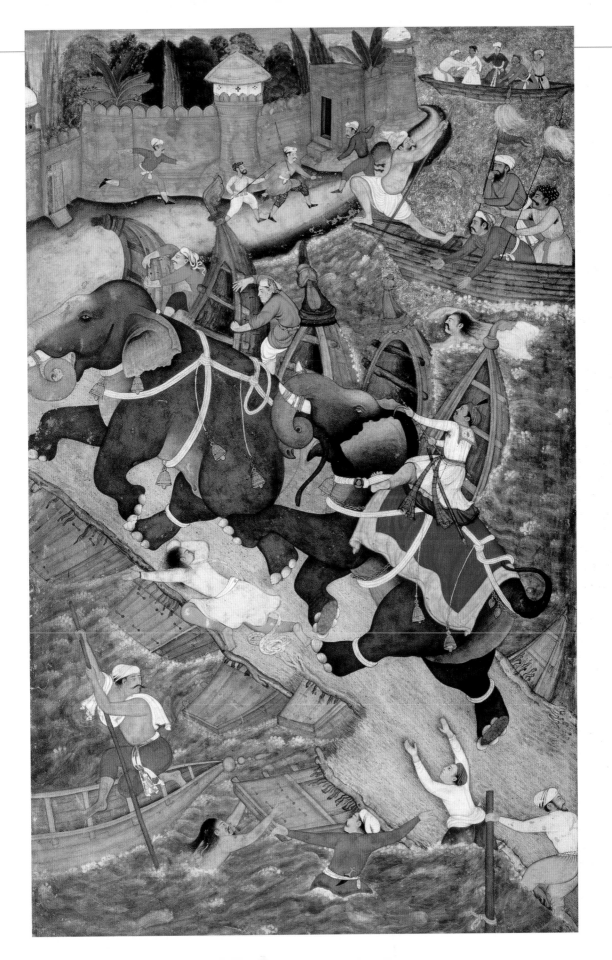

1600–1700

David with the Head of Goliath

c.1609-10 ▪ OIL ON CANVAS ▪ 49¼ × 39¼in (125 × 100cm) ▪ BORGHESE GALLERY, ROME, ITALY

CARAVAGGIO

SCALE

This shockingly realistic image of a young boy holding out a severed head is one of Caravaggio's most striking paintings. It depicts the climax of the biblical encounter between David, an Israelite shepherd boy, and Goliath, a Philistine giant. David killed Goliath with a slingshot, then cut off his head with the giant's own sword.

The dramatic use of light and shadow in the painting is startling. Caravaggio used a technique known as chiaroscuro (meaning "light/dark" in Italian), in which bright light forms a powerful contrast with deep shadow, creating a theatrical effect. David appears to have stepped forward into a spotlight, which also illuminates one side of Goliath's face and glints on the blade of the sword. The brightly lit areas draw attention to the figures' faces, emphasizing the human aspect of the biblical tale.

David is likely to be modeled on a youth from the streets of Naples, as Caravaggio preferred to depict characters who looked like real, solid people in his religious paintings. The head of Goliath is a self-portrait. Caravaggio was seeking a papal pardon after killing a man in a fight, and the painting has been interpreted as the artist offering up his painted head rather than his real one. It is said that as Caravaggio's life became increasingly troubled, his paintings grew darker, and this is one of the last he ever made.

MICHELANGELO MERISI DA **CARAVAGGIO**

1571-1610

Stark realism and dramatic contrasts of light and shade are Caravaggio's trademarks. He broke with the Mannerist tradition in art, creating paintings with solidity, grandeur, and depth of feeling.

Born in Milan in northern Italy, Caravaggio settled in Rome in about 1592. His work was popular with the Catholic Church during the Counter-Reformation because he reinterpreted well-known biblical stories in a realistic manner, more relevant to the lives of real people, and created paintings with a powerful sense of drama and heightened emotion. Although some contemporaries found his approach to religious topics challenging, his work was in great demand and had a profound impact on Italian and, indeed, European art. Caravaggio led a troubled and turbulent life. In 1606, he killed a man in a fight and spent his last four years as a fugitive from justice.

Visual tour

KEY

1

➤ **DAVID** Light falls on one side of the shepherd boy's face from a single, bright source, while the other side is in deep shadow. The light reveals a poignant expression on David's face. He looks resigned, rather than jubilant.

2

▲ **GOLIATH** Although the giant's head has been just severed from his body and is dripping with blood, as in a horror film, it still looks alive. Goliath's brow is furrowed with pain, he looks as if he is gasping, and his left eye stares straight at the viewer.

ON **COMPOSITION**

The central area of the composition is rectangular in shape. Imaginary lines connect Goliath's right eye, the diagonal of the sword, David's barely visible right arm, and his left arm, which is holding Goliath's head.

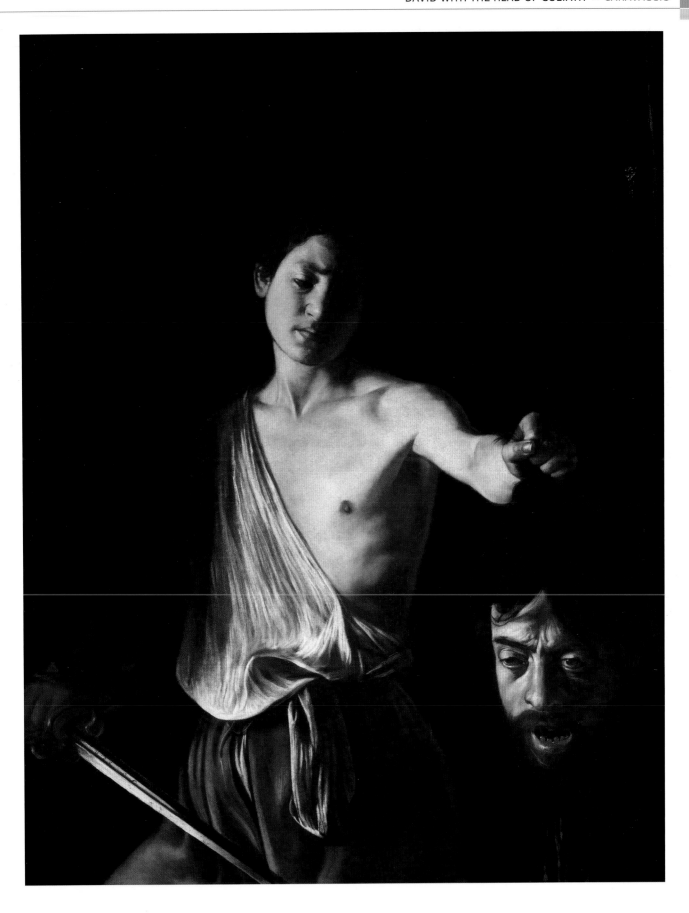

The Judgement of Paris

c.1632-35 ▪ OIL ON PANEL ▪ 57 × 76¼in (144.8 × 193.7cm) ▪ NATIONAL GALLERY, LONDON, UK

PETER PAUL RUBENS

SCALE

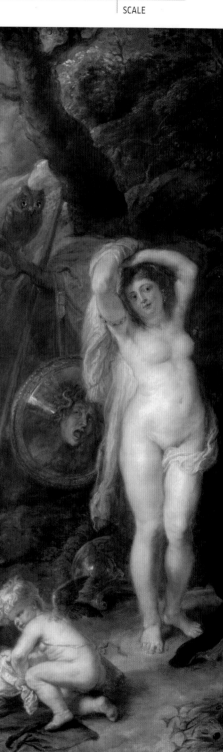

This painting tells a complex story, but clues to its meaning can be found in the form of attributes (identifying objects) that belong to the mythological characters portrayed. The story follows a classical text: Lucian's *Dialogue of the Gods*. Paris, the young Trojan prince, is about to award a golden apple, inscribed with the words "To the Fairest," to one of the three Roman goddesses: Juno, Minerva, or Venus. The beauty contest came about after Eris, the Goddess of Strife, grew angry at not being invited to a wedding feast. She tossed the golden apple into the crowd for Jupiter, the king of the gods, to choose a deserving winner. Her action led to chaos and strife, and eventually Jupiter sent Mercury, the messenger of the gods, to ask Paris to judge who was the fairest. Each goddess offered a bribe to Paris to try to persuade him to pick her.

This is the moment that Rubens chose to illustrate. The scenario gave him an opportunity to paint the voluptuous female nudes for which he is famous—the word "Rubenesque" was coined to describe them. Naked, the three goddesses display themselves to best advantage for Paris's sensual pleasure. They present an image of ideal beauty, based on female figures painted by earlier masters including Titian (see pp.62–65) and Leonardo (see pp.50–53), both of whom Rubens admired. Like his predecessors, Rubens also used colors to create the illusion of space. The bright blue of the sky and hills on the horizon recedes, creating the impression of depth. Green is the dominant color in the middle ground, leaving the darkest reds and browns to push forward, making the foreground feel closer.

Over time, the oil paint Rubens used has deteriorated and become more transparent. Fascinatingly, the changes Rubens made to the composition as he went along are therefore now visible. One such underlying image is the original position of Paris's right leg. And next to the peacock's tail, it is possible to make out the chubby arms of an earlier Cupid.

PETER PAUL **RUBENS**

1577–1640

Rubens enjoyed a career of such resounding international success that a contemporary described him as the "prince of painters and painter of princes."

Rubens was far and away the leading artist in 17th-century Flanders (roughly equivalent to modern Belgium), creating an enormous amount of work in virtually every branch of painting practiced at the time. He lived in Antwerp for most of his career, but he traveled extensively and his style and artistic outlook were mainly formed in Italy, where he was based from 1600 to 1608. Throughout his career, he aspired to match the heroic grandeur of Italian Renaissance art, but his work also has a deeply personal warmth and vitality. He combined his artistic career with diplomatic duties and was justly proud that he helped to negotiate peace between England and Spain (he was knighted by the kings of both countries). His personal life, too, was richly fulfilling, his love of his family shining through many paintings (he was twice happily married and fathered eight children).

In the hands of Rubens, the bodies of women came alive in eddies and whirlpools of nacreous paint

ANNE HOLLANDER *SEEING THROUGH CLOTHES,* 1993

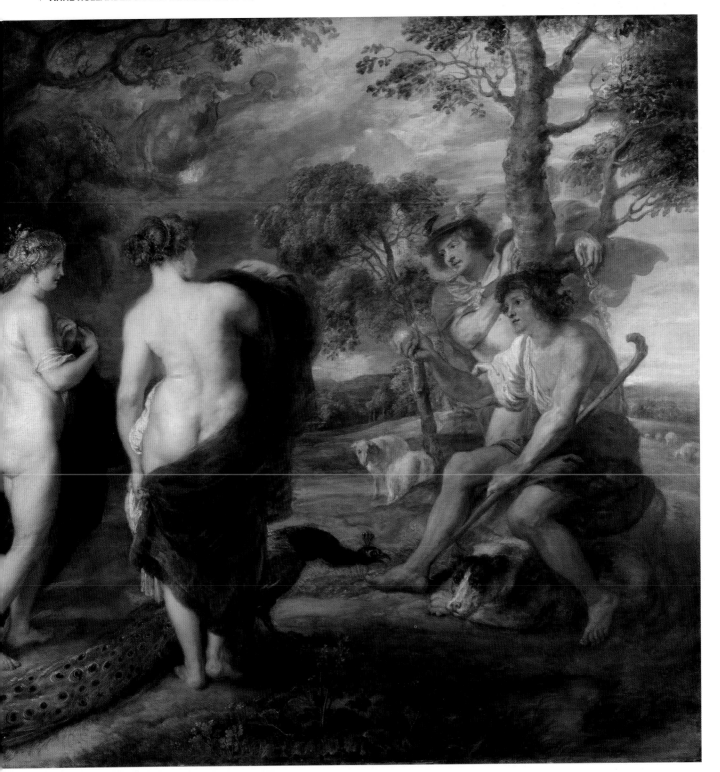

Visual tour

KEY

➤ **VENUS** The goddess of love, beauty, and fertility has roses—symbols of love—in her hair. Pearls are also entwined in her blonde locks, linking to the legend of her birth: she came ashore at Cyprus aboard a shell. Venus tells Paris that if he chooses her as the fairest she will make the most beautiful woman in the world fall in love with him. Her bribe works and she wins the contest.

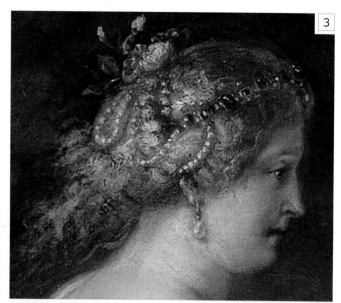

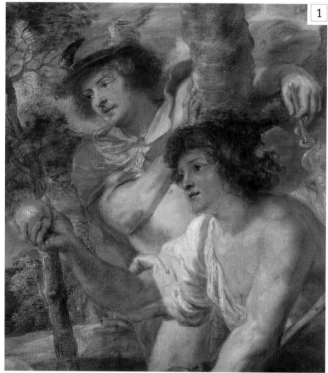

▲ **PARIS AND MERCURY** Paris, the Trojan prince, is dressed as a shepherd in a reference to his birth. According to legend, his mother abandoned him as a baby after dreaming that her son would destroy Troy, and it was a shepherd who rescued him. Mercury, the messenger of the gods, is standing behind Paris, wearing a winged hat and holding his *caduceus*, a wand wrapped with two snakes.

➤ **MINERVA** The goddess of war and wisdom stands on the far left, posing with her hands above her head. She promises Paris that if she wins the golden apple she will grant him victory in battle. She also promises him her powers of insight.

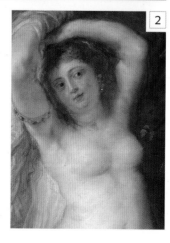

▲ **HELMET AND SHIELD** Minerva can be identified by two objects: a helmet, lying on the ground behind her, and a shield with an image of Medusa, the snake-haired monster who turned people to stone with just one glance. Minerva had helped the Greek hero Perseus to kill the monster.

➤ **OWL** An owl, symbol of wisdom, sits on the tree behind Minerva's head, observing the proceedings. Like the helmet and shield, the owl is an attribute of Minerva and helps identify her.

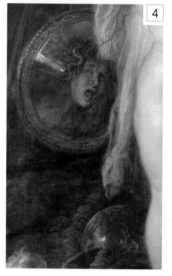

▶ **CUPID** The god of love is often shown as a mischievous baby. He has wings and a quiver to hold his golden arrows, which he fires at people to make them fall in love. His mother, Venus, is about to send him off to Helen to fulfill her promise to Paris.

▼ **FURY IN THE SKY** Flying menacingly through the sky, holding a snake in her hand, is Alecto the Fury. She whips up the thundery clouds to announce that trouble is on its way. This sets the mood for the next part of the story, not shown by Rubens. Paris abducts the beautiful Helen, wife of King Menelaus, from her home in Sparta. As Venus had promised, Helen falls in love with Paris, but the abduction leads to the Trojan War.

▲ **PEACOCK** Juno stands next to her attribute, a peacock. With a crown of feathers on its head and jewel-like eye echoed in the patterns of its long graceful tail, the bird is a natural choice to symbolize royalty.

▲ **JUNO** The queen of the goddesses, wife of Jupiter, poses for Paris, holding a fringed shawl in striking red and green, with the texture of velvet. Her bribe to him is an abundance of wealth in land and other riches.

ON **TECHNIQUE**

The translucence of the flesh tones in this painting comes from using a smooth, primed oak panel instead of a canvas. The smoothness of the surface allowed Rubens to apply oil paint thinly, so that the white ground glowed through. He used fluid strokes of warm red, yellow, and white, offset with touches of blue, for the tints of milky skin. His palette was limited, although his use of red gives an impression of rich color.

IN **CONTEXT**

Rubens was greatly influenced by Renaissance and classical artists. He copied their work and sketched from antique sculptures, reproducing typical poses for the goddesses in *The Judgement of Paris*. Rubens has cleverly painted a female nude in the round, meaning that the same model is shown from three different angles. Minerva is seen from the front, Venus from the side, and Juno from behind, all visually linked with white shawls. It is likely that Rubens based the figure on his second wife, Hélène Fourment.

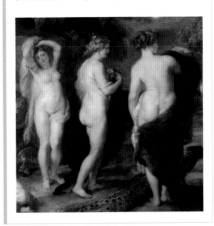

Charles I on Horseback

c.1637 ▪ OIL ON CANVAS ▪ 12ft ½in × 9ft 7in (3.67 × 2.92m) ▪ NATIONAL GALLERY, LONDON, UK

SCALE

ANTHONY VAN DYCK

This life-size equestrian portrait of Charles I, Stuart king of England, Scotland, and Ireland (1600–1649), is clearly intended to convey power and majesty. An extravagant monarch, unpopular with his subjects, Charles believed in the divine right of kings and absolute monarchy. This painting is a superb piece of propaganda designed to bolster his public image. Elegantly mounted on a massive stallion, Charles is clad in armor, as if about to ride into battle, and a servant holds up his helmet. Charles has a commander's baton in one hand, and controls his mighty steed with the other. On the right side of the painting is a great oak tree, a symbol of strength, that bears a plaque with the Latin inscription *Carolus Rex Magnae Britaniae*– "Charles, King of Great Britain."

As a court painter, van Dyck had to portray the king in a flattering light, so reality is tempered with a degree of fantasy. Charles I was a small man, but is given added stature by being set high on a horse. English kings were rarely portrayed on horseback, whereas the tradition was strong in Italy and dated back to Roman times. Van Dyck, a great admirer of Titian, perhaps consciously echoed Titian's *The Emperor Charles V on Horseback*, painted in 1548, which is similar in size and composition. Charles gazes nobly into the distance, seemingly unaffected by the growing dissent in his kingdom. In 1649, following a civil war, he was to be publicly executed.

ANTHONY **VAN DYCK**

1599–1641

Van Dyck ranks second only to Rubens among 17th-century Flemish painters. In his speciality of portraiture, he outshines even Rubens and stands among the greatest artists.

A child prodigy, van Dyck was working as Rubens's chief assistant by the age of 18. He was barely 20 when he was launched on a glittering international career of his own. He painted numerous religious works (he was a devout Catholic), and he always sought opportunities to create the huge decorative schemes at which Rubens excelled. However, his services were increasingly in demand as a portraitist, first in Italy, where he lived from 1621 to 1627 and, later, in England, where he was court painter to the art-loving Charles I from 1632. His portraits of Charles, his family, and his courtiers have a matchless grace and glamour, inspiring other painters for generations, particularly in Britain, where van Dyck was revered by Gainsborough among other artists.

Visual tour

KEY

▶ **CHARLES I** Unlike the rest of the painting, which we look up at, the king's face is painted as though we are looking at it head on, in half-profile. Around his neck, Charles wears a golden locket decorated with an image of St George, martyr and patron saint of England, fighting the dragon. This is symbolic of Charles's role as defender of the realm.

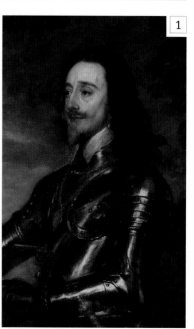

◀ **SPURRED BOOT** The painting was probably hung at ground level at the end of a long gallery. Given its vast height, the approaching viewer would have had a good look at the king's boot, and was probably meant to feel duly humbled.

▶ **HORSE** Charles was an accomplished horseman, but his mastery of this huge, muscular horse is clearly intended to display his strength and capability as a ruler. The horse's head is small in relation to its body, possibly to reduce it in comparison with the king's head and thereby reinforce the impression of Charles's dominance and control.

Self-portrait as "La Pittura"

c.1638–39 ▪ OIL ON CANVAS ▪ 38 × 29in (96.5 × 73.7cm) ▪ THE ROYAL COLLECTION, LONDON, UK

SCALE

ARTEMISIA GENTILESCHI

A strongly built woman leans forward to apply paint to the canvas. Her gaze suggests intense concentration and her pose creates a vigorous diagonal across the picture. It is a suitably powerful image to represent the outstanding woman painter of the 17th century, a formidable personality who achieved success against the odds in what was very much a man's world. However, the picture is more than a self-portrait—it is also a representation of the art of painting (*La Pittura* in Italian). Since the mid-16th century, there had been a tradition in Italian art of depicting a woman as the personification of painting, as well as of the sister arts of sculpture and architecture. Such personifications were described in a book called *Iconologia* by the Italian writer Cesare Ripa, which was first published in 1593. Artists often used it as a guide, and Artemisia has adopted some of the features it describes as part of the image of *La Pittura*.

The picture is first documented in the collection of Charles I, and Artemisia probably painted it when she was in London working at his court, from about 1638 to 1641. She had other royal patrons—an indication of the renown she enjoyed. After her death, her reputation declined, but since the 1960s she has again been recognized as one of the major painters of her time, as well as celebrated as a feminist heroine—almost all her pictures feature women in central rather than subordinate roles.

ARTEMISIA **GENTILESCHI**

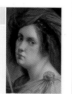

1593–c.1654

One of the greatest of all women painters, Artemisia Gentileschi was renowned in her lifetime, and in the modern age has won new fame as a feminist heroine.

Artemisia was born in Rome, the daughter of the painter Orazio Gentileschi, a gifted follower of Caravaggio. She showed remarkable talent from an early age, but her youth was blighted when, at the age of 17, she was raped by a fellow painter, Agostino Tassi. At his trial, she was tortured to test her evidence. Soon afterward she was "married off" but about a decade later she separated from her husband and subsequently led a life that was remarkably independent for a woman of her time. She eschewed the "ladylike" subjects, such as flowers, preferred by other women painters, concentrating instead on serious figure compositions—traditionally the greatest test of a painter's mettle. In these, she was a match for virtually any male painter of her time. She lived mainly in Rome early in her career and later in Naples, but she also worked in Florence, Venice, and England.

Visual tour

KEY

▼ **SLEEVES ROLLED UP** Painters at this time liked to stress the intellectual aspects of their art, but Artemisia's powerful arm seems to suggest that—in a profession dominated by men—she is not afraid of the physical labor involved in her craft.

1

▼ **FACE AND HAIR** Artemisia's handsome but rather severe face is topped with a mass of disheveled hair. Such hair is specified in Cesare Ripa's book *Iconologia* as part of the standard image of *La Pittura*, to show the "fury of creation."

2

3

▲ **PALETTE AND BRUSHES** In her left hand Artemisia holds a palette and brushes. The shape that is vaguely indicated under the palette perhaps represents the stone slab on which artists ground raw materials to make paints. Their work involved laborious craftsmanship as well as lofty inspiration.

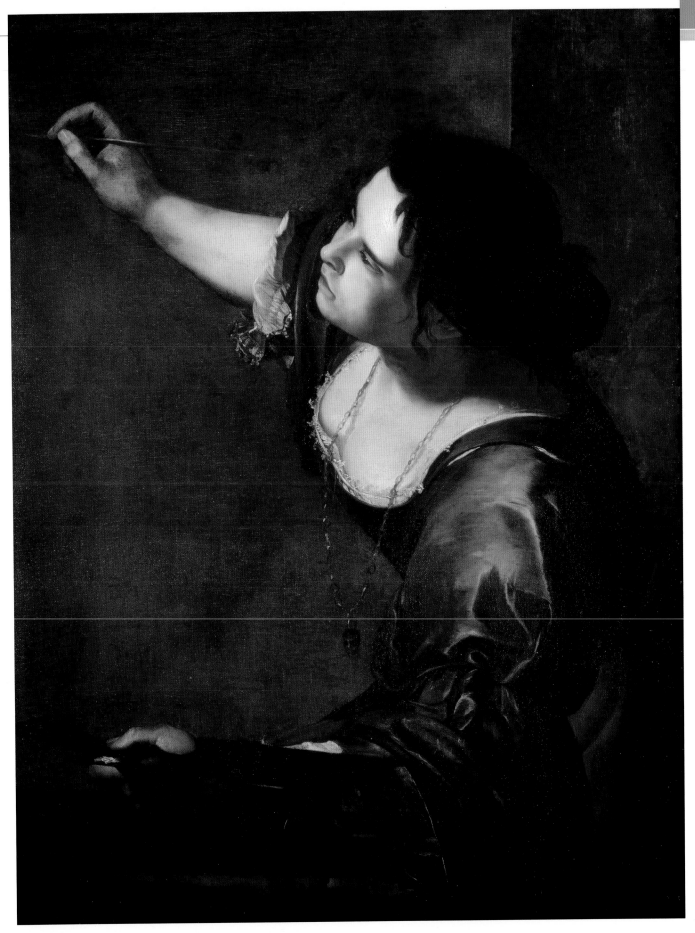

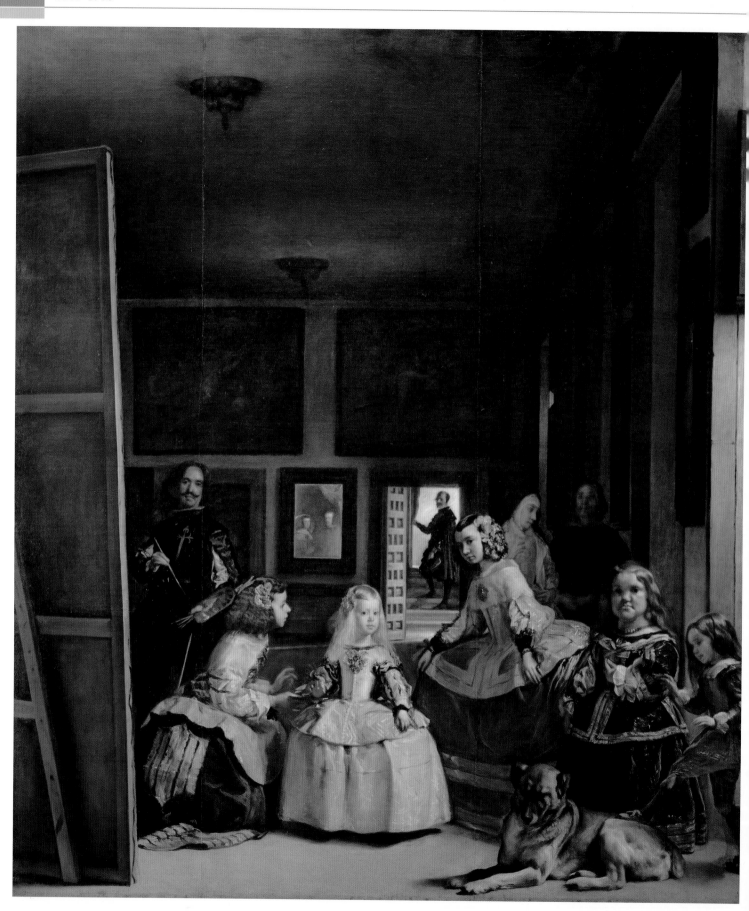

Las Meninas

1656 ■ OIL ON CANVAS ■ 125¼ × 108¾in (318 × 276cm) ■ PRADO, MADRID, SPAIN

SCALE

DIEGO VELÁZQUEZ

Brush in hand, poised as if considering his next stroke, Velázquez is at work on a huge canvas, of which you see only the back. The setting is a large room that he used as a studio in the Alcázar Palace in Madrid, and the other figures are members of the court. The golden-haired little girl in the center is the *Infanta* (Princess) Margarita, aged about five at the time. She is flanked by two *meninas* (maids of honor), who give the painting its familiar title, although this was not adopted until the mid-19th century. Earlier the painting was known by more prosaic names, such as *The Family of Philip IV*. Philip himself, with his second wife, Mariana of Austria, is seen reflected in the mirror on the back wall.

Different interpretations

The painting conveys an astonishing sense of reality: the figures seem caught in an instant of time and to inhabit a palpable space. However, in many ways it is enigmatic, and a huge amount of scholarly commentary has been expended in trying to unravel what exactly is happening in the scene and what Velázquez's intentions were in painting it. It is often suggested that he has shown himself at work on a portrait of the King and Queen, whose little daughter and her retinue have interrupted him. Equally plausibly, it has been proposed that these roles are reversed—Velázquez is painting a portrait of the Princess (whose attitude perhaps suggests that she is tired of posing) when the King and Queen pay a visit to the studio. Certainly it is known that the art-loving Philip IV enjoyed watching Velázquez at work, but whether he was painting the King and Queen or the Princess, it is unclear why he should need such a big canvas.

On a subtler level, *Las Meninas* has been interpreted as a kind of personal manifesto by Velázquez, in which he set forth his claims for the nobility of his profession. He cared deeply about his status in the world, and although he had acquired wealth and prestige, he had long craved the crowning honor of a knighthood. At the Spanish court— a place of rigorous formality—it was no easy matter to achieve this. Even though Velázquez had been the King's favorite for decades, artists were thought to rank low in the social order.

At first his candidature for knighthood was rejected, but Philip obtained special permission from Pope Alexander VII to bestow the honor, and Velázquez was eventually knighted in November 1659, a few months before his death. In *Las Meninas* he proudly wears on his breast the cross that denotes his knighthood. As the picture was finished in 1656, this detail must have been added later. According to legend, Philip painted it himself, but it is much more likely that it is the handiwork of Velázquez or one of his assistants.

> There is **no praise that can match** the taste and skill of this work, **for it is reality, and not painting**

ANTONIO PALOMINO *LIVES OF THE EMINENT SPANISH PAINTERS AND SCULPTORS,* 1724

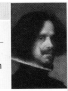

DIEGO **VELÁZQUEZ**

1599–1660

The greatest of all Spanish painters, Velázquez is renowned chiefly for his portraits. However, he also created superb works in other fields—from religion and mythology to everyday life.

Velázquez was born and brought up in Seville, in southern Spain, but he spent most of his adult life in Madrid. When he was only 24, he became the favorite painter of King Philip IV, and he was unchallenged in this position for the rest of his life. Philip admired Velázquez so much that he gave him various prestigious posts in the royal household, and these limited the time he could devote to painting. Nevertheless, he produced an unforgettable array of portraits of the Spanish court, including not only members of the royal family and aristocracy but also the dwarfs and buffoons who were kept to amuse their masters. He made two visits to Italy, from 1629 to 1631 and 1648 to 1651. During the second stay, he painted a portrait of Pope Innocent X that was immediately acclaimed as a masterpiece. His career culminated in a knighthood—an unprecedented honor for a Spanish painter.

Visual tour

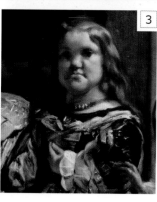

KEY

▶ **MAID OF HONOR** Kneeling in front of the young Princess, one of the maids of honor offers her a tray with a drink. Her charming profile and the silver ornaments in her hair are suggested by Velázquez with a few masterly strokes of the brush.

▼ **INFANTA MARGARITA** The Infanta Margarita (1651–73) was the favorite child of Philip IV, who called her "my joy." (Philip had seven children by his two wives and at least 30 illegitimate children.) In addition to her appearance in *Las Meninas*, Margarita is the subject of several superb individual portraits by Velázquez. In 1666, she married the Holy Roman Emperor Leopold I (her uncle) and died at the age of 21 after bearing four children.

◀ **MARIBÁRBOLA** Contrasting with the delicate Princess and the pretty maids of honor is the lumpish form of Maribárbola, who is described in Antonio Palomino's biography of Velázquez, 1724, as "a dwarf of formidable appearance." Like her companions, however, she is beautifully dressed. Palomino's biography is an invaluable early source of information on *Las Meninas*, providing the first detailed account and identifying the people portrayed.

▶ **SELF-PORTRAIT** Velázquez depicts himself as a serious and handsomely dressed gentleman. To him, painting is not a manual trade but an intellectual pursuit. Palomino wrote of "the high opinion that even noblemen had of him...for his deportment, his person, his virtue, and his honorable conduct."

▼ **MYTHOLOGICAL PAINTINGS** The dimly lit paintings hanging in the background can be identified from old palace inventories. Their subjects are taken from mythological stories in which mortals engage in artistic contests with the gods. In both stories the mortals are punished for their presumption, and Velázquez perhaps includes the pictures as a gesture of humility, tempering the high claims he makes for his own art.

5

6

7

ON **TECHNIQUE**

Velázquez began his career working in a solid and somber style, often showing an acute feeling for highly realistic detail. He always maintained a sense of truth and naturalism, but his way of expressing this changed enormously over the years: he tended more and more to sacrifice detail to overall effect. In his final works, his touch was extraordinarily free and vigorous, so that when seen close-up, as in the detail of the Infanta's dress (below), his brushwork looks almost abstract. Palomino summed this up when he wrote: "One cannot understand it if standing too close, but from a distance it is a miracle." According to Palomino, Velázquez sometimes used long-handled brushes to help achieve his effects, but those he holds in *Las Meninas* seem to be of normal size.

▲ **KING AND QUEEN** Velázquez and his workshop produced many individual portraits of Philip and several of Mariana. As far as is known, he never painted them together as a couple, apart from this intriguing mirror image. It has been suggested that they are standing in the position of the spectator or that the mirror reflects what Velázquez has painted on the canvas.

◄ **JOSÉ NIETO** The figure silhouetted in the doorway is José Nieto, Queen Mariana's chamberlain and head of the royal tapestry works. Velázquez so convincingly suggests he is pausing that it is hard to decide whether he is just about to enter or to leave the room. Although the features are blurred, Palomino said that Velázquez had captured a good likeness. Nieto lived until 1685 and Palomino (1655–1726) conceivably spoke to him and to others in the picture (the two dwarfs lived into the 18th century).

IN **CONTEXT**

Like most of Velázquez's work, which was largely inaccessible in royal palaces, *Las Meninas* was little known to the world at large until it went on public display when Spain's national museum, the Prado, opened in Madrid in 1819. The painting quickly became famous. Among its greatest admirers was another celebrated Spanish artist, Pablo Picasso (see pp.218–21), who in 1957 made a series of 58 paintings inspired by it.

▲ *Las Meninas (group)*, Pablo Picasso, 1957, oil on canvas, 76¼ × 102¼in (194 × 260cm), Museu Picasso, Barcelona, Spain

Self-portrait

c.1665 ▪ OIL ON CANVAS ▪ 44¾ × 37in (114 × 94cm) ▪ KENWOOD HOUSE, LONDON, UK

SCALE

REMBRANDT VAN RIJN

Battered by life's blows, but still proud and defiant, Rembrandt gazes out at us in an image of noble authority. He painted himself many times, but this is perhaps the most imposing of all his self-portraits. Earlier in his career, he had often portrayed himself flamboyantly, playing out some role in fancy costumes or showing off his success in expensive clothes. Now, however, nearing 60, he is content to express the dignity of his profession. The picture's feeling of monumental strength stems partly from the almost geometrical simplicity of the frontal pose, and partly from the breadth of the brushwork. Indeed, the handling is so sketchy virtually everywhere except the head that many experts think the painting is unfinished.

Series of self-portraits

There is no contemporary evidence to explain why Rembrandt portrayed himself so often, but modern writers have made suggestions ranging from the mundane to the metaphysical. It has been proposed, for example, that he used self-portraits to show potential clients how good he was at capturing a likeness—the client could compare the real Rembrandt with the painted image. At the other extreme, the self-portraits have been interpreted as a kind of painted autobiography, in which he charted not only his changing appearance but also his spiritual journey through life. This approach, which was once very popular, is now generally disparaged, not least because it tends to involve reading into the paintings what we happen to know of the triumphs and tragedies of Rembrandt's career.

He was an artist of great diversity, so it is likely that he had not one but several reasons for portraying himself. In his youth he provided a convenient and free model for trying out facial expressions, for example, and later he

was probably inclined at times to celebrate his success and social status. It is also likely that his self-portraits found a ready market, for even in his financially strained later years he remained an admired figure. Very little is recorded about the whereabouts of his self-portraits in his own lifetime (this one, for example, is first documented in 1761), but it is known that Charles I, one of the greatest collectors of the day, owned one as early as 1633.

REMBRANDT VAN RIJN

1606-69

The greatest of all Dutch artists, Rembrandt is renowned for his versatility and technical mastery, but most of all for the emotional depth and subtlety of his work.

The son of a prosperous miller, Rembrandt was born in Leiden, then the second largest town in the Dutch Republic. He showed brilliant talent from an early age. After he settled in the capital, Amsterdam, in 1631 or 1632, he quickly became the leading portraitist in the city. His career was successful for another decade, but in the 1640s his worldly fortunes declined as he began to work more to please himself than his wealthy clients. At this time, he had personal problems, too, not least the death of his beloved wife Saskia in 1642. In the 1650s he had increasing financial troubles (brought about partly by his extravagance) and narrowly escaped bankruptcy, but he recovered with the help of his mistress, Hendrickje, and his son, Titus. Their premature deaths marred his final years, but the quality of his work remained undimmed. In addition to the portraits that were his mainstay, Rembrandt excelled in religious subjects and made occasional but memorable contributions in other fields, including landscape and still life. He was also a superb and prolific draftsman and—by common consent—the greatest of all etchers.

> If Rembrandt's self-portraits constitute a diary, as in a sense they do, it was a diary at least partly intended for publication
>
> ,,

MICHAEL KITSON *REMBRANDT*, 1969

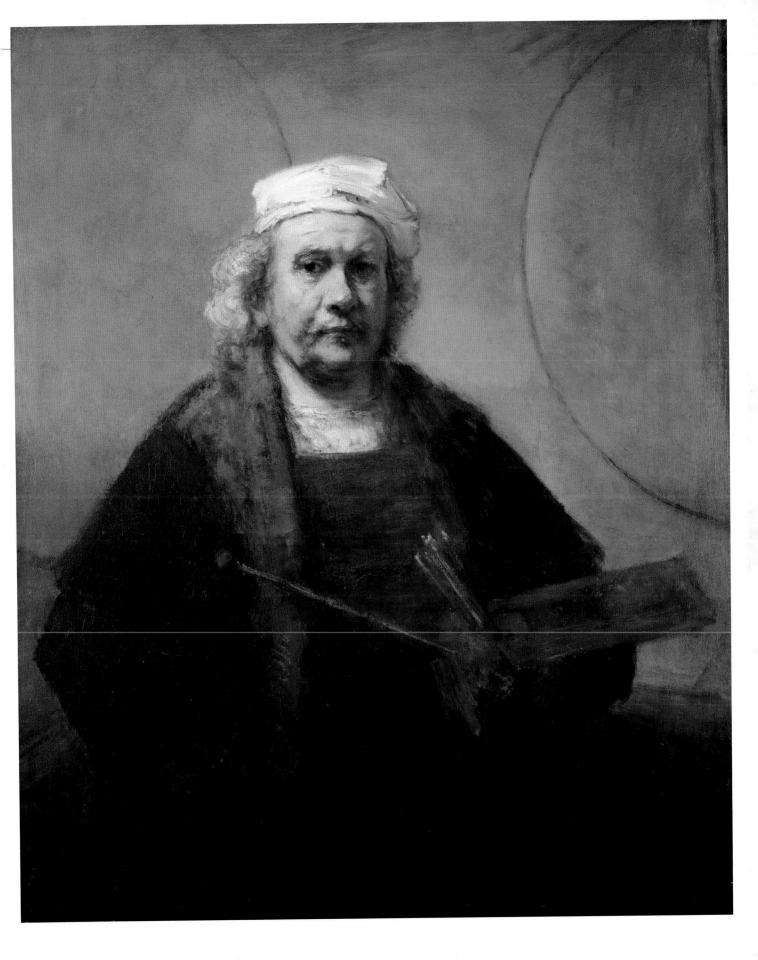

Visual tour

KEY

▶ **EYES** The eyes are often regarded as the most revealing part of the face—"windows into the soul." Rembrandt shows them in heavy shadow, with no highlights in the pupils, helping to create a somber mood. His look of impassive stoicism contrasts with the showiness that was characteristic of many of his early self-portraits, and suggests the setbacks he had lived through.

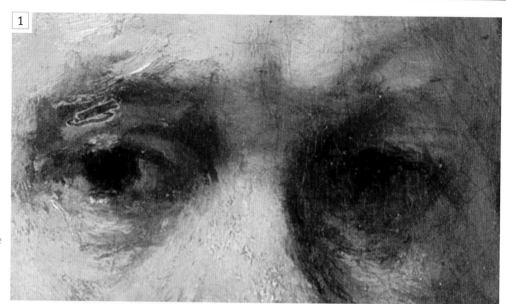

◀ **FUR ROBE** Rembrandt is wearing a fur-lined robe over a red smock and a white undergarment. In his extravagant younger days, he collected costumes, as well as art and curios of all kinds, and although his collection was sold in the 1650s to pay his creditors, he retained a fondness for wearing expensive furs when he depicted himself. The treatment here is so sketchy that it is hard to tell whether his garments are contemporary or historical.

▲ **TOOLS OF THE TRADE** In his left hand Rembrandt is holding a palette, brushes, and maulstick (a rod, padded at one end, that could be used to support the painter's hand). X-rays of the painting show that he originally held these tools in the other hand, accurately reflecting what he would see in a mirror. When they depict such tools in a self-portrait, most artists "correct" the mirror image and show the palette in the left hand, but some do not bother. Rembrandt must have been undecided for a while. The lower part of the picture is painted very broadly (there is almost no indication of the hand), with little sense of depth, so attention is concentrated on the magnificent head.

◄ **CIRCLES ON WALL** The two enigmatic circles on the wall behind Rembrandt have attracted much speculation. It has been suggested, for example, that they are a kind of rough representation of the twin hemispheres found on contemporary maps of the world. However, some scholars consider them purely abstract, included simply because Rembrandt thought they made an effective design.

▼ **WHITE CAP** Several of Rembrandt's earlier self-portraits feature expensive or "fancy dress" headgear. Here, however, he wears the kind of plain white cap that was part of everyday indoor clothing for men of the time. The inventory of his possessions drawn up at his death in 1669 lists 10 "men's caps" among the linen. Rembrandt has painted the cap with bold, thick strokes and it stands out forcefully against the muted background.

ON **TECHNIQUE**

Rembrandt was one of the supreme masters of oil paint, exploring its full expressive potential. In his early paintings, his technique was highly polished, particularly in his commissioned portraits, the subjects of which demanded expertise in depicting the details and textures of their expensive clothes. From the 1640s onward, however, his touch became broader, freer, and more spontaneous, leading to the magnificent breadth and richness of his later works. An early biographer, Arnold Houbraken, wrote with justifiable exaggeration that Rembrandt's final paintings, when seen close-up, "looked as though they had been daubed with a bricklayer's trowel."

IN **CONTEXT**

About 30 painted self-portraits by Rembrandt are known, the first produced when he was in his early 20s, the last in 1669, the year of his death. They are spread fairly evenly over this 40-year period, but there are fewer from the 1640s than from the other decades. In addition to these independent works, Rembrandt sometimes included a self-portrait among the subsidiary figures in a religious or historical painting. He also produced about two dozen self-portrait etchings and about a dozen drawings. Most of these date from the early part of his career—there are few after 1640.

▲ *Self-portrait*, Rembrandt, 1629, oil on panel, 6 × 5in (15.2 × 12.7cm), Alte Pinakothek, Munich, Germany

▲ **HAIR** Grey hair tumbles from under Rembrandt's headgear and falls over his right shoulder. It is depicted with vigorous dabs and swirls of paint, showing his mastery of bold brushwork. Unruly hair is a feature of many of Rembrandt's self-portraits, but in some of the more formal ones he shows himself carefully groomed.

◄ **NOSE** Rembrandt's large nose was one of his most distinctive features. In many self-portraits, he seems to exult in its bulbous shape, rather than trying to disguise it. Here it is given the face's main highlight, boldly rendered with single dabs of white and red.

The Art of Painting

c.1666–68 ▪ OIL ON CANVAS ▪ 47¼ × 39¼in (120 × 100cm)
KUNSTHISTORISCHES MUSEUM, VIENNA, AUSTRIA

SCALE

JOHANNES VERMEER

The sense of reality is so intense that at first glance it is easy to imagine that this picture is an almost photographically exact image of a 17th-century painter's studio. From the heavy curtains in the foreground to the creased map on the wall and the glittering brass chandelier above it, every color and texture rings true, exquisitely bathed in light that enters from unseen windows on the left. However, this is not a straightforward scene of a painter at work, but rather a glorification of the art of painting. The main clue to this is in the painter's costume–these are not working clothes, but a fanciful, old-fashioned outfit. The model is dressed as Clio, the muse of history, whose trumpet will proclaim the painter's fame.

Ironically, fame was a long time in coming to Vermeer. His output was very small (there are only about 35 surviving paintings by him), and as his work was superficially similar to that of other Dutch painters, it simply got lost in the vast outpouring of pictures by his contemporaries. Sometimes his paintings were admired but thought to be by other artists. It was not until about 1860 that his work began to be rediscovered. This was mainly because of the brilliant connoisseurship of a French writer, Théophile Thoré, who identified about two-thirds of the Vermeers known today.

Personal possession

The Art of Painting evidently had special significance for Vermeer, who perhaps created it as a demonstration of his skills. It was still in his possession when he died, and his widow unsuccessfully tried to keep it in the family when she was forced by debt to sell the other works of art in his estate. Its whereabouts were uncertain throughout the 18th century, but in 1813, it was bought by an Austrian aristocrat, Count Czernin. At this time, it was thought to be by Pieter de Hooch, one of Vermeer's Dutch contemporaries. It remained in the possession of the Czernin family in Vienna until 1940, when it was bought by Adolf Hitler for his private collection. By then, it was acknowledged as one of Vermeer's supreme masterpieces. After the war, the Czernin family claimed the picture had been sold under duress and should be restored to them, but in 1946 it became the property of the Austrian state.

JOHANNES **VERMEER**

1632–75

Although he is now one of the most beloved figures in world art, Vermeer made little impact in his lifetime and was virtually forgotten for two centuries after his death.

As far as is known, Vermeer spent his whole life in Delft, which at this time was the fourth largest town in the Dutch Republic and a prosperous center of trade and culture. Little is recorded of his career, although he appears to have been a respected figure among his fellow artists, who twice elected him as the governor of the Painters' Guild. He worked as an art dealer as well as a painter, but he had difficulty supporting his large family. His financial problems were increased by wars against England and France, which depressed the previously buoyant Dutch art market. When he died at the age of 43, he left his widow (and their 11 surviving children) with heavy debts.

> It stands apart from his other works in its imposing scale and pronounced allegorical character

ARTHUR K. WHEELOCK JR.
JOHANNES VERMEER: THE ART OF PAINTING, 1999

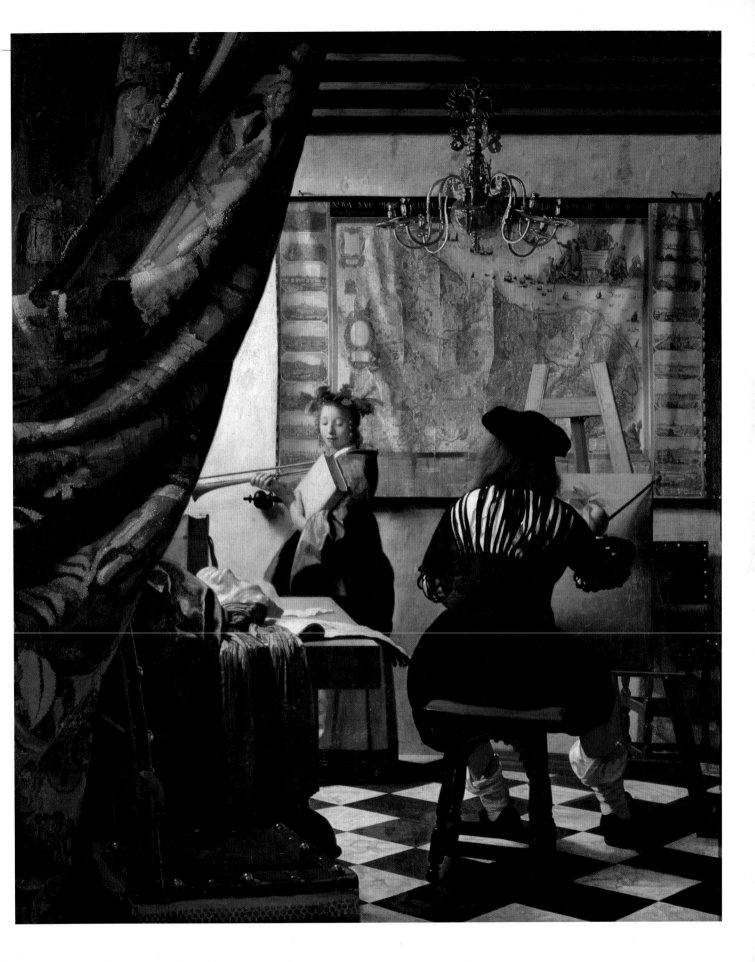

Visual tour

KEY

▶ **THE MUSE OF HISTORY** Various objects that the woman wears and carries identify her as Clio, the muse (goddess of creative inspiration) of history. The crown of laurel leaves symbolizes glory, the trumpet represents fame, and the book indicates the historical record. These features correspond with the description of Clio in Cesare Ripa's book *Iconologia*, a guide to allegorical figures that was much used by artists in the 17th century. A Dutch translation of the book appeared in 1644 and Vermeer presumably owned a copy.

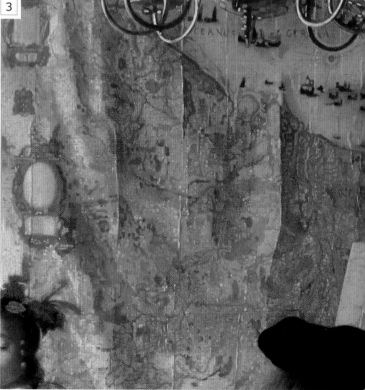

▲ **THE PAINTER** The figure of the painter has often been described as a self-portrait. There is no way of telling, as the back view reveals so little about his appearance, and there are in any case no undeniably authentic portraits of Vermeer with which to make a comparison. However, the figure does perhaps reflect Vermeer's own working methods—sitting, rather than standing, at the easel and using a maulstick (a stick with a padded end on which the artist could steady the brush hand when painting detailed passages).

> **CURTAINS** Dutch artists often showed heavy curtains partially pulled aside as a flanking element in their paintings (Vermeer used the device in several other pictures). It helped to create a feeling of intimacy by suggesting that they have been drawn back to allow us a glimpse into a private world. Such curtains also gave painters an opportunity to show virtuoso skill in depicting complex fabrics. No one was better at this than Vermeer, who convincingly conveys the weight as well as the roughness of the fabric.

▼ **MASK** On the table in front of the woman posing as Clio is a plaster mask. Although it could be interpreted as just a studio prop lying around, a mask can have various meanings and associations in art. In this context, it is almost certainly intended to symbolize imitation. Cesare Ripa's *Iconologia* (see top left) mentions a mask as being one of the attributes (distinguishing symbols) of the personification of painting.

▲ **CHECKERED FLOOR** The same type of checkered floor occurs in several of Vermeer's paintings. He presumably had such a floor in his own house and used it as a model. The strong pattern helps to create a sense of depth. About a dozen of Vermeer's paintings have pin marks (usually visible only in X-rays) at the vanishing point of the perspective scheme, indicating that Vermeer stretched a string along the canvas from this point to help him create the floor pattern accurately.

◄ **MAP** The map on the wall has been identified as one published in 1636. It may make a patriotic allusion to the history of Vermeer's country, the Dutch Republic, which is shown to the right of the central crease. The Spanish Netherlands, (roughly the same area as modern Belgium) is to the left. The Dutch Republic effectively won its freedom from Spanish rule in 1609, but this was not formally recognized by Spain until 1648; the southern territories remained under Spanish rule throughout the 17th century.

ON **TECHNIQUE**

There are no known drawings by Vermeer and it is probable that—like the painter he depicts here—he drew directly on the prepared canvas rather than making preliminary designs on paper. He almost certainly made use of a device called a *camera obscura* (the Latin term for "dark chamber"), an apparatus that works on the same principle as the photographic camera, but which projects an image of a scene onto a drawing or painting surface. Various features of his pictures, such as the slightly out-of-focus highlights on the chandelier, shown below, replicate the effects of the relatively unsophisticated lenses used in the *camera obscura*. Although this helps to explain certain aspects of Vermeer's work, the sparkling beauty of his brushwork and his delicate sense of balance depend on sensitivity and skill rather than mechanical trickery.

IN **CONTEXT**

Clio, as depicted by Vermeer, was one of nine muses, who in classical mythology each watched over a branch of learning or the arts. Here, Clio (on the left) is shown with two of her sisters—Euterpe, the muse of music, who plays the flute, and Thalia, the muse of comedy, who holds a theatrical mask.

▲ *Clio, Euterpe, and Thalia*, Eustache le Sueur, c.1652-55, oil on board, 51 × 51in (130 × 130cm), Louvre, Paris, France

1700–1800

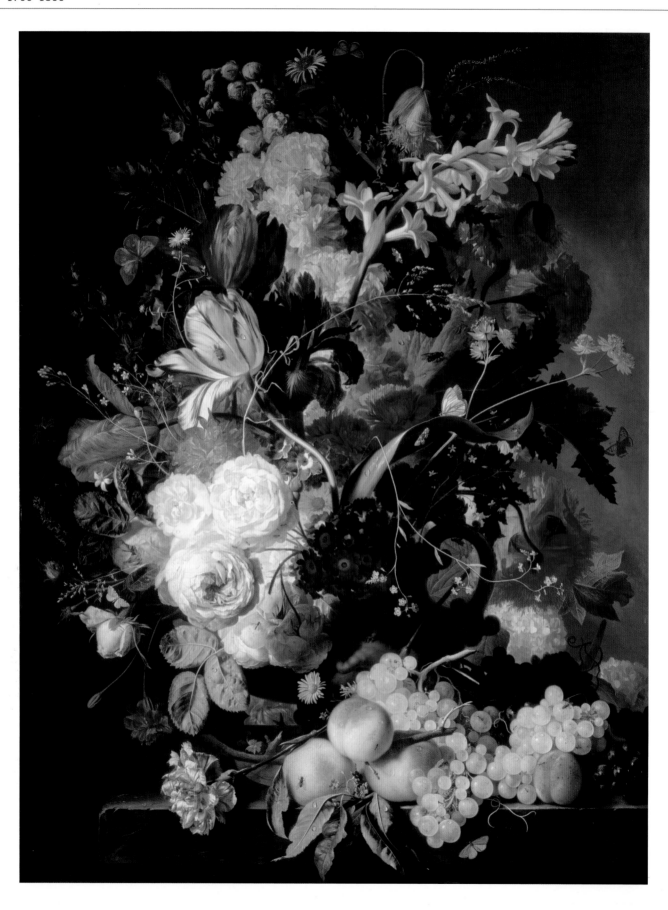

Still Life with Flowers and Fruit

c.1715 ■ OIL ON PANEL ■ 31 × 24in (78.7 × 61.3cm) ■ NATIONAL GALLERY OF ART, WASHINGTON, US

SCALE

JAN VAN HUYSUM

The opulent abundance of this panel represents Dutch still-life painting at its most magnificent. The tightly packed flowers and fruits are arranged with sweeping rhythms and gloriously variegated colors to create a breathtaking display. And beyond the general effect, the detail of each individual bloom is a marvel of precise observation and polished craftsmanship.

Everything is so convincing, down to the tiniest petal and drop of moisture, that it is easy to imagine such a dazzling floral arrangement once really existed. In fact, Jan van Huysum was a master of artifice who took flowers and fruits from different seasons and combined them in his imagination.

He was secretive about the methods with which he achieved his enamel-smooth perfection of surface, refusing to allow anyone—even his brothers—into his studio when he was working. He did once reluctantly agree to accept a pupil, Margareta Haverman, but he is said to have dismissed her when she became deceptively good at imitating his work.

An important insight into van Huysum's methods, however, comes from a letter he wrote to a patron in 1742. In it, he says that he would have completed a painting the previous year if he had been able to obtain a yellow rose; he also lacks grapes, figs, and a pomegranate to finish a fruit piece. From this it seems that he always worked directly from a model in front of him. He occasionally dated his pictures with two consecutive years, suggesting that he did indeed sometimes put a work aside and continue it when he had found the required flower or fruit.

Some scholars have argued that paintings such as this were meant to be deeply pondered by the viewer, as well as admired for their beauty—that they contain subtle symbolic meaning. It is true that some Dutch painters intended symbolic significance, for they included inscriptions to underline their moralistic points. However, there has been a recent tendency to over-interpret Dutch paintings, finding hidden meanings everywhere, and van Huysum's work does not require any intellectual props to sustain our interest.

> Considered the **greatest** of all flower-painters…**his drawing is superb**…**his coloration rich**, and his **compositions** admirably **light and free**
>
> **INGVAR BERGSTROM** *DUTCH STILL-LIFE PAINTING*, 1956

JAN VAN **HUYSUM**

1682-1749

Although he sometimes painted other subjects, mainly landscapes, van Huysum's reputation rests on his pictures of flowers. In this field he ranks as one of the greatest masters of all time.

Jan van Huysum was born into a family of artists in Amsterdam, the Netherlands, where he lived and worked throughout his life. He often visited nearby Haarlem (a major center of horticulture even then) to study flowers. He was taught by his father, Justus van Huysum the Elder, who was primarily a flower painter, and had three painter brothers, two of whom also concentrated on flowers. In terms of the wealth and prestige he achieved in his lifetime, van Huysum was perhaps the most successful flower painter ever. Contemporary writers sang his praises. He had an international clientele, including some of the most distinguished collectors of the day, among them the kings of Poland and Prussia. The famous English connoisseur Horace Walpole commissioned four paintings from him. His work inspired other Dutch painters into the second half of the 19th century, and his reputation has remained high.

Visual tour

KEY

> **PALE PINK ROSES** Of all flowers, roses have the richest tradition in art, with many associations, particularly with the Virgin Mary, who was described as a "rose without thorns"–in other words, sinless. Their prominence in still-life painting, however, owes more to their sheer beauty than to any other factor. Pink was the most common color among wild roses and has also been much favored by horticulturists. Roses generally bloom later in the year than tulips, but it is possible that van Huysum could have had specimens of both to work from at the same time.

▲ **STRIPED TULIP** Tulips are among the most commonly seen flowers in van Huysum's work and in Dutch still-life painting in general. The tulip was introduced to Holland from the Ottoman Empire in the 16th century and became a status symbol because of its rarity and beauty. Huge prices were paid for prize bulbs at the height of "tulip mania." But speculation got out of hand and in the 1630s the tulip-bulb market crashed. In spite of this, the tulip remained enormously popular with the flower-loving Dutch.

> **PEACHES AND INSECTS** The peaches illustrate the extraordinary finesse of van Huysum's technique, as he evokes their voluptuous, round forms and soft, velvety textures. The tiny insects not only emphasize, by contrast, the pristine surfaces of the fruit, but may also have some symbolic significance. Insects are short-lived and, therefore, were sometimes interpreted as an allusion to the brevity of human existence. A butterfly, on the other hand, could stand for resurrection and rebirth.

5 ◀ **LIGHT AND SHADE** Van Huysum was a master at placing contrasting shapes, tones, and textures against one another. Here the lovely, soft form of a rose—with a tiny butterfly hovering above it—stands out against the dark, flat background. He makes his effects seem natural, although they were in fact contrived.

▼ **STRIPED CARNATION** A single, beautifully observed carnation bloom lies on the ledge in the foreground. Like the rose, the carnation has had a long tradition in art, often being associated with love and romance. As with roses, most examples at this time were pink.

6

▲ **DARK BACKGROUND** In the earlier part of his career, van Huysum invariably used a dark background in his pictures, in common with most other Dutch flower painters, the brightly lit blooms thereby standing out all the more clearly. From the 1720s, however, he began to use light backgrounds, as his paintings became increasingly airy and lively. This was in line with a move from the weighty Baroque style of the 17th century to the more frothy Rococo style of the 18th century.

7

◀ **COLOR CONTRASTS** Van Huysum was a vibrant and subtle colorist, keeping a great variety of tones and hues in delicate balance. Here he sets one color off strongly against another, where the red of the poppy stands out against its white neighbors.

8

◀ **GRAPES** The translucent skins of the grapes provide another challenge to van Huysum's powers of verisimilitude, which he meets with his customary panache. Grapes were common in still-life paintings. On some occasions they may be a deliberate allusion to the wine of the Eucharist and therefore to Christ's blood.

ON **TECHNIQUE**

17th-century Dutch flower painters generally favored static compositions, arranged more or less symmetrically in a centrally placed vase. Van Huysum, however, introduced a sense of lively movement, with curling lines and the flowers overflowing towards the viewer. Often an S-shaped curve flows through the composition. Unlike most of his peers, van Huysum made numerous drawings, usually in chalk or ink—some are vigorous compositional sketches for his paintings.

IN **CONTEXT**

Still-life painting flourished in the 17th-century Netherlands, expressing the Dutch taste for subjects that celebrated their surroundings and hard-won peace and prosperity. It grew so popular that there were sub-specialities such as shells or breakfast tables. Flowers were perhaps the one area in which 18th-century Dutch artists such as van Huysum rivaled or even surpassed the achievements of the 1600s.

▲ *Still Life with Drinking Vessels*, Pieter Claesz, 1649, oil on panel, 25 × 20½in (63.5 × 52.5cm), National Gallery, London, UK

Marriage à-la-Mode: The Marriage Settlement

c.1743 ▪ OIL ON CANVAS ▪ 27½ × 35¾in (69.9 × 90.8cm) ▪ NATIONAL GALLERY, LONDON, UK

SCALE

WILLIAM HOGARTH

In the grand interior of a London house, a wealthy merchant and an earl are negotiating a marriage settlement that will benefit them both in different ways. The merchant (in the red coat) is buying his way into the aristocracy by marrying off his daughter to the son of Earl Squander (sitting opposite), who, as his name suggests, has frittered away his wealth. The groom (in the blue coat) seems oblivious to the proceedings, a lawyer is whispering into the bride's ear, and an accountant is pushing another unpaid bill towards the earl. This lively scene is the first in a narrative sequence of six paintings by master satirist Hogarth depicting the unfortunate course and tragic conclusion of the ill-conceived marriage. A satirical look at marrying for money, it is an uncompromising but comic depiction of human weakness and moral failings.

Innovative visual satire

Hogarth's satirical paintings were innovative in terms of both their form and subject. Taking the form of narrative sequences—as opposed to single works—on topical themes, they revealed his cynical view of 18th-century London society and its materialism, his subversive attitude, and his love of mischief-making. With these "modern moral subjects," as they were known, Hogarth estabished a new genre of painting.

The Marriage Settlement is typical of his other works in this genre in that it resembles a theater set and the whole sequence tells an entertaining story, rather like the unfolding scenes of a stage play. In this first painting the young couple seem uninterested in the proceedings and sit with their backs to each other. From this unpromising beginning a horrid melodrama is about to unfold, featuring infidelity, sexually transmitted disease, indolence, self-indulgence, violence, and death.

The painting is humorous, cleverly composed, and well executed. There is abundant detail to enjoy, from the expressions of the characters to the paintings on the walls and the scene outside the window. Hogarth developed this style of painting because he was unable to make enough money from producing either portraits or history paintings, but The Marriage Settlement and the other five paintings in the series were not well received at first. He found it difficult to sell his work, but once he had turned the painted images into high-quality engravings and circulated prints of them on subscription, they reached a wide audience and generated a considerable income.

Hogarth's satirical paintings continue to fascinate because their gritty themes have a timeless appeal and the narrative is acted out to its unpleasant conclusion in a series of engaging set pieces. Given their topical themes, they were, perhaps, the 18th-century equivalent of today's soap operas.

WILLIAM **HOGARTH**

1697–1764

An innovative painter and engraver, Hogarth was instrumental in popularizing British art through printmaking. He also established artists' copyright.

At the age of 23, after serving an apprenticeship with an engraver, Hogarth started his own printing business in London. He also studied painting at Sir James Thornhill's free academy in St Martin's Lane, London. Later, he set up his own art school there.

During the 1730s, Hogarth painted informal group portraits, known as "conversation pieces," for wealthy families but his portrayals were insufficiently flattering for his client's tastes and had limited success. In the same period, Hogarth began developing his own genre of satirical paintings. These became hugely popular and made him a wealthy man. Indeed, he was one of the first British artists to work independently without financial patronage. His best-known series are A Harlot's Progress, c.1731, A Rake's Progress, 1735, and Marriage à-la-Mode, c.1743.

All Hogarth's scenes look like scenes
of a crime. The viewer is invited to cast a
detective eye, left and right, picking up clues…
the artist has carefully placed

TOM LUBBOCK *THE INDEPENDENT,* 2008

Visual tour

KEY

▶ **CITY MERCHANT**
In the center of the composition, resplendent in a bright red coat, the wealthy father of the bride-to-be is scrutinizing the marriage contract. With his back to his daughter, he is peering through his spectacles at the print.

▼ **EARL SQUANDER** Bewigged and distinctly pompous looking, Earl Squander is doubtless requesting a substantial sum in return for accepting the merchant's daughter into his aristocratic family. Hogarth has added wonderful comic touches, such as the partly unrolled family tree dating back centuries, with the earl proudly pointing at its illustrious branches. Earl Squander's self-indulgent nature is clearly indicated by his bandaged, gout-afflicted foot, which he rests on a stool adorned with the family crest. Gout, known as "the rich man's disease," was attributed to excessive consumption of rich food and fine wines.

▲ **BUILDING WORKS** Through the window, we can see a grand building complete with scaffolding. This is the earl's new home, another detail that Hogarth has included to indicate the scale of the earl's ill-advised spending. The building is unfinished, suggesting that the earl has run out of money.

▶ **UNPAID BILLS** The accountant is showing Earl Squander a document, possibly setting out the amount owing on his new mansion. In juxtaposing the unpaid bill and the marriage settlement, Hogarth is satirizing the union, which is a cynical business deal between the two fathers.

THE GROOM The puny Viscount seems to be more interested in admiring his reflection in the mirror than looking at his bride-to-be. Dressed in the latest French fashions, the earl's son has no doubt been to the Continent. Like his father, he leads a life of dissipation: the black mark on his neck is a symptom of syphilis, popularly called "the French pox."

THE BRIDE Dressed rather plainly in comparison with her vain husband-to-be, the daughter of the merchant is listening intently to what the lawyer, appropriately named Silvertongue, is whispering in her ear. This is an early indication of his dishonorable intentions. Later in the series we learn that the lawyer has seduced her.

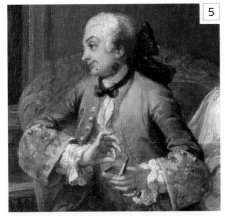

5

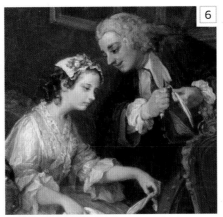

6

7

MEDUSA On the wall between the bride and groom hangs a painting of a screaming Gorgon, rather like Caravaggio's *Medusa*, made in 1597. This Greek mythological monster with snakes for hair probably indicates the horrors that will befall the ill-matched couple.

DOGS Echoing the unhappy union of the bride and groom and their sorry fate, the two dogs in the bottom left-hand corner are shackled together.

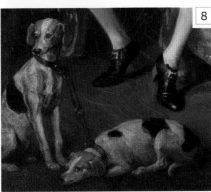

8

ON **TECHNIQUE**

Hogarth was a skilled engraver and the painting of *The Marriage Settlement* was used as a model for the engraving print below. To make an engraving, the image was incised into a copper plate, which was then used to make black-and-white prints. The image was reversed as a result of the printing process. Because the print would not be in full color like the painting, areas of tone had to be created in a different way. The engraver would use crosshatching (intersecting parallel lines) to create areas of tone, incising lines very close together and in different directions on top of each other to build up the darkest areas of tone. The paler areas of the image would have been created with lighter crosshatching, or left almost blank.

▲ *Marriage à-la-Mode: the Marriage Settlement*, William Hogarth, 1745, engraving print on paper, Victoria & Albert Museum, London, UK

IN **CONTEXT**

The painting below is the second episode in Hogarth's *Marriage à-la-Mode*. It depicts the newlyweds at home the morning after the night before. It is midday and both seem exhausted after their separate nocturnal entertainments. The viscount lolls in a chair, another woman's cap poking from his pocket with the dog about to retrieve it. His wife might be signaling to someone out of sight, possibly a lover who had to make a quick exit, hence the upturned chair. On the left, a servant clutching unpaid bills walks out of the room making a gesture of despair.

▲ *Marriage à-la-Mode: The Tête à Tête*, William Hogarth, c.1743, oil on canvas, 27½ × 35¾in (69.9 × 90.8cm), National Gallery, London, UK

Mr. and Mrs. Andrews

c.1750 ▪ OIL ON CANVAS ▪ 27½ × 47in (69.8 × 119.4cm) ▪ NATIONAL GALLERY, LONDON, UK

THOMAS GAINSBOROUGH

SCALE

One of the first painted scenes of provincial English country living, *Mr. and Mrs. Andrews* started a fashion for informal portraiture among the wealthy classes of the 18th century. Gainsborough was commissioned to paint this celebrated double portrait early in his career, just after he had moved back from London to Suffolk, but landscape painting was his real passion and this striking composition displays his brilliance in both genres.

Mr. and Mrs. Andrews was probably commissioned to commemorate the couple's recent wedding and this fresh, luminous portrait is above all a statement of their social standing. The newlyweds are pictured in open fields at Auberies, Mr. Andrews's family estate near Sudbury, in eastern England, which had been extended as a result of the marriage. Not only the landscape but also the couple's faces seem quintessentially English. Gainsborough has chosen to place his sitters off-center, with their lands unfolding expansively to the right. Mr. Andrews, every inch the country gentleman, leans informally on the bench beside his new wife and proudly displays the extent of his fertile domain, the visible proof of his wealth and status. The latest farming methods are also alluded to in the painting, to show that the couple are forward-looking as well as prosperous. Although Mr. Andrews wears the clothes of a country squire, his wife is elegantly attired in the latest French-inspired fashions and the Rococo–style bench is further evidence of their cosmopolitan tastes.

Evocative landscape

In this great painting, Gainsborough has lavished as much attention on the Suffolk landscape as he has on the young couple. The green and gold fields, the billowing clouds, the carefully observed ties around the sheaves of corn, and the cow parsley growing wild in the fields are all testament to the artist's deep love of nature and make this an English rural idyll. Gainsborough found it hard to make a living from landscape painting alone but was fortunately in such great demand as a society portrait painter that he was able to subsidise his real love.

THOMAS **GAINSBOROUGH**

1727–1788

One of the great masters of 18th-century painting, Gainsborough was best known for his portraits and for his lyrical and naturalistic depiction of the English countryside.

Born and educated in Sudbury, Suffolk, Gainsborough moved to London when he was 13, to study drawing and etching with the French draughtsman and engraver Hubert Gravelot. He may also have studied at the academy set up by William Hogarth in London in 1735.

Around 1748, Gainsborough returned to Suffolk, where he worked for 10 years, painting the portraits of local gentry and merchants. He developed a naturalistic approach and often painted head-and-shoulder portraits rather than conversation pieces.

In 1759, he moved to Bath, where he found a ready demand for his portrait skills. Seeing the works of Van Dyck inspired a new, elegant style that appealed to his wealthy clients and in 1768 he was elected a founder member of the Royal Academy. Gainsborough settled in London in 1774.

Visual tour

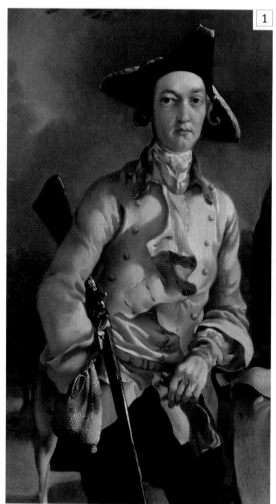

KEY

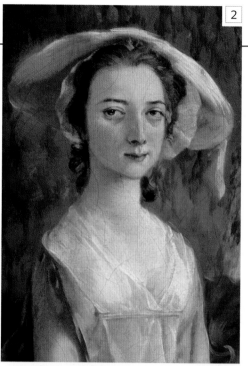

◄ **FRANCES MARY ANDREWS**
Mrs. Andrews is thought to have been 16 years old when she got married. Gainsborough painted her with a tiny head to emphasize her dainty physique. Her feet and unfinished hands are also disproportionately and flatteringly small and almost doll-like: at the time petite features were very fashionable. Mrs. Andrews's slightness and sitting postition also emphasize her husband's dominance of the composition.

▲ **ALL SAINTS' CHURCH** Just visible through the trees is the church of All Saints' in Sudbury, where the couple were married in November 1748. The tower of Holy Trinity Church, in the nearby village of Long Melford, can also be glimpsed above Mr. Andrews's left elbow. These small details help to identify the actual location of the Andrews's estate.

▲ **ROBERT ANDREWS** Presiding over his possessions: his ancestral land, his dog, and, in accordance with the social conventions of the time, his wife, Mr. Andrews appears satisfied with his life and looks directly at us. The gun under his arm symbolizes virility and is echoed by his stance—he leans casually on the bench with his legs crossed, to show off the musculature. A member of the landed gentry and a graduate of Oxford University, Mr. Andrews was around 22 years old at the time the portrait was painted.

▲ **MODERN METHODS** The bushels of corn are a symbol of fertility, both of the land and perhaps also of the couple. The neat rows show us that Mr. Andrews's farm is both orderly and modern. The agricultural revolution of the 18th century brought about new farming methods, helped by inventions such as the mechanical seed drill. Before such inventions, the rows would have been far less uniform in shape. Enclosed fields and selective breeding were also introduced to increase yields of wool and milk, as indicated by the fenced field of sheep in the distance.

▼ **EMPTY LAP** Gainsborough has depicted the soft folds and delicate sheen of Mrs. Andrews's silk dress with consummate skill, but the area where her hands rest on her lap is left puzzlingly unpainted. A popular theory is that the space was intended for a bird shot by Mr. Andrews, but his wife would surely not have sullied her expensive dress with a carcass. A craft bag is a more plausible explanation.

▼ **DOG** The gun dog, a pointer, looks obediently at his master, waiting for his next command. The line of the dog's head directs our gaze towards Mr. Andrews's face, reinforcing the painting's principal point of focus. As a symbol of loyalty, the dog is included to represent the couple's fidelity and appears as a frequent motif in other Gainsborough portraits.

▲ **OAK TREE** In formal portraits a classical column was frequently employed as a compositional device. Here, Gainsborough uses the trunk of a mature oak tree. Traditionally used in shipbuilding, the "mighty" oak is a symbol of great strength and stability as well as being particularly evocative of the English countryside.

◄ **CLOUDY SKY** The grey tones of the clouds to the right suggest that the weather is about to change and that rain is on its way. A cloudy, as opposed to a bright, sunny, sky was unusual in a commissioned portrait. It is more commonly seen in narrative paintings to warn of problems looming ahead.

ON **TECHNIQUE**

Gainsborough would have taken his sketchbook outdoors to make detailed studies of the local landscape. He would not, however, have expected his sitters to pose outside and Mrs. Andrews's fashionable footwear is hardly appropriate for outdoor wear. Preparatory work for the portrait would have been carried out in the comfort of the couple's home and when they were unavailable, mannequins—small, clothed, articulated wooden dolls—would have been substituted.

This painting clearly displays the sensitivity and delicacy of Gainsborough's brushwork, particularly in the fabric of Mrs. Andrews's sky-blue dress with its shimmering highlights.

IN **CONTEXT**

It is tempting to draw comparisons between Gainsborough's *Mr. and Mrs. Andrews* and the 20th-century painting by British artist David Hockney of the late fashion designer, Ossie Clark, and his wife, textile designer Celia Birtwell. Both paintings are double portraits of newlyweds and in both of them the fashionable clothes and style of furniture set them firmly within a particular epoch. In Hockney's painting, it is the woman who is standing and assuming the dominant pose. The man is seated and is accompanied by a cat, rather than a dog, possibly introducing the idea of infidelity rather than loyalty.

▲ *Mr. and Mrs. Clark and Percy*, David Hockney, 1970-71, acrylic on canvas, 8½ × 12in (21.3 × 30.5cm), Tate, London, UK

Allegory of the Planets and Continents

1752–53 ▪ FRESCO ▪ 62 × 108ft (c.19 × 33m) ▪ RESIDENZ, WÜRZBURG, GERMANY

GIAMBATTISTA TIEPOLO

SCALE

He is full of wit, with boundless inspiration, a dazzling sense of color, and works with amazing speed

COUNT CARL GUSTAV TESSIN LETTER, 1736

This breathtaking ceiling soars over the main staircase of one of the most magnificent palaces in Europe—the Residence of the Prince-Bishops of Würzburg in southern Germany. The Prince-Bishop who commissioned this masterpiece was Karl Philipp von Greiffenklau, who reigned from 1749 until his death in 1754. Although very wealthy, he was a figure of only minor historical importance, but Tiepolo, with superb confidence and inventiveness, has immortalized him in this painting as though he were a mighty hero. Figures representing the four quarters of the globe (all the continents that were known at the time) are arranged around the edges of the ceiling, and each one, improbably but gloriously, pays tribute to Karl Philipp, whose portrait is held aloft over Europe. The gods of Olympus join in.

Tiepolo was renowned for the speed at which he worked, and was extraordinarily inventive: he overflowed with ideas even when given the unpromising task of glorifying a minor German ruler. The ceiling is full of vividly imagined and characterized details, not just among the humans but also in the animals, such the enormous crocodile on which the figure of America rides. Even more impressive than the exuberant details, however, is the way in which Tiepolo blends them into a coherent and vibrant whole. The ceiling is enormous and must have involved months of backbreaking effort, but Tiepolo makes it seem as light and spontaneous as a sketch.

GIAMBATTISTA **TIEPOLO**

1696-1770

The greatest Italian painter of the 18th century, Giambattista Tiepolo had a hugely successful international career, working mainly on resplendent fresco decorations in palaces and churches.

Tiepolo was born in Venice, Italy, and spent most of his life there, but he was employed in many other places in northern Italy; he also worked in Würzburg, Germany, from 1750 to 1753, and spent the last eight years of his life in Madrid, in the service of Charles III of Spain (earlier he had turned down an invitation to decorate the royal palace in Stockholm for Frederick I of Sweden). He was enormously energetic and productive, even in old age. Although he created various kinds of paintings, he is best known as the greatest fresco decorator of his age. He particularly excelled in the difficult art of ceiling frescoes, showing a prodigious ability to orchestrate hosts of figures overhead and create exhilarating effects of light, space, and color. Most of his work is secular, but he also painted many religious pictures—altarpieces as well as frescoes. In addition to paintings, he produced a large number of drawings and was a brilliant, albeit occasional, etcher.

Visual tour

KEY

▼ **MARS AND VENUS** Reclining on a cloud are Mars, the God of War, and Venus, the Goddess of Love. Mars was a brutal character, but his aggressive spirit was tamed when he fell in love with Venus, and their relationship was often used in art as an allegory for how love overcame strife.

2

1

◄ **APOLLO** Near the center of the ceiling, with the rising sun behind him, is Apollo, one of the major gods of the Greeks and Romans. He is traditionally depicted as a beautiful, graceful young man and represents the virtues of civilization and rational thought. Here his radiance symbolizes the life-giving force of the sun over all the continents, as well as the enlightenment of the Prince-Bishop's rule, under which the arts flourish. Apollo is accompanied by two Horae—spirits who symbolized the seasons.

▼ **EUROPE** The figure representing the continent of Europe is less immediately striking than her more exotic counterparts, but she has great dignity. She resembles the traditional image of Juno, the Queen of the Gods, and rests her hand on the head of a magnificent bull—a reference to Europa, the mythological character from which the continent derives its name. Europa was a beautiful princess with whom Jupiter (the King of the Gods and Juno's husband) fell in love; he transformed himself into a white bull and abducted her.

3

4

▲ **MERCURY** Hovering near the portrait of the Prince-Bishop is the god Mercury, easily recognized by his winged sandals and hat (symbolizing his speed) and his caduceus or herald's staff (indicating that he was often employed as a messenger by the other gods). Typically he was a bearer of good fortune and he personified eloquence and reason.

▼ **ASIA** The figure personifying Asia wears a beautiful, jeweled turban and is riding a sumptuously clad elephant. She makes a commanding gesture with her left hand, a pose—as we look up at her—that shows off Tiepolo's formidable skill as a draftsman. This skill underpinned all his work and he made many preparatory drawings for the ceiling.

▼ **AMERICA** With her spectacular feather headdress, America is one of the fresco's most arresting figures. At this time, the Americas were generally regarded by Europeans as barely civilized, and Tiepolo shows the woman as a noble savage with a bow slung over her shoulder. Several of the figures who accompany her are of warlike aspect or engaged in hunting.

ON **TECHNIQUE**

Tiepolo had to be highly organized to carry out his immense workload. He prepared for his frescoes with drawings and oil sketches. This is a detail from an unusually large sketch he made for the Würzburg ceiling, which he would have shown to the Prince-Bishop for approval. It sets out the essentials of the design, but Tiepolo made many changes in the finished work. He used assistants on his frescoes, including his sons, but orchestrated his team so well that even experts have difficulty in detecting any hand other than his own. The assistants presumably handled parts, such as the sky or architectural background, that did not need his personal touch.

5

6

▲ *Allegory of the Planets and Continents*, Giambattista Tiepolo, 1752, oil on canvas, 73 × 55¾in (185.4 × 139.4cm), Metropolitan, New York, US

7

◀ **AFRICA** Like America, Africa is bare-breasted, but she is more finely attired. Her dark skin contrasts strikingly with her white draperies and the huge gold earrings she wears. She rides a camel and is accompanied by figures and still-life details that suggest the great wealth of the continent. In Tiepolo's time, the coastal areas of Africa were virtually the only parts that were known to Europeans. A great deal of trade was carried on with them, notably in slaves.

IN **CONTEXT**

Several architects worked on the Residenz, but the most important was Balthasar Neumann, who was occupied with the vast building for most of his career. He is regarded as the greatest German architect of the 18th century, and this majestic staircase forms a fitting setting for Tiepolo's most famous ceiling painting.

8

▲ **FATHER AND SON** Tiepolo freely mixes imaginary and real figures, including—tucked in a corner of the area devoted to Europe—portraits of himself and his eldest son, Giandomenico (or Domenico for short). Tiepolo had ten children, seven of whom survived to adulthood. Two of his sons, Domenico and Lorenzo, became painters; both accompanied their father to Würzburg. Lorenzo was a boy at the time, but Domenico was already a talented painter and valued assistant.

▲ View of the main staircase of the Würzburg Residenz, showing part of Tiepolo's ceiling

An Experiment on a Bird in the Air Pump

1768 ▪ OIL ON CANVAS ▪ 72 × 96in (183 × 244cm) ▪ NATIONAL GALLERY, LONDON, UK

JOSEPH WRIGHT OF DERBY

SCALE

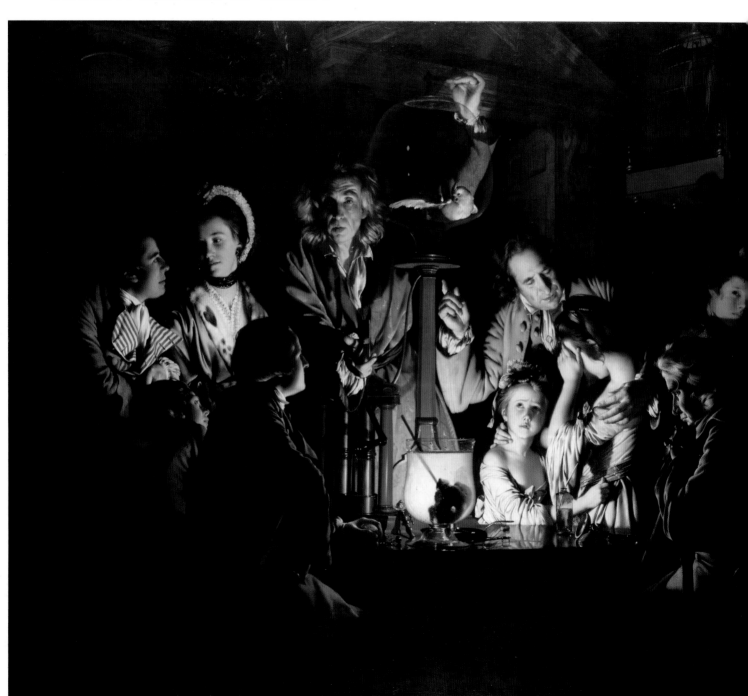

...ly lit by a single brilliant light source that ...n extraordinary play of shadows, this ... painting depicts an unusual domestic scene. ...oup is watching the progress of a scientific ...t that is being performed in front of them at ...responses of the audience are skillfully ...nd their exquisitely illuminated faces express ...human emotions. Life-size and painted in a highly polished style that looks almost photographic, *An Experiment on a Bird in the Air Pump* is one of Joseph Wright of Derby's famous and original "candlelight" scenes.

This painting was created during a period of major scientific activity in 18th-century Europe. At the time, it was fashionable for scientists to travel with their equipment and perform demonstrations at country houses– events that were entertaining as well as educational. Wright took a keen interest in the new scientific discoveries: he had probably attended lectures and also sought to promote interest among the wealthy classes in the innovations of the day. In his painting, a living bird has been enclosed in a large, glass flask and the air then pumped out to create a vacuum. The experiment has been set up to demonstrate the effect on living creatures when they are deprived of air. We are witnessing the make-or-break moment when the scientist can choose to reintroduce air into the flask to revive the dying bird or let it perish. We can never know the outcome and Wright offers few clues. This sense of uncertainty and the emotional reactions of the group heighten the human drama of the painting.

Effects of light

By means of strongly contrasting light and shadow, the technique known as chiaroscuro, Wright immediately engages our attention, directing our focus on the dramatically illuminated figures that are sharply outlined against the gloom of the background. The white-haired, magician-like scientist, his left hand at the top of the flask, looks directly out at us from the painting. With his penetrating stare, he is immediately captivating. The brightly lit faces and gestures of each of the onlookers–especially the children–register distress, concern, and even detachment. The background of the painting is in shadow, except for a second light source– the full moon in the window on the far right.

Wright was fascinated by the depiction of lighting effects–a preoccupation he held throughout his life, whether he was painting scenes of the Industrial Revolution in Britain or Mount Vesuvius erupting in Italy. The originality of *An Experiment on a Bird in the Air Pump* lies in his mastery of light combined with a highly unconventional subject. It is his best-known painting and a wonderful insight into the age of the European Enlightenment.

> Everyone is illuminated by a single source of light…all of them, and us, are capable of being enlightened by the power of science

ROBERT CUMMING *ART EXPLAINED*, 1995

JOSEPH **WRIGHT OF DERBY**

1734-97

The first major English painter to base his career outside London, Wright excelled at unusual subjects characterized by dramatic light and shadow.

Wright, the son of an attorney, was born–as his name suggests–in the Midlands town of Derby. He spent two periods in London training as a portrait painter before settling in his native town, where his reputation was soon established. Although Wright went on to paint industrial scenes and landscapes, portraiture was a consistent and reliable source of income throughout his career.

In the 1760s, Wright began to experiment with chiaroscuro in his paintings. His candlelit scenes displayed flair and originality and were justly celebrated, especially the two depicting serious scientific themes: *A Philosopher Giving a Lecture on the Orrery* and *An Experiment on a Bird in the Air Pump*, exhibited in 1766 and 1768 respectively. Wright continued his exploration of unusual lighting effects in his landscapes, such as *Grand Fire Work at the Castel of St. Angelo, Rome*, c.1775, and his views of Vesuvius erupting, which he witnessed in 1774. Apart from short periods in Liverpool and Bath and a visit to Italy from 1773 to 1775, Wright spent his later career working in Derby.

Visual tour

KEY

▼ **YOUNG GIRLS** The youngest child looks up at the dying bird. Her shocked face is depicted with great skill and sensitivity, especially the creased brow and tearful yet fascinated eyes. Her gestures, too, are eloquent. She clings to the dress of the older girl (perhaps her sister, as they wear matching dresses), who has covered her eyes in distress and is being comforted. This self-contained section of the overall composition portraying a tender scene has an almost religious quality.

◄ **SCIENTIST** This archetypal wise man with his long white hair stares straight at us. He appears very excited by the high point of the performance: his lips are slightly parted and the skin of his face is flushed pink. The rich, red fabric of his robe further accentuates the sense of drama. Wright appears to be focusing on the scientist's omnipotence. His left hand is on the air valve that will decide the fate of the living creature, so his power over nature is almost godlike.

▼ **THE BIRD** A white cockatoo is slowly suffocating in the bottom of the glass flask. It would have been more usual to conduct such demonstrations using common birds, such as sparrows, rather than a rare, expensive breed. Wright may have chosen the bird for its size and color, which show up well against the dark background. Perhaps the cockatoo was also selected for its resemblance to a dove, a symbol of the Holy Spirit.

◄ **JAR** At the center of the painting is a brightly lit jar containing an unidentifiable object. It was first thought to be the lung of a pony with a straw inserted so it could be inflated and deflated. In more recent interpretations of the painting, the object has been identified as a partly dissolved skull. The scientist's right index finger appears to be pointing at the skull, possibly reminding the audience that he is in control at this life-or-death moment.

◄ IN CONTEMPLATION The older man on the right of the frame, his face seen in profile and subtly lit, appears absorbed in his thoughts. Most of his body is in deep shadow and he seems aloof from the demonstration. If we follow his line of vision, it leads directly to the skull in the jar, a symbolic reminder of death. This senior figure may be lost in contemplation of his own mortality.

▲ MAN AND BOY The clock is ticking for the cockatoo. The man on the left of the table holds a pocket watch in his left hand, probably to time the experiment. He may represent the cool, detached observer, while the young boy behind him is clearly captivated by the experiment.

◄ BOY WITH CAGE Illuminated only by the moon and depicted in part-shadow, the boy on the far right is on the margins of the group. It is unclear whether he is in the process of retrieving the cage hanging from the ceiling, because the bird will be spared, or hoisting it back up because the creature is about to die.

◄ YOUNG COUPLE More interested in each other than in the experiment, the young couple add a touch of romance. Wright is known to have used friends and family in his paintings and the man is probably his friend Thomas Coltman with his fiancée, Mary Barlow. Wright's painting *Mr. and Mrs. Coltman* celebrated their marriage.

ON **TECHNIQUE**

The main source of illumination for this complex nighttime scene is the light of a single, central candle. It is located immediately behind the glass jar on the round table in the middle of the group (see below). Wright reveals a knowledge of optics in the way he has constructed the scene. A reflection of the candle is just discernible on the left side of the jar. It appears distorted by the curvature of the glass. The light also refracts through the cloudy water, similarly distorting the wand-like rod. The second light source is the softly diffused moonlight from the window on the right, which picks out the face and hands of the boy beneath the bird's cage.

The air pump, too, is brightly lit. The precision with which Wright has painted it implies that he found such instruments beautiful.

IN **CONTEXT**

When Wright's two best-known paintings were shown they caused great excitement. Nothing like them had been exhibited in Britain and they fitted none of the conventional categories.

A Philosopher Giving a Lecture on the Orrery, c.1764 (below), depicts a mechanical device that shows the movements of the planets around the sun being demonstrated to a family group. The device, which illustrated Sir Isaac Newton's theories of planetary motion and gravity, helped to make scientific knowledge more accessible to a receptive public. Wright's great scientific paintings show the profound effects on people of the new discoveries and may well have been created in the same spirit.

▲ *A Philosopher Giving a Lecture on the Orrery*, Joseph Wright of Derby, c.1764–66, oil on canvas, 58 × 80in (147.3 × 203.2cm), Derby Museum and Art Gallery, Derby, UK

The Death of Marat

1793 ▪ OIL ON CANVAS ▪ 65 × 50½in (165 × 128cm)
MUSÉES ROYAUX DES BEAUX-ARTS, BRUSSELS, BELGIUM

SCALE

JACQUES-LOUIS DAVID

Propaganda rarely produces great art, but this is a notable exception. In this stark yet moving picture, David mourns the death of a close friend and fellow revolutionary. The victim, Jean-Paul Marat, was a leading member of the National Convention—the short-lived governing body in France during the Reign of Terror, the most violent days of the Revolution. His extreme views made him many enemies, particularly after the fall of the Girondins (one of the more moderate factions).

On July 13, 1793, one of their supporters, a young woman named Charlotte Corday, was granted an audience with him in his bathroom. This was not unusual. Marat suffered from a debilitating skin condition that required him to take frequent baths, so he used the place as an office. During the meeting, Corday pulled out a knife and stabbed him to death. At her trial, she proclaimed, "I killed one man to save 100,000 lives." On July 17, she was sent to the guillotine.

A revolutionary tribute

On the day after Marat's murder, David was invited by the Convention to arrange the funeral ceremony and to paint a memorial for the dead man. He began work immediately and had completed the picture by November. David was the obvious choice for this task, partly because he knew Marat very well and shared his ideals, and partly because his rigorous, Neoclassical style was well suited to the moral gravitas required for such a theme.

David stripped the scene down to its essentials. He removed the ornate decor of Marat's bathroom and replaced it with a darkened void. This may have been inspired by the gloomy lighting in the Cordeliers (a former church), where the victim's body lay in state. David exchanged Marat's unusual, boot-shaped bath for a more traditional design and focused the viewer's attention on the limp, dangling arm in the foreground, deliberately conjuring up associations with the pose of Christ's body as he was lowered from the Cross. The artist may also have been inspired by memories of an ancient sculpted relief known as the *Bed of Polycleitus*. After the Revolution, the painting proved an embarrassment to

the new regime and in 1795 it was returned to David. It was not exhibited again in France until 1846, 21 years after David's death, when the poet and art critic Charles Baudelaire's lyrical praise restored its reputation.

> This work contains something both **poignant and tender; a soul is taking flight** in the **chill air** of this room, within these cold walls, **around this cold funerary tub**
>
> **CHARLES BAUDELAIRE** *SALON DE 1846*, 1846

JACQUES-LOUIS **DAVID**

1748-1825

The leading Neoclassical painter in Europe, David drew inspiration from the turbulent times in which he lived, producing his finest masterpieces during the French Revolution.

David was born in Paris, France, where he trained under Joseph-Marie Vien. In 1774, he won the Prix de Rome, which financed further studies in Italy. David spent five years there, absorbing the traditions of ancient classical art. On his return to Paris, he developed a potent new vision of the antique. Drawing on themes from Greek and Roman history, he painted a series of canvases that proclaimed the virtues of moral rectitude, courage, and self-sacrifice. These appeared to reflect the growing mood of rebellion in the country in the days leading up to the Revolution.

When the uprising began in 1789, David committed himself fully to the cause. He joined the National Convention, organized revolutionary spectacles, and voted for the execution of Louis XVI. These activities almost cost him his life, but he managed to escape with a brief spell of imprisonment. Undeterred by the experience, David supported Napoleon's rule with the same degree of passion, becoming his official painter. After Napoleon's fall, however, there were no further reprieves. David retired to Brussels in 1816 and lived out the remainder of his days in exile.

Visual tour

KEY

▶ **MARAT** During the Revolution, Jean-Paul Marat was one of the most powerful men in France. He made his mark as a fiery journalist, running a radical paper called *L'Ami du Peuple* (The Friend of the People), in which he railed against the "enemies of the state," calling for their destruction. David's depiction of Marat is more propaganda than portrait. He altered his friend's appearance to make him fit the image of a martyred hero. He removed the discoloration and blemishes from his skin and made him look younger than his 50 years. One detail, however, is entirely accurate. Marat did indeed wear a cloth soaked in vinegar around his head, to ease the discomfort caused by his skin complaint.

▶ **TRACES OF BLOOD** David was anxious to create a tender tribute to his friend, so he deliberately played down the most violent aspects of his subject. There is only a very light sprinkling of blood on the sheet. Similarly, there is virtually no blood on the body of the victim. The stab wound in Marat's chest is largely hidden in the shadows, while the cut itself scarcely looks severe enough to have been a fatal blow. Instead, the goriest indicator of the attack is the fact that Marat's blood has turned the bathwater red. Even here though, David has minimized the effect by adopting a very low viewpoint, so that only a thin streak of blood is visible.

▼ **FURNITURE** David placed considerable emphasis on the spartan conditions in Marat's bathroom, to underline his friend's credentials as a man of the people. This battered old crate served the politician as a makeshift writing desk. Its worn surface also provides an admirable space for the artist to display a dedication—*À Marat* (To Marat)—and his own signature.

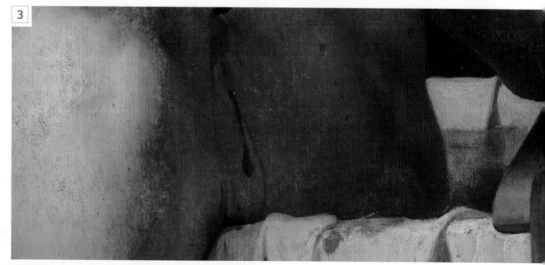

◀ **MURDER WEAPON** Corday's knife lies on the floor, as if the assassin has dropped it and fled. In fact, she made no attempt to escape, but waited to be arrested. According to some accounts, the knife remained lodged in Marat's chest, but David excluded any features that would undermine the sense of heroic martyrdom in his picture.

◀ **THE SHEET** David's painting displays a compelling mixture of truth and artifice. The artist had visited Marat in his bathroom and was well acquainted with the unpleasant details of his skin condition. He removed the disfiguring marks that the ailment had left on the victim's face, but recorded other elements with great precision. It is perfectly true, for example, that Marat draped a sheet over the surface of his bath, so that his sores would not chafe against its copper lining.

◀ **WRITING MATERIALS** One of the highlights of the painting is this superb still-life section. Each of the objects tells its own part of the story. Because of his skin condition, Marat was obliged to spend a considerable amount of time in his bathroom, so he used it as a part-time office. In the foreground, he has left a letter and some money for a war widow. Marat had presumably just completed the note, as the quill pen is still in his hand.

▲ **LETTER IN HAND** This is Corday's letter of introduction, smudged with blood in the corner. It reads, "my great unhappiness is sufficient reason to entitle me to your kindness." Once again, David is twisting the truth, to highlight the generous nature of his friend and the perfidy of the killer. In fact, Corday was granted access because she claimed to have information about royalist rebels.

ON **TECHNIQUE**

In common with those of most other Neoclassical artists, David's figures display a smooth, polished finish and a sculptural appearance that is reminiscent of antique statuary. It is no accident that one of the possible sources for Marat is a classical relief. David was also fond of using theatrical lighting effects to highlight the most significant elements in his pictures. So, while Marat's head, arms, and the crate are brilliantly lit, the gorier details are bathed in shadows.

IN **CONTEXT**

David embraced the Napoleonic cause with the same fervor that he had shown during the Revolutionary era. He was appointed Napoleon's *Premier Peintre* (First Painter) in 1804 and went on to produce a series of stunning canvases that glorified the new regime. Ironically, however, the portrait below was commissioned by a British patron, Lord Alexander Douglas.

▲ *The Emperor Napoleon in His Study at the Tuileries*, Jacques-Louis David, 1812, oil on canvas, 80¼ × 49¼in (203.9 × 125.1cm), National Gallery of Art, Washington, DC, US

1800–1900

The Valpinçon Bather

1808 ■ OIL ON CANVAS ■ 57½ × 38¼in (146 × 97cm) ■ LOUVRE, PARIS, FRANCE

SCALE

JEAN-AUGUSTE-DOMINIQUE INGRES

In this graceful nude, with its perfect balance of intimacy and grandeur, of detached contemplation and sensuous enchantment, Ingres has created what is surely one of the greatest back views in the history of art. The painting takes its name from a collector who owned it before it was acquired by the Louvre in 1879; originally, it was simply titled *Seated Woman*. Ingres painted it in Rome, where he was a prize-winning student at the French Academy from 1806 to 1810 (he won the highly prestigious Prix de Rome in 1801, but lack of funds during an unsettled time in France delayed his move to Italy). Prizewinners had to send several works back to Paris, so the authorities could make sure that they were making good use of state funding. This was one of the paintings Ingres chose to represent his progress.

Its reception (like that of other early works by Ingres) was cool. Some critics thought that figures such as this were lacking in a traditional sense of three-dimensional solidity, seeming rather boneless and vapid. Ingres, however, looked beyond conventional naturalism and was prepared to modify or exaggerate appearances for the sake of pictorial harmony. He was a superb draftsman and was easily capable of depicting human anatomy accurately when he wanted to. But he had a high-minded conception of art in which the imperfections of nature must be corrected to create an "ideal" beauty.

This outlook was influenced by his main teacher, Jacques-Louis David (see pp.132–35), who was the leading representative of Neoclassicism in painting, aiming to revive the spirit as well as the style of the classical world of the Greeks and Romans. Even more important than David, however, was the effect Rome had on Ingres. He was inspired not only by the remains of ancient art, but also by High Renaissance paintings and, above all, by the work of Raphael (see pp.54–57).

There is a common thread of clarity and balance in classical art and the paintings of Raphael and David. Ingres also loved these qualities, but in some respects he differed greatly from his exemplars. In particular, he was far less severe in outlook than his teacher David, placing a personal emphasis on suave beauty of line and exquisite surface polish. Thus in *The Valpinçon Bather* he is more

concerned with creating flowing contours from the woman's body than with suggesting its underlying bone structure. This is especially apparent in her right leg: it is drawn with superb grace, but when examined closely, it appears to have been grafted onto the draperies above it rather than convincingly connected to the body.

Ingres was a perfectionist who often subtly reworked his favorite themes and motifs. In *The Turkish Bath*, 1863, for example, one of the principal figures is clearly derived from *The Valpinçon Bather*, although she now plays a mandolin. *The Turkish Bath* is an acknowledged masterpiece, with an erotic charge that is remarkable coming from an artist in his eighties. But even Ingres could not improve on the timeless poise he achieved in *The Valpinçon Bather* more than half a century earlier.

> # Draw lines, young man, many lines, from memory or from nature

INGRES ADVICE TO THE YOUNG DEGAS, 1855

JEAN-AUGUSTE-DOMINIQUE **INGRES**

1780–1867

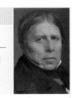

One of the giants of 19th-century French art, Ingres is celebrated for the purity and discipline of his style, but his work also has a deeply personal and sensuous side.

Ingres's long career was divided mainly between Paris and Italy, where he lived in 1806–24 and 1835–41. He began his first Italian period as a student at the French Academy in Rome, and he spent the second period as the Academy's Director. In the earlier part of his career, his work was sometimes controversial, as it was considered quirky by conservative critics. However, by the time of his much-honored old age, he was one of the most revered figures in French art. In addition to being one of the greatest portrayers of the female nude, he was renowned for his paintings on historical, mythological, and religious subjects and as a portraitist (he produced exquisite portrait drawings as well as paintings). Ingres left a large bequest of work (by himself and other artists) to his native city of Montauban, now housed in a museum named after him.

Visual tour

KEY

▶ **BACK** The broad area of the back creates a set of majestic abstract forms, but at the same time conveys the suppleness of living flesh. Ingres always stressed the primacy of drawing over color, but in fact he often created ravishing color effects, as in this glorious expanse of golden skin. When the painting was exhibited at the huge Exposition Universelle in Paris in 1855, the art critics Edmond and Jules de Goncourt compared Ingres with one of the supreme masters of flesh painting: "Rembrandt himself would have envied the amber color of this pale torso."

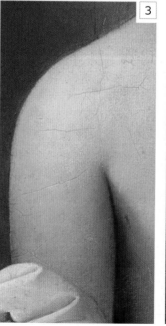

▲ **TURBAN AND FACE** The bather's face is only partially visible, so attention is drawn all the more to her striped headgear. Turbans had appeared in European paintings from the 15th century and in Ingres's day they often appeared in a vein of art called Orientalism. This term describes the fashion for imagery inspired by the Near and Middle East and North Africa. Napoleon's invasion of Egypt in 1798 was a catalyst for the fashion, which flourished in several European countries, particularly France. Some of Ingres's other nudes are more obviously in the Orientalist tradition, depicting odalisques (female slaves or concubines in a harem).

▶ **SHOULDER** The smooth, taut contour of the left shoulder epitomizes Ingres's idealistic approach to depicting the female body. All the angularities and irregularities found in real life, indicating the presence of bone and sinew beneath the skin, are replaced by a serene flawlessness.

> **ELBOW AND DRAPERY**
Elaborate folds of white drapery are swathed around the bather's left elbow. Ingres probably included the drapery here purely for pictorial reasons—to soften what would otherwise have been the pointed outline of the elbow, and to provide a contrast of color and texture with the bather's skin.

> **LION'S HEAD SPOUT**
The only obvious movement in the painting comes from the jet of water gushing from the ornate spout into the sunken pool. Although the setting of the painting is generalized, this small detail hints at some exotic society, distant in time or place.

▼ **CURTAINS** Ingres was a superb painter of draperies. Here, the curtains—with their dark color and deep folds—help emphasize the unruffled perfection of the bather's skin. There is a black marble column at the bottom of the curtains. Ingres has signed and dated the painting on its base.

▲ **FOOT AND SANDAL** Some contemporary critics said that the bather seemed boneless and had no ankles. Certainly, Ingres has conceived the forms of this part of the figure broadly, especially compared with the delicate pattern he makes from the sandal's laces.

◀ **LEGS AND DRAPERY** Ingres had an extraordinarily polished technique: one of his best-known comments on art is that a paint surface should be as smooth as "the skin of an onion." His fastidiousness is obvious in the impeccably crafted forms of this detail.

ON **COMPOSITION**

The Valpinçon Bather has a feeling of monumental dignity, stemming from Ingres's unerring sureness in placing each form. The firm verticals created by the draperies in the picture are subtly echoed in the curvaceous forms of the bather's body. Line takes precedence over color, but he shows great mastery in balancing the broad masses of flesh and fabric against one another.

IN **CONTEXT**

Among Ingres's contemporaries, the most famous sculptor was the Italian Antonio Canova. His *Venus Italica* has a clear kinship with *The Valpinçon Bather*—in the subtle turn of the head, the smoothly rounded forms, and the tension between coolness and eroticism.

▲ *Venus Italica*, Antonio Canova, c.1812, marble, Galleria Palatina, Florence, Italy

The Third of May 1808

1814 ▪ OIL ON CANVAS ▪ 105½ × 136½in (268 × 347cm) ▪ PRADO, MADRID, SPAIN

FRANCISCO DE GOYA

SCALE

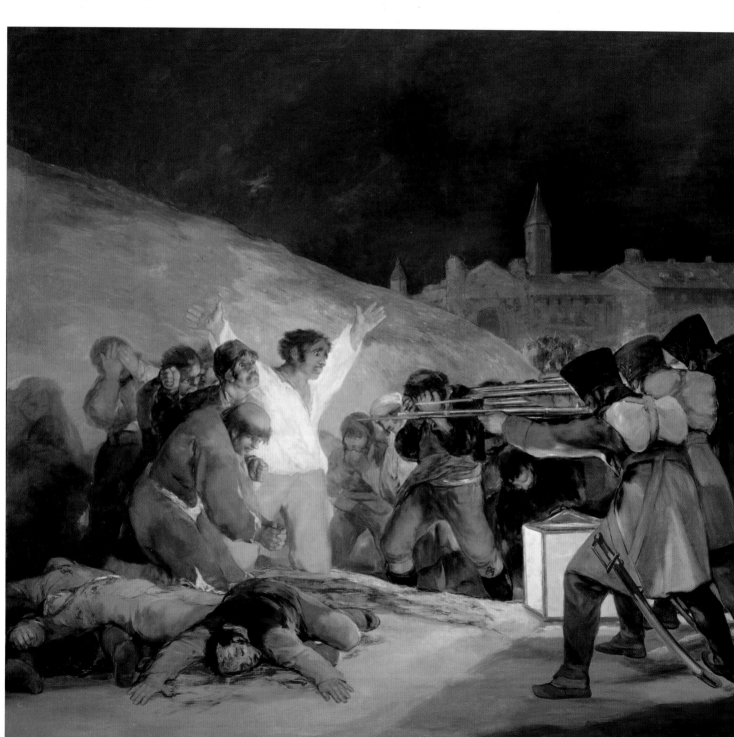

A defenseless man kneels in front of a firing squad, his brilliant white shirt reflecting the light of the single lantern on the ground. With arms thrown open in a powerful yet tragic gesture—the symbolic pose of the crucified Christ—he faces a solid wall of uniforms and guns. This is a scene of brutal execution on a bare hillside outside a city where ghostly, fortress-like buildings are silhouetted against the night sky. Dense blackness, without stars or moonlight, fills almost a third of the composition and intensifies the nightmarish quality of the scene.

Goya's compelling painting shows the cruel fate of a group of civilians who had risen up in rebellion against the occupying French army during the Peninsular War in Spain (1808–14). Following a day of violent insurrection on the streets of Madrid, the French soldiers rounded up rebels and innocent bystanders caught up in the conflict and shot them the following day—the date of the painting's title. Nationwide uprisings and guerilla warfare followed.

Brutality of war

In this painting, Goya not only created a lasting tribute to the bravery of the Spanish rebels, he also created a revolutionary image of the dehumanizing effect of war. Braced to carry out their task, the soldiers have their heads down, but the terror on the faces of those about to be slaughtered, and their helpless gestures, are depicted with heartbreaking eloquence. Unlike other contemporary painters, such as Jacques-Louis David (see p.132), Goya did not try to glorify war in this painting, or in its companion work, *The Second of May 1808*. This is a shocking image of an act of atrocity and a graphic condemnation of man's inhumanity to man.

The tight composition of Goya's painting increases the sense of doom. Ranged diagonally on the right, the soldiers form an impenetrable barrier.

Facing them, the heroic central figure and his ragged compatriots are on their knees, and a long file of the condemned men who are next in line straggle uphill. Goya's colors are muted and somber, there are pools of deep shadow, and fine detail is scarce. Your attention is focused on the man in the white shirt, and the awful inevitability of his next moment.

Goya painted *The Third of May 1808* six years after the actual event portrayed. He asked for a commission from the newly restored Spanish monarch, Ferdinand VII, to commemorate the insurrection against the French in two companion works. The commission was agreed and Goya made his two paintings, but this one, his masterpiece, was not appreciated at first and it was put in storage for 40 years. When it finally surfaced, the painting proved a source of inspiration to other artists. It remains to this day one of the most famous paintings of the atrocities of war.

> This is **the first great picture which can be called revolutionary in every sense of the word,** in style, in subject **and in intention**

KENNETH CLARK *LOOKING AT PICTURES*, 1960

FRANCISCO DE **GOYA**

1746–1828

The Spanish painter and printmaker Goya was one of the outstanding figures of the Romantic movement. He created portraits of the aristocracy as well as extraordinary etchings.

Born the son of a master gilder in Saragossa, Spain, Goya was apprenticed at 14. He later settled in Madrid, where he designed cartoons for royal tapestries and began to make a living as a portraitist, becoming painter to the court in 1789. Goya was inspired by the paintings of Velázquez (see p.98) but developed his own innovative style, bringing out the character of his royal and aristocratic sitters with an honesty that was not always flattering. In 1792, a severe illness left Goya permanently deaf. While a court painter, he created a series of disturbing satirical etchings called *Los Caprichos* (The Caprices) in 1799, including *The Sleep of Reason Produces Monsters*. His other great series of prints, *The Disasters of War*, published after his death, depicted atrocities on both sides during the French occupation. In his last years Goya painted his famous murals known as the *Black Paintings*. He died in France.

Visual tour

KEY

▼ **THE MARTYR** The focal point of the painting is the kneeling man about to be shot, holding his arms out in a pose reminiscent of Christ's crucifixion. There is even a wound similar to Christ's stigmata on his right hand. Brightly lit, his white shirt and pale trousers seem to emit light. Goya has made him larger than life for dramatic effect. If he were to stand up, he would tower above the French soldiers.

➤ **LANTERN** As the sky is pitch dark, the only source of light in the painting is the huge lantern on the ground in front of the soldiers. It illuminates the condemned men as if they were on a stage and marks a clear line of separation between the riflemen and their human targets.

▲ **MONK** Clasping his hands to make a final prayer, even a monk is at the mercy of the firing squad. He may have been included as an oblique reference to the Spanish Inquisition or to the tradition in Christian art of depicting martyrs. He draws attention to the brutal and random nature of such executions. No one is spared.

◀ **FIRING SQUAD** The French soldiers lined up in identical poses are so close together that they have merged into a group and lost all individual identity. Their faces are in shadow and are hidden from view by their hats. The repetition of shapes made by their hats, coats, holsters, and swords emphasize their machinelike brutality and their long rifles and bayonets, pointing at their targets, are cruelly highlighted in white.

▼ **TOWNSCAPE** A town and a church tower loom out against the black night sky. The executions took place near the French barracks outside Madrid, but none of the buildings in the painting can be identified with any certainty. Goya may have imagined them, to create a sinister backdrop.

5

ON **TECHNIQUE**

Rather than giving a straightforward, narrative depiction of the massacre, Goya used color and form to create an emotional response to his painting. In real life, the shooting took place during the day, but Goya set the scene at night and used a palette dominated by browns, blacks, and greys to create a nightmarish atmosphere. Whereas many of his contemporaries aimed for a polished effect in their paintings, lavishing attention on every detail, Goya painted loosely, using bold, dynamic brushstrokes and manipulating the paint with a palette knife or even his fingers, to create a more expressive style. Goya said, "I see no lines or details…There is no reason why my brush should see more than I do." His dramatic use of color and free handling of paint are clear in this detail of a man's face and the treatment of the white shirt to the right.

▶ **HUDDLED FIGURES** The condemned men cowering behind the central figure look terrified. They all have different expressions, emphasizing their individuality. Some cover their eyes, but one stares defiantly at his executors. The men's clothing is drab and they seem to be merging into the shadows.

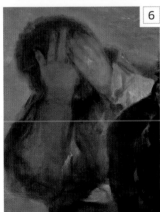

6

7

IN **CONTEXT**

Goya was commissioned to create two paintings to commemorate the heroism of the Spanish rebels. *The Second of May 1808* (below), the other painting of the two, shows a crowd in the Puerto del Sol area of Madrid attacking the Mamelukes, the Turkish cavalry in Napoleon's French Imperial Guard, who are charging. The news that the youngest members of the royal family were being taken to France had brought people out on to the streets and Goya's painting shows the scenes of bloody chaos that erupted. The following day the occupying army rounded up the rebels and executed them.

8

▲ **NEXT IN LINE** A shockingly long line of condemned men trudges up the hill to face the firing squad. Their despair is graphically conveyed in their faces and gestures.

◀ **CORPSE** Slumped in the foreground are two men who have just been shot, one naked. This corpse's arms echo the pose of the central figure in a harrowing reminder, if one were needed, that he too will soon be lying on the bloodstained earth.

▲ *The Second of May 1808*, Francisco de Goya, 1814, oil on canvas, 105½ × 136½in (268 × 347cm), Prado, Madrid, Spain

Wanderer Above the Sea of Fog

c.1818 ■ OIL ON CANVAS ■ 38½ × 29½in (98 × 75cm) ■ KUNSTHALLE, HAMBURG, GERMANY

SCALE

CASPAR DAVID FRIEDRICH

In this haunting painting, a lone figure stands on a pinnacle of rock, contemplating an awe-inspiring Alpine landscape. Nearby rocky peaks loom up out of the dissolving sea of mist, and a distant mountain rises majestically above the scene against a luminous sky.

The scene is based on sketches of mountains that Friedrich made while staying in Switzerland, but the dense fog obscures what lies between the mountains, creating a sense of mystery. Compositionally, the man is standing right in the middle of the painting, and the horizontal lines of rocks and distant mountain slopes all lead toward him. The striking contrast in tone between the dark silhouette of the man on the rock and the pallor of the fog and sky adds to the impact of the image.

The painting may have been a posthumous tribute to a colonel in the Saxon Infantry—the central figure stands upright and heroic as he contemplates the scene before him—but it can be interpreted in many ways: as a symbol of man's yearning for the unattainable or as an allegory of the journey through life. The work encapsulates Romantic ideas about man's place in the world—the isolation of the individual when faced with the sublime forces of nature. As such, it has become an iconic image of the Romantic individual.

CASPAR DAVID **FRIEDRICH**

1774–1840

A great 19th-century German Romantic artist, Friedrich painted intense landscapes of haunting beauty, which captured the power of nature and gave it a religious quality.

Born in Greifswald, on the Baltic coast of Pomerania, Friedrich had a strict Protestant upbringing. His mother and brother both died when young, which had a marked effect on him. After studying in Copenhagen, he settled in Dresden, where he learnt the latest ideas about Romantic literature and philosophy. Friedrich only took up oil painting in 1807, depicting striking landscapes imbued with strong spiritual or allegorical overtones. One of his paintings, *The Cross in the Mountains*, caused controversy because of the way in which Friedrich filled the landscapes with religious significance.

Visual tour

KEY

▶ **THE WANDERER** Friedrich's solitary figure has his back to us, giving him complete anonymity, and gazes down at the scene before him. From his stance, he appears calm and self-possessed, but it is left to us to imagine his expression or his attitude to the dramatic landscape before him.

1

▼ **SEA OF FOG** The fog conceals much of the landscape, stimulating the viewer's imagination, and blurs our view of the distant mountains, creating a sense of infinity. It also reflects the pearly light from the sky, which gives the painting an eery feeling of otherworldliness.

3

2

▲ **ROCKY PEAKS** The mountain tops break out of the fog like jagged rocks emerging from the sea. Because the fog obscures the lower-lying landscape, you have no sense of how near or far away the mountains really are. The tiny trees just visible on some of the peaks are the only thing to provide a true sense of scale.

The Hay Wain

1821 ■ OIL ON CANVAS ■ 51¼ × 73in (130.2 × 185.4cm) ■ NATIONAL GALLERY, LONDON, UK

SCALE

JOHN CONSTABLE

This atmospheric painting evokes the feeling of a summer's day in the English countryside. This is where the artist, John Constable, used to play as a boy. The landscape, with two figures in a cart (the "wain" of the title) crossing a shallow river, looks uncontroversial, but when the work was first exhibited in London in 1821, it represented a radical departure from convention in both subject matter and technique and was not taken seriously. Its reception in Paris some three years later, however, was entirely favorable: the painting won a gold medal and its unpretentious subject and loose brushwork were much admired by French artists.

For Constable, the natural world—especially the lush, fertile landscape of Suffolk—was an inspiration and affected him deeply. He sought to communicate his personal response to nature through his paintings, which were novel because they depicted the everyday English landscape on a grand scale. In terms of technique, Constable's expressive brushwork, with its network of dabs and flecks, was misunderstood and criticized for being overly loose. In *The Hay Wain* Constable was attempting to convey the movement, vitality, and reflected light he saw in this beautiful stretch of the River Stour, where he had spent his childhood. The sky, in particular, has a realistic sense of depth; its changing patterns are reflected on the surfaces of both fields and river, and the beautifully painted billowing clouds add rhythm and movement to the scene.

Constable worked slowly and his preparations for large landscapes such as *The Hay Wain* were painstaking. He filled books with sketches made outside in the Stour Valley to take back to his London studio. He then created a full-size oil sketch on canvas to help with the composition, which was an unusual way of working. The oil sketch for *The Hay Wain* is held in the Victoria and Albert Museum's collection in London.

JOHN **CONSTABLE**

1776-1837

One of the greatest painters of the English landscape, Constable brought a new freedom and inventiveness to the subject. Although underappreciated in Britain, his work influenced the leading French artists of the day and, through them, the Impressionists.

Constable grew up in Suffolk, England, and was passionate about painting the local landscape from an early age. Mainly self-taught, he did not attend the Royal Academy Schools in London until he was in his early twenties. Constable's early work was influenced by Gainsborough and 17th-century Dutch landscape artists, but he soon developed his own original style, using vigorous brushwork and highlights to capture the effects of light and weather. Critics considered his paintings unfinished and failed to understand his passion for painting the natural landscape at a time when classical subjects were fashionable. From 1821, Constable lived and worked in London, but spent much of his time painting in his home area in Suffolk, now known as "Constable country." He also painted Hampstead Heath and Salisbury Cathedral. He was finally elected a full member of the Royal Academy in 1829.

Truth immediately strikes the viewer…that delicious landscape…is the true mirror of nature

STENDHAL *SALON OF 1824*, 1824

Visual tour

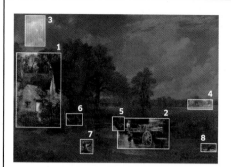

KEY

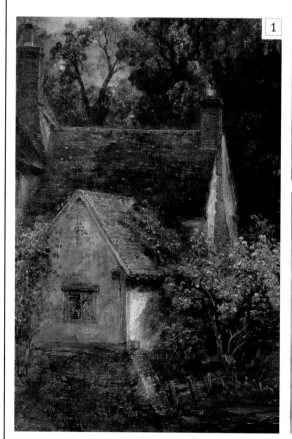

▲ **WILLY LOTT'S COTTAGE** The location of the painting can be identified by the cottage on the left. Constable's father rented it to tenant farmer Willy Lott. The smoke rising from the chimney is a charming detail suggesting the farmer's presence indoors. The cottage is still standing—in an area of Suffolk known as "Constable Country."

▶ **HAYMAKERS** Tiny specks of white, brown, and red paint in the distant field below the line of trees represent laborers harvesting the hay by hand with scythes. You can also make out another cart heavily loaded with freshly cut hay. Note, too, that Constable's depiction of light and shadow on the field suggests the changing pattern of the sky.

▲ **THE HAY WAIN** The focus of Constable's painting is a traditional wooden hay cart that appears to have seen many seasons of use. The two agricultural workers in the cart add human interest to the scene and suggest a way of life that is in tune with the rhythms of nature. The wain is crossing the river at a ford, probably to allow the horses to drink and perhaps to ensure the metal bands around the wooden wheels are fitting properly. Wood shrinks in dry, warm weather, so the metal rims may have become loose, but they could be tightened by immersion in water.

◀ **SUMMER SKY** Fine weather for the summer hay-making season can never be guaranteed in Britain. Constable's fast-moving clouds suggest typically changeable conditions in the big, open skies of this part of East Anglia.

▼ SPLASHES OF RED The collars on the horses stop their harnesses from chafing their shoulders and backs. Red, however, would have been an unusual color for working horses. Constable has used splashes of red here and in other areas of the painting to complement and intensify the lush green of the fields and foliage: the fisherman by the boat in the foreground has a red neckerchief; one of the reapers wears a red sash; and there is a tiny clump of poppies in the bottom left-hand corner of the painting.

5

◀ WOMAN WASHING A woman is kneeling on a landing stage that projects from the cottage. It is unclear whether she is washing clothes in the river or simply collecting water—a terracotta jug stands behind her. Her inclusion, like that of the other figures in this landscape, illustrates an aspect of domestic life in this working rural community.

6

◀ DOG Standing at the water's edge, the dog is an important element in the painting and directs our gaze toward its focus. One of the men in the cart gestures toward the animal, hinting at a narrative. The same dog reappears in other works by Constable.

7

▼ CONSTABLE'S SNOW Small flecks of white dotted throughout the painting, particularly on the water (below) and foliage, convey the impression of glittering, reflected light. Critics (and Constable) referred to this technique as his "snow."

8

ON **TECHNIQUE**

Constable made numerous small studies in pencil (see below), pen, chalk, watercolor, and oil paint. These sketches were done fairly quickly in the open air and in all weathers. He would fill small books with them to use as reference when creating his large paintings in his London studio. He once referred to these sketches as "hasty memorandums."

Constable's studies accurately capture the season, time of day, and even the wind direction. Sometimes he jotted quick notes on his sketches to help him with his final piece. In London, he would lie on his back on Hampstead Heath—which was near his studio—for long periods, sketching clouds as they moved into different formations.

▲ *Towpath near Flatford Mill*, John Constable, 1814, pencil drawing, 4½ × 3½in (11.3 × 8.6cm), Victoria and Albert Museum, London, UK

IN **CONTEXT**

The Hay Wain is one of a series of large paintings known as Constable's "six-footers." Frustrated by his pictures being dwarfed at the annual Royal Academy exhibitions—where paintings were hung frame-to-frame, floor-to-ceiling—and because he considered landscapes to be on a par with history paintings, Constable began to produce large-scale compositions. Not only were his paintings visible from a distance, but the scale of works such as *Hadleigh Castle*, 1829, and *Salisbury Cathedral from the Meadows*, 1831, helped to elevate the subject matter to the status of classical art.

The Fighting Temeraire

1839 ▪ OIL ON CANVAS ▪ 35¾ × 44¼in (90.7 × 112.6cm) ▪ NATIONAL GALLERY, LONDON, UK

J. M. W. TURNER

SCALE

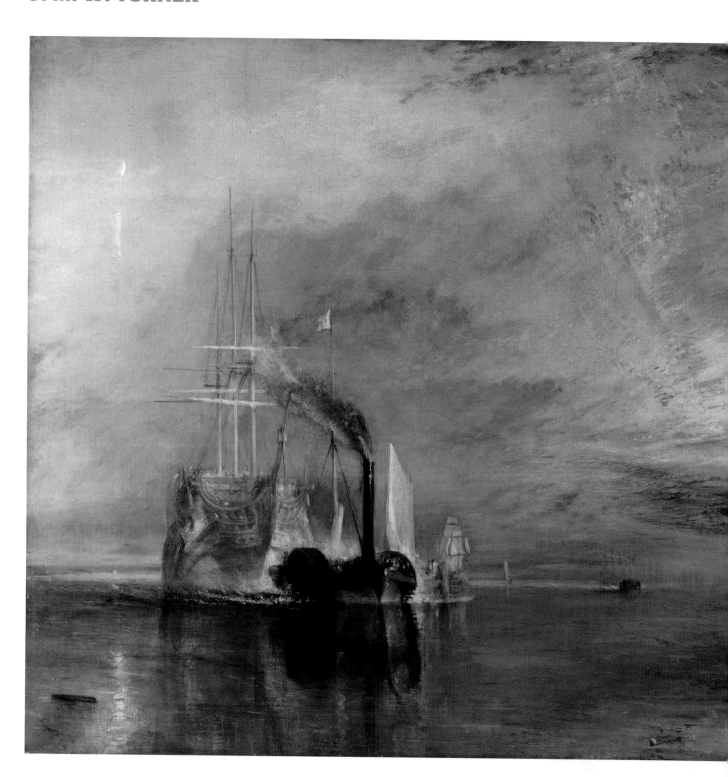

…slow, sad, and majestic, follows the brave old ship, with death, as it were, written on her

WILLIAM MAKEPIECE THACKERAY *BALLADS AND MISCELLANIES*, 1899

Like an apparition, the glimmering spectacle of a tall-masted gunship glides toward us on the still waters of the river Thames. *The Fighting Temeraire* immortalizes the ship on her final journey, which took place 33 years after the Battle of Trafalgar. The *Temeraire* had played a heroic role in the battle, coming to the aid of Lord Nelson's ship the *Victory* when it was locked in close combat. Despite her aura of magnificence, the ship is now in a poor state of repair. Stripped of anything salvageable, she is being towed from Sheerness to Rotherhithe shipyard where she will be broken up. A white flag flies from the tug, symbolizing the *Temeraire's* sad surrender to the breaker's yard.

A moving tribute

Although the Union Jack no longer flies from the mast, the *Temeraire*'s past bravery is acknowledged by Turner in this idealized, theatrical vision. Artistic license has allowed him to manipulate events and he shows the ship traveling east, with a glorious sunset behind her, whereas in real life she would have been traveling west, as Rotherhithe is west of Sheerness.

Many factors combine to make this work so memorable and moving: the sublime setting, the harmonious balance of the composition, the extraordinary quality of light, and the emotion inherent in the visual symbols. A metaphor for the journey of life, the demise of this aged sailing ship represents the end of an era; even the black buoy in the foreground seems to act as a full stop. Turner was in his sixties when he made the painting and perhaps the powerful sentiments echo his own feelings about the passage of time.

When the work was first exhibited, in 1839 at the Royal Academy in London, the nostalgia of the occasion was enhanced by the inclusion in the catalog of two lines from Thomas Campbell's emotionally charged poem *Ye Mariners of England*:

"The flag which braved the battle and the breezes, No longer owns her."

The critics of the day were united in their praise of a painting that not only celebrated a contemporary historical event but also successfully embraced the techniques of the old masters, particularly those of Claude, the 17th-century French landscape painter (c.1604–82), whom Turner admired. The artist refused to sell *The Fighting Temeraire*, calling it "my old darling", and the work was recently voted the most popular painting in Britain.

J. M. W. **TURNER**

1775–1851

The most original artist in the history of English landscape painting, Turner was fascinated by the effects of light.

A gifted and imaginative child, Joseph Mallord William Turner first exhibited a painting at the Royal Academy, London, when he was only 15 years old.

Turner traveled widely and produced a vast amount of work. His style varied considerably over the years, ranging from accurate, topographical watercolors in his early years to grand landscapes in the classical manner that he painted after visiting Italy. By 1805, increasingly influenced by Romanticism, his paintings became freer and more expressive as he sought to capture the power of nature in luminous landscapes depicting violent storms and blizzards. Turner's work was criticized for lack of formal composition, but it also attracted great admirers, notably the critic John Ruskin, who championed his work. When Turner died in 1851, he bequeathed much of his work to the British nation.

Visual tour

KEY

▼ **GHOSTLY SHIP** The 98-gun, three-decked *Temeraire* had been moored off the port of Sheerness for several years. Her three masts had been removed, together with all her rigging, and paint was peeling off her timbers. Turner, however, has chosen to present us with an elegant, romantic vision in white and gold, complete with masts—a more fitting farewell for a ship whose name means bold and fearless.

◄ **INDUSTRIAL TUG** On the day of her final voyage, another boat was following the *Temeraire*. Turner has chosen to exclude it, possibly to emphasize the contrast between the ugly, blackened, steam-powered tug and the majestic white sailing ship. The tug has been interpreted as a symbol of the evils of the British Industrial Revolution but Turner's other work does not support this. On the contrary, Turner embraced the steam-powered engineering of the future in his 1844 painting *Rain, Steam and Speed–The Great Western Railway*, a celebration of the age of the train.

▶ **SHIP IN FULL SAIL** On the horizon, just to the right of the tug, you can just make out the shape of another ghostly sailing ship. Turner may have included it to remind us how the *Temeraire* must have appeared in her full glory. However, this tall-masted ship has almost faded from view, so perhaps it serves to reinforce the theme of the painting: the end of the era of the sailing ship and the irrevocable transition to the age of steam power.

▶ **RISING MOON** A sliver of moon is visible in the sky at the top left of the painting. Its reflection lights up the water beneath, glinting on the rolled-up sails on the masts and on the foam churned up by the paddles of the tug. The silvery light reinforces the ethereal paleness of the ship and contrasts strongly with the fiery tones of the setting sun.

▼ **FLAMING SUNSET** The setting sun is symbolic, representing the passing of the age of sail as well as the demise of the *Temeraire*. The blood-red sky, reflected in the surface of the water, perhaps reminds us of the sacrifices made by the British navy at the Battle of Trafalgar. The *Temeraire* is positioned well to the left of the painting but its visual weight is perfectly balanced by the glowing sunset that dominates the whole right side of the composition. Notice how thickly the paint has been applied above and around the sun, using a technique called impasto.

5

6

◀ **HUMAN LIFE** In the blues and greys in the right-hand corner of the painting, you can just make out the silhouette of a vertical figure standing on a boat. The figure has probably been included to give an idea of scale and help to establish the sheer size of the *Temeraire*. The boats and buildings in the distance also add a human element to the painting.

ON **TECHNIQUE**

Turner's landscapes were influenced by the work of Claude, whose fascination with the qualities of light he shared. Turner painted the sun-drenched clouds in *The Fighting Temeraire* using a technique he learned from Claude. He applied very thin layers of semi-transparent white and yellow oil paint over the darker blue, orange, and red to give the clouds a translucent appearance.

Turner left his works to the British nation on the understanding that some of them be hung next to those of Claude. *Dido Building Carthage* and *Sun Rising Through Vapour* are displayed alongside Claude's *Seaport with the Embarkation of the Queen of Sheba* (below) and *Landscape with the Marriage of Isaac and Rebecca*.

▲ *Seaport with the Embarkation of the Queen of Sheba*, Claude, 1648, 59 × 77½in (149.7 × 196.7cm), National Gallery, London, UK

▲ *Dido Building Carthage*, J. M. W. Turner, 1815, 61¼ × 90½in (155.5 × 230cm), National Gallery, London, UK

IN **CONTEXT**

The *Temeraire* played a key part in one of the most famous sea battles in British naval history, the Battle of Trafalgar. On October 21, 1805, the British navy, led by Lord Nelson, was engaged in combat with a fleet of French and Spanish ships off the Cape of Trafalgar, south of Cadiz, Spain. Under the command of Captain Eliab Harvey, the *Temeraire* came to the rescue of Nelson's flagship, the *Victory*, and also captured two French ships. In four and a half hours, the British navy captured over half the enemy ships and one was destroyed. During the fighting, Lord Nelson was fatally wounded, but was informed that the battle had been won and the threat of invasion by Napoleon's forces averted.

The Artist's Studio

1854-55 ■ OIL ON CANVAS ■ 11¾ × 19¾ft (3.61 × 5.98m) ■ MUSÉE D'ORSAY, PARIS, FRANCE

GUSTAVE COURBET

SCALE

This enormous picture is probably the most elaborate piece of self-advertisement ever painted. Courbet shows himself at work in a cavernous studio, in the midst of a varied and enigmatic crowd of people. It is a dramatically arresting scene, painted with magnificent breadth and assurance, but while the individual figures are vividly

portrayed, collectively they make no obvious sense. Who are all these people and why have they gathered here? Courbet wrote a lengthy description of the painting, but his language is often unclear and open to varied interpretations. What is not in doubt is that this is one of the central masterpieces of 19th-century painting.

The picture was created for the great Exposition Universelle held in Paris in 1855. However, it was rejected by the selection committee, so Courbet—a man of immense self-confidence—staged his own one-man exhibition in a "Pavilion of Realism" he erected at his own expense alongside the official show. Courbet's exhibition was unsuccessful both commercially and critically, but nevertheless it has a momentous place in art history. By challenging the authority of the institutional art world, he led the way for others, including the Impressionists, to follow.

Although Courbet was avowedly a Realist, his paintings often have symbolic aspects, and he gave *The Artist's Studio* a rather baffling subtitle—*A real allegory summing up seven years of my artistic and moral life*. He wrote that the figures on the left represented "the world of commonplace life—the masses, wretchedness, poverty, wealth, the exploited, the exploiters, those who thrive on death." On the right are "my friends, fellow workers, and art lovers"—those who "thrive on life."

It's my way of seeing society with all its interests and passions; it's the whole world coming to me to be painted

GUSTAVE COURBET

GUSTAVE **COURBET**

1819-77

Courbet changed the course of French art by bringing a new grandeur and seriousness to scenes of everyday life, and by exhibiting his work outside the traditional venues.

Courbet was born in Ornans, eastern France, into a prosperous farming family. This background was important, for although he worked mainly in Paris, he often depicted earthy, rural subjects. He became famous in 1850 when he exhibited three remarkable paintings at the Paris Salon, most notably *The Burial at Ornans*, a huge and defiantly unidealized scene of country life. These works established him as the leader of the Realist movement, in which artists believed that everyday life could provide subject matter just as serious as the traditional major themes of history, religion, and mythology.

Courbet's radical views also came out in his politics. After France was overwhelmingly defeated in the Franco-Prussian War (1870-71), Paris was ruled for two months by a revolutionary government called the Commune, in which Courbet was head of the arts commission. When the Commune was crushed, he was imprisoned for six months. Fearing further punishment, he moved permanently to Switzerland in 1873. In addition to his ambitious figure compositions, he painted landscapes and portraits.

Visual tour

KEY

◀ **BAUDELAIRE** Seated among Courbet's friends is Charles Baudelaire, one of the leading French poets of the day and also a lively writer on art. He met Courbet in 1848 at the Brasserie Andler, a haunt of artists and intellectuals. It became so associated with Courbet's circle that it was nicknamed "The Temple of Realism."

▼ **ART LOVERS** The couple standing prominently on the right—exemplifying art lovers or collectors—are described by Courbet as "a woman of fashion, elegantly dressed, with her husband." They have not been certainly identified, although various suggestions have been made.

◀ **COURBET** At the center of the social panoply sits the heroic figure of Courbet, making a sweeping gesture of the brush. In reality, he would not have worked at his easel in this awkward, sideways-on position, but he was extremely vain (he painted numerous self-portraits) and adopted the posture to show off what he regarded as his particularly handsome profile. The nude model who stands behind him has been interpreted as an embodiment of truth, and the little boy who gazes admiringly at him has similarly been seen as an allusion to innocence: like Courbet, he views the world freshly, unburdened by artistic conventions.

◄ CHAMPFLEURY Jules Husson, who wrote under the pseudonym Champfleury, was a close friend of Courbet and the chief literary spokesman of Realism. Courbet's elaborate description of *The Artist's Studio* first appeared in a letter to Champfleury, written late in 1854 when the painting was far from finished.

▼ THE UNDERTAKER Various identifications have been proposed for this figure, who can more accurately be described as an undertaker's mute. Perhaps the most plausible suggestion is that it is a disguised portrait of the journalist Émile de Girardin, a key supporter of Emperor Napoleon III, to whose regime Courbet was opposed.

➤ THE POACHER The prominent seated figure with the hunting dogs has been convincingly identified as Emperor Napoleon III. The nephew of Napoleon Bonaparte, he was elected President of France in 1848 and assumed the title of Emperor in 1852. Open criticism of his dictatorial policies was impossible at the time because of censorship, but Courbet is perhaps suggesting that he has seized the French Republic for his own ends, just as a poacher bags game. Napoleon was deposed in 1870 after leading his country to a catastrophic defeat in the Franco-Prussian War, and ended his life in exile in England.

Olympia

1863 ▪ OIL ON CANVAS ▪ 51¼ × 74¾in (130.5 × 190cm) ▪ MUSÉE D'ORSAY, PARIS, FRANCE

EDOUARD MANET

SCALE

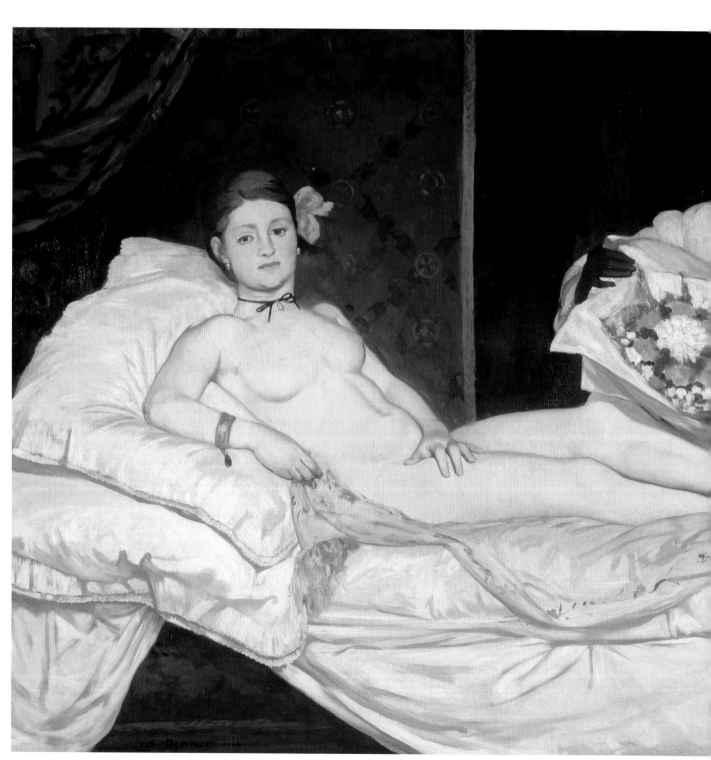

> It wasn't just the fact that…she's a lower class nude, but also…she was painted in…an almost childish or unskilled fashion

ANNE MCCAULEY *THE SHOCK OF THE NUDE*, 2010

Dating to the most controversial part of Manet's career, this provocative picture helped to establish him as a major force on the French art scene, introducing a new slant on traditional themes. There was nothing unusual about nudity itself—mildly erotic scenes of ancient nymphs and goddesses were a common sight in French exhibition halls. However, *Olympia* did not fall into this category. The model in the painting might be emulating the pose of Titian's *Venus of Urbino* (see p.163), but she was far less respectable. In the eyes of the critics, she was too modern, too ugly, too real and, as such, an affront to public morality.

The revolt against academic art

For much of the 19th century, standards in French art were rigidly controlled. Artists wishing to display their work at the Salon—the official public exhibition in Paris—had to submit their entries to a jury. By the 1860s, resentment was growing against this scrutiny. In 1863, permission was granted for a Salon des Refusés (Salon of Rejected Works). Manet's *Déjeuner sur l'herbe*, 1863, was the star of the show. The critics ridiculed it, but it brought the artist overnight fame.

Manet painted *Olympia* at roughly the same time but did not submit it until 1865. The picture was accepted but, as with *Déjeuner sur l'herbe*, reaction was hostile, largely due to Manet's subversion of the academic process. Both images were loosely based on famous Renaissance paintings. But Manet was also influenced by the Realist trends pioneered in the 1850s by Gustave Courbet (see pp.156–59). Courbet had argued that art could only represent "real and existing objects." So, Manet translated his Renaissance fantasies into modern idioms. For *Olympia*, he could not depict a naked, reclining goddess, so he transformed his nude into the nearest, present-day equivalent.

EDOUARD **MANET**

1832-83

One of the key figures of 19th-century art, Manet gained a scandalous reputation with his unique brand of Realism. His adventurous methods endeared him to the Impressionists, though he was never an official member of their group.

Manet came from a well-heeled, middle-class background, and trained under Thomas Couture, a successful academic artist. Couture made a careful study of the old masters and craved recognition at the Salon, the most prestigious exhibiting body in France. In spite of such conventional roots, Manet produced works that were controversial and original. In the early 1860s, he gained considerable notoriety when *Déjeuner sur l'herbe* and *Olympia* were pilloried as immoral spectacles. As the decade wore on, Manet became something of an elder statesman figure for the young Impressionist circle. He did not share their enthusiasm for painting in the open air, but his memorable scenes of modern Parisian life proved an inspiration for the movement.

Visual tour

KEY

▶ **TORSO** To modern audiences, it may seem surprising that the form of the model's torso came in for particularly hostile criticism. The art lovers of the time were used to seeing sculptural, well-rounded, and idealized figures. Olympia's body, on the other hand, was far too realistic for their tastes. In addition, a number of critics commented unfavorably on Olympia's coloring. One noted that her "flesh tones were grubby," while another described her as an "odalisque with a yellow stomach."

▲ **VICTORINE-LOUISE MEURENT** Manet used his favorite model, Victorine Meurent, to convey his vision of Olympia. She was no stranger to controversy, having already gained notoriety as the naked picnicker in Manet's breakthrough picture, *Déjeuner sur l'herbe*. Meurent was not a conventional beauty, but her spirited personality created the desired effect. Her self-assured gaze shocked the Parisian public, reinforcing the impression that Manet's subject was a hardened prostitute. Meurent herself was a painter, and several of her works were exhibited at the Salon.

▲ **BOUDOIR SLIPPERS** One of the silk shoes that the girl is wearing has slipped off her foot. Although apparently nothing more than a casual detail, the wearing of a single slipper was a conventional symbol of lost innocence. Accordingly, this tallied with the immoral interpretations of the model's nudity.

◀ **HAND OVER GENITALIA** In both standing and reclining versions of the female nude, this coy gesture is a standard feature of the *Venus pudica* (modest Venus). The pose was extremely common in classically inspired academic art, but its effect is jarring in Manet's picture, as the woman's candid stare is anything but modest.

▼ BOUQUET OF FLOWERS When portraying the female nude, artists often liked to heighten the erotic mood of their work by including other forms of sensual stimuli. Thus, the depiction of expensive fabrics and exotic flowers evoked the senses of touch and smell. For Manet's contemporaries, however, *Olympia's* bouquet of flowers struck a more unsavory note. Spectators interpreted it as a gift from an admirer or a prospective client.

ON **TECHNIQUE**

The Parisian public was chiefly outraged by the moral implications of Manet's work, but many critics were equally appalled by the artist's technique. Visitors to the Salon were accustomed to seeing a high degree of finish in their paintings. Flesh tones, in particular, were meant to display an enamel-like smoothness, even when viewed from very close quarters. Manet, however, paid relatively little attention to the finer subtleties of modeling and tonal gradation. Instead, he tended to flatten out his figures and their surrounding space. As a result, the critics often likened these to cartoons on playing cards. One pundit described *Olympia* as "the Queen of Spades stepping out of the bath."

Manet was also fond of structuring his compositions around powerful contrasts of light and shade—a trait he borrowed from Spanish art. The critics acknowledged his skill in this regard, but complained about the lack of detail in his somber backgrounds.

IN **CONTEXT**

The immediate source of inspiration for *Olympia* came from Titian's *Venus of Urbino*. Manet had made a sketch of this famous masterpiece during his visit to Florence in 1857. It is by no means certain that Titian meant to represent Venus—the figure is not accompanied by any of her traditional, mythological attributes—but the woman's coy smile does at least indicate a warm relationship with the viewer. This is entirely lacking in *Olympia*. There is no hint of recognition or affection in the model's expression. Instead, her gaze is cold and direct, as if she is staring at a total stranger.

▲ PULLED-BACK CURTAIN The moral impact of Titian's *Venus of Urbino* was mitigated by the fact that the nude was placed in a large, well-appointed chamber. In contrast, Olympia is compressed into an extremely shallow space. The dark curtains and the screen block off any background details, forcing you to focus squarely on the provocative, sexual connotations of the model and her rumpled bed.

◄ CAT Titian's nude was accompanied by a sleeping dog, a traditional symbol of marital fidelity. Black cats generally had more sinister overtones and the one in Manet's painting, with its arched back, seems decidedly unimpressed with the spectator—or "client"—scrutinizing its mistress.

▲ *Venus of Urbino*, Titian, 1538, oil on canvas, 46¾ × 65in (119 × 165cm), Uffizi, Florence, Italy

Arrangement in Grey and Black, No. 1

1871 ▪ OIL ON CANVAS ▪ 56¾ × 64in (144.3 × 162.5cm) ▪ MUSÉE D'ORSAY, PARIS, FRANCE

SCALE

JAMES McNEILL WHISTLER

Grave and pensive, the elderly woman sits in a rigidly formal pose, her hands clasping a white lace handkerchief. Her grey hair is flat and neat, her dark clothes are plain and puritanical. The feeling of austerity is underlined by the subdued color scheme and the strong horizontals and verticals of elements such as the picture frames, the long curtain, and the deep skirting board. Yet for all its severity, a sense of fragile but dignified humanity glows through the painting. Its full title is *Arrangement in Grey and Black No. 1: Portrait of the Artist's Mother*, but it is familiarly known as *Whistler's Mother* and has become enduringly popular as an archetypal image of a sober but sincere matriarch.

Art for art's sake

The artist's mother, Anna McNeill Whistler (1804-81), was widowed in 1849. She left America in 1863 to escape the Civil War and moved to London to live with her son. A few years after this, he began using musical terms—such as symphony, nocturne, or, as here, arrangement—in the titles of his paintings. This practice expressed his belief that painting was more concerned with formal qualities—lines, shapes, colors— than the ostensible subject. Other artists of the time shared this view, but Whistler was a particularly strong and influential spokesman for the "art for art's sake" doctrine because of his personal magnetism and his way with words. "As music is the poetry of sound, so is painting the poetry of sight, and the subject matter has nothing to do with the harmony of sound or of color," he wrote in 1878; and at the same time he commented on this work, "to me it is interesting as a picture of my mother; but what can or ought the public to care about the identity of the portrait?"

Arrangement in Grey and Black, No. 1 was first exhibited at the Royal Academy, London, in 1872. Initially the selection committee rejected it, but Sir William Boxall, the Director of the National Gallery,

London, and a friend of Whistler, used his influence to have it accepted. In general the portrait was poorly received, but it also had admirers, notably the great writer Thomas Carlyle, who thought it had "massive originality." Soon afterward, Whistler painted a portrait of Carlyle in a similar vein, *Arrangement in Grey and Black, No. 2* (1872-73). In 1891, it was bought by the City of Glasgow in Scotland, making it the first Whistler painting to be acquired by a public collection. This was a milestone in Whistler's fortunes, and later that year the portrait of his mother was bought by the French state, which had made him a knight of the Légion d'Honneur in 1889.

JAMES McNEILL **WHISTLER**

1834-1903

One of the most fascinating personalities of late 19th-century art, Whistler was flamboyant in his lifestyle, but subtle and deeply thoughtful in his approach to painting.

Whistler led a cosmopolitan life: an American by birth, he lived in Russia as a boy and spent most of his career in London and Paris (he also worked memorably in Venice). He became one of the best-known figures in London's artistic and literary circles, partly because of his talent, but also because of his wit, dandyism, and love of controversy. Many critics thought that his work, which was atmospheric and restrained, looked unfinished, and in 1877 he sued one of them, the famous John Ruskin, for accusing him of "flinging a pot of paint in the public's face." Whistler won the case, but the judge awarded him derisory damages and the legal costs led to his bankruptcy in 1879. He recovered, however, and his reputation was restored. By the end of his life, he was much honored. In addition to his paintings, mainly portraits and landscapes, he produced numerous prints—etchings (these are particularly admired) and lithographs.

Whistler, if you were not a genius, you would be the most ridiculous man in Paris

EDGAR DEGAS QUOTED BY GEORGE MOORE IN *REMINISCENCES OF THE IMPRESSIONIST PAINTERS*, 1906

Visual tour

KEY

◄ **CHAIR** This is the only inanimate object in the painting that deviates slightly from strict angularity. Whistler's favorite form of portrait was the full-length standing figure, and initially he is thought to have proposed a standing pose for his mother. However, her age and a recent illness made this uncomfortable for her, so he adopted the sitting pose. Quiet and reserved (the opposite of her son), she was a patient model.

▼ **HANDS AND HANDKERCHIEF** Apart from the head, the most detailed and visually forceful element in the painting is the area showing the hands clutching the handkerchief. Like other portraitists, Whistler often used "props"—such as a glove, a hat, or a fan— to make the sitter's hands look naturally occupied.

▲ **PROFILE** Whistler has shown his mother in pure profile. This form was much used by Renaissance artists and remained popular in specialist types of art such as coins and medals, but by this time it was rarely seen in conventional portrait painting. It sets the tone for the formal rigor of the picture. The white lace against the black dress recalls the work of Frans Hals, an artist whom Whistler admired.

▲ **ETCHING** This picture is one of Whistler's etchings, *Black Lion Wharf* (1859). It was published in 1871 as part of a series entitled *Sixteen Etchings of Scenes on the Thames*, which helped establish his reputation as a printmaker. Whistler lived near the Thames and the river was one of his favorite subjects.

5 ◀ **JAPANESE INFLUENCE**
The curtain is flecked with a floral pattern, recalling the Japanese screens Whistler admired. Japan isolated itself from other countries until 1853, but in the late 19th century it had a major impact on Western culture. Whistler collected Japanese art and included many references to it in his work.

6 ◀ **FOOTSTOOL** The footstool provides a note of domesticity that slightly softens the overall severity of the composition. X-rays of the painting show that Whistler originally made it higher. Changing it was one of several alterations he made as he worked on the picture: he tried out various positions for the arms and knees, and he originally placed the curtain and picture further to the right.

7 ◀ **TONAL CONTRASTS** Whistler was extraordinarily sensitive to tonal values in painting, and here he achieves a perfect balance of light and dark. He enjoyed creating such subtle, low-key effects, and his emphasis on the flatness of the picture surface, rather than three-dimensional depth, helped to create the conditions from which abstract art later emerged. Although discreet, Whistler's art was also radical.

ON **TECHNIQUE**

Whistler was a self-critical perfectionist and worked very slowly. He often left paintings incomplete (or even destroyed them) when they failed to meet his exacting standards. At other times, he scraped away the paint or rubbed it down on the canvas so that he could start again. Remarkably, his laborious process of creation does not show in his finished works, which display a flawless composure.

Whistler often applied paint very thinly but varied his handling a good deal, and the lightly brushed passages frequently coexist with richer, creamier touches. In the portrait of his mother, the face receives more detailed treatment than anything else. The lace head-covering and the handkerchief are painted with somewhat drier brushwork than the rest of the picture.

IN **CONTEXT**

This famous portrait of a girl in white against a white curtain helped to establish Whistler's name when it was shown at the Salon des Refusés in 1863. It depicts his mistress of the time, Joanna Hiffernan. Whistler originally called the portrait *The White Girl*, but a French journalist referred to it as a "*symphonie du blanc*", and Whistler later adopted the idea, adding the words to the title and using them for other works, too.

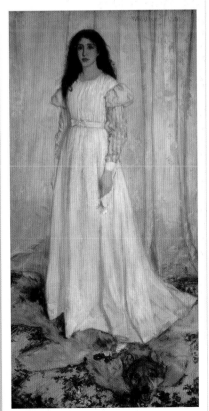

▲ *Symphony in White, No. 1: The White Girl*, Whistler, 1862, oil on canvas, 83¾ × 42½in (213 × 108cm), National Gallery of Art, Washington DC, US

The Dancing Class

1871–74 ■ OIL ON CANVAS ■ 33½ × 29½in (85 × 75cm) ■ MUSÉE D'ORSAY, PARIS, FRANCE

SCALE

EDGAR DEGAS

This beautiful painting is full of movement, color, and charming details. From a position in the left-hand corner of the room, just behind the piano, you see the ballerinas of the Paris Opera in rehearsal. This unusual viewpoint helps to create the illusion that you are standing next to Degas, sharing his privileged access to the ballet class. From the piano, you look along the line of dancers right to the back of the room and, like the artist, can observe each ballerina in turn.

Degas produced several paintings of the young ballerinas of the Paris Opera performing on stage, but he much preferred to depict them in the more relaxed setting of the rehearsal room, where he was a frequent visitor. He spent many hours observing and drawing the dancers as they practiced, and it is this sense of being present during the ballerinas' daily routine that gives *The Dancing Class* such an intimate quality. Although the painting appears relaxed and informal, Degas constantly refined and perfected his work once he was back in his studio. In its apparent spontaneity and realism, the painting resembles a snapshot—and Degas was familiar with the latest advances in photography—but its seemingly casual composition was meticulously arranged. X-rays of the painting indicate that some figures were moved from one position to another until Degas achieved the perfect degree of balance and the right atmosphere.

Respect for the classics

The Dancing Class is a contemporary scene that pays homage to the style of the old masters, whose techniques and draftsmanship Degas greatly admired. As a young man, he spent a great deal of time in the Louvre, studying and copying masterpieces by painters such as Velázquez. It was not until his late twenties, however, that Degas stopped depicting historical or mythological themes in his own work and turned his attention to painting scenes of 19th-century Parisian society, from horse racing to theater and ballet. In emulating the style of great classical works but applying it to less elevated subjects, such as young

girls practicing their dancing skills, Degas was breaking with convention and his work came under strong criticism from the French art establishment.

Degas was the one Impressionist who was successful from the beginning and, although he remained rather aloof from them, he did exhibit in group shows. Like the other Impressionists, he sought to convey a sense of movement and spontaneity in his work. In *The Dancing Class*, the girls appear to have been captured unawares and their gestures and expressions appear completely natural, an effect Degas achieves with his superb drawing skills and confident sense of composition. He also employs other devices to suggest movement, such as the bright red accents in the painting that lead from the girl's hair decoration and the fan in the foreground to the collar of the teacher, and then to the sashes of the two dancers towards the back of the room.

> Watching rehearsals, Degas had an opportunity of seeing bodies from all sides in the most varied attitudes

ERNST GOMBRICH *THE STORY OF ART*, 1950

EDGAR **DEGAS**

1834–1917

Degas was a superb draftsman whose work has a quality of freshness and immediacy. Although he exhibited with the Impressionists, he chose not to be closely associated with them.

Born in Paris into a wealthy, cultured family, Degas decided to become an artist at the age of 18 after studying law. He trained at the academic École des Beaux-Arts under Louis Lamothe, former pupil of French classical painter Ingres. His studies inspired him to visit Italy, where he lived for three years. In 1861, Degas met Edouard Manet (see p.161) who introduced him to the circle of artists later known as the Impressionists. Unlike most of the group, Degas had little interest in landscapes, and preferred to paint ballet dancers, women bathing, and racehorses, and to work in his studio rather than outdoors.

Degas was interested in photography and was a great admirer of Muybridge, the pioneer of "freeze-frame" images. From 1880, when his eyesight began to fail, Degas tended to work with pastels and also made wax sculptures. His most famous sculpture, *Little Dancer, aged 14*, was first shown at the 1881 Impressionist exhibition in Paris.

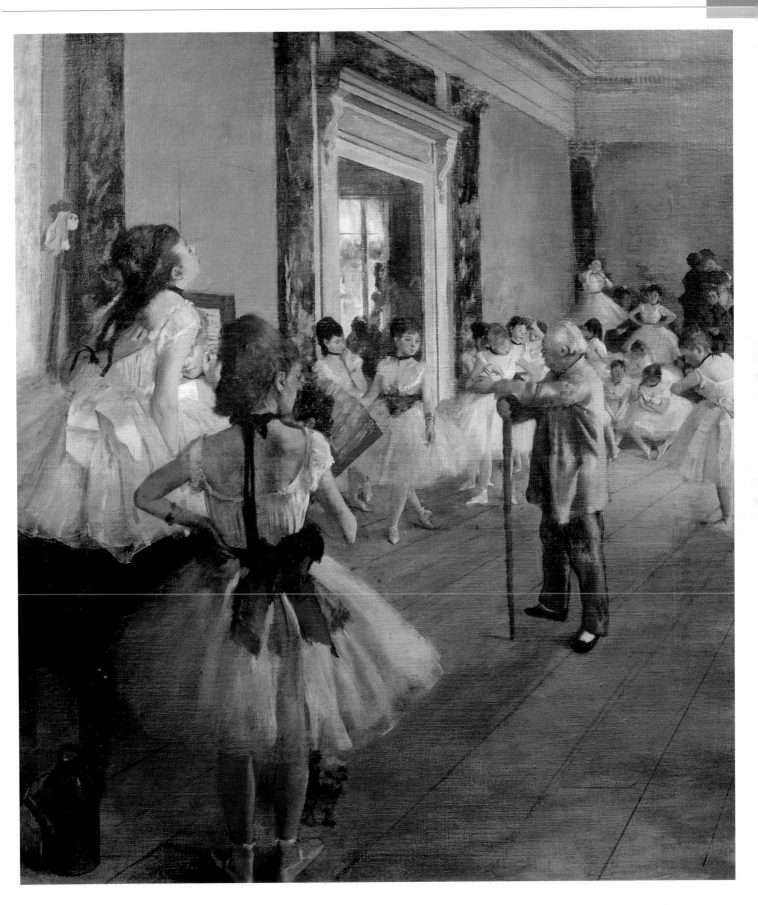

Visual tour

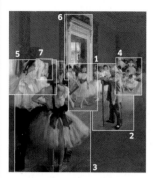

KEY

◄ **BALLET MASTER** As the class comes to an end, Jules Perrot, the ballet master, leans on his wooden stick. He is the principal character in the painting and the focus of the dancers' attention. He appears to be instructing the dancer in the doorway. Jules Perrot was himself a famous dancer and is wearing ballet slippers.

▲ **FRAMED FIGURE** Although most of the girls in the painting are relaxing, the dancer framed by the doorway in the center of the painting is being put through her paces by the ballet master. With an expression of concentration on her face, she adopts a classic ballet position.

► **BACK VIEW** The dancer in the foreground with her back to us enhances the informality of the scene. X-rays of the painting show that she was originally the other way round, looking out of the painting, but Degas changed her position, reinforcing the impression that we are actually in the room with him and the dancers are oblivious to our presence.

5

▶ **CROPPED EDGES** We can see the influence of photography in this painting, particularly in Degas' use of cropping–cutting off details at the margins. Part of the tutu of the girl sitting on the piano lies outside the frame. This helps to create an air of spontaneity, as if the image has been snapped rather than carefully composed. The right-hand side of the painting is similarly cropped.

4

6

◀ **DOORWAY** The view through the door frame draws our gaze beyond the rehearsal space to the next room. A double bass lies next to the doorway, so perhaps there is music playing. The window in the adjoining room is an important source of light in the composition and makes you aware of the world outside.

7

◀ **CHARMING DETAILS** Small areas of activity add to the informality and charm of the painting and bring the whole scene to life. Behind the girl sitting on the piano is a dancer playing with her pearl earring. This intimate detail possibly indicates that her attention has wandered.

◀ **TAKING A BREAK** These ballerinas appear to be relaxing before they perform in front of the ballet master. The three seated girls form a triangle, and this shape is repeated by the ballerina standing just above them with with her hands on her hips This ballerina's pose echoes that of the dancer with the green sash in the foreground.

ON **COMPOSITION**

The perspective diagram below shows how Degas carefully composed the painting around a set of converging lines that meet outside the picture frame. This creates the impression that we are looking into a three-dimensional space. The artist uses the strong diagonals of the floorboards and the line of the cornice and door frame to draw your eye right into the picture. The tops of the ballerinas' heads are aligned in the same way.

IN **CONTEXT**

Degas often used the same figures in different paintings. The central ballerina in *The Dancing Class*, the girl in front of the doorway, also appears in *Ballet Rehearsal on Stage*, a painting he made a year later, in 1874. The sketch below is the original study for the dancer and you can see the grid lines that Degas drew to help him establish the proportions for the drawing. The head takes up one-sixth of the total figure.

▲ *A Ballet Dancer in Position Facing Three-Quarters Front*, Edgar Degas, 1872-73, graphite and chalk on pink paper, 16 × 11in (41 × 27.6cm), Harvard Art Museums Collection, Massachusetts, US

A Sunday on La Grande Jatte

1884-86 ▪ OIL ON CANVAS ▪ 81¾ × 121¼in (207.5 × 308.1cm) ▪ ART INSTITUTE OF CHICAGO, CHICAGO, US

GEORGES-PIERRE SEURAT

SCALE

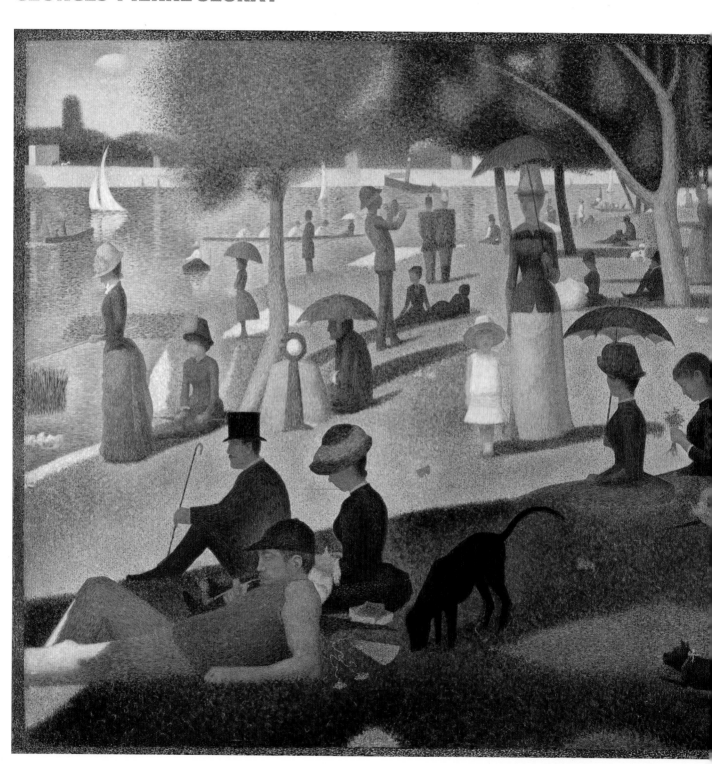

In his mature paintings Seurat deploys his pointillist method, achieving…unparalleled sensations of color and luminosity

JODI HAUPTMAN *GEORGES SEURAT: THE DRAWINGS*, 2008

Seurat's luminous masterpiece portrays fashionable Parisians enjoying a Sunday afternoon at a popular beauty spot on the River Seine, but it shows far more than a sunny day's outing. The figures and their island setting are a vehicle for Seurat's innovative experimentation with color, subject matter, and composition.

Birth of a new style

La Grande Jatte created a sensation when it was first shown in May 1886 at the final Impressionist exhibition. It marked the beginning of Postimpressionism: rather than painting intuitively, like the Impressionists, Seurat demonstrated a more systematic and scientific approach to composition and the application of color. Influenced by recent theories on color, he perfected a technique known as divisionism or pointillism over the two years that it took him to produce the painting. This involved placing small dots of pure color next to each other on the canvas, so that they would merge in the mind's eye and create a more vibrant effect than when mixed together on the palette or canvas. The impression of shimmering that this technique creates across the painting brilliantly suggests the effect of warm, hazy sunshine.

Meticulously planned and executed, *La Grande Jatte* has a timeless, monumental quality. Although it depicts a busy scene, most of the figures are stylized and statuesque, and their faces, when visible, are blank and inscrutable. Arranged in static groups across the canvas, they seem frozen in time, forever enjoying their Sunday afternoon.

GEORGES **SEURAT**

1859-91

A brilliant 19th-century French painter and draftsman, Seurat is remembered mainly for his monumental and highly influential pointillist paintings, in which he used myriad dots of pure color to achieve vibrant color effects.

Born in Paris, Seurat enrolled at the École des Beaux-Arts in 1878, but left after a year to do compulsory military service. He returned to Paris in 1880 and concentrated on drawing for two years, producing mysterious, velvety drawings using conté crayon on textured paper. He then started painting, experimenting with styles inspired by Delacroix and the Impressionists. After reading various scientific and aesthetic books that discussed the role of color in art, Seurat tried to formalize their theories in his paintings. His first major project, *Bathers at Asnières*, 1884, was rejected by the Salon but was exhibited at the Salon des Indépendants, an alternative show that Seurat helped to set up, and where he met fellow painters Paul Signac and Henri-Edmond Cross. They helped to develop Seurat's pointillism and Seurat continued to work on the style, becoming interested in how the direction of lines has an emotional effect on the viewer, a theme that he tried to embody in *Le Chahut*, 1890, and *The Circus*, 1890–91. Tragically, Seurat died suddenly of meningitis at the age of 31, having produced only a handful of major paintings.

Visual tour

KEY

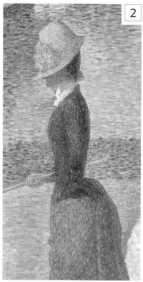

◀ ◀ **STATUESQUE FIGURES** Seurat's training involved drawing casts of classical sculptures and, perhaps reflecting this, his figures look strangely still, like statues. They are simplified and stylized, and the distinctive shapes of some of them, such as the women with bustles (see left), or the seated women in hats, are repeated across the painting, giving the composition a sense of repetition and rhythm.

▼ **WOMAN AND CHILD** Almost in the center of the composition, a fashionably dressed woman and a child are coming straight towards us, unlike most of the other figures in the painting, who are seen in profile. The white dress of the child and and pink dress of the woman stand out sharply against the green grass. The couple provide a sense of movement in a scene that is otherwise static, apart from the girl skipping behind them, the rowers on the river, and the animals in the foreground.

▼ **DOTS OF COLOR** If you look closely at the painting, you can see that each color is made up of small dots of contrasting colors, creating a sparkling effect. The bright green of the sunlit grass is flecked with dots of yellow and orange, whilest the shadowy areas are interwoven with blue and pink. The dots change slightly toward the edge of each block of color, such as where the shadows border the sunlit grass.

◄ **PAINTED BORDER** Instead of framing *La Grande Jatte*, Seurat painted a border around it. The dots of color in the border are the complementaries of the colors next to them in the painting: red against green, orange next to blue, purple against yellow, for example.

◄ **MONKEY** Capuchin monkeys were fashionable pets at the time. The French word for a female monkey, *singesse*, was slang for a prostitute, so the monkey's well-dressed owner may in fact be a prostitute with her client. The monkey provides a touch of humor as it shrinks away from the dogs.

▼ **SIMPLIFIED FORM** This seated figure has been simplified into a series of geometric shapes. The orange headscarf, however, identifies her as a wet nurse.

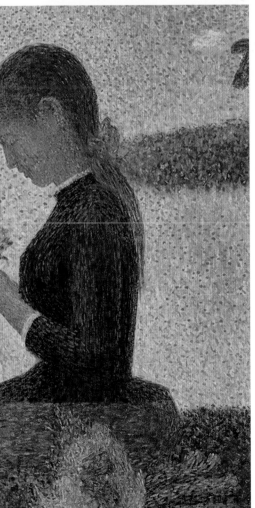

▲ **FRENCH FLAG** In the background of the painting, through the trees, you can see a boat flying the French flag from its stern—a reminder that Seurat was a patriotic Frenchman. A similar detail is found in Seurat's *Bathers at Asnières* (see right).

ON **TECHNIQUE**

The sheer size of Seurat's painting made it impossible for him to work on it outdoors, as the Impressionists did with their paintings. Seurat made at least 60 drawings and oil sketches of the scene at La Grande Jatte over a number of months, then used them to map out his painting back in the studio, refining the figures and rearranging them in a number of small studies and a large compositional sketch of the whole work. The final picture was meticulously planned, including which colors to use where. Seurat started the painting by covering the canvas with a background layer, then returned to each area to work on it in detail. Rather than being a naturalistic depiction of the scene, the finished painting demonstrates Seurat's interest in color harmonies and their effect on the viewer.

▲ Oil sketch for *La Grande Jatte*, Seurat, 1884, oil on panel, 6 × 9½in (15.5 × 24.3cm), Art Institute of Chicago, Chicago, US

IN **CONTEXT**

La Grande Jatte has an earlier companion piece entitled *Bathers at Asnières*. Both paintings show Parisians relaxing by the Seine, but on nearby stretches of the river. *Bathers at Asnières* was Seurat's first large-scale painting, made before he developed his pointillist technique, but small areas of colored dots can be seen in the water and around the red hat of the boy in the river. This painting shows only men and boys, perhaps on their lunch break from the factories visible in the background. They do not appear in *La Grande Jatte*, which shows more middle-class figures. Seurat's compositional balance and his majestic sense of form have been attributed to the influence of Piero della Francesca (see pp.30–33).

▲ *Bathers at Asnières*, Seurat, 1884, oil on canvas, 79¼ × 118in (201 × 300cm), National Gallery, London, UK

Van Gogh's Chair

1888 ■ OIL ON CANVAS ■ 36 × 28¾in (91.8 × 73cm) ■ NATIONAL GALLERY, LONDON, UK

SCALE

VINCENT VAN GOGH

Looks can be deceptive. At first glance, van Gogh's painting of a simple rustic chair appears to be a straightforward still life—the kind of picture that might have been created in a calm atmosphere, with no emotional or symbolic overtones. In reality, it was painted just a few weeks before van Gogh's breakdown, at a time when his friendship with Paul Gauguin (see pp.182–85) was disintegrating.

When van Gogh moved to Arles, in the south of France, in February 1888 he hoped that it might become the center of an artists' colony. Gauguin's arrival that year seemed a promising start. Van Gogh was delighted. He bought furniture for the house and started painting in a frenzy, to show the Frenchman how far his art had progressed. Unfortunately, it was not long before the dream turned sour. Gauguin had come mainly for practical reasons, as van Gogh's brother was helping him financially, and he rapidly regretted his decision. He disliked the town, feeling "very much a stranger in Arles," and soon quarreled with his host: "Vincent and I generally agree on very little, above all when it comes to painting...."

Van Gogh painted two pictures of chairs—his own and Gauguin's—in early December 1888, when it seemed likely that his visitor would leave. It is possible that he thought they might persuade Gauguin to stay, but more probable that they were a sad acknowledgment of the two men's irreconcilable differences.

A coded portrait

Van Gogh may well have borrowed the idea of using an empty chair as a form of symbolic portrait from a well-known illustration by the British artist Luke Fildes, showing the chair in which Charles Dickens died. The objects on Van Gogh's chairs were definitely designed to identify the sitters. It is also likely that van Gogh had intended the pictures to be a vindication of his art. Gauguin had encouraged him to paint from imagination, rather than from nature. Van Gogh had tried, but found the results unsatisfactory. So, while Gauguin's chair was depicted in dark, artificial conditions, his own was plain and simple, but fulfilled all his needs. As such, it echoed his artistic philosophy: "I cannot work without a model... I exaggerate, sometimes I make changes, but I do not invent the whole picture...I find it all ready in nature."

VINCENT **VAN GOGH**

1853–90

Neglected during his lifetime, van Gogh has since become celebrated as one of the world's most popular painters and a major influence on modern art.

Vincent van Gogh was born in the Netherlands, but spent much of his brief career in France. He worked as a clerk, a teacher, and a lay preacher, before devoting himself to art in 1880. His early work was dark and naturalistic, but his style was transformed after he moved to Paris in 1886. There, he came into contact with the Impressionists and other progressive artists. His palette lightened and he absorbed the influence of Japanese prints. In 1888, van Gogh moved to Arles, his "Japan of the South." Most of his greatest masterpieces date from this final period, when he worked at a furious pace, completing hundreds of canvases. The strain, coupled with a disastrous visit from Gauguin, triggered a breakdown. Van Gogh made a partial recovery, but committed suicide the following year.

> I cannot help that **my pictures do not sell.** Nevertheless the **time will come** when people will see that **they are worth more** than the **price of the paints and my own living**

VAN GOGH LETTER, 1888

Visual tour

> **OBJECTS ON CHAIR** Van Gogh chose very carefully when deciding which objects to include in his chair pictures. They were intended to have a symbolic meaning, referring not only to the person who used the chair but also to the person's artistic approach. In Gauguin's case, the books signified that his work stemmed from the intellect and imagination. On his own chair, by contrast, Van Gogh placed his pipe and a pouch of tobacco. Through these, he meant to show that he required nothing more for his painting than the everyday objects that surrounded him.

KEY

△ **HUMBLE CHAIR** As soon as he found out that Gauguin was coming to Arles, van Gogh made special efforts to provide a welcoming atmosphere in the house. Among other things, he bought a set of plain rush chairs. These reflected the image that van Gogh was trying to project to his guest—one of honest, rustic simplicity. In his letters to Gauguin, he was self-deprecating about his own work, saying, "I always think my artistic conceptions extremely ordinary when compared to yours."

△ **SIGNATURE** Van Gogh did not always sign his pictures, but when he did, he modestly tried to make his signature as unobtrusive as possible. In this instance, it is not in the conventional position at the bottom of the canvas. Instead, the plain lettering blends into the background, resembling a firm's name stenciled onto a box.

◁ **SPROUTING ONION** Some still-life artists might have discarded this detail, preferring to concentrate on pristine items, but van Gogh enjoyed depicting natural objects at every stage of their development. In his famous sunflower pictures, he placed wilted flowers alongside the fresh blooms. The emphasis on organic growth may also have been a symbolic rejection of Gauguin's advice to paint from his imagination.

▲ **BRUSHSTROKES** One of the reasons why van Gogh's pictures seemed so shocking to his contemporaries was because he made no attempt to conceal his brushstrokes. In academic art, paintings were expected to have a smooth finish, with no visible brushwork. However, van Gogh used so much paint that this was impossible. Often he squeezed the paint directly from the tube onto the canvas, before modeling it with his brush. In his late paintings, such as *The Starry Night*, the sweeping, rhythmic brushstrokes form an essential part of the composition.

◀ **JAPANESE FLOOR** Van Gogh discovered Japanese prints during his time in Paris and they had a huge influence on his art. He liked their bright colors, their bold outlines, and their sheer immediacy. Among other things, Japanese artists disregarded the strict rules of perspective, to bring the viewer closer to the subject. Van Gogh followed suit. Here, he adopts a high viewpoint, but exaggerates the perspective of the tiled floor. This has a dizzying effect, as if the entire composition were sliding toward the viewer.

◀ **THICK IMPASTO** Van Gogh was always fond of applying his paint very thickly, a practice that he followed even more enthusiastically in his final years. This gives his paintings an extraordinary texture, which can only be fully appreciated when the picture is viewed in person. However, this was the source of many arguments with Gauguin, who wrote, "in the matter of color, he wants the chance element of thickly applied paint...and I for my part hate mixing techniques."

ON **TECHNIQUE**

During his stay at Arles, van Gogh perfected his unique technique. He used firm, dark contours to outline his forms clearly, drawing his inspiration from Japanese prints. The forms themselves, together with their coloring, were often exaggerated, but they were always rooted in nature. As Vincent explained, "I won't say that I don't turn my back on nature ruthlessly... arranging the colors, enlarging and simplifying, but in the matter of form I am too afraid of departing from the possible and the true."

IN **CONTEXT**

By early December 1888, van Gogh was well aware of the gulf between himself and Gauguin. Everything in his painting of Gauguin's chair is the antithesis of the other painting. This is a nocturnal scene, whereas van Gogh's chair is shown in daylight. Gauguin's seat is more sophisticated: it stands on a patterned carpet, rather than bare tiles. Van Gogh also acknowledged that Gauguin's approach to painting was more intellectual: his attributes are books, rather than tobacco.

▲ *Gauguin's Chair*, Vincent van Gogh, 1888, oil on canvas, 35½ × 28½in (90.5 × 72.5cm), Van Gogh Museum, Amsterdam, Netherlands

The Child's Bath

1893 ▪ OIL ON CANVAS ▪ 39½ × 26in (100.3 × 66.1cm) ▪ THE ART INSTITUTE OF CHICAGO, US

SCALE

MARY CASSATT

Cassatt was at the peak of her powers when she produced this touching domestic scene. She had absorbed the influence of the Impressionists, sharing their enthusiasm for scenes of modern city life, but had also developed her own, unique slant on the subject. First and foremost, she presented the theme from a female perspective. Cassatt is best known for her paintings of mothers and children, but her repertoire extended far beyond this, and she also produced images of women going boating, having dress fittings, traveling on the bus, and driving a carriage in the Bois de Boulogne.

Influence of Japanese prints

Cassatt's style was equally distinctive. One of her key influences came from Japanese prints, which she had seen at an exhibition in Paris in May 1890. This influence is evident in the striking composition of *The Child's Bath*.

The unusual viewpoint, the strong emphasis on decorative patterns, and the narrow focus on the two main figures all confirm the importance of this source of inspiration.

MARY **CASSATT**

1844-1926

Mary Cassatt was one of the leading figures in the Impressionist movement. She is renowned for her sensitive images of mothers and children, and for her pioneering printmaking techniques.

Cassatt was born in Allegheny, now part of Pittsburgh, US. Her family traveled widely, and although she trained at the Pennsylvania Academy, Philadelphia, her style was formed in France, where she spent most of her career. Cassatt settled in Paris in 1874, the year of the first Impressionist exhibition. A chance meeting with Degas brought her into the Impressionists' circle, and she later contributed to four of their group shows. Degas inspired her taste for striking, asymmetrical compositions and awakened her keen interest in printmaking. Her finest achievement in this field was a groundbreaking series of color prints in a mix of aquatint and drypoint.

Visual tour

KEY

▶ **PROTECTIVE ARM** Several of Cassatt's pictures focused on the tender bond between mother and child. These show her skill in depicting affectionate gestures, and conjuring up an air of quiet, domestic harmony. Although Cassatt had no children herself, she came from a close-knit family and observed her nephews and nieces growing up.

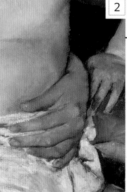

▶ **HEADS** Cassatt's fascination with Japanese prints was at its peak during the early 1890s, which may account for the unusual structure of the composition in this painting. The high viewpoint, looking down upon the figures, is typical of Japanese prints, as is the artist's close proximity to the action, cropping the woman's dress at the picture's edge. The little girl even seems to have slightly Asian features.

▲ **CHILD'S FEET** Like her friend and mentor Edgar Degas, Cassatt was keen to avoid the clichéd poses that were taught in the academies. Instead, she preferred to depict her models in poses that were unusual and yet also entirely natural.

◀ **WATER JUG** Japanese printmakers were more interested in decorative impact than precise perspective. Cassatt followed this style: the jug is prominent, but its lack of foreshortening does not tally with the steep slant of the carpet.

Where Do We Come From? What Are We? Where Are We Going?

1897-98 ▪ OIL ON CANVAS ▪ 54¾in × 147½in (139.1 × 374.6cm) ▪ MUSEUM OF FINE ARTS, BOSTON, US

SCALE

PAUL GAUGUIN

A huge frieze glowing with exotic color, this is perhaps Gauguin's most ambitious painting. The setting is Tahiti, where the artist spent most of the last decade of his life. The solid, sensuous bodies, the sinuous shapes of the trees, and the intense color evoke the tropical paradise, partly real and partly imagined, that inspired him. Like many other of Gauguin's paintings, this one tells a story. Reading from right to left, the figures in the fore- and middle ground depict the cycle of life, reflecting the questions Gauguin poses in the title of the painting. The cycle starts on the right with a sleeping baby, and ends on the far left with an old woman and a bird.

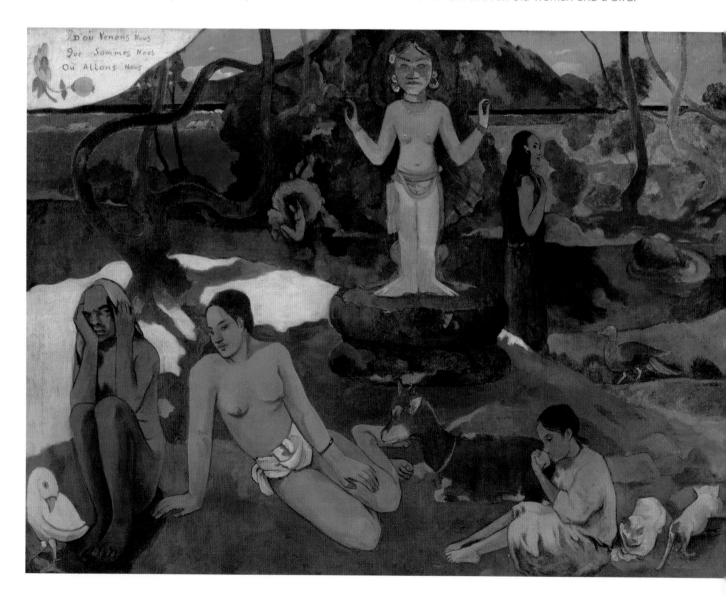

Where Do We Come From? shows Gauguin's characteristic use of areas of saturated color and bold figures with strong outlines to create a flat, almost abstract composition with a strong sense of pattern, influenced in part by Japanese prints. Gauguin employs color in a non-naturalistic manner, juxtaposing the lush blue-greens of the luxuriant flora with the vibrant yellow-gold of the half-naked bodies to create a powerful impact. Color not only had a sensual and decorative function for him, but was also used to suggest ideas and express emotions.

Gauguin considered this painting, rich in symbolism and mythological references, the culmination of his work. It demonstrates the radical use of color and form that made him so influential, paving the way for the Expressionists and abstract art.

PAUL **GAUGUIN**

1848–1903

Reacting against Impressionism and attracted by non-Western art, Gauguin created his own style, using pure color as a form of expression. His life was as unconventional as his paintings.

Born in Paris, Gauguin spent part of his childhood in Peru (his mother was half-Peruvian). He became a successful stockbroker and painted in his spare time. An admirer of the Impressionists, he bought their paintings, and exhibited in their shows. By 1883, he was painting full time but was unable to make a living. Estranged from his wife and five children, he settled in Pont-Aven, Brittany, where he created *Vision of the Sermon*, a work with areas of pure, intense color that marks his abandonment of the Impressionist style.

After trips to Panama and Martinique, Gauguin returned to France, visiting Van Gogh in Arles, where the two famously argued. A troubled and driven man, he set off in 1891 for the French colony of Tahiti. Despite living in poverty and being infected with syphilis, this was one of the most creative periods of his unconventional life. He died in the Marquesas Islands.

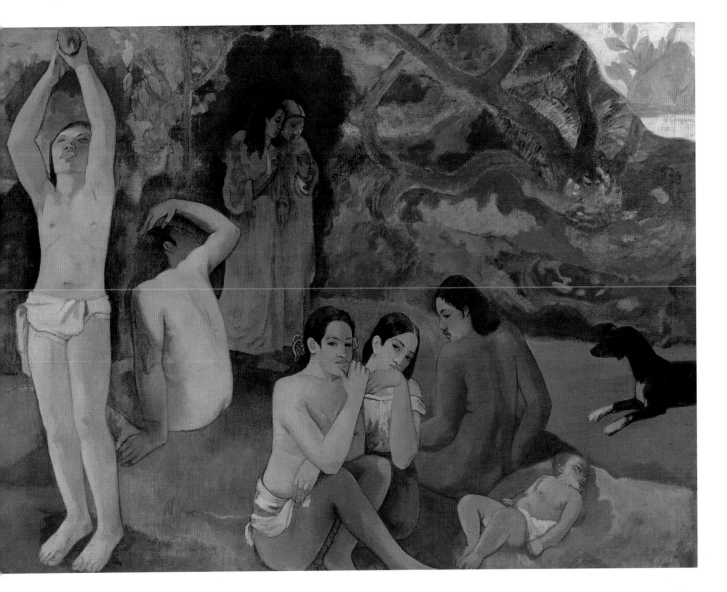

Visual tour

KEY

▲ **SLEEPING BABY**
Following the Eastern convention of reading from right to left, the sleeping baby represents the beginning of the human life cycle. The small, still group of the baby and three women is beautifully composed and illustrates Gauguin's reaction against naturalism and conventional perspective.

▶ **WOMAN LISTENING**
An oversized figure of a woman is sitting with her back to the light. The luminous color has been applied in Gauguin's typically flat style, with little or no modeling.

▲ **FRUIT PICKING** Filling the height of the canvas, the young man reaching up to pick fruit— perhaps symbolic of life's pleasures, and reminiscent of Eve in the Garden of Eden—is the focal point of the painting. As with other figures, the shape of his body is outlined in black. The bright tones of his skin are enhanced by the contrasting blues and greens of the background.

▲ **DEITY** Based on Polynesian carvings, this standing figure painted in unearthly blue indicates the world beyond. The same image appears in Gauguin's *Day of the God*, 1894. The artist was horrified by Christian missionaries' destruction of native sacred art in Tahiti.

ON **TECHNIQUE**

Early in his career Gauguin painted with spontaneous, visible brushstrokes in the style of the Impressionists. He then reacted against them, using thick paint to stop colors merging into each other. Financial hardship forced Gauguin to make his paint go further, and he found a way to keep colors separate while using thinner paint. He blended the brushstrokes to flatten the color. He also used black lines to separate areas of color, a technique that heightens the abstract quality of the painting.

Gauguin's blocks of flat, matte color and his limited use of shading to suggest three-dimensional form give *Where Do We Come From?* a distinctive design and a pattern-like quality. The painting also shows Gauguin's characteristic juxtaposition of contrasting and complementary colors. In the detail below, the blues and greens of the sky and foliage heighten and intensify the small area of strong orange.

IN **CONTEXT**

Gauguin reuses several figures from his past compositions in this work. It was painted, for lack of money, on cheap sacking rather than on artists' canvas. Gauguin considered it his masterpiece, the painting that brought together elements from all his best work. He also expected it to be his last. By his own account—and he was prone to self-mythologizing—he made a failed suicide attempt after its completion.

The figure of the woman leaning to the right at the bottom left of *Where do We Come From?* appears in Gauguin's painting *Vairumati*, made in the same year (see below). The motif of the white bird with a lizard between its feet is also present in both paintings.

▲ *Vairumati*, Paul Gauguin, 1897, oil on canvas, 29 × 36½in (73.5 × 92.5cm), Musée d'Orsay, Paris, France

◄ **GIRL WITH MANGO** In the foreground, a young girl with two cats playing beside her is eating a mango. The pinks, blues, and greys of the earth harmonize with the fruit, injecting an accent of dazzling complementary color. This central part of the composition, which includes the standing youth, depicts scenes from daily life and links to the second part of the title, *What Are We?*.

▼ **TAHITIAN LANDSCAPE** The strong horizon line brings out the flowing shapes of the island's trees. The branches curve luxuriantly, creating pattern and a sense of harmony.

7

6

▲ **TITLE** Toward the end of his life, Gauguin gave his paintings questions as titles. This one is in French. Of *Where Do We Come From?* the artist wrote: "Where are we going? Near the death of an old woman. A strange simple bird concludes. What are we? Mundane existence. The man of instinct wonders what all this means...Known symbols would congeal the canvas into a melancholy reality, and the problem indicated would no longer be a poem."

► **OLD WOMAN** Sitting next to a beautiful young woman is an old woman with dull skin. She crouches in shadow, as if waiting for the end of her life. The white bird may represent the final, unknown stage that follows death.

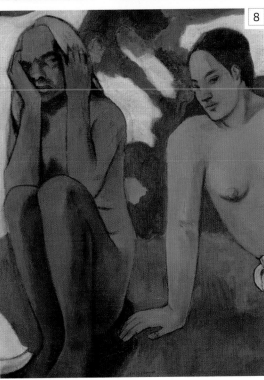
8

The Waterlily Pond

1899 ▪ OIL ON CANVAS ▪ 35¼ × 36½in (89.5 × 92.5cm) ▪ MUSÉE D'ORSAY, PARIS, FRANCE

SCALE

CLAUDE MONET

Harmonies of color, tone, and texture combine with the delicate play of dappled sunlight in this quiet, reflective painting of a water garden. The location of the lily pond with its distinctive, arched footbridge is the artist's famous garden at rural Giverny, northwest of Paris. Monet considered his extensive garden his "most beautiful masterpiece" and it occupied him for much of his life, especially in his later years when this painting was made.

Patterns of light

Monet, the quintessential Impressionist painter and cofounder of this group of French artists, sought to record and communicate the impressions and feelings he experienced when painting outdoors–*en plein air*. Throughout his life he was fascinated by the effects of light and atmosphere. In creating his water garden, Monet had the perfect subject for observing light. He could paint it at different times of day and even had a studio built there in 1914.

In *The Waterlily Pond*, short, rapid, brushstrokes and dabs of paint form the water's flower-strewn surface, creating a harmonious pattern of color. Monet has sometimes applied paint with a palette knife to suggest the shapes and texture of the foliage, and the layers of paint have been built up then worked and reworked while still wet to form a thick crust. The invention of the collapsible metal tube for oil paints (patented in 1841) had an important impact on artistic practice. The availability of ready-mixed paints in a range of colors helped to facilitate Monet's style of outdoor painting.

Monet created two separate gardens at Giverny, the flower garden and the Japanese-influenced water garden, studying and painting both over a period of more than 20 years. *The Waterlily Pond* shown here is one of Monet's "series" paintings in which he set out to capture the same subject repeatedly, at different times of day and under different light conditions. The lily pond became the dominant motif in his later years and he

exhibited ten views of it in 1900. This painting encapsulates Monet's strongly held Impressionist ideals, conveying a deep sensitivity to nature as well as his enduring passion for his garden.

> I want to paint **the air**…**the beauty of the air**…and that is nothing other than **impossible**

CLAUDE MONET

CLAUDE **MONET**

1840–1926

Monet was the leader of the radical Impressionist movement in France. He painted outdoors and was a master of color, texture, and the effects of light.

The son of a wealthy grocer, Monet spent his youth in Le Havre on the northwest coast of France. There he met landscape painter Eugène Boudin, who encouraged him to paint in the open air, and he developed a lifelong passion for capturing the sensation of being part of nature with its changing light, colors, and textures.

Monet enrolled at an independent art school in Paris, the Académie Suisse, and later studied in the studio of Charles Gleyre, where he met fellow Impressionist painter Renoir. During the Franco-Prussian War (1870–71), Monet spent a brief period in London. He studied Constable and Turner and painted the Thames. In 1871, Monet moved to Argenteuil, near Paris, producing some of his finest work there, including *Wild Poppies*, 1873. He exhibited at the first Impressionist exhibition in 1874 but, by the 1880s, the group was beginning to drift apart. Monet, however, remained true to the group's ideals, especially in his "series" paintings. In 1883, he settled at Giverny. His eyesight deteriorated badly in his last years, but his memory for colors was acute. He died at Giverny, a famous and wealthy man.

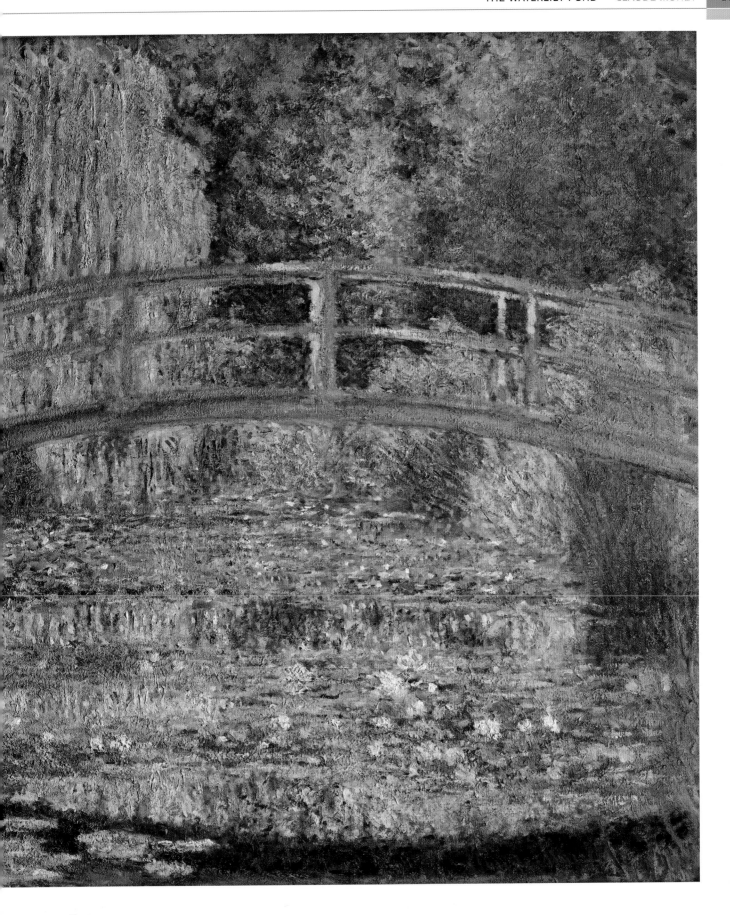

Visual tour

KEY

◀ **DAPPLED SUNLIGHT** Monet used flicks of thick yellow and light green paint to convey the impression of sunlight coming through the trees. Once the underlayer of paint was dry, he applied dark green and blue with a slightly drier brush. The darker tones add volume to the trees and the brushstrokes resemble individual clumps of leaves. Further layers of lighter yellow and green pick up the highlights.

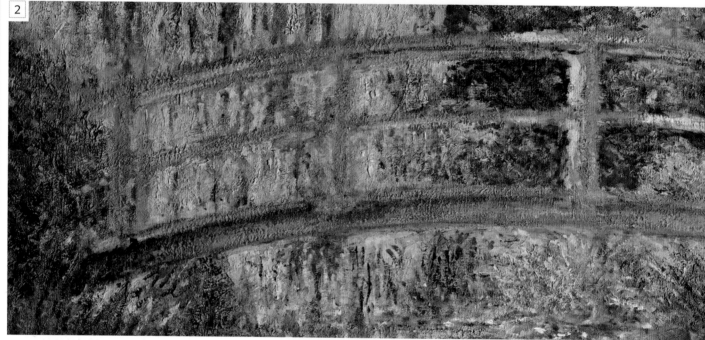

▲ **THE BRIDGE** The gentle curve of Monet's bridge bisects the painting. The soft mauve harmonizes beautifully with the lily pond beneath and with the colors of the surrounding foliage. The simple, decorative structure recalls the bridges in the prints of 19th-century Japanese artist Hiroshige, and there are other Oriental references in the planting of the water garden. Many Japanese prints were displayed in the house at Giverny and Monet admired the Japanese reverence for nature. In reality, the bridge is a vivid green with an upper trellis, draped in early summer with white wisteria. Of the five bridges in the water garden, the Japanese bridge is the most impressive.

▶ **THE LILY POND** Monet's treatment of the patterns of sunlight on the surface of the pond creates an almost abstract effect. The lily pads are picked out using short, horizontal strokes in blue-green tones. These brushstrokes become smaller and the color graduates to mauve and purple as your eye is led towards the far edge of the pond. The reflections of the trees, particularly the willow at the top left of the frame, can be seen in the clear areas of water and are depicted using vertical strokes of light color.

◄ **WATERLILIES** With dabs of thick white paint, splashes of pink, and touches of deepest red, Monet captures the delicacy of the lilies floating on the surface of the pond. The petals are more defined than in his later works, such as the huge *Waterlilies*, after 1916. The flowers in those paintings appear to merge into a richly colored pattern with a decorative quality.

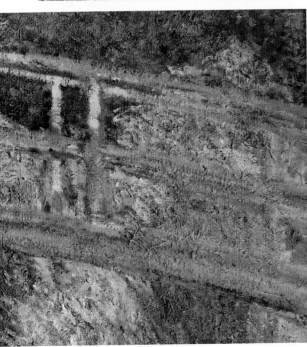

▼ **SIGNATURE** Monet returned periodically to the canvas, adding further touches each time until he was satisfied that he had captured the quality of light. He signed the painting in the bottom right-hand corner, using red paint to complement and contrast with the predominantly green tones of the painting.

▲ **WILLOW TREE** The elongated, slender branches of the willow that hang over the surface of the pond are depicted with strong vertical brushstrokes. Shadow is indicated by areas of green and blue and the thick layers of paint suggest a mass of graceful, lush foliage.

▲ **GRASSES** The curved blades of the grasses growing around the water echo the arc of the bridge and soften the edge of the pond. Unlike the short, angular dabs of paint on the pond's surface, Monet's sweeping brushstrokes follow the strong, linear form of the plants.

ON COMPOSITION

The painting is composed around the shallow arch of the bridge. Below the arch the surface of the pond both stretches towards you and recedes, leading your eyes to a vanishing point through the trees. Seen through the simple structure of the bridge is another spatial plane containing the trees, which enhances the illusion of depth. The surrounding trees and grasses enclose the view of the bridge within a frame of foliage.

IN CONTEXT

Monet was the most dedicated of the Impressionists. This loose group of talented young artists rejected the academically approved art of the day, with its historical or Romantic subject matter, and created a new style of painting. They wanted an art that was immediate, that communicated what the painter really saw at a particular moment. Monet painted outdoors and his style and bright color palette shocked fashionable Parisian audiences. His painting was deemed unpolished at a time when, in the academic style, brushstrokes were rarely visible.

There were eight Impressionist exhibitions in total. The artists—who included Cézanne, Monet, Renoir, Pissarro, and Sisley—were dubbed the "Impressionists" by journalist Louis Leroy who intended a pejorative description when he saw Monet's *Impression: Sunrise* (below) at the first exhibition in 1874.

▲ *Impression: Sunrise*, Claude Monet, 1872, oil on canvas, 19 × 24¾in (48 × 63cm), Musée Marmottan, Paris, France

1900 to present

Lake Keitele

1905 ▪ OIL ON CANVAS ▪ 21 × 26in (53 × 66cm) ▪ NATIONAL GALLERY, LONDON, UK

AKSELI GALLEN-KALLELA

SCALE

Although it is fairly small, *Lake Keitele*, with its boldly unconventional composition, makes a forceful impact. The high horizon line allows the lake to predominate. The reflections of the sky on the water are cut through by horizontal bands caused by a phenomenon of the wind while, in the foreground, the breeze ripples the surface like a shiver. Severe, concentrated, and bracing, *Lake Keitele* seems almost like a visual equivalent of the music of Sibelius, Finland's greatest composer (of whom Gallen-Kallela painted a memorable portrait). The painter and the composer were exact contemporaries—both were born in 1865—and each played a prominent part in the upsurge of nationalistic pride that accompanied their country's quest for independence from Russia. Finland became a republic in 1917.

A reflection of strength

The patriotism of the period is often expressed in Finnish art of the time. Architects moved on from the polished Neoclassical style linked to Russian and, before that, Swedish rule, taking up granite—a metaphor for Finnish strength—as their favorite material.

There is typically a feeling of granite strength in Gallen-Kallela's paintings too, despite their many subtle qualities, including a sensitive feeling for light.

This is one of several pictures of Lake Keitele inspired by a period when he was recuperating on its shores after contracting malaria in Spain in 1904. The subject is typically Finnish (lakes and forests are the defining features of the country's landscape). But the painting also has aspects that place it in an international context, showing Gallen-Kallela's involvement with the avant-garde European movements of his day—the flattened forms are characteristic of Art Nouveau, and the brooding atmosphere is typical of Symbolism.

AKSELI **GALLEN-KALLELA**

1865–1931

The most famous of all Finnish painters, Gallen-Kallela became a national hero in his country. Although he was so closely identified with his native land, he was also widely admired elsewhere.

Gallen-Kallela was born in Pori, a city on the west coast of Finland. Like many ambitious young Scandinavian artists of the time, he had part of his training in Paris, and he later traveled widely, in Africa and the US as well as Europe, and he exhibited his paintings successfully in many countries. However, he was deeply patriotic and his work was rooted in his native soil. His output was highly varied, ranging from large murals, notably in the National Museum, Helsinki, to the design of jewelry and textiles. He was also an architect, creating, among other buildings, a combined house and studio for himself at Tarvaspää, near Helsinki. This is now a museum dedicated to his life and work.

Visual tour

KEY

▶ **COOL COLORS** Blue and white—with the sky vividly reflected in the water—are predominant in the painting. They evoke the cold, quiet, unspoiled beauty Finland's austere landscape.

◀ **BOLD SIMPLIFICATION** Gallen-Kallela began his career painting in a naturalistic manner, but he came to prefer a flatter, more stylized idiom. The dark reflections of the copse contrast with the white cloud reflections on the other side.

ON **TECHNIQUE**

By the time he painted *Lake Keitele*, Gallen-Kallela was in his full maturity, expressing himself with a fluid, rich, and confident technique. In places, notably the white of the clouds and the white highlights on the water, he applied the paint extremely thickly, so that the pigment stood out all the more brightly from the cool palette of darker surrounding tones.

The Large Bathers

1906 ▪ OIL ON CANVAS ▪ 82¾ × 98¾in (210.5 × 250.8cm) ▪ PHILADELPHIA MUSEUM OF ART, PENNSYLVANIA, US

PAUL CÉZANNE

SCALE

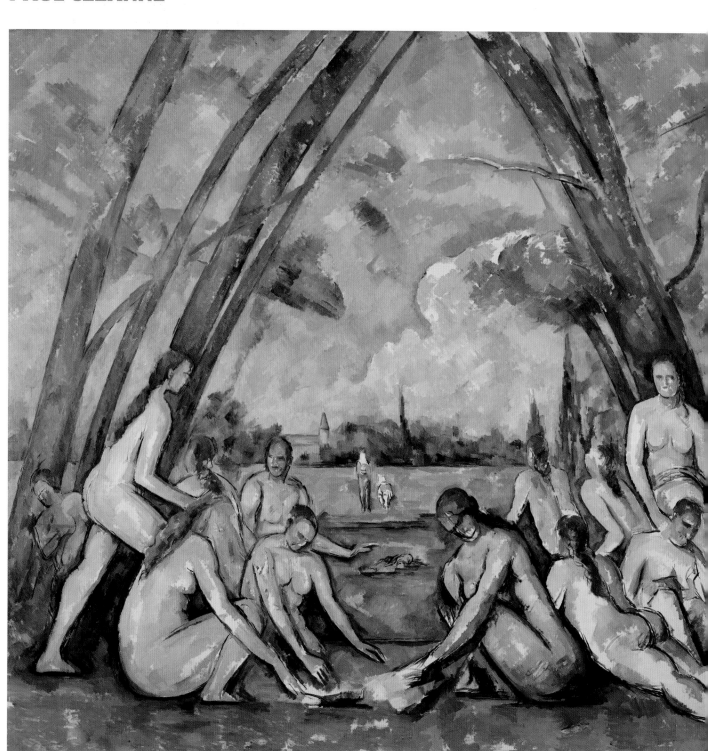

These nude figures have such timeless grandeur that they seem to be "sliced out of mountain rock." The memorable phrase comes from the great English sculptor Henry Moore, who first saw the painting in 1922, when he was a student. It made an indelible mark on him, and 40 years later he recalled, "For me this was like seeing Chartres Cathedral." Many other artists and critics have expressed similar feelings of awe about this picture–the largest Cézanne ever painted and one of the culminating works of his career. In it he combined majesty of form with subtle beauty of color and atmosphere, achieving his goal–in his own much-quoted words–"to make of Impressionism something solid and enduring, like the art of the museums."

Figures in a landscape

The young Cézanne had a fiery temperament, and his early work included highly emotional scenes of violence and suffering. In the 1870s, however, he abandoned such subjects as he came under the influence of Impressionism. From this time his art was based almost entirely on the people and places of the world around him, but there was one imaginative theme that he did not give up–groups of nude figures in a landscape setting. He depicted such figures, generally called "Bathers," throughout his career, in well over a hundred oils, watercolors, and drawings. The groups are usually exclusively male or female. Originally the scenes of female bathers were slightly erotic in feeling, but–as with his other subjects–they became mainly a vehicle for stylistic exploration.

Most of these works are fairly small, but in the final decade of his life Cézanne painted three large oils of female bathers that rank among his most ambitious works. The other two are in the Barnes Foundation, Merion, Pennsylvania, US, and the National Gallery, London. These two were possibly begun as early as about 1895 and were still being worked on by Cézanne just before his death in 1906 (it is often difficult to date his paintings because he worked slowly and sometimes intermittently, putting them aside for a time and then taking them up again).

The Philadelphia painting, on the other hand, may belong entirely to the final year of Cézanne's life and was unfinished when he died.

Subtle brushwork

It is the grandest of the three paintings, the most serene and exalted in feeling, and the most beautiful and subtle in brushwork (in spite of its unfinished state). The whole surface is alive with vibrant touches, and the figures are wonderfully harmonized with their setting, as if sky, trees, and human flesh were all made of the same mysterious substance. This concern with the overall feel and balance of the picture surface was at the heart of Cézanne's great legacy to modern art. It led the way from naturalism to such developments as Cubism and abstract art.

> # Nature reveals herself to me in very complex forms "
>
> **PAUL CÉZANNE**

PAUL **CÉZANNE**

1839–1906

Dubbed "the father of modern art," Cézanne was a hugely significant figure in painting at the turn of the 19th and 20th centuries.

Born in Aix-en-Provence in southern France, Cézanne initially studied law before turning to art. Like many of his colleagues, he suffered hardship and abuse early in his career, but at the age of 47 he became a wealthy man when his father died, and he was able to devote the remaining 20 years of his life to developing his personal vision.

Cézanne's life was divided mainly between Aix-en-Provence and Paris, where he studied and became involved in the Impressionist movement. Pissarro was an early friend and mentor. However, Cézanne only partially adopted the outlook of the core Impressionists, aiming to combine their naturalness and freshness of spirit with the grandeur of the Old Masters. Although he worked in isolation, by the end of his life he had become a hero to progressive artists and his subsequent influence has been deep and enduring.

Visual tour

KEY

▶ **SIMPLIFIED SHAPES** Cézanne made drawings of nude models when he was a student, but in later life he very rarely did so. His dealer, Ambroise Vollard, said that "women, even when clothed, frightened him," and it would in any case have been difficult to work from unclothed models in the rather puritanical atmosphere of Aix-en-Provence. Instead, Cézanne based his figures on other sources, particularly drawings he had made much earlier, but also photographs. This approach helps to explain the simplified shapes of his nudes, which sacrifice anatomical accuracy for grandeur.

▲ **FORM AND OUTLINE** Cézanne worked slowly and intuitively, constantly feeling his way, subtly blending and overlapping brushstrokes to achieve the exact balance of form and color he was seeking. Whereas the Impressionist ideal was to capture an image of a scene as it existed at a single moment, he tried to present an accumulated vision of it, whether the subject was a real one or imaginary, like this. Every line and every gradation of tone was carefully pondered, and they all interacted. Here, many of the forms of the bathers are firmly outlined, but the lines are combined with delicately modulated areas of tone.

▲ **TIGHT GROUPING** The figures on the right are arranged in a tightly knit group. Although Cézanne sometimes painted pictures of a single bather, he preferred groups. His fascination with the theme may have its origins in happy memories of his boyhood, when he enjoyed swimming with friends in the River Arc. These friends included Émile Zola, who became a famous writer.

◄ **TREES** The trees have a feeling of great strength and resilience, but also show Cézanne's delicacy of touch and sensitivity in handling variegated and interlinked colors. The trunks are tinged with touches of blue and green, helping link them with sky and earth.

▼ **LANDSCAPE** Through the center of the composition, across the river, you can see a landscape with open ground, trees, and buildings. The colors Cézanne uses here are closely related to those of the nude figures.

▲ **MOVEMENT** Some of the paintings from the early years of Cézanne's career are characterized by violent movement, but his mature work is usually distinguished by dignity and serenity. There is a sense of movement in this striding figure, but it is stately movement, in tune with the lofty grandeur of the work.

◄ **CROUCHING VENUS** The figure on the left here is the only one in the painting known to be based on another work of art. It is derived from an ancient Roman marble sculpture of Venus in the Louvre in Paris. Cézanne knew the sculpture well when he was a student and made drawings of it.

ON **COMPOSITION**

Cézanne was a master at creating a sense of dignified balance and calm resolution in his paintings. Often this was achieved in an understated way, but here his approach is bolder and more direct than usual, with a strong feeling of formal staging. The picture indeed suggests theatrical comparisons: the figures have been described as looking like goddesses in a grand opera, with the great curving forms of the trees above them recalling the proscenium arch at the front of the stage. This tree "arch" forms the sides of a huge, stable triangle around which the composition is based. The feeling of stability is echoed in the figures, which likewise are arranged into evenly balanced triangular groupings at either side of the painting. Beneath the central area of sky, an inverted triangle is formed by the outstretched arms of the bathers. Figures and landscape interlock in majestic harmony.

IN **CONTEXT**

Cézanne had an enormous influence on progressive painters, such as Braque and Picasso, in the early 20th century, particularly after a retrospective of his work was held in Paris in 1907, the year after his death. Many sculptors also had a high regard for his paintings. Among them was Henry Moore (1898–1986), who greatly admired the strength and dignity of Cézanne's figures. Indeed, Moore revered Cézanne so much that in 1960 he bought one of the artist's small paintings of bathers. He hung it in his bedroom and described it as "the joy of my life," adding, "Each of the figures I could turn into a sculpture, very simply."

▲ *Reclining Figure*, Henry Moore, 1929, brown Hornton stone, 33in (84cm) high, Leeds Art Gallery, West Yorkshire, UK

The Kiss

1907-08 ▪ OIL AND SILVER AND GOLD LEAF ON CANVAS ▪ 70¾ × 70¾in (180 × 180cm)
ÖSTERREICHISCHE GALERIE BELVEDERE, VIENNA, AUSTRIA

SCALE

GUSTAV KLIMT

The heady mix of sensuality and opulence in this iconic image captures the essence of Klimt's unique approach. He was fascinated by the theme of the human embrace, returning to it on several occasions, but this is the definitive version. The couple are locked together, so absorbed in each other that they are no longer aware of anything beyond their own passion. They are encased in a strange, golden covering, which emphasizes their union and cocoons them from the outside world. Wearing extravagant, multicolored robes that seem to merge into each other, the lovers embrace on a small patch of grass, carpeted with an improbable profusion of flowers. The setting is pure fantasy. In spite of all this, *The Kiss* remains an ambivalent picture. The embrace appears to take place beside an abyss, with the woman's feet dangling over the edge. Is Klimt hinting that both love and passion are precarious, perhaps even dangerous?

An eclectic style

The Kiss was produced at the height of Klimt's career, when he was drawing upon a wide range of influences. It reflects the fashionable taste for Art Nouveau, which was the predominant style of the works exhibited by Klimt and the other artists of the Vienna Secession. Art Nouveau was characterized by a preference for stylized forms and sinuous, linear patterns. Above all, however, it placed more emphasis on decoration than on realism. In *The Kiss* this is evident not only from the amorphous shape of the lovers' robes, but also from the unrealistic dimensions of the woman. She is kneeling down while her partner appears to be standing, suggesting that she is considerably taller than him. However, this is well disguised by the wealth of decorative detail surrounding the lovers.

The theme of *The Kiss* had been popularized by Symbolist artists, such as Edvard Munch. It was often used as a pretext for depicting a femme fatale, although that is not the case here, as Klimt has portrayed the woman in a purely passive role. However, the erotic content and the mysterious, evocative setting are very much in keeping with the spirit of Symbolism.

The greatest influence on the artist's style perhaps came from mosaics. Klimt had always been interested in this medium, but his enthusiasm was fired after studying the Byzantine mosaics in the churches at Ravenna in Italy in 1903. He extended his practice of creating designs from tiny fragments of color so that the painted surface–the man's robe, for example–resembles a painted mosaic. The Ravenna mosaics also reinforced Klimt's conviction that his compositions would look more imposing and atmospheric when set against a golden background, rather than a naturalistic one.

GUSTAV **KLIMT**

1862-1918

An Austrian painter and designer, Klimt dominated the art scene in Vienna in the early 1900s. Nothing evokes this magnificent era more effectively than Klimt's "golden period" paintings.

Born in a suburb of Vienna, Gustav Klimt trained at the city's School of Applied Art. He made his mark quickly, producing large-scale decorative schemes for major building projects. These were well received and a successful academic career appeared to beckon, but Klimt's interests were shifting toward avant-garde art. Finding the official artists' association too staid, he withdrew from it in 1897 and, together with a group of like-minded friends, formed the Vienna Secession.

The Secession functioned mainly as an exhibiting body, opening its doors to painters, architects, and decorative artists working in a broad range of styles. Klimt's controversial new venture curtailed commissions from official sources, but he was in great demand as a portraitist, winning particular acclaim for his sensual depictions of beautiful women. He also continued to produce decorative work for patrons, most notably at the Palais Stoclet in Brussels, Belgium.

The Kiss is the icon of a post-religious age, and Klimt gives it the glitter and grandeur of an altarpiece

JONATHAN JONES *THE GUARDIAN,* 2001

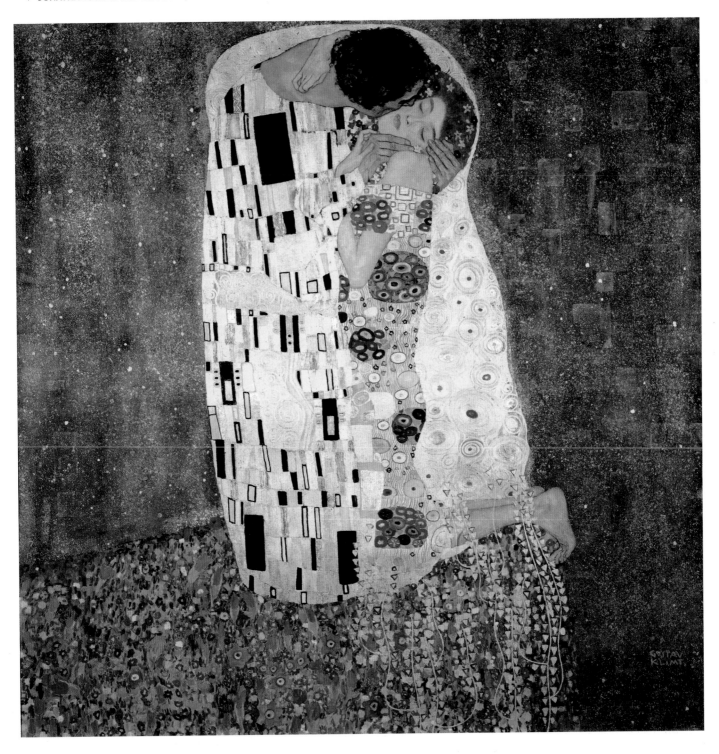

Visual tour

KEY

◀ **LUXURIOUS PATTERN**
During this phase of his career, Klimt enjoyed experimenting with beguiling combinations of abstract and figurative elements. He portrayed his friends in wildly extravagant, patterned clothing, so that they almost seemed to disappear into their voluminous robes. Often, only their hands and faces were visible and, as in *The Kiss*, the precise outline of their figures was obscured.

◀ **WOMAN'S ROBE** The woman's dress provides a striking contrast to that of her partner. The golden decoration is composed predominantly of small, circular forms linked by thin, wavy lines. However, the most eye-catching features of her robe are the large, brightly colored rondels, each containing an array of smaller circles. These were meant to echo the flowers beneath the lovers' feet. Some of the examples at the bottom of the woman's robe even appear to have stylized petals. The profusion of flowers and the patterns on the dress can both be read as emblems of fertility.

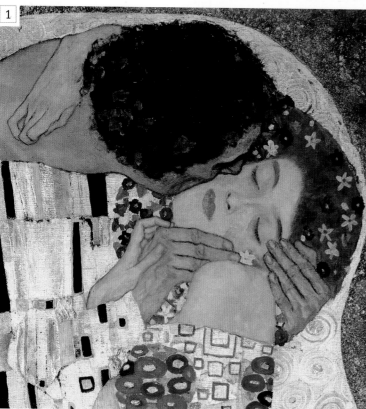

▲ **THE KISS** As in Klimt's other versions of this subject, the man's face is largely hidden from view. However, his virile power is conveyed by his robust, bull-necked appearance and by the way that his huge hands dwarf those of his partner. He is also wearing a crown of ivy, a plant sacred to the Greek god Dionysus and his followers, the satyrs. Through these figures, there are associations with both fertility and lust. The woman, by contrast, is entirely passive. Her eyes are closed, presumably in ecstasy, although her ashen complexion and the painfully horizontal tilt of her head may have been inspired by the theme of the severed head, which was fashionable in Symbolist art. In 1901, Klimt had painted *Judith with the Head of Holofernes*.

▶ **BED OF FLOWERS** Klimt used to relax by painting landscapes. These were highly unconventional, focusing primarily on densely packed areas of brightly colored flowers. In part, the inspiration for these came from his studio garden, which he allowed to run wild, but they are also reminiscent of the floral decoration found in early tapestries. In *The Kiss*, the flowery bank provides a platform for the lovers, but it also enhances the air of opulent fantasy. In its own way, it seems as exotic and unreal as the shimmering, golden background.

▶ **TEXTURE** Klimt liked to heighten the sensual impact of his pictures by embellishing them with a variety of precious materials. In the background of *The Kiss* he created a shimmering, granular effect by layering gold dust on an umber background. He achieved a different textural effect on the lovers' robes by modeling some of the patterns in gesso, before painting them gold.

▼ **MAN'S ROBE** Klimt used different symbolic motifs to distinguish between the lovers' robes. The man's attire is decorated with plain, rectangular shapes, which are colored black, white, or silver. These angular patterns were intended specifically to conjure up male attributes, and to contrast with the curved and colorful motifs of the woman's robe.

▲ **FEET** In stark contrast to the physical beauty of many of his figures, Klimt's portrayal of their limbs was often quite distorted. The hands are too large, while their fingers and toes may appear twisted or deformed. This trait was probably influenced by the Expressionist style, which was just emerging at the time. In this case, the detail of the woman's feet is quite ambiguous. It may be that her toes are curled in rapture, or else they are desperately clinging on to the last piece of solid ground, at the edge of the precipice. On a similar note, the position of the woman's right hand, along with her unseen right arm, is also extremely awkward.

ON **TECHNIQUE**

Although he is best known as a painter, Klimt had a firm grounding in the decorative arts and this never ceased to affect his style. As a child, he learnt from his father, who was a goldsmith and engraver, and he built on these foundations at the School of Applied Art. In later years, he was chiefly influenced by mosaics, particularly after seeing the outstanding examples at Ravenna, Italy. This prompted Klimt to build up his pictures using brilliantly colored, fragmented forms. In the detail below, the painted mosaic pattern is overlaid with gilded, leafy chains like the stems of a plant twining over the woman's feet.

IN **CONTEXT**

Klimt was the first president of the Vienna Secession, which was formed in 1897. The group held their exhibitions in the spectacular Secession Building, which critics disparagingly referred to as "the golden cabbage" because of its glittering dome. The Secession's motto—"To each age its art, to art its freedom"—is inscribed in gold letters above the imposing geometric entrance.

▲ Secession Building (1897–98), Joseph Maria Olbrich, Vienna, Austria

Composition VII

1913 ▪ OIL ON CANVAS ▪ 78¾ × 118in (200 × 300cm) ▪ TRETYAKOV GALLERY, MOSCOW, RUSSIA

WASSILY KANDINSKY

SCALE

Kandinsky made the most important breakthrough of his career in the years leading up to World War I. Working in Munich, Germany, he developed a new pictorial language, which helped him to create pioneering abstract paintings. The cornerstone of his achievement was a series of canvases entitled *Compositions*. Kandinsky regarded these as the definitive statements of his artistic philosophy. He produced only 10 in his lifetime, and each of these was the result of careful meditation and planning. *Composition VII* is widely acknowledged as the finest and the most adventurous of the series.

Inevitably, the *Compositions* proved controversial. Spectators stood in front of the vast, mural-like paintings and were utterly baffled. The paintings seemed chaotic, with no recognizable subject, structure, or natural forms. Kandinsky would not have been entirely displeased with this verdict. "Each work originates in the same way as the cosmos," he wrote, "through catastrophes which, out of the chaotic din of instruments, ultimately bring forth a new symphony."

A spiritual approach

Kandinsky explained the philosophy behind his new approach in an influential treatise, *Concerning the Spiritual in Art*, 1911. He did not believe that the public was ready for art that was totally non-representational, and he certainly did not want his abstracts to be merely decorative. Instead, he believed they could convey his purest and most spiritual feelings. Initially, he drew his inspiration from religious subjects—the Garden of Eden, the Deluge, the Apocalypse—but gradually he suppressed these narrative themes. In their place, he relied solely on form, color, and line, orchestrating these into his sublime creations.

WASSILY **KANDINSKY**

1866-1944

Hailed as one of the creators of abstract art, Kandinsky is universally recognized as one of the greatest pioneers of modern art. His radical experiments, typified by the *Compositions*, proved an inspiration to the Abstract Expressionists.

Kandinsky was born in Moscow, the son of a wealthy tea merchant. He trained as a lawyer but, at the age of 30, decided to become a painter. Moving to Munich, he studied briefly at the Academy of Fine Arts under Franz von Stuck. By now, Kandinsky was mixing in progressive, artistic circles, and his style underwent rapid changes, as he was influenced by Russian folk art, Fauvism, and Expressionism. His private income gave him free rein to experiment, but his daring works shocked contemporaries. From the outset, Kandinsky's primary inspiration came from color and music. In his youth, he had been dazzled by one of Monet's paintings, and he adored the music of Wagner and Schoenberg. Eventually, he managed to combine these passions, making them the basis of his abstract style.

The very word composition called forth in me an inner vibration...I made it my aim in life to paint a "composition" 🙶

WASSILY KANDINSKY

Visual tour

KEY

▶ **COLOR** Kandinsky always regarded color as the most crucial element in his paintings. He was influenced by the writings of philosopher Rudolf Steiner. Steiner had argued that "each color, each perception of light, represents a spiritual tone." Kandinsky took this a stage further and devised his own color code, attributing spiritual and expressive values to each hue.

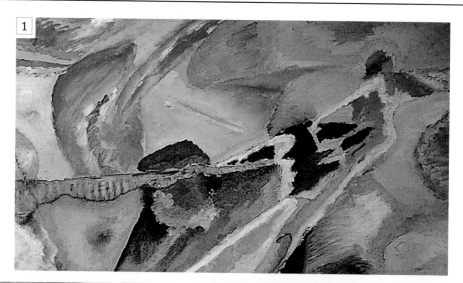

▲ **LINE** Kandinsky used linear motifs to instil energy and direction into his paintings. Here, the parallel, horizontal lines offer a rare element of stability at the edge of the work while, more importantly, the spidery red diagonal hints at an underlying structure. It seems to trace part of the outline of a very faint lozenge, which is most evident from the thick, right-angled corner at the foot of the canvas. The interplay between line, color, and form was even more effective in *Black Lines I*, also produced in 1913.

▶ **TONE** When describing tone, Kandinsky used a musical analogy and likened it to timbre. With it, he was able to vary the mood in his paintings. One favorite ploy was to introduce plain, almost monochrome passages of color, to counterbalance the furious activity elsewhere. Here, for example, this "quiet" corner of the composition heightens the effect of the maelstrom that dominates the center of the canvas.

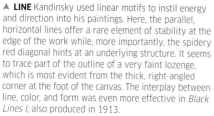

▼ **BOAT MOTIF** One of Kandinsky's favorite motifs was a boat, which could be reduced to a simple curved shape and a row of lines, representing the oars. In the past, Kandinsky had painted recognizable versions of this image (*Boat Trip*, 1910), but it also became a recurrent theme in *Compositions* because it was relevant to his theme of the biblical Deluge.

▼ **HIDDEN IMAGES** Kandinsky took great pains to disguise any figurative elements in his abstract works, but a few can still be discerned. This detail is sometimes interpreted as a ladder and a flower. Most elements, though, can usually be identified only by referring to his preparatory studies.

ON **TECHNIQUE**

Kandinsky's methods varied depending on the type of picture. He produced *Impressions* and *Improvisations* relatively spontaneously. The *Compositions* were a different matter. These evolved slowly, as the artist formulated his ideas for an "expression of inner feeling." *Composition VII* was the most elaborately prepared in the series. More than 30 studies survive, in a range of media. Once these preparations were complete, Kandinsky worked quickly, covering the huge canvas in a little over three days. In structural terms, Kandinsky refined the ebb and flow of his composition, while veiling the figurative elements that had inspired him. In the study below, for instance, a blue-faced angel blows a trumpet (top right). The trumpet-shape appears in the finished picture, but its figurative meaning is removed.

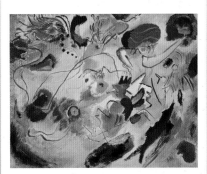

▲ *Study for Composition VII*, Wassily Kandinsky, 1913, oil and tempera on canvas, 31 × 39½in (78.5 × 100.5cm), Städtische Galerie im Lenbachhaus, Munich, Germany

IN **CONTEXT**

In the period leading up to the outbreak of World War I, Kandinsky made rapid progress toward pure abstraction. Just two years before the creation of *Composition VII*, the subjects of his paintings were still usually fairly explicit. Here, for example, Kandinsky depicted a New Year's concert by his friend, Arnold Schoenberg. In addition to the audience, it is possible to identify two broad, white pillars, and the huge, black lid of a grand piano.

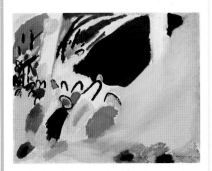

▲ *Impression III (Concert)*, Wassily Kandinsky, 1911, oil on canvas, 30½ × 39¼in (77.5 × 100cm), Städtische Galerie im Lenbachhaus, Munich, Germany

▲ **DISSONANCE** Kandinsky aspired to mirror the qualities of music. His favorite composer was Arnold Schoenberg, the pioneer of atonal music. Kandinsky admired his approach and felt no compunction about combining harshly dissonant passages. For him, this was just part of the "thundering collision" that was essential to his art.

◄ **SHAPE** In his preparatory studies, Kandinsky experimented with a broad repertoire of components, as he searched for the right formula. Most of the sketches included a variant of this powerful feature, which dominates the heart of the picture. Critics have likened it to a gigantic, cyclopean eye, establishing contact with spectators and drawing them in. It also functions as an anchoring device, remaining constant while other elements swirl frantically around it.

Berlin Street Scene

1913 ▪ OIL ON CANVAS ▪ 47¾ × 37½in (121 × 95cm) ▪ NEUE GALERIE, NEW YORK, US

SCALE

ERNST LUDWIG KIRCHNER

The jagged forms, acidic colors, and tense, mask-like faces give this picture a nightmarish intensity. It is one of a series of street scenes of Berlin—perhaps Kirchner's most powerful and original works—that he painted between 1913 and 1915, after he moved to the city from Dresden in 1911. Whereas Dresden was cosily provincial, Berlin was one of the largest and most culturally vibrant capitals in Europe at this time, and even though he felt lonely there, Kirchner was intoxicated by what he called "the symphony of the great city." Among its many and varied attractions was its decadent night life, and the clothes, as well as the brazen demeanor, of the two central women leave no doubt that they are prostitutes.

The illusion of being close
The claustrophobic atmosphere of the picture is created partly by the feeling that the street is tilted up toward the viewer, so that the figures loom oppressively close. We see the scene as if through the eyes of a friendless wanderer in the city—physically close to other people but emotionally distant. More than any other artist, Kirchner captures the giddy excitement as well as the vulgar materialism of the German capital on the eve of world war.

ERNST LUDWIG **KIRCHNER**

1880–1938

One of the key figures of 20th-century German art, Kirchner created powerful and disturbing works expressing the tensions of modern life. His work included prints, sculpture, and paintings.

Born in Aschaffenburg, Germany, Kirchner moved to Dresden in 1901. He was the leading member of the first organized group of Expressionists, Die Brücke (The Bridge), which operated from 1905 to 1913. Expressionists used distortion and exaggeration to intensify their work's emotional effect. They were part of a broad movement that was a major force in European art in the early 20th century, particularly in Germany. Kirchner had a mental and physical breakdown while serving in the German army during World War I, and moved to Switzerland when he was recuperating. Although his work had been much admired, in 1937 it was declared "degenerate" (in effect outlawed) by the Nazis, who hated modern art. The following year, Kirchner committed suicide.

Visual tour

KEY

▶ **MAN SMOKING** The man who rather awkwardly turns his head away from the women—perhaps in embarrassment or disdain—has been interpreted as a self-portrait of Kirchner. He wrote that "an agonizing restlessness drove me onto the streets day and night."

▶ **TWO WOMEN** The fur-collared coats and extravagant feathered hats were typical of prostitutes' dress in Berlin at the time. The women's heavily made-up faces are also characteristic of the profession. As models, Kirchner used the sisters Erna and Gerda Schilling, nightclub dancers he met soon after moving to Berlin.

1

2

3

▲ **THE GREEN BUS** In the background is a horse-drawn bus. It is a number 15—a service whose route passed through Berlin's red light district. Motorized buses had first been used in Berlin as early as 1898, but when Kirchner painted this picture horses were still a major form of transport, even in the largest cities.

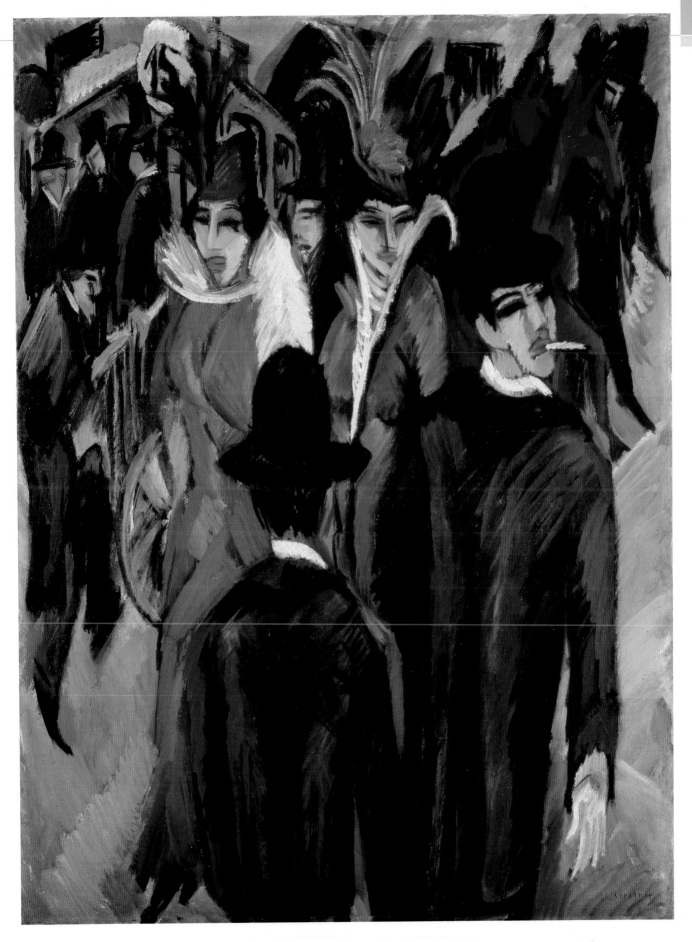

Northern River

1914-15 ▪ OIL ON CANVAS ▪ 45¼ × 40¼in (115 × 102cm) ▪ NATIONAL GALLERY OF CANADA, OTTAWA, CANADA

SCALE

TOM THOMSON

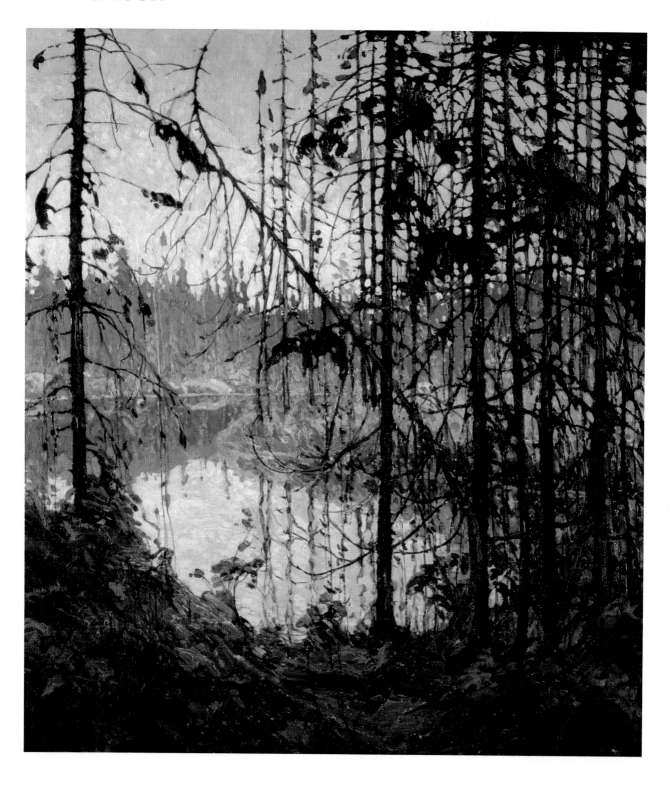

The luminous beauty of northern Ontario's wild places is captured in this evocative late-autumn landscape by Canadian painter Tom Thomson. The mood is still and contemplative: most of the leaves have fallen from the trees and the glowing autumn tones will soon fade. *Northern River* is a keenly observed and innovative depiction of a time of seasonal transition in nature. The vibrancy of the colors, the strong sense of pattern, and the bold, expressive brushwork represented a break with the European tradition of landscape painting that was the norm in Canada. Thomson was not trying simply to make a visual representation of the wilderness, but to communicate something of its spirit.

Inspired by nature

The painting shows a tranquil stretch of river in the Algonquin Provincial Park, a vast area of designated wilderness that fascinated Thomson and which he first visited in 1912. At that time, the area's harsh beauty was not widely appreciated, but he found the landscape inspiring and from 1914 camped there each spring and autumn, working as a ranger and making fluent oil sketches outdoors on small wood panels, often from his canoe.

He immersed himself in nature, observing and painting the changing patterns of light and color through the seasons. During the winter, in the small wooden shack that served as his studio in Toronto, Thomson created *Northern River*. It is an atmospheric and romantic work that combines his instinctive feel for the landscape with a strong sense of design and composition. Thomson died prematurely but his vision was developed by other Canadian artists, such as the Group of Seven collective.

THOMAS **THOMSON**

1877–1917

Internationally recognized for his innovative and expressive painting of wild landscapes, Thomson helped to establish a modern style of painting with a uniquely Canadian identity.

Brought up on a farm in Ontario, Thomson spent time at business college in Seattle before moving back to Toronto in 1905 and working as a commercial artist. While at Grip Ltd., a leading Toronto company, his creative development was encouraged by the senior designer, and he met other young painters there. As a group, they often made weekend painting trips together. From 1914 to 1917, Thomson spent long periods in southern Canada, where he made sketches for works such as *Jack Pine*, 1916–17. He was an expert canoeist and acted as a guide for artist friends and summer visitors, so his death by drowning in Canoe Lake, Algonquin Park, was both mysterious and tragic.

Visual tour

KEY

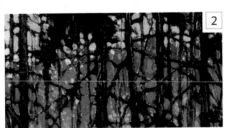

◀ **SILHOUETTES** The dark, outlines of the bare trees that extend almost to the full height of the canvas form a decorative grille. You look through the branches to the brightly colored foliage beyond and the smoky mauve of the horizon line. There is a gentle interplay between foreground and background.

▼ **FRAMING** The intricate tracery of the upper branches of the trees and the strong verticals of their slender trunks frame the background of sky. The darkness of the timber contrasts with the luminosity of the sky and there are splashes of color, notably bright blues and yellows. The juxtaposition of light with the tracery creates an effect similar to that of looking through a stained glass window.

◀ **COLOR** Thomson's use of brilliant color and bold brushstrokes is very striking. Vibrant reds and russets are interspersed with dots of bright complementary blue-mauve and this color is echoed in the conifers on the horizon line.

▲ **RIVER** The sweeping curve of the river winds from the foreground into the middle distance. The reflections of the trees in the still water extend and soften the verticals of the trees and help to create a mood of deep tranquillity.

Red Balloon

1922 ▪ OIL ON CHALK-PRIMED GAUZE, MOUNTED ON BOARD ▪ 12½ × 12¼in (31.7 × 31.1cm)
▪ GUGGENHEIM MUSEUM, NEW YORK, US

PAUL KLEE

SCALE

Floating jauntily above a stylized townscape, the balloon seems like a symbol for the whimsical flights of imagination that are so characteristic of Klee's work. His intellectual curiosity was wide-ranging and his mind was nourished by all manner of artistic traditions, both ancient and contemporary. Like many progressive painters of the time, he was interested in types of art that had an untutored sincerity and vitality, in particular children's art. He tried to achieve a childlike freshness of vision in his work, but at the same time it is highly sophisticated: no child could produce the subtle balancing act between abstraction and representation shown in this painting or rival its exquisite color harmonies.

Music, color, and form

Klee was almost as passionate about music as he was about art, and was a talented violinist. In his writing and his teaching he paid a great deal of attention to color, comparing it to music in its ability to enchant and transport the viewer in a way that went beyond rational understanding. However, this sensitivity to intangible qualities was combined with close observation of the natural world, which he considered the essential starting point for artistic creation. Consequently, he rarely painted purely abstract pictures. Here the rectilinear forms evoke an arrangement of buildings, particularly the sloping lines of roofs, and there is the faint suggestion of a tree at the top left.

PAUL **KLEE**

1879-1940

One of the best-loved figures in modern art, Paul Klee created unconventional works of magical wit, color, and beauty.

Klee had a Swiss mother and a German father. He is often described as Swiss, but in fact he was a German citizen all his life. Early in his career he was principally an etcher, but on a visit to Tunisia in 1914 he suddenly became entranced by color and thereafter he worked mainly as a painter. Most of his paintings are small in scale—intimate, lively, and with a joyful spirit that is distinctively his own. For ten years, from 1921 to 1931, he taught in Germany at the Bauhaus, the most famous art school of the time, first in Weimar, then in Dessau, and he was adored by his students. His final years were marred by debilitating illness, but although his work grew darker in mood, it never lost an element of playfulness.

Visual tour

KEY

▼ **CHALKY BACKGROUND**
In matters of technique, Klee was unconventional and experimental. He would often combine painting methods that are normally kept completely distinct—such as oils and watercolor—in the same picture. Here he painted on a fine fabric primed (coated) with chalk, which helped him to create subtle effects of color and texture.

▼ **RED BALLOON** Klee often used a colorful circular form in his paintings: the sun was a favorite motif, and the flowers he depicted often have a sun-like form and radiance. He was fascinated by the subject of flight, and hot-air balloons feature in many of his works from the postwar years. The red pigment of the balloon is applied thickly in relation to the thin wash of the background. Its strong, simple shape is clearly outlined in black.

1

2

3

▲ **GEOMETRIC SHAPES** The blocklike shapes suggest a view over the roofs of a town, with the balloon floating above them, but the variegated, delicately modulated colors come from Klee's imagination rather than from observed reality. "Color possesses me," he once wrote, and he used it emotionally and intuitively rather than descriptively.

Red Canna

c.1924 ▪ OIL ON CANVAS ▪ 36 × 30in (91.4 × 76cm) ▪ UNIVERSITY OF ARIZONA ART MUSEUM, TUCSON, US

SCALE

GEORGIA O'KEEFFE

In this magnificent painting, Georgia O'Keeffe displays her gift for discovering the extraordinary in the everyday —a simple flower is transformed into an organic wonder. This is not a straightforward nature study, but an explosive, magnified close-up of a flower, whose brilliant colors and markings draw us into the picture, just as a real flower attracts an insect.

O'Keeffe studied the abstract qualities of the things she found beautiful and used them as a form of self-expression. Here she tries to capture the essence of the bloom by conveying the energy of its growth, translating her detailed observation of the plant into a composition of lines, shapes, and exaggerated color. Despite the abstract shapes, however, the image is still recognizably a flower: the petals, with their crimped edges, look delicate and you can see lines like the honey guides that lead insects towards the pollen in the center of the flower.

Early in her career, O'Keeffe was influenced by Russian artist Wassily Kandinsky's (see pp.202–05) ideas on the links between the visual arts and music, and in *Red Canna*

the fiery shapes of the petals appear to dance. The flower has movement, form, and warmth. It was bold compositions such as this and her other close-ups of flowers that made O'Keeffe's work so dazzlingly innovative at a time when most other American painters were still producing far more traditional representational art.

GEORGIA **O'KEEFFE**

1887–1986

A major figure in American art, Georgia O'Keeffe was an individualist whose striking paintings of landscapes, flowers, and animal bones were based on the abstract forms in nature.

Born in Wisconsin, O'Keeffe studied art in Chicago and New York. When teaching in 1915, she created an innovative series of abstract charcoal drawings that were exhibited by influential photographer and gallery owner Alfred Stieglitz. O'Keeffe married Stieglitz in 1924 and he championed her work until his death in 1946. During the 1920s, O'Keeffe painted New York City and landscapes. She started painting large-scale close-ups of flowers in 1924 and was soon recognized as one of America's most important artists. In 1929, O'Keeffe spent the first of many summers in New Mexico, painting animal bones and the mountains. The monumental landscape of New Mexico continued to inspire her painting for the rest of her life.

Visual tour

KEY

➤ **FOCAL POINT** You look straight into the fiery center of the flower, where strident pinks and oranges meet—and where the plant's reproductive parts are. O'Keeffe's flower paintings have been interpreted as symbols of female genitalia, but she always vehemently denied that this was her intent.

1

2

◀ **SINUOUS LINES** The flowing lines in the painting were developed from a series of abstract charcoal drawings that O'Keeffe made in 1915, influenced by Art Nouveau plant motifs. Note how the lines flow right off the edges of the image.

3

◀ **BOLD SHAPES** The details in the painting are in such dramatic close-up that it feels as if you have an insect's perspective. Each magnified part of the flower is simplified down to a geometric shape and takes on an abstract quality.

ON **COMPOSITION**

You cannot see the whole flowers in O'Keeffe's magnified close-ups. To give her images added dramatic impact, she cropped the edges of the petals so that each flower would fit within the confined space of the picture frame.

▲ *Black Iris*, Georgia O'Keeffe, 1926, oil on canvas, 36 × 30in (91.4 × 75.9cm), Metropolitan, New York, US

The Metamorphosis of Narcissus

1937 ■ OIL ON CANVAS ■ 20 × 30¾in (51.1 × 78.1cm) ■ TATE, LONDON, UK

SALVADOR DALÍ

SCALE

> # The only difference between myself and a madman is that I am not mad "
>
> **SALVADOR DALÍ**

This haunting picture marks the pinnacle of Salvador Dalí's achievements as a Surrealist. Dalí himself was proud of it, regarding it as the finest product of the paranoiac-critical method (see below) that he invented.

The subject of the painting was drawn from classical mythology. As recounted by the Roman poet Ovid, in his book *Metamorphoses*, Narcissus was a beautiful youth who fell in love with his own reflection. Transfixed by it, he became as motionless as a statue, gradually wasting away. At his death, he was transformed into a flower, which bears his name. Dalí was also inspired by a conversation that he overheard between two local fishermen. They spoke of an odd fellow having "a bulb in his head," a Catalan expression for a mental condition. This gave Dalí the idea of portraying the flower bulb bursting through the egg–the transformed skull of Narcissus.

The paranoiac-critical method

The use of the dual image stemmed from the paranoiac-critical method, which Dalí had been developing since the early 1930s. He described this as a form of "reasoning madness," through which he aimed to warp the dividing line between illusion and reality. By simulating a state of mental disturbance, he created a series of striking compositions that are, in effect, self-induced hallucinations. The most typical examples are the double images, where the same elements can be interpreted in different ways– a landscape, for example, might also be viewed as a human face. Some of these pictures were rather gimmicky–one fellow Surrealist dismissed them as "entertainment on the level of crossword puzzles"–but *The Metamorphosis of Narcissus* is far more complex, as it is closely bound up with the artist's interest in psychoanalysis.

Dalí was a keen devotee of the founder of psychoanalysis, Sigmund Freud. He took this painting with him when he met the great man in 1938. Freud had coined the term "narcissism," citing it as a potential cause of a personality disorder, linked with arrested sexuality. Dalí had his own fears in this regard, which had eased only after he met his wife, Gala. In part, this painting is a celebration of the beneficial effect she had exerted, for he described the flower in the egg as "the new Narcissus, Gala–my narcissus."

SALVADOR **DALÍ**

1904-89

A showman, an eccentric, and a self-proclaimed genius, remembered above all for his startlingly original paintings, Dalí was the most famous, as well as the most controversial, of the Surrealists.

Salvador Dalí was born in Figueras, in the Spanish region of Catalonia. He was proud of these roots, and the local landscape–with its strange rock formations–appears as the backdrop in many of his pictures. He trained in Madrid, at the Academy of Fine Arts, and staged his first one-man show in 1925. In his youth, Dalí toyed with a number of different styles before making contact with the Surrealists in 1929.

Surrealism–with its emphasis on dreams, the subconscious, and the theories of Freud–proved an ideal vehicle for Dalí's flights of fancy. Drawing on his own fears and obsessions, he created a series of memorable pictures, which raised the profile of the movement. On a personal level, though, Dalí's right-wing politics and his taste for self-publicity grated with many of the Surrealists. He gradually drifted away from their circle. In addition to painting, Dalí was a writer, a designer, and a filmmaker.

Visual tour

KEY

▶ **GOD OF SNOW** A miniature, disintegrating version of the metamorphosis can be seen in the distance, nestling in a lofty range of snow-capped mountains. But, as Dalí specified in his poem about this picture, the season is spring, when the youth—the "god of snow"—is beginning to "melt with desire."

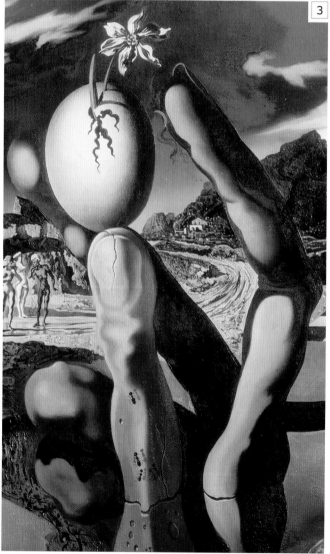

▲ **NARCISSUS** The youth gazes into the pool, obsessed with his own reflection. Face down, immobile, he is already beginning to pine away. A shadow on his scalp resembles the crack in the egg. Dalí advised his viewers to observe the figure in a state of "distracted fixation." If they did, the body would seem to dissolve, melting into the rock formations that surround it.

▶ **HAND HOLDING EGG** This is an imaginative reworking of the tragic end of the mythical tale, when the beautiful youth dies and is transformed into a narcissus. With masterful ease, Dalí manages to juxtapose two important, contradictory themes. For, while the egg and the flower affirm the creation of new life, the hand that bears them is already cracked, ossified, and dead.

◄ DOG On the right-hand side of the picture, the dog is associated with the theme of waste and decay. Lean and half-starved, the scavenging creature displays no interest in the transformation of Narcissus. Instead, it gnaws hungrily at a wretched piece of meat. This serves as a reminder that flesh, however beautiful it may appear in its prime, is destined to wither and perish.

◄ EGG AND FLOWER
The eye is immediately led toward the narcissus, breaking through the eggshell. It is the brightest part of the composition and, from Dalí's point of view, the most important. Quite different from the legend, it represents the symbolic cure for the sexual ills of narcissism. In Dalí's own case, this cure was his wife.

▲ **ANTS** They appear frequently in Dalí's work as emblems of death. This association stemmed from a vivid, childhood memory: with morbid fascination, he had watched a swarm of ants feast on the decomposing remains of a lizard.

◄ FIGURE ON PODIUM
This figure is linked with the egg motif directly above it. A beautiful youth stands in glorious isolation, having set himself on a pedestal. He turns his back on the main incidents in the picture. Instead, he appears totally absorbed in gazing down admiringly at his own, naked form.

➤ GROUP OF FIGURES In his related poem, Dalí described this strange assembly as "the heterosexual group" waiting in a state of "preliminary anticipation," pondering the impending "libidinous cataclysm." He went on to list the nationalities and characteristics of these devotees of narcissism. They included a Hindu, a Catalan, a "blonde flesh-eating German," an English woman, a Russian, an American, a Swedish woman, and a "tall, darkling Andalusian."

ON TECHNIQUE

The impact of Dalí's Surrealist paintings depended on their power to conjure up rich associations in the mind of the viewer. He composed a poem about this picture, but it offers up cryptic hints, rather than a precise guide to its meaning. As with all his best work, the image is ambiguous, open to personal interpretation.

Dalí employed a meticulous, realistic style to endow individual details of his pictures with a dreamlike clarity. Indeed, he described his canvases as "hand-painted dream photographs." On closer inspection, however, the enigmatic shadows, the bizarre landscape, and the inconsistent lighting all emphasize the underlying, irrational tone.

IN CONTEXT

Earlier versions of the Narcissus story had appeared in paintings, sculpture, and tapestry. Most were literal versions of the myth, carrying no psychological overtones. However, Dalí may have drawn some inspiration from a picture attributed to Caravaggio. The fulcrum of this bold composition is the boy's knee, which looms out of the dark at a strange angle, enjoying the same prominence as the limbs of Dalí's Narcissus.

▲ *Narcissus*, attributed to Caravaggio, c.1597–99, oil on canvas, 43¼ × 36¼in (110 × 92cm), Galleria Nazionale d'Arte Antica, Rome, Italy

Guernica

1937 ▪ OIL ON CANVAS ▪ 11ft 5¾in × 25ft 7in (350 × 780cm) ▪ MUSEO REINA SOFÍA, MADRID

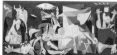

SCALE

PABLO PICASSO

One of the most striking images of 20th-century art, *Guernica* is a nightmare vision of violence, pain, and chaos. The painting is full of energy but there is no color and its monochrome, nighttime palette is bleak and disorientating. Picasso uses jagged, fragmented forms and distorted faces to great effect, creating an atmosphere of panic and terror. The painting makes a big impact, both emotionally and physically. More than eleven feet high

and more than twenty-five feet long, it is enormous and its vast scale meant that Picasso had to use a ladder in order to paint the upper sections.

In early 1937, Picasso had been commissioned to create a mural for the Spanish Pavilion at the Paris World's Fair, but he had not decided on a theme for the work. At that time, Spain was in the grip of a civil war and in April 1937, in broad daylight, the population of the small town

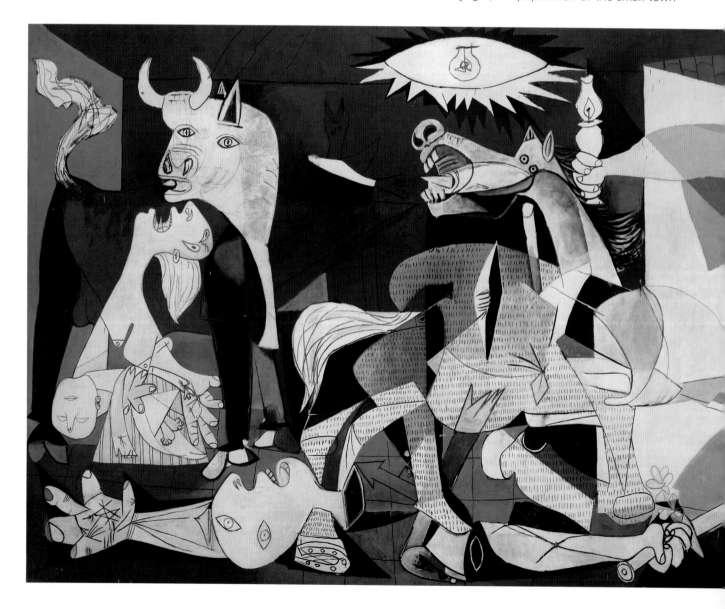

of Guernica in the Republican-held Basque region of Spain was devastated by German bombers and fighters from the Condor Legion acting on General Franco's orders. Picasso, who had allied himself to the Republican cause, read about the massacre of defenseless civilians and the theme of the mural for the Spanish Pavilion suddenly presented itself. The Paris Fair would give him an opportunity to bring the atrocities visited on the defenseless people of Guernica to the attention of the world, and so he set to work.

The power of art

The antiwar message of *Guernica* is fairly clear. Like Goya's celebrated painting, *Third of May 1808* (see p.142), with which Picasso would have been familiar, it is a profound condemnation of the brutal massacre of innocent people. It can also be seen as an anguished response to the tragedy and suffering of war in general. For Picasso, art was an intensely powerful medium and he saw *Guernica* as a political vehicle that would resonate with people on an emotional level. When the work was exhibited, both its subject matter and its artistic style caused great controversy. After Paris, the painting traveled to the United States where it was shown in San Francisco and at the Museum of Modern Art, New York.

Picasso's masterpiece is considered by many to be the greatest painting of the 20th century. Wars are still being fought around the globe and *Guernica* is a humbling reminder of man's destructiveness and inhumanity.

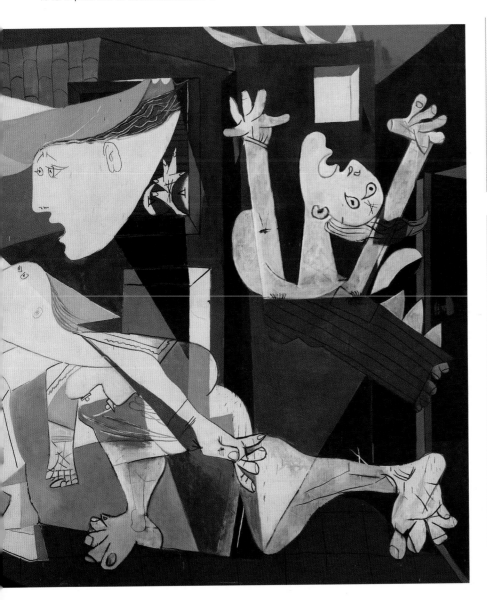

> …painting is not interior decoration. It is an instrument of war for attack and defense against the enemy

PABLO PICASSO

PABLO **PICASSO**

1881–1973

The prodigious and varied career of the innovative painter and sculptor Pablo Picasso provides the backbone of 20th-century art.

Born in Málaga, Spain, Picasso was a precocious art student. As a young artist, he lived in Barcelona before settling in Paris.

Picasso's early career is defined by his Blue Period, when his paintings featured melancholic figures in blue tones, and his Rose Period, when he used pinks and greys to create a lighter mood. From 1909 to 1914, he and artist Georges Braque were the leading figures in the development of Cubism and, after World War I, he took part in the revival of classicism. In 1925, Picasso allied himself with the Surrealists and, after World War II, he took up ceramics. Picasso's work went through many phases inspired by the women in his life, medieval and African art, bullfights, mythology, and old masters, all of which he reprocessed with his unique humor and vision.

Visual tour

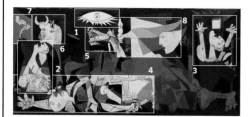

KEY

> **MOTHER AND CHILD** The disjointed style of the woman's face conveys an impression of deep anguish. Her head is thrown back in a scream of despair and Picasso has painted a spike for her tongue, a shape that expresses the sharpness of her pain. There is an echo of the Christian image of suffering, the *pietà*, in the way she cradles the lifeless child in her lap.

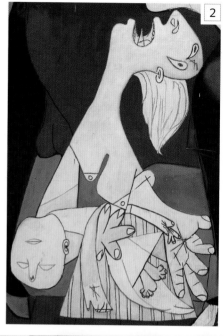

> **ELECTRIC LIGHT** The single bulb in the ceiling light illuminates a room of nighttime horror. Its glow has a jagged edge and suggests a burst of light, surely a reference to the incendiary bombs that fell on Guernica. The light also resembles a huge eye that observes everything, perhaps a symbol of the all-seeing eye of God.

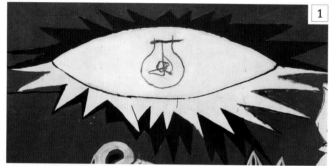

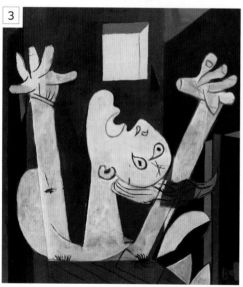

▲ **BURNING FIGURE** Kneeling with arms outstretched, this figure is engulfed by flames. Echoing the shape of the woman's head on the opposite side of the painting, the man or woman—it is difficult to tell which—screams at the sky. Flames lick through the window in front of the figure, suggesting that the rest of the town is also under attack.

> **THE HORSE** When asked for his interpretations of the images in the painting, Picasso said that the shrieking horse represented the innocent people. The contorted head and neck of the horse form a dramatic image of panic. A wound that looks like a slash in the canvas has opened in its side and the animal seems to be screaming in agony, its tongue a sharp spike, like that of the bereaved mother.

▲ **FALLEN SOLDIER** Perhaps the most difficult image to interpret is the fallen soldier in the foreground. His head and arm have been severed from his body. In his dismembered hand he holds a broken sword, and a single, delicately drawn flower appears to be growing there, perhaps signifying the faintest glimmer of hope. On the outstretched palm of the other hand is a wound that suggests the stigmata of Christ.

▼ **BULL** An important cultural symbol in Spain, the bull usually signifies strength and the bull or minotaur is a motif that the artist used many times in his work. According to Picasso, who was usually unwilling to offer any analysis of his imagery, the bull in *Guernica* is a symbol of brutality. This bull, however, does not appear particularly aggressive. Perhaps the image is intentionally ambiguous.

◀ **BULL'S TAIL** It is unclear whether the bull is twitching its tail or whether the tail is actually on fire. The proud bull appears almost helpless in the face of the carnage, and it looks straight out at us with a peculiarly human expression.

6

7

8

◀ **FLOATING FEMALE**
A female figure flies in through the open door, a lighted candle or a lamp in her hand. This floating woman, whose style is reminiscent of Picasso's surrealist work, could be bringing enlightenment to the scene. Yet her candle flame is next to the electric lightbulb (a symbol of war), drawing attention to the significance of these juxtaposed symbols.

ON **TECHNIQUE**

Picasso concealed several motifs of death in *Guernica* that appear to work on a subliminal level. Focus on the horse in the center of the painting, an important point of the composition, and you will see two hidden symbols. Its nostrils and upper teeth cleverly double up as a skull, a stark symbol of death, an inclusion that serves to increase the intensity of the horse's agony (top). The wounded horse is stumbling and at the angle of its bent front leg, there is the skull-like head of a second bull seen in profile (bottom).

IN **CONTEXT**

The harrowing realities of the front line had been captured by government-sponsored war artists during World War I. Spain was a neutral country, so Picasso was not called up for military service, but he would have seen these powerful war paintings. American artist John Singer Sargent, who had visited the Western Front, created *Gassed*, a harrowing twenty-foot long painting showing a line of soldiers blinded by mustard gas. Blindfolded and holding on to each other, the vulnerable soldiers appear dignified amid the horrors of the battlefield.

▲ *Gassed*, John Singer Sargent, 1918–19, oil on canvas, 7ft 7in × 20ft ½in (231 × 611.1cm), Imperial War Museum, London, UK

Nighthawks

1942 ▪ OIL ON CANVAS ▪ 33 × 60in (84.1 × 152.4cm) ▪ THE ART INSTITUTE OF CHICAGO, CHICAGO, US

SCALE

EDWARD HOPPER

An iconic image with an unsettling atmosphere, Hopper's powerful painting is, above all, a study of light. An intense, fluorescent glow streams from the windows of a late-night diner into the empty street, creating sharp angles and casting deep shadows. The place is almost empty and its few occupants are starkly illuminated, particularly the pale-skinned woman in the red dress. The composition is simple and strong, and the colors are mostly muted. Moody, downbeat, and yet also romantic, Hopper's painting resembles a still from a classic *film noir*.

Many of Hopper's paintings depict people, often solitary, who appear alienated from their environment and from each other. There is little interaction between them, or, as in *Nighthawks*, the relationships are ambiguous. It is tempting to inject a narrative into this painting, but, like a film still, a single image cannot tell the whole story.

As a realist painter, Hopper possibly based the location of *Nighthawks* on an exisiting New York street, but the scene has been carefully constructed and it is more likely to be a composite of various elements from different places. The shapes of the buildings have been simplified, the shop fronts have no displays, and the street is deserted. These compositional devices allow the huge, sweeping curve of the window and bar of the diner to dominate. At the same time the brilliant light from a single source contrasts with the background gloom, focusing our attention on the uncluttered interior.

Emotional landscape

Several elements combine in *Nighthawks* to create a sense of tension and unease. The shadowy, nighttime street is devoid of people or movement, the diner occupants in their glass box appear remote and inaccessible, and a feeling of uncertainty and loneliness pervades the scene. It is difficult to feel any connection with either the characters or the location of the painting, but we can recognize and respond to the emotional space that Hopper has created. Unlike his contemporaries, such as Norman Rockwell, whose images of life in 1940s America are largely sentimental, Hopper invested his everyday scenes with a psychological intensity. His understated style is beautifully expressed in *Nighthawks,* one of this painter's most haunting works.

> A triangle of ceiling, as sharp as it is bright, hangs above them like a blade. You're the unobserved watcher, the watcher from the shadows, a kind of private eye

PAUL RICHARD *WASHINGTON POST*, 2007

EDWARD **HOPPER**

1882–1967

One of the most celebrated painters of modern life, Edward Hopper is best known for atmospheric everyday scenes that explore universal feelings of solitude and loneliness.

Born in New York State, Hopper was the son of devout Baptist parents. He trained at the New York School of Art, studying under the realist painter, Robert Henri, who encouraged him to paint subjects from everyday life. Hopper made two visits to Paris and was attracted by the light effects he saw in Impressionist paintings, but it is debatable whether these influenced his style.

Until 1923, when he sold *The Mansard Roof*, a watercolor, Hopper's sole source of income was his work as a commercial illustrator, but in 1924 he began to paint full time. He studied light obsessively and painted the sunlit buildings and seascapes around Cape Cod, where he and his wife Jo owned a summer house. The distinctive style that made his reputation, most famously in *Automat*, 1927, and *Nighthawks*, 1942, hardly changed throughout his career despite the rise of Abstract Expressionism. He died in New York.

Visual tour

KEY

▶ **THE COUPLE** The angular features of the man and woman are accentuated by the stark, fluorescent lighting overhead. They sit in close proximity but there is little suggestion of communication between them and their relationship is ambiguous. The woman stares at a piece of paper, the man looks preoccupied. Both seem lost in their own thoughts. With her distinctive auburn hair, red dress, and red lipstick, the woman is the focal point of the composition.

▲ **ANONYMOUS MAN** Balancing the composition of figures around the wooden bar, the smartly dressed man with his back toward us is particularly enigmatic. Hopper has depicted him in half shadow and with great skill: the way the light falls on his face and back, the slightly hunched posture, and the casual handling of the glass add up to a convincing portrayal of a solitary figure who is just passing through.

◀ **PERIOD ITEMS** The white hat and jacket of the waiter and the equipment in the café—the large gleaming urns and the classic sugar shaker and cruet sets—are typical of the period. The waiter appears to be busy but his hands are obscured and the figure, like the others, is curiously static.

5 **◀▼ LIGHTING** Hopper expertly contrasts the moody streetscape with the brightly illuminated café. The flat, bleached-out tone of the interior suggests the harsh effect of the overhead lighting, which casts triangular shadows on the pavement in the foreground.

6

4

7

▲ LINE OF STOOLS Only three stools are occupied in the diner. The sparseness of the setting serves principally to emphasize the sense of isolation. Compositionally, the regular elliptical shapes reinforce the strong lines of the windowsill and the bar.

▶ EMPTY SPACE Hopper used empty (or negative) space to great effect. The simple shapes made by the concrete pavement and road combined with the complete absence of activity or small incidental detail, such as litter, serve to concentrate all our attention on the interior scene.

8

◀ SIGNAGE Hopper's experience as an illustrator and commercial designer can be seen in the strong geometry and graphic style of the painting. The name of the diner appears in a classic, hand-lettered serif font. It is probably fictional, but identifies the diner in what is otherwise a totally anonymous place.

ON **TECHNIQUE**

The wedge shape of the diner projects into the composition, filling two-thirds of the canvas. Its Art Deco-style frontage features huge sheets of glass interrupted by few verticals, and there is no door. The expanse of empty pavement and the shop fronts balance the left side of the painting.

In terms of perspective, the strong lines of the windowsill and roof appear to converge toward a vanishing point somewhere beyond the left side of the frame. Looking more closely at the perspective, however, slight distortions become apparent, such as the way the top of the wooden counter is painted, and these may contribute to the atmosphere of unease. The row of shops on the left, the plain windows and doors represented by simple rectangles, acts as a barrier, as if it is containing the tension within the frame.

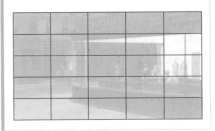

IN **CONTEXT**

Hopper was painting during the heyday of Hollywood movies, an era of memorable black-and-white films, some adapted from the crime fiction of popular American writers such as Dashiell Hammett and Raymond Chandler. Hopper was a keen filmgoer and it is interesting to draw parallels between *Nighthawks* and early *film noir* classics with their dramatic lighting, unusual camera angles, and tense, brooding atmosphere.

This same atmosphere of unease pervades many of Hopper's best-known works, including *Gas* (shown below). Superficially, the scene appears unthreatening: a man is attending to one of the pumps at a petrol station. Yet this carefully composed image with its solitary figure, backdrop of dark trees at dusk, empty road, and complete absence of cars, has an eerie stillness. As with many of Hopper's paintings, there is an air of melancholy that continues to resonate.

▲ *Gas*, Edward Hopper, 1940, oil on canvas, 26¼ × 40¼in (66.7 × 102.2cm), Museum of Modern Art, New York, US

Without Hope

1945 ■ OIL ON CANVAS MOUNTED ON HARDBOARD ■ 11 × 14¼in (28 × 36cm)
MUSEO DOLORES OLMEDO PATIÑO, MEXICO CITY, MEXICO

SCALE

FRIDA KAHLO

Few painters have been so intensely autobiographical in their work as the Mexican artist Frida Kahlo: of her 150 or so known paintings, more than a third are self-portraits. A few are fairly straightforward renderings of her striking appearance, but many of them are entirely different in approach—deeply personal and highly specific commentaries on the physical and emotional pain of her life. *Without Hope* shows the artist confined to bed in a harsh, barren landscape, a hideous cornucopia of assorted meat and fish in a fleshy cone suspended above her mouth. Even though it is very small, it is one of the most powerful and disturbing of her paintings.

Autobiographical painting

Kahlo's medical problems were mainly the result of horrific injuries (to her spine, pelvis, and other parts of her body) sustained in a bus crash in 1925, when she was still at school. Even before this accident, however, she walked with a limp because of childhood polio, and in later life she suffered from digestive disorders and alcoholism. At the time she painted *Without Hope*, a lack of appetite had caused such serious weight loss that she had to be fed through a funnel. In the painting, the funnel has been transformed to a monstrous size—so big that it has to be supported on a stout wooden frame—and it is filled not with puréed food but with mounds of dead flesh. On the back of the picture, Kahlo wrote an inscription that gives the painting its title: "not the least hope remains to me...Everything moves in tune with what the belly contains."

Although her work had numerous admirers, Kahlo was overshadowed in her lifetime by her husband, Diego Rivera, a huge man with a huge personality. While her paintings were generally small and intimate, his were highly conspicuous: he specialized in large murals for public buildings—the field in which Mexico made its most distinctive contribution to modern art.

Growing reputation

It was not until about 1980, some 25 years after her death, that Kahlo's reputation began to rise and then to soar, as part of the feminist movement to reexamine and celebrate the work of women artists. She is now firmly established as a feminist heroine, admired not only for the passion and originality of her paintings, but also for the strength of spirit that enabled her to create these works in the face of great suffering. In 2007, the largest Kahlo exhibition ever staged was held in Mexico City to mark the centenary of her birth; it smashed attendance records, attracting more than 360,000 visitors in just two months.

FRIDA **KAHLO**

1907-54

On the strength of her colorful, intense, and often harrowing self-portraits, Kahlo has become one of the most famous of all women painters.

Frida Kahlo spent most of her remarkable life in Mexico City. It was there, at the age of 18, that she suffered multiple injuries in a traffic accident, leaving her permanently disabled and often in severe pain. She began painting during her initial convalescence. In 1929, she married Diego Rivera, the most famous Mexican painter of the time. Their relationship was a stormy one (they divorced in 1939 and remarried in 1940), but it survived until her death. Their shared passion apart from art was politics—both were militant Communists. Kahlo's posthumous reputation has grown so rapidly since the 1980s that her face now adorns all manner of popular merchandise and her flamboyant dress has made her a style icon.

I paint myself because I am so often alone
and because I am the subject I know best

FRIDA KAHLO

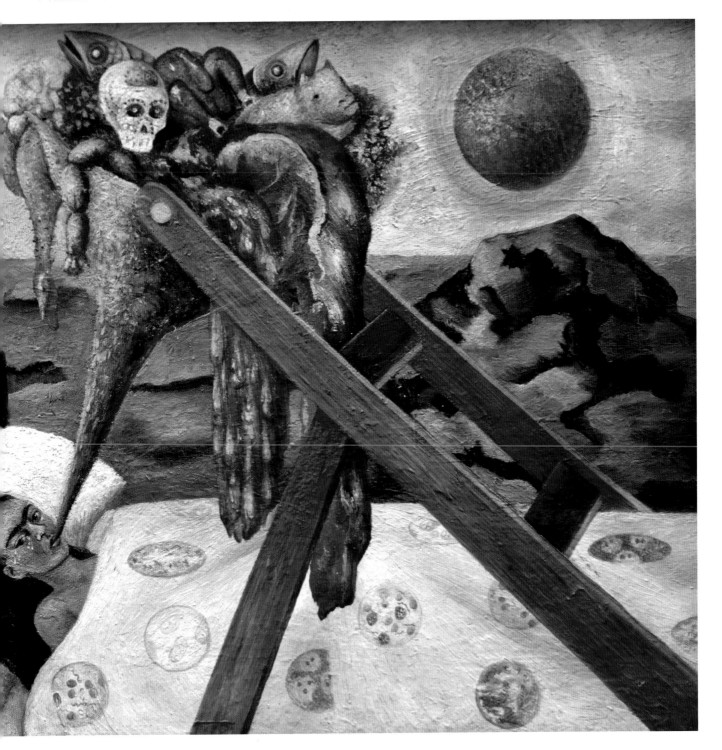

Visual tour

KEY

▶ **FEAST OF DEATH** The huge feeding funnel overflows with a nauseating mix of meat, fish, and poultry. Kahlo probably took the idea of a funnel as an instrument of torture (which is what it seems to represent here) from a book on the Spanish Inquisition she had in her library. The Inquisition used funnels in water torture. On top of the pile is a sugar skull inscribed with Kahlo's name. Such skulls feature prominently in Mexico's annual Day of the Dead celebrations on November 2. This holiday, which blends Aztec with Christian elements (it coincides with the Christian festival of All Souls' Day), is an occasion when Mexicans honor friends and relatives who have died. The skull (a macabre link with Mexico's Aztec past) is an obvious allusion to death, while sugar represents the sweetness of life.

▼ **FACE OF PAIN** Kahlo turns toward the viewer with an imploring look, tears running down her cheeks. Only her head and shoulder project above the bedclothes. This helps to convey a sense of constriction, and during this time Kahlo was indeed forced to spend a great deal of time lying in bed wearing an orthopedic corset. She endured more than 30 operations during the course of her life.

▲ **BEDCOVER** The shroud-like bedcover is adorned with curious patterning. In her book, *Frida: A Biography of Frida Kahlo* (1983), the American art historian Hayden Herrera proposed that the circular forms are biological cells or unfertilized eggs, linking them with the images of the sun and moon in the painting as "opposite worlds of the microscope and the solar system." Herrera's biography was the first major book on Kahlo written in English, and it played an important part in establishing the artist's reputation with a wide audience. It formed the basis for the biographical feature film *Frida* (2002), starring Salma Hayek as Kahlo.

▼ BARREN BACKGROUND The landscape setting of the picture is a parched desert. It has been interpreted as a reference to Kahlo's childlessness. The injuries she suffered when she was 18 made it impossible for Kahlo to bear a child. After suffering a traumatic miscarriage at 25, she painted *Henry Ford Hospital* (1932), which depicts her lying in a hospital bed on blood-soaked sheets.

ON **TECHNIQUE**

Kahlo was mainly self-taught and her working methods reflect the unusual circumstances of her life. She began painting in earnest while recuperating at home after the bus crash in 1925. A special easel was fixed to her four-poster bed and an overhead mirror was fitted, so she could see herself while lying flat and act as her own model. Kahlo's brushwork was delicate and nimble, although in her later years, when she was affected by alcoholism, it became coarser.

▲ Frida Kahlo's bed with the overhead mirror

IN **CONTEXT**

Kahlo's husband Diego Rivera (1886–1957) was the most famous of three muralists who dominated 20th-century Mexican art (the others were Orozco and Siqueiros). The President of Mexico initiated a program of mural painting from 1920 to 1924. Following a violently unsettled period, the paintings were intended to help create a feeling of national identity among a population that was still largely illiterate.

▲ *Vaccination Scene and Healthy Human Embryo Surrounded by Diseased Cells*, Diego Rivera, 1933, fresco, Detroit Institute of Arts, Detroit, US

▲ MOON On either side of the painting are large images of the moon and sun. These have been interpreted in many different ways, for example, as a way of indicating that Kahlo's pain is relentless and persists throughout both day and night. Alternatively, the pale moon—a traditional feminine motif—has been seen as a symbol of the frail Kahlo herself, its wan light a reflection of the huge, brightly burning sun.

▲ SUN Kahlo was passionately interested in the pre-Columbian culture of Mexico, in which sun worship plays a prominent role. The sun sometimes appears in her paintings as a generalized symbol of life-giving energy, but here it may be a more specific allusion to her husband, Diego Rivera, a man of great vigor and confidence. The image may also be a visual reference to the orange marigolds that feature in the Mexican Day of the Dead festivities.

Red Interior, Still Life on a Blue Table

1947 ▪ OIL ON CANVAS ▪ 45¾ × 35in (116 × 89cm)
▪ KUNSTSAMMLUNG NORDRHEIN-WESTFALEN, DÜSSELDORF, GERMANY

SCALE

HENRI MATISSE

The joyful spirit of this painting is so heartwarming that it is hard to believe the artist who created it was old and frail. It is, in fact, one of the last oil paintings Matisse ever produced, one of a glorious series of interiors he made between 1946 and 1948; at this time he was approaching 80 and was confined to bed or a wheelchair, following major surgery for cancer in 1941. He was active right to the end of his life, but after he completed these interiors he no longer worked in the traditional medium of painting: in 1948–51 he concentrated on the design of the Chapel of the Rosary at Vence, France (a gift of thanks for a Dominican nun who had nursed him). In his final years he devoted himself mainly to large paper cutouts (*découpages*), employing assistants to arrange the shapes according to his instructions (see p.233).

Tranquility through art

Throughout virtually the whole of his long career, Matisse was captivated by the theme of the interior, especially when it featured a window looking onto a garden or landscape. The fascination was an expression of his love of tranquility, as he greatly valued the peace of mind he found when working in a calm atmosphere. Even though the colors here are dazzling and the patterning bold, the feeling is peaceful rather than flamboyant.

Matisse was a renowned teacher with an orderly mind and a scholarly air (when he was still a student his friends nicknamed him "the professor"). He wrote no books, but he produced various statements on art in the form of interviews, catalogue introductions, essays, and so on. In one of these he eloquently summed up his aims: "What I dream of is an art of balance, of purity and serenity…a soothing, calming influence on the mind, something like a good armchair that provides relaxation from physical fatigue." The words were written in 1908, but they could well be applied to this luminously beautiful painting produced 40 years later.

HENRI **MATISSE**

1869-1954

Regarded by many of his admirers as the supreme painter of the 20th century, Henri Matisse is celebrated for his exquisite sensitivity of line and radiant beauty of coloring.

Matisse was a late starter in art, taking it up after initially studying law. Early in his career, he suffered some of the critical abuse typically encountered by avant-garde artists, but he soon found sympathetic patrons and from the 1920s he enjoyed international acclaim. At first he worked mainly in Paris, but from 1916 he began spending winters on the French Riviera, where the strong sunlight encouraged his sparkling colors, and in 1940 he settled there permanently. His subjects were varied, including nudes, portraits, landscapes, interiors, and still lifes. Almost always they are life-affirming in attitude, "devoid of troubling or disturbing subject matter," as Matisse put it. In addition to paintings, he produced sculptures, prints in various techniques, book illustrations, and stage décor. One of his greatest achievements was the design of a chapel, 1948–51, in the French Riviera town of Vence, for which he designed everything from the stained glass to the priests' vestments.

> My choice of colors does not rest on any specific theory; it is based on observation, on sensitivity, on felt experiences

HENRI MATISSE *NOTES OF A PAINTER*, 1908

Visual tour

KEY

> **TABLE** Matisse freely varies the viewpoint from which he sees various objects in the painting, as visual impact and harmony were much more important to him than conventional naturalism. The table is the most obvious example, being viewed from above whilst other objects are seen from eye level. In his essay *Notes of a Painter*, 1908, Matisse wrote, "Composition is the art of arranging in a decorative manner the diverse elements at the painter's command to express his feelings."

▲ **CLAY MEDALLION** The medallion is Matisse's first surviving piece of sculpture–a portrait of Camille Joblaud, a young woman he loved when he was a student. She bore him a daughter, Marguerite, in 1894, the same year that Matisse made the sculpture. Camille left him in 1897 and the following year he married another woman, Amélie Parayre, who became a loving adoptive mother to Marguerite. The medallion hung in Matisse's studio in Vence.

> **PULSATING PATTERN** The black, zigzagging lines create a vibrantly bold pattern against the red background, suggesting a discharge of electrical energy. Matisse wanted the whole of his picture surface to feel alive: "Expression, for me, does not reside in passions glowing in a human face or manifested by violent movement. The entire arrangement of my picture is expressive."

▲ **SHAPE AND COLOR** The sinuous, flowing lines of the bowl containing the fruit recall the Art Nouveau style, which was a major force in art at the turn of the century, when Matisse was taking his first steps as a painter. He was strongly influenced by it at the time, and echoes of the style recur in his work throughout his life. The vigor of the shapes here is matched by the lush beauty of the red and blue. Matisse had an extraordinary ability to place such rich colors against one another and make them harmonious rather than dissonant. As the art critic John Berger memorably put it, "he clashed his colors together like cymbals and the effect was like a lullaby."

◄ **VASE OF FLOWERS** Whereas the table is viewed from above, the vase is seen side on. Matisse loved flowers and often included them in his paintings, sometimes as the main subject but more often as a detail of a figure composition or an interior. He also regularly used floral motifs in his paper cutouts and his designs for stained glass—media that occupied much of his time in his final years.

▼ **COLOR BALANCE** The window shutter is rendered in a glowing orange punctuated with red stripes. In his writings on art, Matisse devotes a great deal of attention to color, which was of central importance to him. He was much concerned with achieving the exact balance of color and tone that satisfied him, and he did this intuitively, seeking "a living harmony of colors, a harmony analogous to that of a musical composition."

ON **TECHNIQUE**

Matisse's love of pure color and bold shapes found its final expression in a series of large paper cutouts—his principal form of working from 1951 until his death in 1954. Assistants brushed gouache (opaque watercolor) onto sheets of white paper and Matisse cut shapes out of these with scissors—he referred to the technique as "painting with scissors." The cutouts were pinned and then glued onto a background sheet of paper according to Matisse's directions, and this was later mounted on canvas.

▲ *La Tristesse du Roi*, Matisse, 1952, gouache-painted paper cut-outs on canvas, 115 × 152in (292 × 386cm), Musée National d'Art Moderne, Paris, France

IN **CONTEXT**

Matisse first made a major impact on the art world in 1905, when he and a group of young painters exhibited together in Paris. They were called Fauves ("wild beasts" in French) because they used bright, non-naturalistic colors and bold brushstrokes, as in this painting of the small fishing port of Collioure in the South of France. Such works seemed crude and vulgar to conservative eyes and attracted mockery, but Fauvism is now recognized as the first of the innovative movements that shaped modern art.

▲ *Open Window, Collioure*, Matisse, 1905, oil on canvas, 21¾ × 18in (55.3 × 46cm), National Gallery of Art, Washington DC, US

► **VIEW THROUGH WINDOW** A view through a window was a favorite motif in Matisse's work. In particular, he liked depicting tall windows that let in floods of strong Mediterranean light. He used this device at Coullioure in the south of France near the Spanish border, where he painted in the summer of 1905 (far right), as well as in numerous paintings set in his own homes on the French Riviera (he lived mainly in Nice but also for a time at Vence, a few miles inland). Even the dark colors in the garden here seem warmed by the sunshine.

Autumn Rhythm (Number 30)

1950 ■ ENAMEL ON CANVAS ■ 105 × 207in (266.7 × 525.8cm)
METROPOLITAN, NEW YORK, US

SCALE

JACKSON POLLOCK

Action painting, the physical engagement and emotional struggle of the artist with the canvas, is a hallmark of Jackson Pollock's work and is shown to exemplary effect in *Autumn Rhythm (Number 30)*. It is one of the artist's best-known drip paintings and its massive size and restless energy draw you into its complex web of swirls and splashes. With these dynamic works, Pollock revolutionized the way a painting was made. He abandoned the easel in favor of his studio floor, where he laid out his large canvases and flicked paint on them from the end of the brush, dripped it from sticks, or threw it on straight from the can. He worked in a spontaneous, yet highly

controlled, manner. In this painting Pollock appears to limit himself to four harmonious, earthy colors. These suggest the fading tones of the autumn landscape, while their energetic application hints at strong winds and swaying branches. Although Pollock dispensed with focal points, edges, and other conventional ideas of composition in his abstract works, the painting is neither wild nor chaotic. Layers of color combine in a rhythmic mesh of intricate patterns, flowing lines, and curves.

Photographs of Pollock at work in his studio on *Autumn Rhythm (Number 30)* show him moving around and over his canvas, reaching across it and swinging his arms or flicking his wrist to throw the paint down. This energetic form of action painting and Pollock's total absorption in the process created the powerful lines and arcs that are the characteristic feature of this work.

Influences

Pollock's innovative style drew on a wide range of diverse influences, from Picasso and aspects of Surrealism to the artists of the Mexican mural movement, such as Orozco and Siqueiros, as well as Jung's theories of the unconscious. He was also inspired by Native American artworks in New York museums and the ritual Navajo sand painting he saw in 1941. Indeed, Pollock's unusual working methods, which involved demanding physical activity as well as intense mental concentration, were often described as ritualistic.

This painting was made at the peak of Pollock's career, during a relatively settled period in his turbulent personal life. Its free, fluid style, subtle tones, and complex, web-like structure show his mastery of paint at its most expressive.

> These drip paintings by Pollock **are so full of things to look at…that you can't avert your eyes. They pour thoughts into your mind**

PAUL RICHARD *WASHINGTON POST*, 1998

JACKSON **POLLOCK**

1912–56

A leading American Abstract Expressionist, Jackson Pollock revolutionized art. His extraordinary drip paintings established him as one of the most original painters of his time.

Born in Cody, Wyoming, Pollock spent his childhood in Arizona. He moved to New York in 1930 and took classes at the Art Students League with painter Thomas Hart Benton. While making paintings, including landscapes, he worked in the mural division of the Federal Arts Project, part of a national funding program set up during the Depression. In his ongoing fight against severe alcoholism, Pollock sought treatment from a Jungian analyst. Paintings heavy with symbolism, such as *The She-Wolf* (1943) and *Guardians of the Secret* (1943), were included in his first one-man show at Peggy Guggenheim's Art of This Century gallery. Following his marriage to artist Lee Krasner in 1946, the couple moved from New York to Long Island, where Pollock made his first drip paintings in 1947. These abstract works were much larger than his previous canvases, giving him space for movement and self-expression. In 1956, depressed and still battling with alcoholism, Pollock died in a car crash.

Visual tour

KEY

◀ **AUTOMATISM** Pollock was influenced by Surrealist automatism—allowing the subconscious to guide the artist's hand. He once said, "When I am in my painting, I'm not aware of what I am doing." He did not start the painting with an image in mind, but allowed it to develop as he worked.

▲ **RESTRICTED PALETTE** Pollock preferred enamel house paint to artists' oils because it was more fluid. He only used four colors in this painting. He began by flicking thinned black paint on to the canvas from a stubby brush. The canvas was unprimed, so the paint sank in and the weave remained visible, adding texture to the work. An intricate network of white, brown, and blue-grey rhythmic lines was then built up over the black, making the black appear to come forward. If you look very closely, you can see that the thicker areas of paint dried slowly, giving them the texture of wrinkled skin.

◀ **SENSE OF MOVEMENT** The swirling tangle of lines, splashes, and dots looks explosive. Pollock's energetic, dance-like movements have been translated into dynamic sweeps of seemingly haphazard marks—elegant lines of diluted black paint collide and intersect with broader white and brown lines, smudges, and splatters. The whole canvas is full of movement; some marks are the result of chance, while others are not at all random, but carefully choreographed.

◀ **PERSONAL INVOLVEMENT**
The dazzling intricacy of the painting draws the viewer right into it. Although Pollock has painted an abstract work with no recognizable forms at all, you try to make sense of what you can see, following the switchback lines as they rise and fall, then double back upon themselves, like fireworks falling from the sky.

ON **TECHNIQUE**

Pollock made his drip paintings in a barn at his home in East Hampton, Long Island. His method was known as action painting. He unrolled a large canvas on the floor of his studio so that he could walk all the way around it and stretch across it to flick, pour, or throw paint where he wanted (see below). He even stepped on the canvas when necessary. His painting implements ranged from brushes and sticks to knives and turkey basters.

▲ *Pollock painting*, Hans Namuth, 1950

IN **CONTEXT**

In 1939, while undergoing treatment for alcoholism, Pollock began to take his drawings along to therapy sessions, exploring possible interpretations with his Jungian analyst. As an artist, he was interested in the idea that creative impulses came directly from the unconscious. He was also intrigued by the Surrealist automatism of André Masson, who advocated abandoning conscious control in order to create random images (see below).

In 1946, Pollock began to focus exclusively on the act of making a painting rather than worrying about its figurative or symbolic content. This was the turning point in his career, when he forged his distinctive personal style.

▶ **ALL-OVER COMPOSITION** There is no focal point in the composition and the center of the painting is no more important than the edges. Pollock said that his paintings had "no beginning or end" and they have been described as "all-over compositions." *Autumn Rhythm (Number 30)*'s huge size evokes the epic landscapes of the American West, where Pollock grew up.

▲ *Automatic Drawing*, André Masson, c.1924–25, Indian ink on paper, 9½ × 10¾in (24.2 × 27.1cm), on loan to the Kunsthalle, Hamburg, Germany

Untitled

c.1950-52 ▪ OIL ON CANVAS ▪ 74¾ × 39¾in (190 × 101cm) ▪ TATE, LONDON, UK

MARK ROTHKO

SCALE

Glowing softly and mysteriously, with hazy forms that seem to pulsate gently, this sonorous canvas conveys a feeling of exalted contemplation. Its creator, Mark Rothko, was one of a loose group of American painters, now known as Abstract Expressionists, who changed the course of art in the late 1940s and 1950s. Before this, abstract art had always been something of a minority—even esoteric—taste, but the success of these painters put it center stage in world art. Their paintings were often very large, but they were even more remarkable for their emotional intensity. To these painters, abstract art was not a matter of arranging shapes and colors, but of conveying deep feelings about the human condition.

None of them cared more passionately about their art than Rothko—a melancholy, solemn, temperamental character. He said that his paintings were about "expressing basic human emotions—tragedy, ecstasy, doom, and so on," and although they are often tranquil in feeling, he found working on them intensely effortful ("torment," he once said). Even when they were finished, the struggle was not over, as he liked to have control over how they were hung and lit. He thought that ideally his paintings should be arranged in groups filling a whole room, without the presence of work by other artists.

MARK **ROTHKO**

1903-70

Rothko was one of the leading figures in a group of American abstract painters whose success helped New York replace Paris as the world capital of progressive art.

Born in Russia as Marcus Rothkowitz, Rothko settled in the US with his family when he was 10. He was mainly self-taught as an artist. Early in his career, his work showed varied influences, including Expressionism and Surrealism, but from the late 1940s, he developed the distinctive style of abstraction for which he became famous. Like many other American artists of his generation, he struggled during the Great Depression of the 1930s and also during the 1940s. However, in the 1950s, he finally gained critical and financial success. The seal was set on his reputation in 1961 when he had a major one-man exhibition at the Museum of Modern Art, New York (the world's most prestigious institution of its kind). In spite of enjoying great acclaim, Rothko became increasingly depressed (he had various personal problems, including overindulgence in alcohol, tobacco, and barbiturates), and he committed suicide in his studio in 1970.

Visual tour

KEY

▶ **VARIED YELLOWS**
Rothko's paintings may look simple, but he made them with great care, first in the planning stage and then in the actual application of paint. He used layer after layer to create the subtle variations in color, tone, and texture he desired.

1

2

3

▲ **LINE** Just above center, a horizontal line shows the delicate modulations of Rothko's brushwork. A dedicated craftsman, he kept favorite brushes for many years. Contrary to what some say, he did not use sponges to apply paint.

◀ **NATURE COMPARISON**
Rothko disliked the notion that his paintings could be interpreted as abstracted landscapes. Still, to many observers they evoke the mystery and vast spaces of nature, as in a view over an ocean to a distant horizon. The blurred brushwork can suggest waves or mist.

Marilyn

1967 ▪ SCREENPRINT ON PAPER ▪ 35¾ × 35¾in (91 × 91cm) ▪ TATE, LONDON, UK

ANDY WARHOL

SCALE

Shortly after the death of Marilyn Monroe in 1962, Warhol began work on his series of portraits of the actress. He transformed a single image—a black-and-white publicity still from the 1953 film *Niagara*—into an array of prints and paintings. In the original photo, Monroe seemed glamorous and carefree, but Warhol's alterations created a range of moods. In some images, Marilyn was exalted, like a religious icon, while in others she was turned into a grotesque victim of the celebrity culture that had brought her fame.

The high priest of Pop

Warhol mined a rich vein of new, popular imagery. Previous generations of artists had reached a saturation point in their attempts to shock. As Pop artist Roy Lichtenstein remarked, "It was hard to get a painting, which was despicable enough, so that no one would hang it. Everyone was hanging everything." Despite this attitude, the art world remained snobbish about one area of creative endeavor—commercial art. Critics paid no attention to advertisements, to labels and packaging, or grainy newspaper photos. Warhol had cut his teeth on this type of work and recognized its potential. From the 1960s, he focused on "comics, celebrities, refrigerators, Coke bottles—all these great modern things that the Abstract Expressionists tried so hard not to notice at all." Warhol's treatment of this imagery cast the objects in a new light. The rows of soup cans resembled the stacked shelves of a supermarket, while the smudged, fading strips of Marilyn photos underlined the illusory nature of stardom.

ANDY **WARHOL**

1928–87

The most celebrated exponent of Pop art, Warhol rose to prominence in the 1960s. He gained notoriety with his iconic images of movie stars, soup cans, and Coke bottles.

Andy Warhol (originally Andrew Warhola) was born to East European immigrants in Pittsburgh, and trained at the Carnegie Institute of Technology. Moving to New York, he became an award-winning commercial illustrator. Reacting against the highly personal, handmade art of the Abstract Expressionists, he began to create work that seemed mass produced, impersonal, and disposable. In a deliberate bid to counter the traditional association of the artist with craftsmanship and individuality, he used assistants and named his studio "The Factory."

Visual tour

KEY

◀ **LIPS** In traditional portraiture, every care is taken to perfect the completed picture. Warhol did the opposite. He deliberately mimicked the printing blemishes. Here, the pink blob of color does not precisely correspond with Marilyn's lips, and the artist has consciously neglected to whiten her teeth.

ON **TECHNIQUE**

Warhol produced many of his most memorable images using the silkscreen process. This type of screenprinting had been widely employed since the early 20th century, when it played a major role in textile production. Warhol had used the process in his own commercial work, but soon found that it was equally suitable for fine art, because "you get the same image slightly different each time." A photographic image was transferred onto a fine mesh screen, where it served as a form of stencil. The screen was placed over canvas or paper, and then paint was pushed through the mesh using a squeegee—a rubber blade. The paint was prone to clogging, but Warhol made a virtue of these accidental blemishes.

▲ **EYES** Warhol manipulated his source photo, here exaggerating the cosmetic elements to create a grotesque parody of conventional notions of beauty. Marilyn's eye-shadow, like her lipstick, is overpainted with a crude slab of color, while her peroxide hair is the same bilious shade of yellow as her eye.

▲ **HAIRLINE** Warhol did his utmost to make the real appear unreal. A firm, schematic line separates Marilyn's face from her hair, and neither component appears genuine. Her face resembles a mask and her hair looks like a wig. Their artificial appearance is emphasized further by the flat, unnatural colors.

To a Summer's Day

1980 ▪ ACRYLIC ON CANVAS ▪ 45½ × 110½in (115.5 × 281cm) ▪ TATE, LONDON, UK

SCALE

BRIDGET RILEY

One of Riley's most beguiling works, this painting takes its title from a Shakespeare sonnet: "Shall I compare thee to a summer's day?" Fittingly, the picture does precisely that. It conjures up memories of warm and sunny days during the artist's early years in Cornwall, "swimming through saucer-like reflections, dipping, and flashing on the sea surface."

A pioneer of Op art

Riley had forged her reputation 15 years earlier working in the heady atmosphere of the "Swinging Sixties" in London. There, she joined the vanguard of the Op art movement, which explored the artistic possibilities of visual illusions. For a brief period, this style was hugely popular in Britain and the United States. It influenced many branches of the arts, coinciding with a taste for eye-catching, psychedelic effects. Op art designs could be found on women's fashions, wallpapers, album covers, and commercial packaging. One American company even pirated a Riley composition for their range of clothing.

In her later work, Riley distanced herself from some of these trends. With the introduction of color, she began to create far more subtle effects. Basing her compositions on the simplest components—often just parallel bands of curved or vertical lines—she exploited the interaction between adjacent colors to create a calming sense of movement, rhythm, and depth. Even though her mature work is entirely abstract,

Riley's paintings often represent her response to the physical world. As she explained, "I draw from nature, although on completely new terms. For me, nature is not a landscape, but the dynamism of visual forces—an event rather than an appearance."

BRIDGET **RILEY**

1931–

One of the pioneers of the Op art movement, which blossomed in the 1960s, Riley is a major force in British art. She is famed for her mesmerizing, large-scale paintings.

Though born in London, Riley was influenced more by her childhood years in Cornwall, during World War II. These instilled in her a profound love of nature, which was to shape the future course of her art. On her return to the capital, she trained at Goldsmiths' College and the Royal College of Art. She had an early interest in the shimmering, optical effects achieved by Georges Seurat (see pp.172–75), but her own experiments soon took her into more abstract territory. Riley's breakthrough came with a series of dazzling, black-and-white pictures in the early 1960s. These created a huge impression at *The Responsive Eye*, a keynote exhibition for the Op art movement. Riley's later paintings relied less on optical trickery. Memories of Cornwall, as well as a seminal trip to Egypt in 1981, both had a telling effect on her style. Her paintings have been used to adorn public buildings and in the theater.

Visual tour

KEY

▼ **OPTICAL ILLUSIONS** From the 1970s, Riley produced a series of paintings of waves rippling the sea. She made a pattern of curved lines, which narrow and broaden at intervals. Diagonals, formed by the crest of each wave, add to the impression of a gentle swell of water.

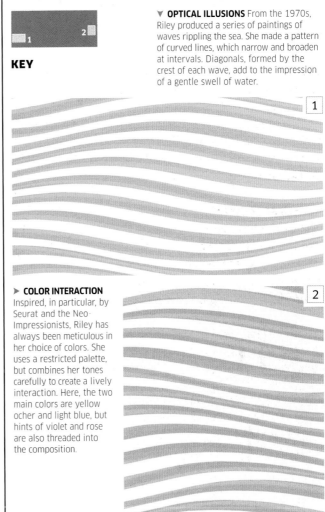

▶ **COLOR INTERACTION** Inspired, in particular, by Seurat and the Neo-Impressionists, Riley has always been meticulous in her choice of colors. She uses a restricted palette, but combines her tones carefully to create a lively interaction. Here, the two main colors are yellow ocher and light blue, but hints of violet and rose are also threaded into the composition.

ON **TECHNIQUE**

Riley's compositions are structured and precise, a tribute to her rigorous preparation methods. She begins by making small studies in gouache to test out her color combinations. If the results are satisfactory, she proceeds to create a full-size cartoon, outlined in pencil and gouache. She draws out the cartoon on cartridge paper, on the floor. Riley then hangs it on her studio wall, so that she can study its effects in detail. In view of the size of her pictures, she often uses templates, made out of hardboard, to help with the preparation of the cartoon and the final painting. On some occasions, she also employs assistants.

The Dance

1988 ▪ ACRYLIC ON PAPER LAID ON CANVAS ▪ 83½ × 107¾in (212.6 × 274cm) ▪ TATE, LONDON, UK

PAULA REGO

SCALE

By the silvery light of a full moon, we see a group of figures dancing by a seashore. Painted in blues and greys, with splashes of intense color, the scene is bathed in an eerie glow that suggests an episode from a dream or a Surrealist fantasy. The dancing figures are short and stocky and their movements and dress are reminiscent of traditional folk dances and the fashions of the 1950s. Looming behind them on a rocky outcrop a sinister, fortress-like building adds to the strange, unsettling mood of the painting.

Stories and memories

Some of Paula Rego's best-known works draw upon folk and fairy tales; in others she creates ambiguous, uncomfortable images connected with her childhood memories, fantasies, and personal fears. Their narratives change and evolve as Rego works on her paintings and their meaning is rarely clear or resolved. Painted on an epic scale, *The Dance* appears to contain autobiographical references to Rego's Portuguese upbringing—primarily in the figure of the adolescent girl on the left—but the focus of this expressive and symbolic painting is the role of women. It represents the cycle of female life, from childhood to sexual maturity, motherhood, and old age. The composition bears a marked similarity to that of *The Dance of Life*, 1899-1900, by the Norwegian Symbolist painter Edvard Munch, which also shows groups of people dancing by a moonlit sea, with a figure of innocence on the left.

In contrast with the enduring solidity of the rock and building in the background, the dancers twirl and sway. The oddly proportioned figures, distorted perspective, and uneasy atmosphere are all hallmarks of Rego's distinctive style.

PAULA **REGO**

1935–

Rego was born in Portugal but has spent most of her life in Britain. A leading contemporary painter and printmaker, she creates subversive images based on storytelling.

The only child of wealthy parents, Rego grew up in Portugal, then attended an English finishing school. She trained at the Slade in London, where she met the artist Victor Willing, whom she later married. An accomplished draftswoman, Rego has developed a style of narrative painting that draws on real or imagined events, stories from her childhood, and fairy tales. For her large-scale figurative paintings she draws inspiration from specially made props and models in costume. Themes of sexuality, control, and submission recur in her work, such as *The Policeman's Daughter*, 1987. The Casa das Histórias (House of Stories) in Cascais, Portugal, is dedicated to her art.

Visual tour

KEY

▼ **DARK BUILDING** In Rego's preliminary drawings, this building looked more like a castle. Its shape has been simplified and it is an oppressive and solid presence in the composition. Its meaning, as with other elements in the work, is very much open to interpretation.

◀ **COUPLE** The young couple dancing cheek-to-cheek convey a feeling of nostalgia, possibly for the artist's past. The bright yellows of the woman's clothes are intensified by the blues of the landscape and the grey of the suit.

◀ **YOUNG GIRL** Absorbed in the dance, the girl in Portuguese dress may represent the young Rego. Her white blouse and petticoats suggest inexperience. She is larger than the other figures, perhaps to signify her importance as the central character.

▲ **CIRCLE OF LIFE** The three figures dancing in a circle with their hands joined together look like a child, her mother, and her grandmother. Together, they represent the three main stages of a woman's life.

Athanor

2007 ■ EMULSION, SHELLAC, OIL, CHALK, LEAD, SILVER, AND GOLD ON CANVAS
■ 30 × 15ft (9.15 × 4.56m) ■ LOUVRE, PARIS, FRANCE

SCALE

ANSELM KIEFER

A naked man is lying flat on his back on the ground, with his arms by his sides. It is not clear whether he is dreaming or dead. Rising above him and filling almost the entire space in this massive painting is the swirling, star-studded cosmos, to which his body is connected by a silvery thread of light. Kiefer uses a restricted palette and the work is monochrome, apart from tiny glimpses of blue and the reddish-brown earth that cakes the foreground. Horizontal lines of gold and silver break up the composition and the surface is dusted with silver and gold powder. As in other works, the artist has added words that are integral to the composition in his spidery handwriting.

This is a painting that poses fundamental questions about man's place in the universe and explores notions of space, time, and memory, as well as the transcendent power of art. The title, *Athanor*, refers to the furnace used by medieval alchemists to try to transform base metals into gold. The term was also sometimes used to describe the quest for spiritual rebirth. Kiefer gave the same title to earlier paintings, and the theme of transformation has been a recurrent motif throughout his work.

After the success of Kiefer's *Falling Stars* exhibition at the Grand Palais in Paris in 2007, which included a similar work, *Athanor* was commissioned by the Louvre for the permanent collection—the first piece to be commissioned by the museum since Georges Braque painted a ceiling in 1953, and an acknowledgement of Kiefer's international reputation. The artist made two sculptures, incorporating lead and sunflowers, to complement the painting, which is enclosed in an arch at the top of a staircase. These works

Visual tour

KEY

▼ **SELF-PORTRAIT** The head of the foreshortened naked male bears a strong resemblance to Kiefer. Indeed, in a 2007 interview when the work was first exhibited, the artist described the painting as a self-portrait, as well as an image of mankind. He said, "I am that man...man is linked to the universe, he is in metamorphosis, he will be reborn. But it is a sad work as he does not know why he is reborn."

▶ **THREAD OF LIGHT** A filigree shaft of light connects the figure to the sky and may also run down through the body into the earth. The light enters through the solar plexus, the place where *prana*—the life force—is stored, according to Eastern traditions such as yoga. The silvery thread helps to create a strong upward movement in the painting and links man and the universe: the microcosm and the macrocosm of esoteric thought.

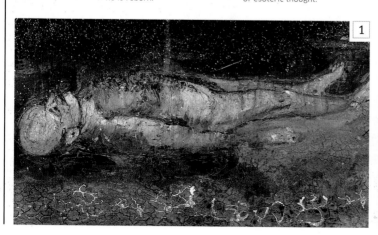

▲ **SILVER AND GOLD** Thick layers of black paint evoke the depths of the cosmos. The stars are pinpricks of light that appear to recede into infinity. Kiefer has used silver and gold powder; its lightness balances the heavy paint.

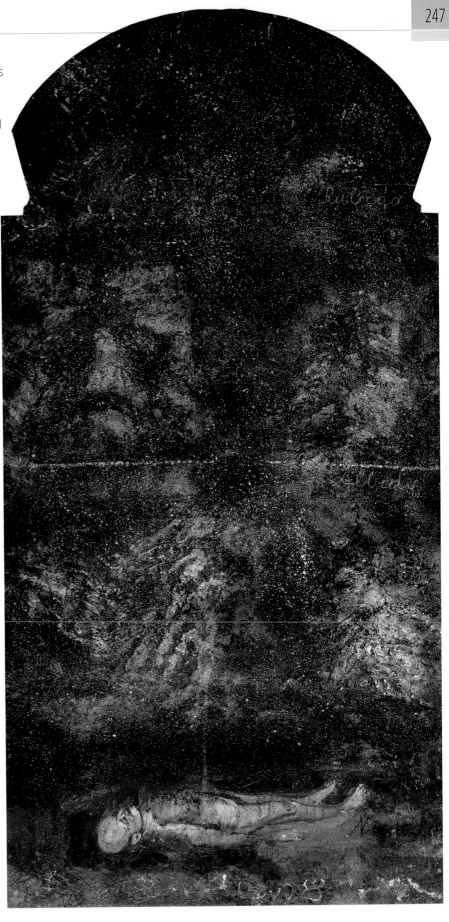

also allude to changing states: *Danaë*, a princess seduced by Zeus in the form of a golden rain shower; and *Hortus Conclusus* ("enclosed garden" in Latin), which was a medieval symbol of Mary's virginity and of paradise.

ANSELM **KIEFER**

1945–

Drawing largely on German mythology and history, Kiefer's paintings and sculptures blend imagery and medium to explore questions about human existence.

Born in Donaueschingen, Germany, Kiefer had a varied and intermittent training in art. Most of his works from the 1960s to the 1990s were based on German history, myth, and culture, often exposing the Third Reich's use of nationalistic imagery. Kiefer is best known for his vast paintings, which are often layered with thick paint, lead, minerals, and dried plant matter. Since the late 1960s, as well as paintings, drawings, and photographs, he has created many large-scale artist's books. Kiefer moved to the South of France in 1992. He has exhibited worldwide, and currently lives in Paris.

▼ **SCRIPT** Three hand-painted words can be seen at the right-hand side. Reading from bottom to top, they are: *nigredo*, *albedo*, and *rubedo*. These Latin terms correspond to the three main stages of the alchemical process and their associated colors—black, white, and red.

▲ **ROUGH TEXTURES** The thick, raised surface at the bottom of the painting is made of reddish soil from the artist's former home in southern France. Kiefer has poured molten lead into the cracks of its rough surface, creating a series of solidified rivulets, like hieroglyphics. Lead was the base material and starting point of the alchemical process.

Glossary

ABSTRACT ART
Art that does not represent recognizable objects or scenes.

ABSTRACT EXPRESSIONISM
A type of abstract painting that emerged in New York in the 1940s and dominated American art through the 1950s. Abstract Expressionists mainly used large canvases and emphasized the sensuousness of paint.

ACADEMIC ART
Western art produced from the 16th century onward by artists trained at professional schools (academies). These tended to foster tradition rather than originality, so the phrase "academic art" is often used pejoratively.

ALLEGORY
A work of art in which the surface meaning is used as a metaphor to convey an abstract idea, often a spiritual or moral truth.

ALTARPIECE
A painting or other work of art placed on, above, or behind the altar in a Christian church. Altarpieces often depict multiple scenes, typically showing episodes from the Bible, or lives of saints *See also* predella.

ART NOUVEAU
A decorative style that spread throughout Europe at the end of the 19th century and the beginning of the 20th century. It featured curved shapes derived from tendrils, plant stems, flames, waves, and flowing hair.

AUTOMATIC DRAWING
A type of drawing in which the artist suppresses conscious control, to let the hand move randomly across the page, revealing the workings of the subconscious.

BAROQUE
The dominant artistic style during the 17th century (and in some places well into the 18th century). The style is characterized by rhetoric, intense emotion, and a sense of movement.

BRÜCKE, DIE (THE BRIDGE)
Pioneering group of German Expressionist artists, formed in Dresden in 1905 and disbanded in 1913. The leading member was Ernst Ludwig Kirchner.

BYZANTINE ART
Art produced in the Byzantine Empire (and in territories under its influence). The empire lasted from 330 to 1453. Byzantine art was overwhelmingly religious in subject, and highly formal and conservative in style.

CHIAROSCURO
A term (Italian for "light-dark") describing the use of strongly contrasting areas of light and shadow in a painting. Caravaggio was notable for his use of chiaroscuro.

CLASSICAL ART
The art and architecture of Greek and Roman antiquity and later art inspired by it. In its broadest sense, classical art describes art that is created rationally rather than intuitively, and in which adherence to traditional ideals takes precedence over personal expression.

COMPLEMENTARY COLORS
Colors that are considered the "opposite" of each other. The complementaries of the three primary colors (blue, red, and yellow) are made up of a mixture of the other two—so red is the complementary of green, which is made up of blue and yellow. When they are used next to each other, complementary colors appear to be stronger and more vibrant.

COMPOSITION
The arrangement of the various parts of a painting or other work of art to form a satisfactory whole.

CUBISM
A revolutionary and highly influential type of painting that was developed in 1907–14 in Paris by Braque and Picasso. Cubist paintings abandoned the fixed viewpoint that had dominated Western art since the Renaissance. Instead, objects are seen from multiple viewpoints, and forms are fragmented and rearranged.

DIVISIONISM
See pointillism.

ENLIGHTENMENT
An 18th-century philosophical movement in Europe that placed great value on reason.

EN PLEIN AIR
A term (French for "outdoors"), used to describe the practice of painting outdoors.

EXPRESSIONISM
Art in which the artist's subjective reactions and emotions take precedence over observed reality. Color and form are often distorted or exaggerated.

FAUVISM
A short-lived but influential movement in French painting, launched in 1905. The Fauves ("wild beasts" in French) were so called because they used fierce, expressive colors. Matisse was the leading figure of the group.

FIGURATIVE ART
Art that depicts recognizable scenes and objects. It is the opposite of abstract art.

FOCAL POINT
The place in a composition to which the eye is drawn most naturally.

FRESCO
A technique of painting on walls (and ceilings) in which pigments mixed with water are applied to wet plaster.

GENRE PAINTING
A painting that shows a scene from daily life, particularly popular in 17th-century Holland.

GLAZE
In painting, a transparent layer of thin paint (usually oil paint) that is applied over another layer to modify the color and tone.

GOTHIC
The style of art and architecture that flourished in most of Europe from the mid-12th to the early 16th century. Gothic architecture is characterized by pointed arches and elaborate tracery.

GOUACHE
Opaque type of watercolor, also called body color.

HIGH RENAISSANCE
The period from c.1500 to c.1520, when the great Renaissance painters Leonardo, Michelangelo, and Raphael were all working.

HISTORY PAINTING
Painting depicting momentous or morally significant scenes from history, myth, or great literature. For centuries history painting was traditionally considered the highest branch of the art.

ICON
A sacred image. The term is particularly applied to small pictures of saints and other holy personages in Byzantine art.

IMPASTO
Thick, textured brushwork applied with a brush or a knife. Many of Rembrandt's paintings contain impasto passages.

IMPRESSIONISM
A movement in painting that started in France in the late 1860s and spread widely over the following half century. Rather than producing detailed, highly finished paintings, the Impressionists worked with freshness and spontaneity, using broken brushwork to capture an "impression" of what the eye sees.

LINEAR
A term used to describe a work of art in which line (rather than mass or color) predominates.

MINIATURE
A term applied to two distinct types of small painting: illustrations in manuscript books (in Eastern as well as Western art); and portraits that are small enough to be held in the palm of the hand or worn as jewelery. The latter were popular in Europe from the 16th century.

MODELING
Creating the illusion of three-dimensional form in a painting.

NATURALISTIC
A term for art that looks realistic, faithfully imitating forms in the natural world.

NEOCLASSICISM
A movement based on Ancient Greek and Roman art that began in the mid-18th century, partly as a reaction to the frivolities of Rococo. It is characterized by seriousness of mood and clarity of form.

OP ART
A type of abstract art, popular in the 1960s, that used hard-edged flat areas of paint to stimulate the eye and create an impression of movement.

ORIENTALISM
The imitation or depiction of Eastern culture in Western art. The term often refers specifically to a fashion in 19th-century art (especially in France) for exotic imagery taken from the Near and Middle East and North Africa.

PAINTERLY
A approach to painting in which the artist sees in terms of color and tone rather than line. It is the opposite of linear.

PERSPECTIVE
A method of suggesting depth on a two-dimensional surface, by using such optical phenomena as the apparent convergence of parallel lines as they recede from the viewer.

PIETÀ
A term (Italian for "pity") applied to a painting or sculpture showing the Virgin Mary supporting the body of the dead Christ.

PIGMENT
The coloring matter, originally often made from clays or ground minerals, that is mixed with a binding agent, such as egg or oil, to make paint.

POINTILLISM
A technique of painting with dots of pure color that, when viewed from a suitable distance, appear to merge together to create a new color. Also called divisionism.

POP ART
Art that makes use of the imagery of popular culture, such as comic strips and packaging. Pop Art began in Britain and the US in the 1950s and flourished in the 1960s.

POSTIMPRESSIONISM
A term applied to various trends in painting arising from and after Impressionism in the period c.1880–1905. Cézanne, Gauguin, van Gogh, and Seurat are generally considered to be the leading Postimpressionist painters.

PREDELLA
A small painting or series of paintings set horizontally below the main part of an altarpiece.

REALISM
A mid-19th century French movement, in which contemporary subject matter, including urban and rural life, was painted in a sober and unidealized manner.

RENAISSANCE
A rebirth of the arts and learning that occurred from the end of the 14th century to the end of the 16th century, especially in Italy, the Germanic states, and Flanders. It was inspired by the classical cultures of Rome and Greece and informed by scientific advances, especially in anatomy and perspective. In Italy, the period is usually divided into the Early Renaissance until c.1500, the High Renaissance until c.1520, and the Late Renaissance until c.1580.

ROCOCO
A lighter and more playful development of the Baroque style that emerged c.1700. In some parts of Europe the style flourished until almost the end of the century, but in France, for example, taste turned to the severe Neoclassicism from about 1760.

ROMANTICISM
A broad movement in the visual arts, music, and literature in the late 18th and early 19th centuries. Romantic artists reacted against the reason and intellectual discipline of Neoclassicism and the Enlightenment. Instead, they celebrated individual experience and expression, and often sought inspiration in nature and landscape.

SALON
An official French painting exhibition, first held in 1667. In 1881 the government withdrew support, and it began to lose prestige to independent exhibitions—including the Salon d'Automne and the Salon des Indépendants.

SALON D'AUTOMNE
An annual exhibition first held in Paris in 1903. The Fauves made their public debut there in 1905.

SALON DES INDÉPENDANTS
An annual exhibition that was first held in Paris in 1884. Seurat was the most important figure in establishing it.

SALON DES REFUSÉS
A controversial exhibition held in Paris in 1863 on the orders of Napoleon III, to show works rejected from the official Salon.

SATURATED
A term for color that is concentrated and undiluted, so at its most intense.

SFUMATO
A term (Italian for "faded away") used to describe the blending of tones so subtly that there are no perceptible transitions—like smoke fading into the air.

SURREALISM
An artistic, literary, and political movement that flourished in the 1920s and 1930s, initially in France and then in several other European countries and in the US (it was the most widespread and influential avant-garde movement in the period between the two world wars). The main aim of Surrealism was to liberate the creative powers of the subconscious; it was envisaged as a way of life rather than a matter of style.

SYMBOLISM
Loose term for an artistic and literary movement that flourished from about 1885 to 1910. Symbolist artists favored subjective, personal representations of the world and were often influenced by mystical ideas.

TEMPERA
A binding medium, usually egg yolk, mixed with pigment. In Italy, egg tempera was the standard medium used for panel paintings from the 13th to the 15th century.

TRIPTYCH
A picture consisting of three panels, which are often hinged so that the outer wings can fold over the central panel.

VANISHING POINT
A term used in relation to perspective to denote an imaginary point in a painting toward which lines seem to converge as they recede from the viewer.

Index

Acknowledgments

Dorling Kindersley would like to thank the following for their assistance with the book: Megan Hill, Anna Fischel, Satu Fox, Simone Caplin, Neha Gupta, Bincy Mathew, and Priyaneet Singh for editorial assistance; Margaret McCormack for compiling the index; Lucy Wight for design assistance; Sarah and Roland Smithies (luped.com) for picture research; Adam Brackenbury for creative technical support; and Peter Pawsey for colour correction.

The publisher would like to thank the following for their kind permission to reproduce their photographs.

Key: a = above; b = below/bottom; c = centre; f = far; l = left; r = right; t = top

Achim Bunz. **127** Bayerische Schlösserverwaltung: Munich (br). Photo Scala, Florence: The Metropolitan Museum of Art / Art Resource (cr). **128-29** The National Gallery, London. **129** Getty Images: Science & Society Picture (crb). **130-31** The National Gallery, London. **131** Getty Images: (br). **132-33** © Royal Museums of Fine Arts of Belgium, Brussels: J. Geleyns / www.roscan.be. **132** Corbis: Summerfield Press (crb). **134-35** © Royal Museums of Fine Arts of Belgium, Brussels: J. Geleyns / www.roscan.be. **135** akg-images: Erich Lessing (br). **136-37** Photo Scala, Florence. **138-39** Photo Scala, Florence: White Images. **139** Corbis: Alinari Archives (br). **140-41** Photo Scala, Florence: White Images. **141** Photo Scala, Florence: Courtesy of the Ministero Beni e Att. Culturali (br). **142-43** Photo Scala, Florence. **143** Getty Images: (br). **144-45** Photo Scala, Florence. **145** Photo Scala, Florence: (br). **146-47** Corbis. **146** Corbis: The Gallery Collection (cr). **148-49** The National Gallery, London. **148** Getty Images: Hulton Archive (cb). **150-51** The National Gallery, London. **151** V&A Images / Victoria and Albert Museum, London: (cr). **152-53** Photo Scala, Florence: The National Gallery, London. **153** Getty Images: Imagno (crb). **154-55** Photo Scala, Florence: The National Gallery, London. **156-57** RMN: Gérard Blot / Hervé Lewandowski. **157** Corbis: Hulton-Deutsch Collection (crb). **158-59** RMN: Gérard Blot / Hervé Lewandowski. **159** Photo Scala, Florence: The Metropolitan Museum of Art / Art Resource (cr). **160-61** Photo Scala, Florence: White Images. **161** Getty Images: Time & Life Pictures (br). **162-63** Photo Scala, Florence: White Images. **163** Getty Images: (br). **164** Corbis: (crb). **164-65** Photo Scala, Florence: White Images. **166-67** Photo Scala, Florence: White Images. **167** Image Courtesy National Gallery Of Art, Washington: Harris Whittemore Collection (br). **168-69** Photo Scala, Florence. **168** Corbis: The Gallery Collection (crb). **170-71** Photo Scala, Florence. **171** Harvard Art Museums: Fogg Art Museums, Bequest of Meta and Paul J. Sachs, 1965.263 / Allan Macintyre © President and Fellows of Harvard College (br). **172-73** Photography © The Art Institute of Chicago: Helen Birch Bartlett Memorial; Collection, 1926.224. **173** akg-images: (br). **174-75** Photography © The Art Institute of Chicago: Helen Birch Bartlett Memorial; Collection, 1926.224. **175** Photography © The Art Institute of Chicago: Gift of Mary and Leigh Block, 1981.15 (cr). Photo Scala, Florence: The National Gallery, London (br). **176-77** The National Gallery, London. **177** Corbis: The Gallery Collection (crb). **178-79** The National Gallery, London. **179** akg-images: (br). **180-81** Photography © The Art Institute of Chicago: Robert A. Waller Fund, 1910.2. **180** Photo Scala, Florence: The Metropolitan Museum of Art / Art Resource (cra). **182-83** Photograph © 2011 Museum of Fine Arts, Boston: Tompkins Collection–Arthur Gordon Tompkins Fund, 36.270. **183** Corbis: Francis G. Mayer (tr). **184-85** Photograph © 2011 Museum of Fine Arts, Boston: Tompkins Collection–Arthur Gordon Tompkins Fund, 36.270. **185** Corbis: The Gallery Collection (br). **186-87** Photo Scala, Florence. **186** Corbis: Condé Nast Archive (crb). **188-89** Photo Scala, Florence. **189** Photo Scala, Florence: The Metropolitan Museum of Art / Art Resource (br). **190-91** © Tate, London 2011. **192-93** Photo Scala, Florence: The National Gallery, London. **192** Wikipedia: (tr). **194-95** Philadelphia Museum Of Art, Pennsylvania: Purchased with the W. P. Wilstach Fund, 1937. **195** Corbis: Francis G. Mayer (br). **196-97** Philadelphia Museum Of Art, Pennsylvania: Purchased with the W. P. Wilstach Fund, 1937. **197** The Bridgeman Art Library: Henry Moore Foundation (br). **198-99** Photo Scala, Florence: Austrian Archives. **198** Getty Images: Hulton Archive (br). **200-01** Photo Scala, Florence: Austrian Archives. **201** Getty Images: DEA / W.BUSS (br). **202-03** akg-images: © ADAGP, Paris and DACS, London. **202** Corbis: Bettmann (cb). **204-05** akg-images: © ADAGP, Paris and DACS, London. **205** akg-images: (cr, br). **206-07** Photo Scala, Florence: Neue Galerie New York / Art Resource. **206** Kirchner Museum Davos, www.kirchnermuseum.ch: Ernst Ludwig Kirchner, Self-portrait, c.1919, photograph (cra). **208-09** National Gallery Of Canada, Ottawa: Musée des beaux-arts du Canada. **209** Library and Archíves Canada: PA-121719 (cra). **210-11** Photo Scala, Florence: Photo Art Media / Heritage Images. **211** Corbis: Walter Henggeler / Keystone (br). **212-13** The University of Arizona Museum of Art & Archive of Visual Arts, Tucson: Gift of Oliver James, 1950.001.004 © Georgia O'Keeffe Museum / DACS, London 2011. **212** Corbis: Bettmann (cra). Photo Scala, Florence: The Metropolitan Museum of Art / Art Resource / © Georgia O'Keeffe Museum / DACS, London 2011 (br). **214-15** © Tate, London 2011: © 2011 Tate, London / Salvador Dali, Fundació Gala-Salvador Dali, DACS, 2011. **215** Corbis: Bettmann (tr). **216-17** © Tate, London 2011: © 2011 Tate, London / Salvador Dali, Fundació Gala-Salvador Dali, DACS, 2011. **217** Photo Scala, Florence: Courtesy of the Ministero Beni e Att. Culturali (br). **218-19** Museo Nacional Centro de Arte Reina Sofía, Spain: © Succession Picasso / DACS, London 2011. **219** The Bridgeman Art Library: Private Collection / Roger-Viollet, Paris (crb). **220-21** Museo Nacional Centro de Arte Reina Sofía, Spain: © Succession Picasso / DACS, London 2011. **221** The Bridgeman Art Library: Christie's Images (cra). **222-23** Photography © The Art Institute of Chicago: Friends of American Art Collection, 1942.51 / © Heirs of Joephine N. Hopper. **223** Corbis: Oscar White (br). **224-25** Photography © The Art Institute of Chicago: Friends of American Art Collection, 1942.51 / © Heirs of Joephine N. Hopper. **225** Photo Scala, Florence: The Metropolitan Museum of Art / Art Resource (br). **226-27** Museo Dolores Olmedo: © 2011 Banco de México Diego Rivera Frida Kahlo Museums Trust, Mexico, D.F. / DACS. **226** Getty Images: Popperfoto (crb). **228-29** Museo Dolores Olmedo: © 2011 Banco de México Diego Rivera Frida Kahlo Museums Trust, Mexico, D.F. / DACS. **229** The Bridgeman Art Library: Detroit Institute of Arts, USA / © 2011 Banco de México Diego Rivera Frida Kahlo Museums Trust, Mexico, D.F. / DACS (crb, br). Corbis: Susana Gonzalez / dpa (cra). **230-31** The Bridgeman Art Library / Kunstsammlung Nordrhein-westfalen: © Succession H Matisse / DACS, London 2011. **230** Corbis: Bettmann (cr). **232-33** The Bridgeman Art Library / Kunstsammlung Nordrhein-westfalen: © Succession H Matisse / DACS, London 2011. **233** Image Courtesy National Gallery Of Art, Washington: Collection of Mr and Mrs John Hay Whitney / © Succession H Matisse / DACS, London 2011 (br). Photo Scala, Florence: White Images / © Succession H Matisse / DACS, London 2011 (cra). **234-35** Photo Scala, Florence: The Metropolitan Museum of Art / Art Resource © ARS, NY and DACS, London 2011. **235** Getty Images: Arnold Newman Collection (crb). **236-37** Photo Scala, Florence: The Metropolitan Museum of Art / Art Resource © ARS, NY and DACS, London 2011. **237** The Bridgeman Art Library: Hamburg Kunsthalle, Hamburg, Germany (br). Getty Images: Martha Holmes / Time Life Pictures (cra). **238-39** © Tate, London 2011: © 1998 Kate Rothko Prizel & Christopher Rothko / DACS, London 2011. **238** Getty Images: Time & Life Pictures (cb). **240-41** © Tate, London 2011: © Andy Warhol Foundation for the Visual Arts, Inc. / ARS, NY and DACS, London 2011. **241** Corbis: Andrew Unangst (cra). **242-43** © Tate, London 2011: © Bridget Riley 2011. All rights reserved, courtesy Karsten Schubert, London. **243** Corbis: Hulton-Deutsch Collection (ca). **244-45** © Tate, London 2011: © Paula Rego 2011. **244** Rex Features: ITV (cra). **246-47** Musée du Louvre: Pierre Philibert. **247** Corbis: Reuters / Alex Grimm (cla).

All other images © Dorling Kindersley
For further information see: www.dkimages.com